# Writing on Hands
## Memory and Knowledge in Early Mode

MW01069376

*Writing on Hands: Memory and
Knowledge in Early Modern Europe*

The Trout Gallery
Dickinson College
Carlisle, Pennsylvania
8 September through 25 November 2000

The Folger Shakespeare Library
Washington, D.C.
13 December 2000 through 4 March 2001

This exhibition was made possible, in part,
by the National Endowment for the Arts,
a federal agency.  Additional support has
generously been provided by the Ruth Trout
Exhibition Fund, The Henry D. Clarke, Jr.
Foundation for the Arts, and Dickinson
College; with the participation of The
Folger Shakespeare Library.

The catalogue was produced by the staff of
The Trout Gallery
Director and Editor, Peter M. Lukehart
Administrative Assistant, Stephanie Keifer
Office Assistant, Carrie Bergman
Copy Editor, Anne R. Gibbons
The catalogue is distributed by
University of Washington Press

Library of Congress
Cataloguing-in-publication data
Sherman, Claire Richter
*Writing on Hands: Memory and Knowledge
in Early Modern Europe*
Claire Richter Sherman, with contributions
by Brian P. Copenhaver,
Martin Kemp, Sachiko Kusukawa, and
Susan Forscher Weiss
"Exhibition dates, The Trout Gallery,
Dickinson College, Carlisle, Pennsylvania,
8 September through 25 November 2000;
The Folger Shakespeare Library,
Washington, D.C.,
13 December 2000 through 4 March 2001"
T.p. Verso includes index.
ISBN 0-295-98072-9
CIP

Cover: Detail from *The Hand as
the Mirror of Salvation*, 1466
Anonymous, Netherlandish (?)
Handcolored woodcut
National Gallery of Art,
Washington, D.C.,
Rosenwald Collection, 1943

# Writing on Hands
# Memory and Knowledge in Early Modern Europe

*Claire Richter Sherman*

*With contributions by*

Brian P. Copenhaver
Martin Kemp
Sachiko Kusukawa
Susan Forscher Weiss

*Edited by*

Claire Richter Sherman and
Peter M. Lukehart

The Trout Gallery, Dickinson College,
with the participation of The Folger Shakespeare Library

Distributed by University of Washington Press
Seattle

# Writing on Hands
# Contents

# Foreword and Acknowledgements
## of The Trout Gallery's Director

"…the soul is like the hand; for the hand is the instrument of instruments."
Aristotle, *De Anima*, 3.8

"…the hand is the instrument of the intellect, and without it [the intellect] nothing good can be created." Giovanni Battista Paggi, in a letter to his brother, c. 1591[1]

If Aristotle's opinion may be allowed to stand for the view of the ancient Greeks, Paggi's rephrasing of the well-known quotation represents a shift in societal values that aptly characterizes the early modern period. Paggi, a painter living in Florence, wrote this letter around 1591 to his brother, a nobleman, who was advocating for painting to be accepted as a liberal art in the city of Genoa. Here, Paggi followed the Roman rhetorician Quintilian and the contemporary polymath Leonardo da Vinci in accepting the paradoxical nature of artistic creation: the hand is simultaneously under the control of the mind and an instrument that transforms the brain's commands into intelligible actions or objects, whether they be military maneuvers, letters, poems, paintings, orations, or mathematical equations.[2] Reading at a distance of 400 years, Paggi's argument seems both quaint and arcane. Why was it necessary to defend the liberality of painting while concurrently denying the manual nature of his profession?

The answers to these questions lead us to one of the principal themes of *Writing on Hands: Memory and Knowledge in Early Modern Europe*; that is, the centrality of the hand to the acquisition and dissemination of knowledge. More than eighty images have been assembled in this exhibition in order to reacquaint the twenty-first-century viewer with the role of the hand in early modern methods of calculation, anatomical nomenclature, solmization (sight singing), memorization of saint's and feast days, as well as in astrology, chiromancy (palmistry), and alchemy. In addition, *Writing on Hands* addresses the relationship between the hand and the brain, sensory perception, the rhetoric of gesture, early forms of finger–spelling for the deaf, morality, and spirituality. The encyclopedic sweep of the exhibition's contents is emblematic of pre-Enlightenment concepts of the ontology of learning. The present-day viewer has first to be (re)introduced to the structure of early modern hierarchies of knowledge and then to be familiarized with theoretical models by means of verbal and visual prompts.

The idea for the present exhibition was first suggested during a conversation with the curator, Claire Richter Sherman, who had just completed research on *Psychology: Understanding Ourselves, Understanding Each Other* for the American Psychological Association. The exhibition was co-organized by the Ontario Science Centre, where it opened in 1991 and then travelled to the Smithsonian Institution's Experimental Gallery in the Arts and Industries Building (1992). Claire was then considering a book concerning the vast array of images of hands with inscriptions that survive from the early modern period, a project that built on years of research she had conducted on illuminated manuscripts of Aristotle.[3] An inherently visual concept, "Writing on Hands" made perfect

1. The original passage reads: "…la mano è istromento dell'intelletto, e senza questo nulla può di buono operare" (Paola Barocchi, ed. *Scritti d'arte del Cinquecento* [Milan and Naples: Riccardo Ricciardi, ed., 1971] 1:201). I would like to thank Sylvie Davidson for her assistance in translating the ambiguous pronoun "questo"; I am grateful to Wendy Lukehart for helpful comments.

2. Quintilian, *Institutio oratoria*, bk. 11, 3:85 (as in *The "Institutio Oratoria" of Quintilian*, trans. H.E. Butler [Cambridge, Mass.: Loeb Classical Library, 1929], 4:289): "As for the hands, without which all actions would be crippled and enfeebled, it is scarcely possible to describe the variety of their motions, since they are almost as expressive as words. For other portions of the body merely help the speaker, whereas the hands may almost be said to speak." I would like to thank Melinda Schlitt for bringing this passage to my attention. For the source in Leonardo's writing, see *Leonardo on Painting*, Martin Kemp, ed. (New Haven and London: Yale University Press, 1985), 35: "Yet words are less noble than deeds; and you, writer on sciences, do you not copy with your hand, rendering what is in your mind, just like the painter.…"

3. For the history of the *Psychology* exhibition, see Claire Richter Sherman, "Beyond the Photo Archive: Imaging the History of Psychology," *Visual Resources* 9 (1993):39-52. For her work on Aristotle, see Claire Richter Sherman, *Imaging Aristotle: Verbal and Visual Representation in Fourteenth-Century France* (Berkeley and Los Angeles: University of California Press, 1995).

sense for translation into an exhibition. For the past three years, Claire has been laboring to perfect the selection of and research on the images that comprise this exhibition, and we owe her our deepest gratitude for organizing such a highly original enterprise.

ACKNOWLEDGEMENTS

An exhibition of this magnitude assumes a vast network of colleagues in order to move from ideation to fruition. Principal among these is the curator, Claire Richter Sherman, who contributed the introductory essay, a staggering 68 single-author entries and 5 collaborative ones, as well as countless hours of editing, organizing, and planning. Claire and I both owe a great debt to her husband, Stanley, who has assisted us with many aspects of the exhibition: measuring images and book openings, proofreading the various versions of the catalogue, and serving as chauffeur and confessor. We are extremely grateful to the authors of the essays and remaining entries: Brian P. Copenhaver, Martin Kemp, Sachiko Kusukawa, and Susan Forscher Weiss. Each of these distinguished scholars contributed to the success and timeliness of the catalogue, this despite the demands of their own academic careers. Claire and I are most grateful to Mimi Cazort for her uncanny ability to track down elusive lenders. In addition, her exhibition, *The Ingenious Machine of Nature* (1996), blazed important new trails that we are happy to follow.

At Dickinson, I am beholden to the senior administrators—President William G. Durden, Dean Neil Weissman, and Treasurer Annette Parker—without whose unflagging support this exhibition would not have seen the light of day. Joanne Gingrich and Miriam McMechen were also instrumental in tracking the budget. Enthusiastic thanks go as well to Corporate and Foundation officers Glen Peterman and Christina van Buskirk for their help and creativity in securing funding.

We are also grateful to our colleagues who proved that humanism is indeed alive at Dickinson College: JoAnne Brown, for information concerning the history of science; Christopher Francese, for his expert translations of difficult passages from Latin and Greek; Robert Leyon, for his assistance with the history of chemistry and alchemy; Blake Wilson, for his patient explanations of the Guidonian hand and early modern music theory; and Chuck Zwemer, whose specialized knowledge of human anatomy helped us avoid many grievous errors of fact. Here I must add a personal word of thanks to my lifelong friend Michael Delluva, whose tenacious pursuit of "the right answer" resolved several conundra raised in this exhibition.

Within The Trout Gallery, I am deeply indebted to my colleagues Sharon L. Hirsh and Melinda Schlitt who steered a smooth course for the exhibition during my absence in fall 1998 and spring 1999. They and I would like to extend heartfelt thanks to our peerless staff, whose energy and indominitability have buoyed every aspect of this exhibition, from its inception to its completion. Stephanie Keifer assisted with every aspect of *Writing on Hands*, from loans and photographs to grants and receptions. She was also responsible for the masterful entry of all editorial changes to the catalogue. She was ably assisted by Carrie Bergman, our extraordinary Gallery intern. Sherron Biddle proved once again to be more than a match for the unforeseeable aspects of the exhibition, safe-guarding the loans, monitoring the lenders' requests, as well as advocating the

programs with members of the scholarly community and the press. Dwayne Franklin took responsibility for the tasteful installation and provided much-needed artistic counsel for the web page. The educational outreach coordinators Martha Metz and Wendy Pires played a central role not only in designing the pedagogical programs, but also in the content of the web page. Our tireless gallery attendants Susan Curzi and Ann Martin contributed significantly to the installation of the exhibition. In addition to the regular Gallery staff, I was pleased to have worked with five outstanding student interns: Sara Adams, Carrie Berger, Matthew Coleman, Tiffany Edwards, Krista Mancini, as well as Dana Intern Ronald Youhouse. The gallery staff has asked that we also offer thanks to our respective families for supporting us as we undertook this venture: it could not have been accomplished without their patience and their encouragement.

One of the great pleasures of this collaborative venture was the opportunity it provided to work with the exceptional administrative staff of The Folger Shakespeare Library. Director Werner Gundersheimer and Chief Librarian Richard Kuhta graciously accommodated our substantial requests for loans and photography. Further, we appreciate the Folger's financial commitment both to the catalogue and to the installation. Curator of Books and Exhibitions Rachel Doggett has set a new qualitative standard for partnerships; intelligent and organized, she made the negotiations and the planning sessions a joy. At the same time, we benefited from the wise counsel of the head of conservation and exhibition preparator extraordinaire Frank Mowery; he was assisted by Linda Blaser, Senior Book Conservator and Linda Hohneke, Conservator. Thanks are also due to Janet Field-Pickering, Head of Education and her staff. Julie Ainsworth, Head of Photography, provided excellent images for the catalogue.

Both The Trout Gallery and The Folger Shakespeare Library would like to acknowledge the generosity of our lenders (beyond the Folger itself): the College of Physicians of Philadelphia, especially librarians Charles Greifenstein and Christopher Stanwood; the Library of Congress, with special thanks to conservator Thomas Albro, II; the National Gallery of Art, in particular curators Margaret Morgan Grasselli, Gregory Jecman, Peter Parshall, and Andrew Robison, as well as special loans coordinator Stephanie Belt; the National Library of Medicine, National Institutes of Health and their registrar Carol Clausen; the Philadelphia Museum of Art, and curatorial intern in the department of Prints, Drawings and Photographs, Wendy Thompson; The Pierpont Morgan Library, especially curator Christine Nelson; and The Walters Art Gallery, with warm thanks to William Noel, Curator of Books and Manuscripts. Finally, we wish to recognize Dr. Kenneth B. Roberts for the important and timely donation of anatomical images he made to The Trout Gallery. We are pleased to present these prints for the first time in this exhibition.

For their essential advice and excellent work, we are grateful to conservators John Hartmann, Brian Howard, and Jane Stewart, as well as case designer Steve Tucker. My staff and I are also beholden to Jason Say and Mike Fiorill for their help with the web page. It was an education for all of us, and we appreciated their patience, a quality matched only by their creative talents. Similarly, we have enjoyed the exchanges with our catalogue designer, Antonio Alcalá, at Studio A. Rarely does one find a designer who understands, and is sensitive to, the scholarly as well as the aesthetic concerns of catalogue production. Finally, we were fortunate to have found a careful editor in Anne R. Gibbons; she kept us all honest.

Just as an ambitious exhibition depends for its success on the talent and determination of the individuals who produced it, so too does it depend for its survival on the generosity of donors and foundations. Thus, The Trout Gallery would like to acknowledge the significant financial support we received from the National Endowment for the Arts, a federal agency, the Ruth Trout Exhibition Fund, The Henry D. Clarke, Jr. Foundation for the Arts, as well as Dickinson College and our partner, The Folger Shakespeare Library.

The exhibition at The Trout Gallery is dedicated to Claire Richter Sherman, who was the intellectual impetus behind the exhibition, and to Ruth Trout for her unswerving support of the high ambitions of the Gallery she and her sister founded seventeen years ago.

Peter M. Lukehart
*Director*
The Trout Gallery

## Foreword of The
## Folger Shakespeare Library's Director

An exhibition about the hand is actually an exhibition about humankind, for the hand functions as metonymy for both mind and body. The higher primates do many interesting things with their hands, but no one would claim for them either the functionality or the gestural range achieved by even the least expressive member of our species. One offers this observation not out of a sense of triumphalism, but simply to acknowledge the inexhaustible interest that hands have held, so to speak, for artists and writers over the centuries.

Now Dr. Claire Sherman, a talented historian of art as well as a reader of long standing at the Folger, has mined the Library's resources as well as other collections for ideas and images of the hand in early modern Europe. Her findings, as one might expect, are rich and varied. Viewers of the exhibition, and of this catalogue, will find themselves indebted to Dr. Sherman for the deftness with which she has picked ideas and images from a vast universe of possibilities, as well as for the clarity of her explanations and analyses.

Thanks are due to the Winton M. and Carolyn Blount Exhibitions Endowment, which has helped to underwrite the installation at the Folger. The Library's Andrew W. Mellon Publications Endowment made a substantial grant towards the cost of the present catalogue. It is also a pleasure to acknowledge the generosity of several lenders to the exhibition at its Washington venue–the Library of Congress, College of Physicians of Philadelphia, The Pierpont Morgan Library, The Metropolitan Museum of Art, National Library of Medicine, and The Walters Art Gallery. The Folger is especially pleased that this project has emerged as a cooperative undertaking between our Library and The Trout Gallery at Dickinson College. It is gratifying that a community of undergraduates and faculty at one of Pennsylvania's outstanding liberal arts colleges will be able to enjoy and benefit from resources such as are usually deployed in major cities like Washington. This collaboration might well point the way in the future for similar shared efforts, both real and virtual, with other institutions.

Werner Gundersheimer
*Director*
The Folger Shakespeare Library

# Curator's Acknowledgements

Claire Richter Sherman would like to thank the following librarians for their help: Chistopher Stanwood and Charles Greifenstein, College of Physicians of Philadelphia; Rachel Doggett and the reading room staff of The Folger Shakespeare Library; Thomas Albro II (retired), Clark Evans, Thomas Mann, Bruce Martin, Gerald Wager, and Raymond White, Library of Congress; Carol Clausen, Stephen J. Greenberg, Philip Teigen, and the staff members of the History of Medicine Division, National Library of Medicine; and Anna Lou Ashby and Inge Dupont, The Pierpont Morgan Library. In London, Stephen Parkin of the British Library and William Schupbach of the Wellcome Institute for the History of Medicine were of great assistance.

She is also indebted to Nadine Orenstein, The Metropolitan Museum of Art, William Noel, The Walters Art Gallery, and Kathleen Brown and John Ittman, the Philadelphia Museum of Art. At the National Gallery of Art, George T. Dalziel, Roger Lawson, Ruth Philbrick, and Anna Rachwald in the library and photo archives were very generous with their help, as were Virginia Clayton, Gregory Jecmen, and Peter Parshall in the department of prints and drawings.

The following professors greatly assisted her with linguistic problems: Albrecht Classen, Luke Demaitre, Christopher Francese, Ellen Ginsberg, Jadwiga Krupski, Deborah Lyons, Paul and Marianne Meijer, and Bernhard B.F.H. Scholz.

Gill Heyert, Bernard Klionsky, Mary Martin McLaughlin, H. Diane Russell, and Bernice Sandler provided encouragement and support. Her husband Stanley M. Sherman gave unstintingly of his time and help throughout the entire project.

Claire Richter Sherman

# Introduction
## *Claire Richter Sherman*

**REGARDING THE HAND**

*Writing on Hands: Memory and Knowledge in Early Modern Europe* examines visual images of the hand, independent of the body, as figures of both generic and individual human identity.[1] From the earliest surviving figurative imagery to the present day, the hand symbolizes human or divine action, power, creativity, and intelligence. The hand stands for both the material, physical aspect of the body, as well as its relationship to invisible, spiritual, and immaterial aspects of human experience. In the ability to touch and grasp, the hand serves as mediator between the individual and the natural world. For example, even in the twentieth century, an image such as M.C. Escher's carefully constructed lithograph shows his hand holding a mirror as the essential instrument for locating his physical presence in space (Fig. 1).

The many words in English and other modern languages derived from the Latin *manus* (e.g., manual, manipulate) show that this root describes the hand as literally and figuratively grasping and guiding the quest for control of all things and knowledge of all kinds. As the most distinctively human and anatomically advanced part of the body, after the head, of which it is the agent, the hand embodies the distinctive attributes of recorder of knowledge, creativity, and skill. In another lithograph by Escher, the *Drawing Hands* (Fig. 2), the artist's hands stand not only for his complete identity as a person, but also for the unique quality of the object that they have produced.

**THE INSCRIBED HAND**

The present exhibition centers on miniatures, prints, or drawings inscribed with, or surrounded by, natural or artifical marks: lines, letters, words, symbols, and/or numbers. The common functions of such representations are to understand, order, and recall abstract concepts related to universal human experience and culture. In other words, images of the hand serve as iconic metaphors, bodily mnemonics, and cognitive maps encompassing processes of association, memory, and recollection. Such images are analogous to visual theories of memory in which the mind, viewed as a blank wax tablet, is imprinted with marks or images that can be accessed, sorted, and retrieved during the process of recollection.[2] In explaining processes of learning and memory, such theories stress the essential role of the mental image as a visual copy of the thing remembered, which enters the brain through sense perception.[3] Memory thus has a visual element, located in a part of the body. But in classical mnemonic theory, memory, one of the five parts of rhetoric, is also an essential part of verbal communication. Linking these two aspects of memory is the sequential association of visual places, based on an architectural model, with striking images fixed upon them. This method was originally designed to aid an orator in organizing and remembering the parts of a speech.[4] For example, a woodcut of 1520 in a treatise by Guillaume Le Lièvre on the art of memory (Fig. 3) illustrates in an ordered sequence ten different locations within a house. Upon them the reader can place appropriate images: visual and verbal guides with which to connect an equal number of subjects.

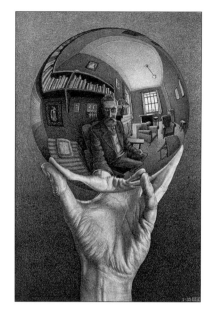

Fig. 1. M.C. Escher, *Hand with Reflecting Sphere*, lithograph, 1935, National Gallery of Art, Washington, D.C., Rosenwald Collection, 1964

For complete references, see the Bibliography of Frequently Cited Sources, 268-269.

1. As a sign of total human identity, as well as a part of the body, the hand corresponds to the rhetorical figure of synecdoche, "understanding one thing with another," or "substitution of part for whole, genus for species, or vice versa." See Richard Lanham, *A Handlist of Rhetorical Terms*, 2d ed. (Berkeley and Los Angeles: University of California Press, 1991), 148.

2. A classic source of this theory is found in Plato, *Theaetetus*, trans. Harold North Fowler (Cambridge, Mass.: Harvard University Press, Loeb Classical Library, 1942), 192. For a discussion of this idea, see Carruthers, *The Book of Memory*, 21-23. See also Jocelyn Penny Small, *Wax Tablets of the Mind: Cognitive Studies of Memory and Literacy in Classical Antiquity* (Routledge: London and New York, 1997).

3. For a basic text, see *Aristotle on Memory*, trans. and ed. Richard Sorabji (Providence, R.I.: Brown University Press, 1972), 2-9.

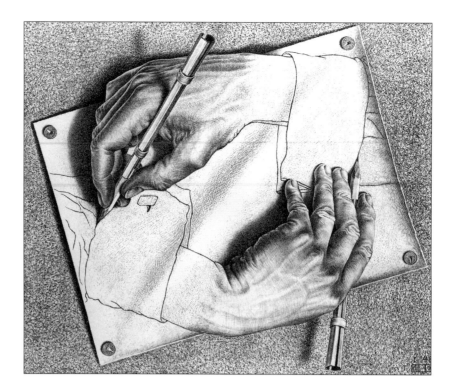

Fig. 2. M.C. Escher, *Drawing Hands*, lithograph, 1948, National Gallery of Art, Washington, D.C., Cornelius Van S. Roosevelt Collection, 1974

4. For a discussion of the Roman sources of the rhetorical tradition, see Yates, *The Art of Memory*, chap. 1; Carruthers, *The Book of Memory*, 71-75, and Small 1997, chap. 8.

5. In an eloquent and fundamental study, to which I am greatly indebted, Karol Berger explored the rhetorical and musical applications of the hand as a memory structure in medieval culture. See "The Hand and the Art of Memory," *Musica disciplina* 35 (1981):87-120.

6. Aristotle's praise of the hand occurs in *Parts of Animals*, trans. A.L. Peck (Cambridge, Mass.: Harvard University Press, Loeb Classical Library, 1937), IV.10 687 a 10. Galen's discussion is found in *On the Usefulness of the Parts of the Body*, trans. and comm. Margaret Tallmadge May (Ithaca, N.Y.: Cornell University Press, 1968), 1:1-21. The exalted view of the hand continues in the famous work of Charles Bell, *The Hand: Its Mechanism and Vital Endowments as Evincing Design* (London: William Pickering, 1833). This work is discussed in John Napier's useful survey, *Hands*, ed. Russell H. Tuttle (Princeton: Princeton University Press, rev. ed., 1993), 9-10.

7. For a study with a similar title, see Katherine Rowe, "'God's handy worke,'": Divine Complicity and the Anatomist's Touch," in *The Body in Parts: Fantasies of Corporeality in Early Modern Europe*, eds. David Hillman and Carla Mazzio (New York and London: Routledge, 1997), chap. 14.

8. For Greek and Roman medical sources for the nomenclature of the hand, see Karl Gross, "Finger," in *Reallexikon für Antike und Christentum*, ed. Theodor Klauser (Stuttgart: Anton Hiersemann, 1969), 7:cols. 909-911.

9. Isidore of Seville, *The Medical Writings*, trans. and comm. William D. Sharpe, *Transactions of the American Philosophical Society* n.s. 2, 54/2 (1964) 1:66-71.

### THE HAND AS A MEMORY STRUCTURE

Like a building, the body can serve as a system of places, as in the *Plutosofia* by Filippo Gesualdo (Cat. 38). Similarly the hand itself forms a complete and familiar visual structure that aids the reader/viewer in mastering all types of knowledge.[5] Unlike imaginary architectural structures, the hand is three-dimensional, easily translatable to an image's planar surface. Moreover, as a system of places, the hand's structure is always available for reference. Anatomically, the hand has a fixed number of parts with distinctive characteristics that follow easily divisible ordering systems, sequences, and subdivisions. For example, the five fingers, their tips, nails, and joints constitute a consistent but surprisingly variable series of mnemonic places in which to deploy letters, words, numbers, images and/or associated concepts (Cat. 56, 64, 2, and 37). Positioning of the fingers singly or in combination, outstretched or flexed, (Cat. 1, 37, and 42) provide patterns of simple or complex combinations of cognitive sequences. Most notably, in his widely influential work, *On the Usefulness of the Parts of the Body*, Galen eloquently expands Aristotle's praise of the hand as "the instrument for instruments" and discusses in detail its anatomical structure and functions, including the workings of each individual finger.[6] In his essay "The Handy Worke of the Incomprehensible Creator," Martin Kemp here examines the effects of these ideas on visual representations of the hand.[7]

Indeed, the naming of the individual digits as part of a fixed series originates in Greek and Hellenistic medical sources.[8] Early medieval works, including the influential writings of Isidore of Seville, continue this practice.[9] Semiotic significance and anatomical properties unite in considering the thumb [*pollex*] the leader and most powerful digit both because of its unique rotating and grasping ability and its position. The second digit, the *index*, is deemed to point toward knowledge.[10] The *medius* [middle] finger was also known as *impudicus* or shameless (so Isidore tells us) because of a certain indecent—and apparently timeless—gesture. The fourth digit was known either as the *medicus*, because of an ancient belief that a vein led directly to the heart, or *annularis* [ring] finger.

Finally, the last one was called *minimus* [smallest] or *auricularis* [ear finger], because of certain cleaning functions it can perform. Thus, correct identification of the fingers is an essential step in constructing a series of memory places.

Furthermore, positions of left and right hands, front and palm sides, and varied patterns of movement lend the hand further flexibility in distinguishing or defining concepts and their relationships. For teaching purposes, the hand is a universal structure common to teacher and student, always available for oral instruction. Sachiko Kusukawa analyzes examples designed for teaching mathematical and calendric calculation known as the *computus* (Cat. 40, 42, and 43). In her essay on "A Manual Computer for Reckoning Time" and entries on "Manipulating Time," illustrations distinguish between left and right hand, palm or exterior sides, names of the fingers, and the joints as essential information for learning and remembering specific concepts. Sometimes, as in computistical and music texts, mnemonic verses, written on the joints of the hand and/or explained elsewhere in the text, reinforce the hand's role as a container, or in Kusukawa's words "a mnemonic table" laying out a complex cognitive sequence (Cat. 42).[11] Ingenious variations in the numbers and lateral or vertical directions of place markers on the hands permit different methods of mnemonic organization (Cat. 37). Once again, the image serves as an instrument uniting verbal and visual communication. In such contexts, the relationship of the decimal structure of mathematical thought to the five fingers of the hand undoubtedly strengthens its value as a mnemonic structure.

### SCOPE OF THE EXHIBITION

*Writing on Hands: Memory and Knowledge in Early Modern Europe* includes many fields of culture. While manuscripts and printed books featuring representations of the hand constitute the predominate media, graphic images of wider subjects produced independently of texts introduce major themes such as palmistry, alchemy, and meditation (Cat. 63, 69, 70, and 74). The date 1466 marks the earliest printed image included in the exhibition. The terminus, 1700, marks the waning of ancient patterns of thought regarding the body as nature's or God's highest creation in favor of a mechanistic world view.[12] The dates of the exhibition also witness the impact of the printed book in promoting the diffusion of all types of knowledge, old and new, rational and irrational. For example, the works of earlier authors such as the Venerable Bede, Petrus von Rosenheim, and Hugo Spechtshart, known from manuscripts (Cat. 40, 34, and 47), enjoyed renewed influence in print format. The development of accompanying visual imagery by increasingly sophisticated print techniques is directly relevant to the underlying thesis of the exhibition that visual representation plays a vital role in cognitive processes. Departures from the exhibition's time frame, like the illustrations in an eleventh-century manuscript (Cat. 40), shed light on the medieval roots of developments in printed books (Cat. 43). Later representations in anatomical engravings of the eighteenth century (Cat. 15 and 16) indicate the persistence of

10. For a history of the use of the index finger as the symbol for finding information, see Paul McPharlin, *Roman Numerals, Typographic Leaves, and Pointing Hands: Some Notes on Their Origin, History, and Contemporary Use* (New York: The Typophiles, 1942), 47-76.

11. Kusukawa, "A Manual Computer for Reckoning Time," 28-34; Weiss, "The Singing Hand," 35-44.

12. Cazort, "The Theatre of the Body," in *The Ingenious Machine of Nature*, 14-15.

Fig. 3. Anonymous, French, *House with Ten Places*, woodcut. From Guillaume Le Lièvre, *Ars memorativa Gulielmi Leporei Avallonensis* (Paris: Jodocus Badius Ascensius, 1520), fol. 9. History of Medicine Division, National Library of Medicine, National Institutes of Health, Bethesda, Maryland

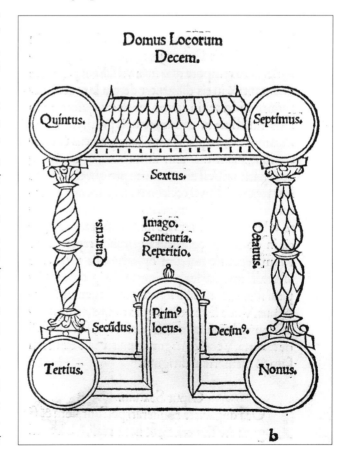

conventions, as well as departures in new directions.

While the selection of individual objects was not based on art-historical grounds, the exhibition includes many works of aesthetic significance. Two single handcolored woodcuts dating from the decade after the invention of printing are important examples of this genre (Cat. 1 and 41), as are two folios from a blockbook (Cat. 64). Although many images, particularly in the six incunables and twelve early sixteenth-century books are by unknown artists, an exception is an arresting woodcut by Albrecht Dürer. The artist combines a diagram of the brain with an individual portrait of his friend Willibald Pirckheimer (Cat. 26). Indeed, the portrait, in which the hand serves as an essential sign of professional status, appears in sixteenth- and seventeenth-century images of the distinguished anatomists Andreas Vesalius and Giulio Casserio (Cat. 5 and 6) and the engraver Wenceslaus Hollar (Cat. 9). Of exceptional interest are two portraits of women. The first is a tiny self-portrait by the calligrapher Esther Inglis (Cat. 8) in a manuscript from her pen; the second, an author portrait by Pierre Woeiriot of Georgette de Montenay (Cat. 76, Fig. 37). In both the pen transmits the work of divinely inspired writing, uniting hand and spirit in praise of God.

Independent graphic images by Dürer, Lucas van Leyden, Marcantonio Raimondi, Hendrick Goltzius, and Rembrandt (Cat. 28, 29, 51, and 74) contribute to a wider understanding of themes important not only to the exhibition, but also to the intellectual and social life of early modern Europe. These artists cast new light on beliefs held by various scholarly and religious circles. Other prints from paintings or graphic images after Bruegel, Goltzius, and Jacques de Gheyn II (Cat. 69, 30, and 63) indicate the popularity and diffusion of imaginative and humorous visual representations regarding alchemy, sexuality, and palmistry. An engraving by the only female artist in the exhibition, Diana Scultori, displays a complex lunar calendar (Cat. 45). The work of Matthäus Merian, a leading master of early seventeenth-century engraving, illuminates two emblem books (Cat. 77 and 81), as well as Robert Fludd's lavishly illustrated encyclopedia (Cat. 60 and Figs. 16-18). Among the highlights of baroque anatomical illustrations are two engravings by Abraham Blooteling after the designs of Gérard de Lairesse (Cat. 25) in Govard Bidloo's anatomical atlas of 1685. Jan Wandelaar's remarkable collaboration with his patron Bernhard Siegfried Albinus led to another landmark in anatomical illustration (Cat. 16).

The exhibition also features books that represent significant milestones in Western culture. Gregor Reisch's *Margarita philosophica* (The Philosophical Pearl) of 1503 (Cat. 27) is the first published encyclopedia. Its ambitious program of illustrations undoubtedly contributed to its continued popularity in ten subsequent editions. Andreas Vesalius' *De humani corporis fabrica* (*On the Fabric of the Human Body*) of 1543 is the first anatomical atlas famed for its woodcuts which were sources of accurate anatomical description (Cat. 13 and 19). Engravings by Diego de Astor the Elder provide the guides for the manual alphabet in the first published treatise on teaching the deaf to speak (Cat. 53), Juan Pablo Bonet's 1620 treatise, *Reduction de las letras, y arte para enseñar a ablar los mudos*. William Harvey's revolutionary discovery of the circulation of the blood in 1628 demonstrates the proof of his discovery by the only two visual images in his treatise (Cat. 23). Another "first" is Johann Amos Comenius' perennial best-seller for over three hundred years. First published in 1658, the *Orbis sensualium pictus* (*The World Seen through Pictures*) is a visual encyclopedia for teaching children

Latin (Cat. 33) through the extensive program of images. In the first textbook on physiology, René Descartes' *De l'homme* (*On Man*), the diagram of *The Sensation of Heat* is again a means of demonstrating the author's method.

Although the exhibition cannot explore interesting interactions among authors, publishers, and artists, it is possible to indicate briefly some personal and intellectual relationships among them. During a diplomatic mission abroad, William Harvey (Cat. 23), temporarily serving as physician to the Earl of Arundel, met Wenceslaus Hollar (Cat. 9), whom the Earl, a noted art collector, brought to England. During his travels in Holland, Comenius (Cat. 33) encountered Descartes (Cat. 32). At the heart of European intellectual life, Marin Mersenne (Cat. 50), a close friend of Descartes, was a declared opponent of Robert Fludd's ideas (Cat. 60 and 83). William Harvey's medical diploma from the University of Padua was signed by Giulio Casserio (Cat. 6, 21, and 22). While Harvey and Fludd, who were colleagues, apparently held disparate intellectual positions, the latter was the first to accept in published form (Cat. 83) the former's revolutionary discovery of the circulation of the blood.

An underlying leitmotif of these personal relationships is the effect of the religious and political conflicts of the sixteenth and seventeenth centuries on the lives of writers and artists. The perennial search for patronage was greatly complicated by the ever-shifting balance of power. Humanists, physicians, and intellectuals were constantly uprooted by the effects of the Reformation and Counter-Reformation. Among those most tragically affected were Leonardo, Comenius, Inglis, and Hollar.

### ORGANIZATION OF THE EXHIBITION

The exhibition has six major parts, each divided into several themes. The first, "Reading the Writing on Hands," introduces two main topics. "Mentor, Metaphor, and Map" considers the hand as a visual symbol for the whole person, a memory structure located in the material body, and a spatial form that creates a map for acquiring knowledge of all kinds. The second theme, "Identity, Creativity, and Intelligence," examines the hand as a distinctively human attribute connected with intellectual and manual mastery, including writing and making art. Part II, "The Handiwork of the Creator," views the hand as a physical structure. The first theme, "The Noblest Creation," focuses on anatomical representations of the whole body as the highest invention of God or nature. Then comes consideration of the design of the hand as "The Instrument of Instruments." Part III, "Messengers of the World," concerns the relationship of the hand to the brain, senses, and memory. "The Sense of Touch" examines a fundamental feature of perception, while a second topic focuses on the hand's role as a means of "Inscribing Memory." Part IV, "Knowledge on Hand," views the hand as a teaching device. "Manipulating Time" embraces arithmetic and calendrical calculation. "Steps to Singing" involves instruction in musical theory and practice, specifically the body of knowledge called the Guidonian Hand. "Companion of Eloquence" examines rhetorical teaching and instruction of the deaf. Despite their diverse subject matter, works in Part IV employ coded systems of gesture as instruments of visual communication. In her essay "The Singing Hand" and entries on "Steps to Singing," Susan Forscher Weiss emphasizes the ties between written tradition and oral practice, as well as the interrelationship between texts and nonverbal graphic symbols. Part V of the exhibition, "The Whole World in the Hand," first investigates the traditional analogy of

13. For recent studies of artists' instruction in anatomy by Mimi Cazort and Monique Kornell, see ibid., 23-31, and 43-70.

14. Kemp, "The Handy Worke of the Incomprehensible Creator," 26.

15. Kusukawa, 29.

16. Martin Kemp, "Medicine in View: Art and Visual Representation," in *Western Medicine*, ed. Irvine Loudon (Oxford: Oxford University Press, 1997), 1-22.

17. For an analytical discussion of the role of diagrams in the history of science, see John E. Murdoch, *Album of Science, Antiquity to the Middle Ages* (New York: Charles Scribner's Sons, 1984), parts 1-3.

"The Body as Microcosm" to illustrate the principles underlying the harmony and order of the universe. Next, in his essay "A Show of Hands," and the entries "Signs Upon the Hand" (written with Claire Richter Sherman), Brian P. Copenhaver analyzes how the hand is regarded as a microcosm of the body. Copenhaver explores the ancient, but always popular, theories and practice of divining character and fate in chiromancy, more familiarly known as palmistry. "The Hand of the Philosopher," the section on alchemy, discusses another area associated with the fundamental human desire to master nature's secrets. In a different but related context focused on spiritual values, Part VI, "Guiding Hands," concentrates on religious and moral instruction. Images as "Defenders of Faith" occur in single prints and texts. From the late medieval period to the Counter-Reformation visual representations, including emblem books, offer techniques for meditation and spiritual practices that lead the individual to inner knowledge of God. In the last section of the exhibition, "Guardians of Morals," the emblem book, combining mottoes, pictures, and an edifying message, features varied secular works on politics and ethics.

This thematic organization should not obscure the overlapping nature of certain basic concepts. Teaching, learning, and remembering are functions common to all sections, but they differ in language, audience, patronage, popularity, and time frame. Also different are the types of writing, or graphic symbols, inscribed on, or around, the hand. Examples include musical notes or numbers (Cat. 46), letters or words (Cat. 56 and 64), or graphic symbols for the planets and metals (Cat. 73). Sometimes, as in anatomical representations (Cat. 19 and 24), the letters written on parts of the body refer to information contained elsewhere in the text and do not form a complete sequence on the hand itself (Cat. 23). In other contexts, such as emblem books, verbal information is not located on the hand itself but above or below the visual representation (Cat. 77).

Functions of the hand vary according to context. In addition to place marking and mnemonic tables, disembodied hands serve as pointing devices (Cat. 23) or as performers of essential actions (Cat. 76) associated with a divine personage (Cat. 78), secular authority (Cat. 79), or interaction between the two (Cat. 83). Chiromantic works examine the hand's natural shapes and lines (Cat. 62) as indicators of fate and fortune. In other spheres, the fingers themselves are the bearers of meaning as makers of gestures comprehensible to the viewers (Cat. 42, 53, and 54).

The exhibition addresses only in a limited way two major themes generally associated with the hand. The first is its expressive character, a feature of many famous works of art. Indeed, both the anatomical and eloquent properties of the hand occur in many textbooks for instructing artists from the Renaissance to the present day.[13] A related subject is gesture, another universal characteristic of visual communication, that differs according to culture. The exhibition's focus on the memorial and didactic functions of the hand necessarily restricts examination of these broad and intensively studied topics. Yet the theme of the artist's hand, explored in Part I, touches on expression, identity, and training. Furthermore, the role of the artist in collaboration with anatomists forms an important leit-motif in Part II on "The Handiwork of the Creator." Martin Kemp points out that anatomical depictions have expressive qualities consistent with the high estimation that the hand enjoyed in philosophical and medical thought.[14] Consideration of gesture as part of coded sign systems finds a place in Part IV of the exhibition, especially the sections on "A Manual Computer for Reckoning Time" and

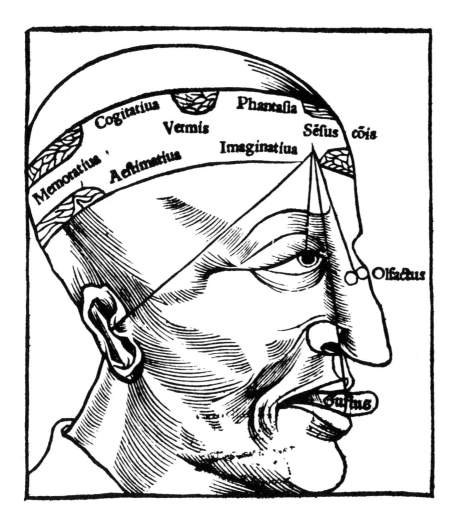

Fig. 4. Anonymous, French, *Imagination, Cognition, Memory and the Senses*, woodcut. From Guillaume Le Lièvre, *Ars memorativa Gulielmi Leporei Avallonensis* (Paris: Jodocus Badius Ascensius, c. 1520), fol. 4v. History of Medicine Division, National Library of Medicine, National Institutes of Health, Bethesda, Maryland

"Companion of Eloquence." In different ways each explores gesture as intrinsic to visual communication. For example, both groups consider a strategy of associating numbers with letters of the alphabet in a system of hand gestures intended to create a secret language.[15]

### TYPES OF VISUAL REPRESENTATIONS

Throughout the exhibition the images selected comprise various pictorial modes. As Kemp has stated, visual representation forms part of a complex cultural and social nexus. Major elements include the author of a text or image, the medium and method of production, the makers of images, and their intentions, the audience, and contemporary reception.[16] Each image results from its maker's choices and selections within a set of contemporary artistic and intellectual conventions governing the communication of information. Visual representations range from simple diagrams of specific bodily functions, such as the location of the senses within the brain (Fig. 4) to complex mnemonic or alchemical symbolic systems (Cat. 72).[17] Almost all of them are connected with verbal information to form changing structures of meaning relating to things seen or known. In all cases, visual representation serves as an essential component of cognition and communication. The essential role of diagrams in promoting comprehension of concepts, both simple and complex, is evident in "Knowledge on Hand," dealing with reckoning time and music, as well as in chiromancy, which has as its theme, "Signs upon the Hand." The earliest known texts in these three fields were originally composed without visual images. Deemed

**CAPVT PRIMVM:**

PRIMA PARS ORATIONIS,
NOMEN: Significatur per Cu-
ratum( quem parœcianū vocant)
de mūdanis & cæleftibus /corpo
rib9 ac rebus/palpabilib9 & ima-
ginabilibus prædicantem. Quod quidem hac figu
ra fubfequenti & difticho adiecto non obfcure o-
ftenditur.

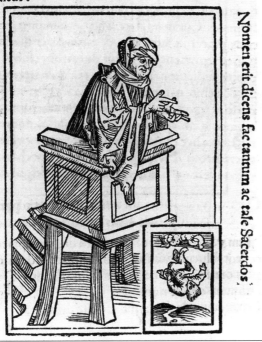

Fig. 5. Anonymous, French or German, *A Preacher Teaching Grammar*, woodcut. From Matthias Ringmann, *Grammatica figurata* (Saint-Dié: Gymnase vosgien, 1509), fol. 7v. New York Public Library, Special Collections

18. See *Right & Left: Essays on Dual Symbolic Classification*, ed. Rodney Needham (Chicago and London: University of Chicago Press, 1973), especially Geoffrey Lloyd, "Right and Left in Greek Philosophy," 167-186.

19. See "Hand Gottes" and "Handgebärden" in *Lexikon der christlichen Ikonographie*, ed. Engelbert Kirschbaum (Rome: Herder, 1970), 2:cols. 211-216.

20. For a discussion of this point, with corroborating images, see Horst Wenzel, *Hören und Sehen, Schrift und Bild* (Munich: Verlag C.H. Beck, 1995), 78-80.

essential for comprehension and memory, diagrams of the hand were added and copied in subsequent manuscripts and continued for centuries in printed books (Cat. 40, 46, and 65).

Also worth noting is that medieval and later representations do not always favor the right hand, associated in many cultures with positive values, while the left is usually linked to negative ones.[18] Of course, within a Christian context, when the hand depicted signifies a divine power, the right is chosen (Cat. 78).[19] Yet, many other types of visual depictions, including hands used for meditation (Cat. 75) or music (Cat. 47) favor the left. One reason for such a preference is that the teacher's or reader's right hand probably pointed to the places on the left assigned to locating certain stages of a conceptual sequence.[20] A visual example of a cleric speaking from a pulpit in a woodcut from Matthias Ringmann's *Grammatica figurata* of 1509 shows the preacher using his hands in this way to make his points (Fig. 5).[21] In chiromancy (palmistry) the left hand was considered a more reliable source of information about an individual; used less than the right, its natural, revealing lines were clearer. A separate, and more negative, connection occurs in the second version of Johann Hartlieb's blockbook on chiromancy dating from about 1475 (Cat. 64A), where the left hand is consistently associated with females and the facing right one (Cat. 64B), with males. Except for texts where a series of views of the hand was necessary, as in computistical treatises (Cat. 42A and 42B), the hand's palm side was chosen for representation, as the interior surface permitted easier identification of the essential parts than the exterior.

Also notable is agreement by scholars that oral practice, passed on from generation to generation, constitutes the source of the hand's use as the instrument of communication and knowledge in finger-reckoning, palmistry, and possibly sign language for the deaf. This hypothesis derives from a lack of specific written evidence in classical texts about these practices.[22] Although medieval manuscripts with verbal and visual information in these areas addressed relatively narrow circles of readers, the oral nature of their origin presumes that the practices were widely shared by literate and illiterate circles alike. With the advent of printing, cheap copies and vernacular translations of chiromantic and other texts illustrated with inexpensive woodcut diagrams (Cat. 62 and 67) extended the audiences for such works.

Furthermore, oral and auditory practices combined with verbal and visual information for teaching purposes. Exercises not only in music, but also in grammar and religion, apparently encouraged vocal repetition of cognitive sequences together with touching the correct places on the hand. As Kusukawa points out, arithmetic and music were part of the medieval quadrivium curriculum, as indeed was grammar.[23] Not surprisingly, textbooks with images of the hand designed as pedagogical devices flourished for centuries (Cat. 47).[24]

**SUMMARY**

The exhibition focuses on the hand as a meeting place of matter, mind, and spirit. Identification of the hand as a metaphor for the whole person, the location of creative intellectual and manual skills, and sites of knowledge and memory unifies the first groups of images. The exhibition's second focus is the hand as part of the body's material structure as the noblest creation of God and Nature. Next, matter and mind working together unify the hand's role in transmitting perceptions of the outside world and inscribing them in memory. Mind comes to the fore in discussing the hand as a means of creating knowledge in calendrical calculation, teaching singing, and enhancing visual communication in rhetorical expression and instruction of the deaf. Matter and spirit unite in conceptualizing the hand as a microcosm of the body. The hand's natural signs, if properly read, reveal profound knowledge of an individual's character and fate. In a different light, the skilled hand of the philosopher acting as alchemist claims to combine knowledge of the material world and spiritual enlightenment in illuminating the deepest secrets of nature. Finally, the hand as spiritual guide points the way to religious practice and to ethical goals. Throughout the exhibition, images of the hand play a vital role in interpeting the search for achieving knowledge of the self and interpreting universal human experience.

21. The woodcut on fol. 7v. uses the figure of a cleric to represent the first of eight parts of speech, the noun, in this inventive text intended to teach students the principles of grammar. Each part is depicted by a different class of society engaged in a pursuit associated with his or her rank. Ringmann uses a playful, humorous approach to forge the connection between the function and properties of each of the eight parts. The cleric depicted speaks of the forms of conduct that distinguish heaven and hell, as exemplified by the humorous small image at the bottom of the illustration, who, unceremoniously expelled from the higher realm, flies through the sky.

22. For a discussion of these points, see Karl Menninger, *Number Words and Number Symbols: A Cultural History of Numbers*, trans. Paul Broneer (New York: Dover Publications, 1992), 201; Charles Burnett, "The Earliest Chiromancy in the West," *JWCI* 50 (1987):189; and Kusukawa, 29 and Weiss, 37.

23. Kusukawa, 31.

24. Weiss, 176.

# "The Handy Worke of the Incomprehensible Creator"
## *Martin Kemp*

1. Aristotle, *Problemata*, 30.5 955$^b$23; and *De anima*, 3.8 432$^a$1. A masterly review of texts on the hand is provided by Schupbach, *The Paradox of Rembrandt's "Anatomy of Dr. Tulp."*

2. For this topos, see Michael Baxandall, *Giotto and the Orators* (Oxford: Oxford University Press, 1971), esp. 16.

3. John Banister, *The Historie of Man, Sucked from the Sappe of the Most Approved Anathomistes* (London: John Daye, 1578), fol. 31.

4. Aristotle, *De partibus animalium*, 4.10 687$^a$5-8.

5. Ibid., 4.10 687$^a$8-687$^b$24.

The wonderfully prehensile dexterity of the hand had ensured its status as the "instrument of instruments" from the earliest writings on the science of the human body. The classic statements, cited and recited throughout the early modern period, were framed by Aristotle. From Aristotle came the repeatedly reworked topos that "the hand is for the body as the intellect is for the soul." In his *Problemata* the hand and the intellect are categorized as the two "inner instruments with which we use outer instruments," while in *De anima* the hand is defined as the "instrument with respect to instruments" just as the "intellect is a form with respect to forms"—form being understood in the metaphysical sense as the essence that gives shape to things.[1] The mechanism of the hand was seen as perfectly designed for *apprehensio*, that is to say "grasping," and it is fitting that "apprehension" in Latin as in English came to assume the dual meaning of taking hold and becoming cognizant of new ideas. When in the Renaissance an artist like Giotto was praised for *manus et ingenium* [hand and innate talent], the two Aristotelian instruments of physical and mental "apprehension" were seen as operating in special concord.[2] The woodcuts and engravings in this exhibition bear eloquent witness to this concord, embodied in depictions of the very organ that best displays what John Banister termed "the handy worke of the incomprehensible Creator."[3]

The hand was seen from the first as distinguishing "man" from the animals no less definitively than the human faculty of reason separated the human mind from that of the brutes. Indeed, as Aristotle reported, Anaxagoras went so far as to deduce "that it was through having hands that man became the intelligent animal."[4] However, Aristotle himself preferred to regard the endowment from the alternative perspective, arguing that "man received hands because he was the most intelligent," on the grounds that "nature, like an intelligent person, always distributes instruments according to the recipient's ability to use them." It is, for example, wiser to give a flute to one who can play it than to one who cannot. Animals, accordingly, have been given simple instruments because their intellects could not handle anything as adaptable as the human hand. According to Aristotle's elegant formulation,

> Animals have one defence which they cannot exchange for another; they must sleep and do everything without, as it were, taking their sandals off; never lay down their bodily protection, nor change whatever weapon they happen to have. But a man can have many defences and always change them, and can have any weapon he pleases on any occasion. For the hand is a claw and a hoof and a horn, and a spear and a sword, and any other weapon or instrument whatever.[5]

The hand was no less adept in the arts of peace than those of war. It served, not least, as a prime instrument of civilized communication through the medium of oratory. Words were the first material of rhetoric, but the wooden orator would be ineffectual, however persuasive the words. Among the visual resources available to the speaker, such as bodily posture and the use of the toga, the hand held a special place. The handbooks of rhetoric, above all, Quintilian's *Institutio oratoria*, recognized that hand gestures "are almost as

expressive as words."[6] Quintilian accordingly outlined a repertoire of speaking signs, from the general and relatively natural, such as the clenched fist, to very elaborate and conventional motions that served as an artificial language. At their most effective, the visual signs and words acted in concert to convey what Leonardo was to call "*il concetto dell'anima.*" The classic formulation was Cicero's: "Every motion of the soul has its natural appearance, voice and gesture, and the entire body of a man, all his facial and vocal expressions, like the strings of a harp, sound just as the soul's motion strikes them."[7] Extending Cicero's analogy, we may say that the hand of the skilled orator is a musical instrument through which the soul transmits its varied tunes.

Alongside their philosophical definition of the hand's status in human affairs, the ancients also provided the stock point of reference for the wonderful anatomical complexity of its mechanism, most notably in the *De usu partium* of the Alexandrian doctor and polymath Galen. According to Galen's intensely teleological view of form and function, "Nature [decreed] that as nothing might be wanting, neither should anything be too much"—to quote Banister's sixteenth-century paraphrase.[8] Thus each tiny detail of form was perfectly created for its function, with no deficiencies and no superfluities. The minutely complex relationships between the muscles, bones, tendons, and ligaments of the hand comprised such a wonderful device as to be "amazing and indescribable." "No words can anyway explain accurately things perceived through the senses alone. Yet one must try to describe them, for until their construction has been explained it is not possible to do justice to Nature's artistry."[9]

A significant part of the problem of functional description for Galen and the Galenic tradition arose from his distrust of illustration. It was this distrust that Leonardo aimed to combat in his superb depictions of human anatomy. As he wrote in a memorandum on a sheet of studies of the heart, "O writer, with what words, will you describe with similar perfection the entire configuration which the drawing does here?"[10] Appropriately, it was Leonardo who was the first to do full visual justice to the Galenic miracle of form and function found in the human hand.

A relatively systematic series of drawings of bones and muscles of the hand dates from around 1510, when Leonardo was aiming to "complete all this anatomy."[11] His intention was to furnish a basic scheme of eight demonstrations, comprising the bones, the binding tendons and ligaments, the muscles, the deep tendons of motion that operate the tips of the finger, the tendons of the lower joints of fingers, the nerves, the veins and arteries, and the superficial anatomy of the whole hand. If we add that he also aspired to compare the hands of an old man, a young man, and a child, with the proportional measures in each case, as well as depicting all the muscles as "threads . . . in order that one should know what muscle goes above or below another muscle" and drawing all the bones separated from each other in "exploded" diagrams, we may gain some idea as to why the sequence remained incomplete. Yet Leonardo being Leonardo, he was not even content to limit his investigations to the marvelous mechanics of the hand's operation. Characteristically, he tries to use his understanding of the pathways of the nerves to explain the illusion that if a small object is placed between two crossed fingers it "appears to be two things." He also proposes more speculatively to "see if it is credible that this sense [touch] is affected in the soul of an organ-player at such moments as he concentrates on the sense of hearing."[12]

6. Quintilian, *Institutio oratoria*, 86. See Fritz Graf, "Gestures and Conventions: The Gestures of Roman Actors and Orators," in *A Cultural History of Gesture*, eds. Jan Bremmer and Herman Roodenburg (Ithaca, N.Y.: Cornell University Press, 1991), 15-35.

7. Cicero, *De oratore*, 3.216.

8. Banister 1578, fol. 31. For Galen on the hand, see Karl Gross, "Galens teleologische Betrachtung der menschlichen Hand in *De usu partium,*" *Sudhoffs Archiv* 58 (1974):13-24.

9. Galen, *De usu partium*, 17:1, 17.

10. Leonardo, Windsor, Royal Library, fol. 19071; Kenneth Keele and Carlo Pedretti, *Leonardo da Vinci: Corpus of Anatomical Drawings in the Collection of Her Majesty the Queen at Windsor Castle* (New York: Harcourt, Brace Jovanovich, 1980), cat. 162r.

11. Windsor 19016r.; Keele and Pedretti, 1980, cat. 150.

12. Windsor 19012v.; Keele and Pedretti, 1980, cat. 142v.

13. Windsor 19009r.-v.; Keele and Pedretti, 1980, cat. 143r.-v.

14. Such terms are found throughout his writings on flight, but see especially the codex in the Biblioteca Reale, Turin: *Codice sul volo degli uccelli e varie altre materie,* eds. T. Sabbacknikoff, G. Piumati, and C. Ravaisson-Mollien (Paris: Quantin, 1893), fols. 6v., 14v., 15v., and 18.

15. Windsor 19115; Keele and Pedretti, 1980, cat. 114v.

16. Martin Kemp, "The Inventions of Nature and the Nature of Invention," in *Leonardo, Engineer and Architect,* ed. Paolo Galluzzi, exh. cat. (Montreal: Museum of Fine Arts, 1987), 144.

17. Andreas Vesalius, *De humani corporis fabrica* (Basel: Johann Oporinus, 1543), vol. 2, chap. 43, 305-306.

A double-sided sheet from the series in the Royal Collection at Windsor (Cat. 17) brooks no rivals in capturing the sheer beauty of the devices of chords and levers through which the force of the muscles is translated into mellifluous action.[13] Leonardo explains that there are four principal movements of the hand from the wrist—inward, outward, and from side to side. From these four basic actions are compounded "composite motions" that are "infinite from being made throughout the continuous quantity of the space interposed between the four principal movements." And within the hand itself, "each finger possesses in itself circular motion with its tip . . . because there are four tendons" —adding another dimension to its infinite continuity of movement in space. Perhaps the most remarkable of the ingenious contrivances to this end is the penetration of the superficial flexor-tendon (which passes to the penultimate joint in each finger) by the deep flexor-tendon, which slips between the bifurcation in the upper tendon to its point of attachment at the tip of each finger. In the inset drawing in the upper center of the recto of the sheet, Leonardo illustrates this remarkable arrangement from a lateral view. On either side of his clarification of this mechanical marvel, he squeezed in a revealing note: "Ensure that the book on the elements of mechanics with its practical applications shall precede the demonstration of the movement and power of man and other animals, and accordingly these will enable you to prove your propositions."

It was in this spirit that Leonardo sought anatomical-cum-mechanical parallels between the hand and comparable organs in animals, above all in the wings of large birds. He speaks of the "fingers," "thumb," "hand," "elbow," and "shoulder" when he investigates the anatomical mechanics of bird wings.[14] When he strove on his own account to contrive a flying machine—"the great bird"—he could do no better than to obey the principles of natural design. In agreement with Galen, he asserted that "although human ingenuity makes various inventions . . . it will never discover inventions more beautiful, more fitting or more direct than nature, because in her inventions nothing is lacking and nothing is superfluous."[15] This teleological stance obviously posed the stiffest challenge for the inventor, not least in the contriving of prosthetic devices. The goal, as in Ambroise Paré's artificial hand (Cat. 20), was not so much the literal imitation of the flesh-and-blood organ—which was manifestly beyond human ability—but to work in an analogous way to the Creator, obeying his principles, so that the human inventor may assume his true role, in Leonardo's words, as "the greatest instrument of nature" in fabricating an infinite variety of compounds from natural things.[16]

Given the reverence for the hand that the Renaissance inherited from antiquity, it is unsurprising that Vesalius should choose to be portrayed in the *Fabrica* (Cat. 5) with a dissection that demonstrates the flexor-muscles and flexor-tendons in the forearm and hand. In his own left hand he holds the corpse's elbow with a strong, concerted grip, while with the thumb and index finger of his right hand he delicately draws aside the belly of the *flexor digitorum superficialis* to disclose the interpenetrating tendons of the fingers. Even in his early *Tabulae sex* in 1538, Vesalius had shown one of the skeletons with its hand raised to display the opposition of the thumb and fingers, a specifically human characteristic, while in the great series of musclemen in the *Fabrica* no subject is accorded more care and attention than the musculature of the hand. In the text of the *Fabrica* he specifically cites Galen to the effect that the arrangement of the tendons in the fingers is "a peculiar and rare occurrence," testifying to

"the marvelous labor of the supreme Creator *[Opifice]* of the world."[17] One witness of a Vesalian dissection performed in Bologna in 1540 specifically recalled the anatomist demonstrating "how the lower ones [tendons] tend to the first joints, the upper ones to the second and third joints, and always pass through the first ones. Certainly this was very beautiful to see."[18]

With this tradition in mind, it is not hard to understand why Dr. Nicholas Tulp in Rembrandt's great group portrait of 1632 (see Flameng's print, Cat. 7) should be demonstrating precisely the mechanism that had so fascinated Galen, Leonardo, Vesalius, and their successors. With the forceps in his right hand, Dr. Tulp holds up the *flexor digitorum superficialis,* while his left eloquently demonstrates the opposing action of thumb and index finger that so declares the subtlety of the hand as an instrument—much to the urgent fascination of the three witnesses immediately behind the corpse.[19] The tone of the portrayal is entirely in keeping with the Aristotelian and Galenic traditions, as fully represented in Dutch seventeenth-century medical writings. A nice précis of the main arguments, relying upon translations and paraphrases from Andreas Laurentius' *Historia anatomica humani corporis* (1559) and Caspar Bauhin's *Theatrum anatomicum* (1605), is found in Helkiah Crooke's Μιχροχοσμογραφια *(Mikrokosmographia). A Description of the Body of Man...Collected...Out of All the Best Authors of Anatomy,* published in London in 1615.[20] Although "man" had been expelled naked from the Garden of Eden, God had not left us helpless, arming us

> with two wondrous weapons, which he hath denied to all other living
> creatures, Reason and the Hand. His [man's] reason is the storehouse
> of all arts and sciences. . . . The hand is an instrument, but as it is the
> first instrument so it is the framer, yea and employer of all other instru-
> ments. . . . By the helpe of the hand Lawes are written, Temples built
> for the service of the maker, Ships, houses, instruments, and all kind of
> weapons are formed. I list not to stand upon the nice skill of painting,
> drawing and carving and such like right noble Artes, whereby many of
> the Ancients have made their names honorable unto us, yea and eternized
> them to the worlds end. By our hands we promise, we call, we dismisse,
> we threaten, we intreate, we abhorre, we feare, yea and by our hands we
> can ask a question.[21]

Crooke explains further:

> For the structure if it be diligently attended, it will imprint in us an
> admiration of the wonderfull skill and workemanship of Nature and it is
> on this manner. Because the Hand was the most noble and perfect organ
> or instrument of the body. . . . [This progresse and insertion of these
> [flexor] muscles is an admirable and strange worke of Nature: for they
> are so severed, that the fingers in their motion might orderly follow one
> another, and each of them bend inward.][22]

There is no well-informed treatise of anatomy in the post-Vesalian era that fails to delight in what John Ray called "this superlative instrument."[23] In particular, the configuration of the tendons of the finger joints was invariably the subject of careful exposition in the illustrations of the anatomical picture books. Giulio Casserio, who had already published a book on the extraordinary organ of hearing in 1601, provided demonstrations of the nerves of the hand in his *Pentaestheseion . . . de quinque sensibus liber* (Cat. 21) in 1609 and vivid illustrations of the tendons in his *Tabulae anatomicae* (1645 ed.; Cat. 22) of 1627 that were

18. Baldasar Heseler quoted in Ruben Eriksson, *Andreas Vesalius' First Public Anatomy at Bologna 1540* (Uppsala: Almqvist and Wiskells, 1959), 97.

19. Schupbach, *The Paradox of Rembrandt's "Anatomy of Dr. Tulp,"* esp. 52-56. For a good recent discussion of the painting in its historical context, see Norbert Middelkoop in *Rembrandt under the Scalpel,* exh. cat. (The Hague: Mauritshuis, 1998), 9-38.

20. Helkiah Crooke, Μιχροχοσμογραφια *(Mikrokosmographia). A Description of the Body of Man . . . Collected...Out of All the Best Authors of Anatomy* (London: Cotes and Sparke, 1615).

21. Ibid., 729.

22. Ibid., 730-731, 787.

23. John Ray, *The Wisdom of God Manifested in the Works of Creation* (London: Samuel Smith, 1701), 286.

24. For Lairesse, see Lycle de Vries, *Gérard de Lairesse* (Amsterdam: Amsterdam University Press, 1998).

25. William Paley, *Natural Theology; Or Evidence of the Existence and Attributes of the Deity,* 12th ed. (London: J. Faulder, 1809), 143-144.

widely diffused with other of Casserio's plates in Adriaan Van den Spieghel's (Adrianus Spigelius) *Opera quae extant omnia.* To underline the now-commonplace view of the body as a wondrous machine, Giovanni Georgi's illustrations for Johannes Vesling's *Syntagma anatomicum* (1677; Cat. 24) reduce much of the morphological detail upon which Galen, Leonardo, and Vesalius had set such store in favor of a mechanically simplified demonstration of the basic workings of the bones, muscles, and tendons.

The peak of this tradition of visual and mechanical wonder is undoubtedly provided by the plates of the hands in Govard Bidloo's great *Anatomia humani corporis* of 1685 (Cat. 25A and 25B), strikingly illustrated by Gérard de Lairesse, known as the "Dutch Poussin," who was famed as a painter and academic theorist in his own right.[24] Bidloo's large volume is a fitting vehicle for Lairesse's assertive visual rhetoric and Abraham Blooteling's state-of-the-art engraving techniques. We are presented with a recognizably grand monument to the mastery of God as the supreme *artifex.* We are also regaled with a magnificent and hugely expensive production accessible only to the moneyed and the privileged. In no sense is Bidloo providing, any more than had Vesalius, an anatomical "handbook" for the run-of-the-mill practitioner. Anatomy, at this level of exposition, was a philosophical science, worthy of the highest minds, most enlightened of patrons, and grandest of institutions.

The unrivaled suite of plates Bidloo devotes to the hand underlines the complexity of the relationship between the fingers and the muscles of the forearm, using spectacular display techniques that are designed to enhance the impression that we are looking at a real dissection in all its flesh-and-blood reality. Muscles and tendons are lifted clear of neighboring and underlying features, draped over boards, boxes, pegs, and books, and supported in position by pins, wedges, compasses, and a quill pen. The textures and cast shadows enhance the pungency of the display, while the refinement of the paraphernalia conveys the idea that investigation of such divine machinery is a gentlemanly pursuit. The interpenetrations of the flexor tendons receive their due, while the layering of the inner over the outer superficial flexor tendons at the point of their emergence from the superficial muscle is correctly observed, probably for the first time. In keeping with the spirit of Galen, the level of intense detail declares that no aspect of the design of natural form can be considered inconsequential. At the end of the early modern period, Bidloo's plates represent a fitting climax of the chorus of praise for the hand that was originally orchestrated by Aristotle and Galen.

This is not to say that later investigators were any less impressed by the hand than the humanist anatomists of the Renaissance and Baroque. Unstinting admiration for the mechanics of the tendons was expressed in William Paley's famous late eighteenth-century treatise *Natural Theology; Or Evidence of the Existence and Attributes of the Deity.* Writing in the context of the Industrial Revolution, Paley used the "argument from design" to prove that there must be a purposeful creator behind the mechanical excellence of natural forms. Looking at the flexors of the hand, Paley is convinced that "There is nothing I believe, in a silk or cotton mill, in the belts, or straps, or ropes, by which motion is communicated from one part of the machine to another, that is more artificial, or more evidently so, than this *perforation.*"[25]

When the Eighth Earl of Bridgewater provided in his will of 25 February 1825 for a series of treatises on Paley's kind of "natural philosophy," he specifically stipulated that one should be dedicated to the hand. Accordingly, Charles Bell's

*The Hand: Its Mechanism and Vital Endowments as Evincing Design* was one of eight original commissions for the "Bridgewater Treatises," aimed at nonspecialist readers who were to be granted access to the latest research into miracles of form and function in the natural world.[26] Bell, the Edinburgh doctor who was deeply involved in investigations into the human brain, nervous system, and mechanisms of facial expressions as relevant to artists, emphasized that a proper modern understanding of the human organ was best achieved through the new discipline of comparative anatomy pioneered by Georges Cuvier in Paris. In so doing, Bell provided the kind of broader insight into the instruments of nature that Bridgewater and Paley had sought.

In modern anatomical teaching, the hand still presents a stiffer challenge to the illustrator than any aspect of gross anatomy, whether using traditional techniques of eye and hand, the photography of prepared specimens, or the dynamic possibilities of computer imagery. Its exemplary status as an enduring masterpiece of anatomical design is reflected in Frederick Wood Jones' revealingly titled treatise *The Principles of Anatomy as Seen in the Hand,* first published in 1920. In his entertaining introduction, Jones berates artists for their often casual treatment of the hand's anatomy and even criticizes Rembrandt, whose *Tulp* provides the book's frontispiece, for transferring features of the right arm to the left—which seems not to be the case. Jones' selection of the hand as providing the best introduction to the wonders of anatomical design remains thoroughly Aristotelian in tone: "Man's place in nature is largely writ upon his hand, and many of the simplest and most familiar details of homely knowledge become important when we examine our hands with the critical spirit we would adopt towards the members of some strange and uncommon beast."[27]

We still retain an undiminished sense that the hand serves as a prime mechanism for personal expression—for the manifestation of individual character and identity. We readily recognize someone's distinctive hand when they write an address on an envelope, and our signatures remain a key way in which we can identify ourselves during a variety of transactions. An artist's characteristic hand provides an important way of distinguishing the authorship of a painting or drawing. In 1515 the great German painter and graphic artist Albrecht Dürer wrote on a drawing by Raphael that he had solicited it from his Italian contemporary specifically as an exemplar of Raphael's admired "hand."[28] Such recognition relies upon our intuition that the marvelous instrument eulogized by Aristotle and Galen acts so subtly as a visual register of individuality as to resist verbal formulation. This intuition remains as strong today as it did when Dürer inscribed Raphael's sheet of drawings at the height of the Renaissance.

26. Charles Bell, *The Hand: Its Mechanism and Vital Endowments as Evincing Design* (London: William Pickering, 1833).

27. Frederick Wood Jones, *The Principles of Anatomy as Seen in the Hand* (London: Churchill, 1920), 5.

28. Inscribed on the drawing for two male figures in the *Battle of Ostia,* Vienna Albertina, Bd. V 17575. For the question of the individual "hand" and style in the Renaissance, see Martin Kemp, "'Equal Excellences': Lomazzo and the Explanation of Individual Style in the Visual Arts," *Renaissance Studies* (Society of Renaissance Studies Annual Lecture), 1 (1987):1-26.

# A Manual Computer for Reckoning Time
*Sachiko Kusukawa*

1. An excellent introduction to this subject, on which this section draws heavily, is Karl-August Wirth, "Fingerzahlen," *Real-lexikon zur deutschen Kunstgeschichte* (Munich: C. H. Beck'schen Verlagsbuchhandlungen, 1987) 8:cols. 1225-1310. Customs of other cultures are mentioned in Karl Menninger, *Number Words and Number Symbols: A Cultural History of Numbers* (Cambridge, Mass., and London: MIT Press, 1969), 201-220. For the Arabic system that inverts the left and right hands of the Roman tradition, see Jean Gabriel Lemoine, "Les anciens procédés de calcul sur les doigts en orient et en occident," *Revue des études islamiques* 6 (1932):1-60.

2. English translations of classical references to finger-reckoning can conveniently be found in Burma P. Williams and Richard S. Williams, "Finger Numbers in the Greco-Roman World and the Early Middle Ages," *Isis* 86 (1995):587-608.

3. Elisabeth Alföldi-Rosenbaum, "The Finger Calculus in Antiquity and in the Middle Ages, Studies on Roman Game Counters I," *Frühmittelalterliche Studien* 5 (1971):1-9. For visual evidence from Roman reliefs, see Anita Rieche, "Computatio Romana. Fingerzählen auf provinzial-römischen Reliefs," *Bonner Jahrbücher* 186 (1986):165-192.

4. For the difference between the Dionysian and Victorine tables, see Olaf Pedersen, "The Ecclesiastical Calendar and the Life of the Church" in G. V. Coyne, M. A. Hoskin, and O. Pedersen, eds., *Gregorian Reform of the Calendar: Proceedings of the Vatican Conference to Commemorate its 400th Anniversary 1582-1982* (Vatican City: Specola Vaticana, 1982), 46-54. The Easter controversy is analyzed by Charles W. Jones, *Bedae Opera de Temporibus* (Cambridge, Mass.: Medieval Academy of America, 1943), 78-104.

5. Pedersen 1982, 54-59.

6. For instance, the *Romana computatio* (688), which similarly dealt with numbers from one to a million, Charles W. Jones, *Bedae pseudoepigrapha: Scientific Writings Falsely Attributed to Bede* (Ithaca, N.Y.: Cornell University Press, London: Humphrey Milford, and Oxford: Oxford University Press, 1939), 106-108. The *Romana computatio* was certainly one of Bede's sources.

## A MANUAL COMPUTER FOR RECKONING TIME

Various cultures, to this day, use hands to express numbers—for trading and exchanging in noisy surroundings or for bidding prices under a cloth to ensure secrecy in an open marketplace. Hands have long provided a means of expressing numbers when oral or written forms of communication have been ineffective, confusing, or inconvenient. In western Europe, a tradition of expressing numbers with fingers reached back to Greco-Roman times and possibly beyond.[1] Many classical authors attest to its widespread diffusion. Quintilian, for instance, believed that a mastery of finger-reckoning was an essential mark of an educated orator (*Institutio oratoria* 1.10.35).[2] The earliest evidence for visual representation of finger numerals occur in the *tesserae*, game-chips made of bone or ivory.[3] Classical authors, however, did not explain systematically how finger-reckoning worked; they took for granted that their audience knew how to flex their fingers to express numbers. Finger-reckoning in antiquity was an art that seems to have been transmitted orally and visually through gestures.

## BEDE ON COMPUTING AND SPEAKING WITH FINGERS

The most influential and systematic explanation of finger-reckoning was written by Bede (about 673-735). Bede spent most of his life at the monastery of Jarrow (near Durham, England) and is today remembered for his *Historia ecclesiastica gentis anglorum* (731), an account of Christianity in England from the beginning to his own time. In this work Bede describes the controversy that raged in England in the seventh century over the different dates of Easter arising from different methods of calculation:[4] the Christians of Northumbria followed an Irish custom, and those of the South, the Roman custom. In 664, at the Synod of Whitby, King Oswy of Northumbria decided to follow the Roman custom. Bede's *De temporum ratione liber* (725) set out to establish and teach the validity and rationale behind this Roman system.[5] It is in the first chapter of this work that Bede explains the finger-reckoning system. Although Bede's was by no means the first text to explain this convention,[6] it certainly became the most comprehensive and widely known writing on the topic.

In the first chapter, entitled "De computo et loquela digitorum" [On computing and speaking with fingers], Bede introduced finger-reckoning as a useful skill for time-reckoning, which was also practiced by theologians. He cites the case of Jerome (*Epistulae* 48.2) who gives a symbolic interpretation of finger numerals from the shapes they formed. For instance, thirty symbolizes marriage, because the index finger and thumb are joined in a "caressing embrace."

Bede's finger-numerals for 1 to 9,999 roughly work like a placement system. The middle, ring, and little fingers of the left hand denote the digits; the thumb and the index fingers on the left hand express the tens; the thumb and the index finger on the right hand the hundreds; and the middle, ring, and little fingers the thousands.

Thus for 1, the little finger is bent into the middle joint of the palm (Fig. 6). For 2, the ring finger is bent next to it. For 3, the middle finger is bent. For 4, the little finger is raised, while keeping the middle and ring fingers bent. For 5, the ring finger is raised. For 6, the middle finger is raised and the ring finger

alone is bent.[7] For 7, the little finger alone is bent again, but this time (in order to distinguish it from 1), the finger is bent over the base of the palm. For 8, the ring finger is bent next to the little finger, and for 9 the middle finger also comes down. For 10, the nail of the index finger is placed against the joint of the thumb. For 20, the tip of the thumb goes between the middle joints of the index and middle finger. For 30, the nails of the index finger and thumb are joined. For 40, the inside of the thumb goes over the side and back of the index finger, both fingers being straight. For the number 50, the thumb, flexed like the Greek letter "gamma," is placed against the palm. For 60, this thumb is covered by the index finger. For 70, the index finger is bent as above, but the nail of the thumb is placed on the middle joint of the index finger. For 80, the nail of the thumb is placed against the middle joint of the index finger. For 90, the nail of the bent index finger is placed against the base of the thumb. From 100 onward, the right hand is used.[8] The 100s correspond to the figures for the 10s on the left hand. Likewise, the figures for the 1,000s correspond to the figures for 1 to 9 on the left hand. Although Bede does not explicitly explain this, by combining the finger-signs for the digits, 10s, 100s, and 1,000s, it is possible to express every number between 1 and 9,999.

From 10,000 onward, gestures were needed (Cat. 40A). For the 10,000s, nine gestures are created by positioning the left hand over the breast, the thigh, the navel, and the hip, with the palm facing inward or outward. Gestures repeated in the same order with the right hand accounted for the 100,000s (Cat. 40B). For a million, both hands are clasped together with the fingers interlaced, above one's head. These gestures make it practically impossible to employ the earlier finger-signs between 1 to 9,999 at the same time, if one wanted to express any number between 10,000 and a million. It thus seems that the gestures between 10,000 to a million have been provided as milestones on the way to a million, demonstrating more the possibility of counting up to very large numbers than facilitating actual counting.

The informal manner in which Bede explains how to flex the fingers and form gestures seems to retain traces of oral instruction.[9] The illustrations that frequently accompany this chapter may also be a reminder of the gestures that went with such oral instruction. At the end of the "De computo et loquela digitorum," Bede explains one application of the finger-numerals. By expressing the numerical position of a letter in the alphabet to stand for that letter, one person can communicate a string of words to another for fun or for sending secret messages. The hand gesture of 3, 1, 20, 19, 5, 1, 7, 5, for instance, can relay the message *caute age* [be careful].[10]

### "COMPUTING" WITH FINGERS

Despite the reference to "computing with fingers," no explanation of arithmetic manipulations by hand was given in the *De temporum ratione liber*. Finger-

Fig. 6. Anonymous, Italian, *Finger Gestures for 1-40*, 11th century. The Venerable Bede, "De computo et loquela digitorum," in *The Tegrimi Computus*, New York, The Pierpont Morgan Library, M.925, fol. 38

7. This explains the riddle in the *Disputatio regalis et nobilissimi iuvenis Pippini cum Albino Scholastico* of how a man holding 8 in his hand takes away 7 and is left with 6. Williams and Williams 1995, 595.

8. Thus Juvenal lauds the longevity of a man who can "count his years on his right hand" (*Satires* 10.248-249). Juvenal, *Saturae*, ed. W. V. Clausen (Oxford: Clarendon Press, 1992), 130.

9. Jones 1943, 331. A similar remark is found in chap. 16, as pointed out by Pedersen 1982, 58.

10. Bede points out that numerical representation of letters by their position in the alphabet can also be used to "write" secret messages. Jones 1943, 181.

11. Williams and Williams 1995, argue that finger-numbers were an integral part of ancient arithmetic in this sense. Leonardo Fibonacci (1170-1250) explained that finger-numerals were useful in keeping track of numbers carried over in long divisions, David Eugene Smith, *History of Mathematics* (Boston: Ginn, 1925), 2:202.

12. See the entries on *computus, computatio,* and *computare* in *Mittellateinisches Wörterbuch* (1985), 2:1128-1134. For the history of the *computus,* see Arno Borst, *The Ordering of Time: From the Ancient Computus to the Modern Computer,* trans. Andrew Winnard (Cambridge: Polity Press, 1993).

13. For Bede's achievement, see Pedersen 1982, 54-59, and Jennifer Moreton, "Doubts about the Calendar: Bede and the Eclipse of 664," *Isis* 89/1 (1998): 50-65.

14. This is referred to in chap. 1 as "alterius modi computus, articulatim decurrens, qui, quoniam specialiter ad paschae rationem pertinet." Jones 1943, 180.

15. Florence Yeldman, "An Early Method of Determining Calendar Dates by Finger Reckoning," *Archeion* 9 (1928): 325-326.

16. For the medieval *computus,* see Pedersen 1982, 59-69, and Borst 1993. For the central role of the *computus* in the teaching of astronomy at universities, see Olaf Pedersen, "The Corpus Astronomicum and the Traditions of Medieval Latin Astronomy," *Studia Copernicana* 13 (1975): 57-96.

17. David Eugene Smith, *Le comput manuel de Magister Anianus* (Paris: E. Droz, 1928).

18. The opening lines are: "Computus est talis proprie dictus manualis / Leva manus totum nobis facit hunc fore notum." Anianus, Compotus cum commento (Lyons: Matthias Huss, 1492), fol. 5v.

19. Ibid.

20. For an explanation of the slightly more complicated means of finding the phases of the moon with the left hand, see S. B. Gaythorpe, "The Lunar Hand-Calendar of Magister Anianus," *Journal of the British Astronomical Association* 69/1 (1959): 80-87.

21. Christopher Wordsworth, *The Ancient Kalendar of the University of Oxford from the Documents of the Fourteenth to the Seventeenth Century, Together with Computus manualis ad usum Oxoniensium* (Oxford: Clarendon Press, 1904). For a seafarer's

reckoning for simple addition and subtraction, however, seems to have been widely known, as Augustine (354-430) expected his audience to be able to add all the numbers from 1 to 17 on their fingers (*Sermones* 248.5). Although Cicero remarked that fingers were needed to calculate the difference between compound and simple interests (*Epistulae ad Atticum* 5.21.13), it is less obvious how multiplication or division could be done with finger-numbers alone. It is more likely that finger numbers were used to aid the process of multiplication and division.[11]

It is important to appreciate that the idea of *computare* [to compute] was closely associated with calendrical calculation in this period.[12] Indeed Bede's work, *De temporum ratione liber,* belongs to the genre of *computus* that explained the theory and method of establishing the dates of Easter.[13] The most important feast in Christianity, Easter, occurred on different dates each year, as did some other movable feasts. Since the Council of Nicaea (C.E. 325), Easter was defined as the first Sunday after the full moon that occurs on or after the spring equinox (21 March). Because lunar cycles (29.5 days) do not exactly fit into one solar year (about 365.25 days), however, the same phase of the moon, and therefore Easter, will not recur on a fixed day of the calendar year annually.

The phases of the moon will recur on the same day of the year every nineteen solar years because 235 full lunar months fit almost exactly into that period. This is the idea behind the medieval convention of a "golden number." The term denotes the position of a particular year in the nineteen-year cycle (also called the lunar cycle). In addition to the golden number, it is necessary to know on which days of the month Sundays fall. The location of Sundays in a particular year was expressed by the convention of "dominical letters." The days of the year were allotted the recurring series of seven letters A to G, starting from 1 January as "A," so the days that have the same letter become the same day of the week. For leap years, however, two alphabets were allotted, since the dominical letter will change after 29 February (which did not have a dominical letter assigned to it). The sequence of dominical letters on which Sundays fall forms a cycle of twenty-eight years (called the solar cycle). In the last chapter of the *De temporum ratione liber,* Bede explains how the dates of Easter recur in a cycle of 532 years, the product of 19 and 28.

Although Bede claimed at the beginning of the *De temporum ratione liber* that finger-reckoning was useful for time-reckoning, he did not explain how the system might be employed in calculating various parameters. In fact, the didactic nature of the work meant that Bede tended to provide precalculated tables in order to alleviate the burden of cumbersome arithmetic on the part of the student. It is in relation to these tables that Bede mentions another influential use of the hand.[14]

In chapter 55 of the *De temporum ratione liber,* Bede pointed out how there were nineteen joints and nails in the left hand, or twenty-eight joints in the two hands, which could be used to memorize the lunar and solar cycles respectively. The description, however, was sketchy and would have needed to be supplemented by oral instruction.[15] It is this use of the hand as a mnemonic locator that became central to later works on the *computus.*

## THE HAND IN THE *COMPUTUS*

With Bede's *De temporum ratione liber,* the *computus* was set on a sure footing, and the need for bishops to issue the correct date of Easter every year to their clergy diminished. Numerous textbooks on the *computus* based on Bede's work

appeared, and they became an essential part of Christian learning in monastic schools and universities.[16] In the late thirteenth century, a cleric known as "Magister Anianus" composed a versified version entitled the *Computus metricus manualis* (Cat. 42).[17] The work comprises 244 lines using the left hand as a system of mnemonic locators; it was thus justifiably called a "manual."[18] At least in one commentary, the use of the left hand was explained as being "quicker in computing" [*promptior ad computandum*] than the right hand.[19] Anianus' manual enjoyed an enduring popularity into the early modern period; many of the editions included a commentary expanding on the versified instruction.

Anianus' *computus* included images of the inside and outside of the left hand, and the accompanying commentary identified the names and positions inscribed on them. Normally 15 places on the outside of the left hand and 19 on the inside were indicated (Cat. 42A and 42B). This hand was then turned into a mnemonic table using a memorable verse. For instance, in order to work out the dominical letter of a given year, 28 places were identified on the left hand for the solar cycle.[20] Anianus directed the student to subtract 8 from the year whose dominical letter is sought and divide it by 28. The remainder is the number of places the student has to count off in the left hand while reciting "filius esto Dei celum bonus accipe gratis" (nonsense verse). The initial letters of each word in this verse indicate the recurring order of dominical letters, F-E-D-C-B-A-G. The words of the verse were to be placed consecutively across the joints of the left hand, starting from the inside base of the index finger *(filius)* moving horizontally to the base of the middle finger *(esto)*, to the base of the ring finger *(Dei),* then to the little finger. The little finger stood for the leap years, so two letters *(celum, bonus)* were always allotted to it. The student then went back to the index finger, next joint up, and continued the same process, repeating the seven-word verse until the place of the number of the remainder is reached. The initial letter of the word that falls on that place was the dominical letter for the required year.

Anianus' handy tables were copied and used widely across Europe, in university calendars, seafarers' charts, and vernacular manuals, well into the eighteenth century.[21] This way of using the hand as a mnemonic placement system was not, however, unique to the *computus* literature. The hands that appear in time-reckoning textbooks closely resemble the hands in Guidonian textbooks on music. The similarity in form, function, and terminology (for example, "keys") may well derive from the fact that the *computus* and music were both parts of the quadrivial curriculum in medieval schools and thus shared didactic strategies that were derived ultimately from classical mnemonic techniques.[22] A more unusual way of using the hand that was certainly unique to the telling of time was the use of the hand as a sundial, as suggested by Jakob Köbel in the sixteenth century (Cat. 44).

## CALENDARS

The *computus* provided the theoretical basis from which calendars were constructed. Some calendars, such as books of hours, were designed to be perpetual so they could be used forever. The problem of movable feasts was tackled with the devices of dominical letters and golden numbers. Instead of the days of the week, the dominical letters were inscribed next to the days of the month so that different weekdays could be assigned to the letters in different years (Fig. 7). The golden numbers were also inscribed against the days of the month,

chart, see Florian Cajori, "Comparison of Methods of Determining Calendar Dates by Finger Reckoning," *Archeion* 9 (1928): 31-42. Mnemonic hands for calculating Easter are further found, for instance, in Jean de Seville, *Le compost manuel* (Rouen: Thomas Mallard, 1695), and Buenaventura Françisco de Osorio, *Astronomica, y Harmoniosa Mano* (Mexico City: Biblioteca Mexicana, 1757).

22. Karol Berger, "The Hand and the Art of Memory," *Musica Disciplina* 35 (1981): 86-120, and the essay by Susan Forscher Weiss in this catalogue, 38.

23. An excellent introduction to the parameters used in medieval calendars may be found in R. Dean Ware, "Medieval Chronology," ed. James M. Powell, *Medieval Studies: An Introduction* (New York: Syracuse University Press, 1976), 213-237, with further bibliography.

24. A collection of these single-sheet calendars is reproduced in Paul Heitz and Konrad Haebler, *Hundert Kalendar Inkunabeln* (Strasbourg: Heitz und Mündel, 1907).

25. H. Rosenfeld, "Bauernkalender und Mandlkalender als literarisches Phäno-menon des 16. Jahrhunderts und ihr Verhältnis zur Bauernpraktik," *Gutenberg Jahrbuch* (1963): 88-96. For a good collec-tion of a variety of calendars, see *Kalendar im Wandel der Zeiten: Eine Ausstellung der badischen Landesbibliothek zur Erinnerung an die Kalenderreform durch Papst Gregor XIII im. Jahr 1582*, exh. cat. (Karlsruhe: Badische Landesbibliothek, 1982).

26. For the Gregorian calendar reform, see Coyne et al. 1982.

27. Jones 1939, 22-24.

28. Bede's finger-reckoning system for 1 to 9,999 is discussed at the end of Robert Recorde's 1542 *The Grounde of Arts* (Amsterdam and New York: Da Capo Press, 1969, facs. ed.), with explanation of how to form the numbers 11, 12, 13, 21, and so on. Johannes Bronchorst (Noviomagus), *De numeris libri duo* (Paris: ex off. C. Wecheli, 1539), 35-39, simply reproduces the text of Bede for the numbers 1 to a million but inserts an illustration for the number 11, combining the gestures for 10 and 1. For arithmetic textbooks from this period, see David Eugene Smith, *Rara arithmetica* (Boston and London: Ginn, 1908).

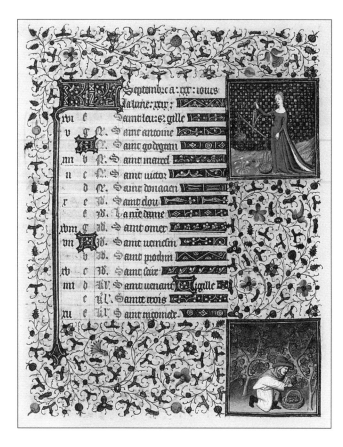

Fig. 7. French, *Calendar Page for September,* early 15th century. Book of Hours, Cambridge, Trinity College Library, MS B.11.31, fol. 9. By kind permission of the Master and Fellows of Trinity College, Cambridge

29. Marcus Valerius Probus, "De computo et loquela digitorum," in *De notis romanorum* occurs at fols. LVr.-LVIv.

30. Aventinus explained that he had the figures of finger-reckoning copied from a manuscript, Johannes Aventinus, *Abacus* (Regensburg: H. Kohl, 1532). I have used the text included in the eighteenth-century edition of the *Annalium Boiorum Libri VII* (Leipzig: J. F. Braun, 1710).

indicating the days on which new moons occurred in that particular year of the nineteen-year cycle. The golden number for any year could be worked out by adding one to the year and dividing it by nineteen, the remainder being the golden number.[23] The importance of the dominical letters and the golden numbers can be seen in a single-sheet Easter calendar from 1466 (Cat. 41).

With the advent of the printing press from the 1450s, single-sheet calendars designed for one particular year became widespread. Many printers issued such annual calendars. They seem to have sold well and were regarded as a means of generating income. Although technically these single-sheet calendars for single years did not need dominical letters or golden numbers, because the date of Easter was already marked, various parameters continued to be printed either to ensure some degree of credibility or to serve as a useful reference point.[24] These calendars marked time with saints and feast days, and typically included astrological and meteorological forecasts for the coming year.

The forecasts in these calendars reflect general astrological beliefs of the time. The medical treatment of bloodletting, for instance, was heavily dependent upon the position of the moon, whose light rays were considered to exert great influence over the human body. This was frequently illustrated in the image of the "zodiac man" (Cat. 57), where signs of the zodiac were connected with particular parts of the human body. Annual calendars typically listed the position and phases of the moon, the zodiac man, symbols marking auspicious and inauspicious days for bloodletting and for mixing and administering medicine, as well as the golden number, dominical letter, saints and feast days.[25]

Identification of the engravers of these popular calendars is unusual, and it is even rarer to find the hand of a woman in them. Yet this is the case of Diana Scultori from Mantua (1547/8-1612), whom Vasari praised for her skills in engraving. In Rome, Diana engraved almanacs designed by her husband, Francesco da Volterra (Cat. 45). Composed in Italian, they contained the sorts of information expected of a single-sheet annual calendar. Diana's almanacs are unusual, furthermore, in that they also included some learned humanist allusions that adorned the Sala dei Venti in the Palazzo del Te at Mantua, where her father had worked. A comparison with Diana's calendars for the years after the Gregorian calendar reform (1582) indicates a general continuity of style and content. The calendar reform had little impact on calendar-making at this popular level.[26]

### THE COUNTING HAND

The finger-reckoning system as set out by Bede was widely copied and well known throughout the Middle Ages. His finger numerals increasingly came to be treated independently, a tradition that continued in print when the first chapter was printed separately from the main bulk of the *De temporum ratione liber* in the 1563 edition of Bede's *Opera*.[27] Bede's finger numbers were also mentioned in elementary arithmetic tracts of the fifteenth and sixteenth centuries. Some of them supplement Bede's description by explaining how a

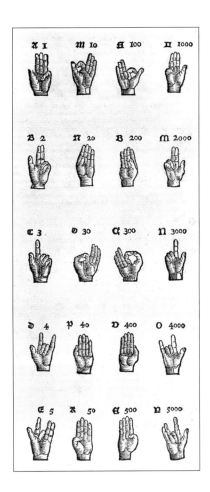

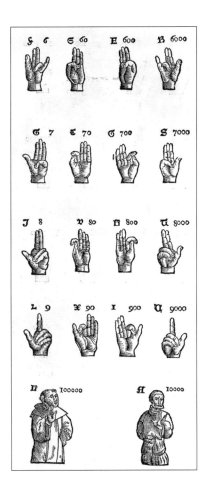

Fig. 8. *(Above left)* Anonymous, German, *Finger Gestures for 1-5,000*, woodcut. From the Venerable Bede, *Abacus, atque vetustissima, veterum latinorum per digitos manusque numerandi (quinetiam loquendi) consuetudo*, ed. Johannes Aventinus (Regensburg: Hans Kohl, 1532), fol. b; facsimile ed. (Leipzig: Johann Friedrick Braun, 1710), Columbia University, Rare Book and Manuscript Library

Fig. 9. *(Above right)* Anonymous, German, *Finger Gestures for 6-100,000*, woodcut. From the Venerable Bede, *Abacus, atque vetustissima, veterum latinorum per digitos manusque numerandi (quinetiam loquendi) consuetudo*, ed. Johannes Aventinus (Regensburg: Hans Kohl, 1532), fol. bv.; facsimile ed. (Leipzig: Johann Friedrick Braun, 1710)Columbia University, Rare Book and Manuscript Library

combination of the finger gestures works as a placement system for numbers between 1 and 9,999.[28]

In 1494, Luca Pacioli (Lucas de Borgo, c. 1445-1517) offered a revision of Bede's system in his *Somma di aritmetica* (Cat. 43). In explaining the finger-counting system, however, Pacioli changed Bede's system. In Bede's system, the figures for the 100s and the 1,000s on the right hand corresponded to those for the 10s and the digits respectively (Fig. 6). Pacioli inverted the figures for the 100s and 1000s so that the order of gestures would stay the same as on the left hand. The *Summa de arithmetica* (in a Latin version) was widely read by sixteenth-century mathematicians who thus came to recognize two types of finger-reckoning.

During the sixteenth century, Bede's finger-reckoning system was increasingly viewed as a quaint system with little practical use. For instance, the first chapter of the *De temporum ratione liber* was included in a collection of ancient scripts and inscriptions in Marcus Valerius Probus' *De notis romanorum* of 1525.[29] In the first illustrated, printed version of Bede's finger-numbers (1532; Figs. 8 & 9),[30] Johannes Aventinus felt the need to defend Bede in the light of the recent controversy between Johannes Trithemius (1462-1516) and Charles de Bovelles (see Cat. 3) over Trithemius' "steganographia."[31] Thus by Aventinus' time, it could not be taken for granted that finger-reckoning was a widespread, living custom transmitted orally and visually from generation to generation.[32] The manner in which the fingers represented numbers apparently became less well known and even mysterious, if it required defense from charges of magic. Instead, finger-reckoning had become an ancient custom needing preservation for a proper understanding of classical works.[33]

31. For the details of this famous dispute, see Joseph M. Victor, *Charles de Bovelles, 1479-1553: An Intellectual Biography* (Geneva: Droz, 1978), 14 and 31-36. According to Trithemius, this was an art of communicating secret messages using various forms of ciphers in which the method of encryption was treated as a form of magic. Bovelles criticized the idea as magical and false. In defense, Trithemius cited Bede as one of the authorities for the idea of ciphers in his *Polygraphia* (1518). Trithemius did not, however, explicitly advocate the use of finger-reckoning as one of the cipher systems, possibly because he was more concerned with long-distance communication. It is noteworthy, however, that Aventinus, writing in the wake of this famous controversy, felt the need to defend finger-reckoning against the possible charge of being magical. He advocated the need to be conversant with Bede's finger-reckoning for understanding ancient theologians and orators.

32. Aventinus 1710, 3.

33. See also the chapter, "Dialogismus secundus de manus et digitorum nominibus deque numerandi per eos antiquorum ratione" in Lilius Gregorius Gyraldus, *Dialogismi* (Venice: G. Scottus, 1553).

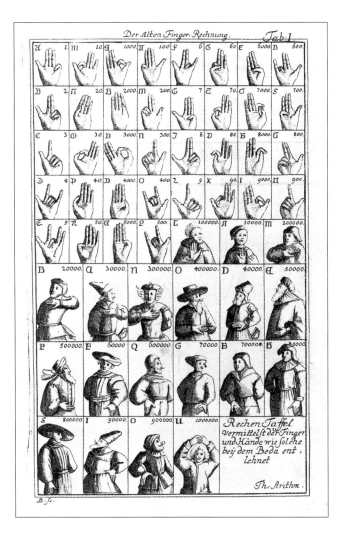

Fig. 10. Anonymous, German, *The Old System of Finger–Reckoning*, engraving. From Jacob Leopold, *Theatrum machinarium oder Schau-Platz der Heb-zeuge* (Leipzig: Christoph Zunkel, 1725), Plate volume, pl. 1. Rare Book and Special Collections Division, Library of Congress, Washington, D.C.

In the eighteenth century, Aventinus' illustrations of finger-reckoning were copied by Jacob Leupold in his *Theater of Machines* (Fig. 10). Leupold's work was an encyclopedia of mechanical devices both practical and imaginary, gathered together from past and contemporary works. In the *Theater of Machines* (1727), Leupold reports all known uses of the hand for representing numbers as well as words. The finger-reckoning systems of Bede and Pacioli are listed, but as with several of Leupold's other devices, it is unclear if they were seen as practicable or not. Thus by the end of the eighteenth century, it seems that Bede's legacy of the calculating and computistical hand had ceased to be a living tradition, and those who wrote about them viewed them more as a quaint old curiosity than as one with practical significance.

In western Europe the hand had once been a reliable tool for reckoning numbers, symbolizing a skill that orators considered a mark of accomplishment. It had also been a memory pad, facilitating the task of "calculating" the most important date of Christianity. The hand, then, had once embodied an important focus for civilization and Christianity. Uses of hands for such purposes were more often than not handed down orally and visually. When methods of communication and instruction began to change, and when cultural values began to shift, the hand ceased to be the tool that people in western Europe counted on.

# The Singing Hand
*Susan Forscher Weiss*

The use of the fingers and joints of the hand as an aid to memorizing music goes back to ancient times.[1] Some say musicians borrowed the notion from almanac makers who also used the hand in recalling the optimum hours and days for important events. The pedagogical device of a symbolic hand is found not only in the West, but also in China, Japan, and India.[2] In many improvised traditions, like those of Arab and Hindu music, both sung and played, model songs were used as points of mental reference. The doctrine of hand signs went through several phases of evolution, from movements in the air (cheironomy) to a combination of written symbols recognized as stylized graphs of those movements to the hand as a kind of reading board. In this latter system the fingers and joints of the hand represented actual melodic intervals, as opposed to fluctuating intonation.

One of the earliest examples of a musical hand in the West is found in a twelve-line poem written in Greek in the ninth or tenth century that has been preserved in at least five manuscripts. In one of those manuscripts (Paris, BNF, MS lat. 7211, fol. 140v.), the poem is inscribed around a figure of the palm of the left hand.[3] Many explanations have been advanced to explain the meaning of the poem. Some suggest that it was a kind of manual for using an eight-stringed instrument to obtain the correct intonation for a chant melody.[4] It is more likely that the hand was used as a mnemonic aid in learning the intonation formulas of Western chant.[5] Because the formulas gave no musical information, the palm and explanatory poem filled a practical need serving two functions. The first of these was to aid in grouping the chants under the correct mode, and the second was as a means for the cantor to establish a pitch and remind the singers of the important characteristic of the mode, particularly the position of the half step or semitone. The technique is not far afield from that which existed in the synagogue.[6]

But one of the most ubiquitous images of the Middle Ages and Renaissance relating to memory and learning in music is the so-called Guidonian hand, associated with the eleventh-century music theorist and pedagogue, Guido of Arezzo, who is credited with developing modern staff notation where lines signify pitches a third apart and a method of sight-singing (solmization) that became associated with a hand that later bore his name. Guido created a melody for a preexisting hymn text to John the Baptist, "Ut queant laxis," (Example 1)in which the first six phrases begin on consecutively higher pitches. The pitches formed a pattern of intervals consisting of whole tones and a single half tone *(mi-fa)* (w, w, h, w, w) or the solmization syllables: *ut* (substitute the modern *do) re mi fa sol la*.[7] "*Ut* queant laxis/ *re*sonare libris/ *mi*ra gestorum/ *fa*muli tuorum/ *Sol*ve polluti/ *la*bii reatum/ Sancte Johannes" [That with full voices your servants may sing of your marvelous deeds, absolve the guilt from their defiled lips, O Saint John]. The model song, with its simple acrostic, contained principles of mnemonics that had existed in earlier times.

1. Egon Wellesz, *History of Byzantine Music and Hymnography,* 2d rev. ed. (Oxford: Clarendon Press, 1961), 287-288. See also Edith Gerson-Kiwi,"Cheironomy," *NGD* 4:190-195; and Joseph Smits van Waesberghe, *Musikerziehung Lehre und Theorie der Musik im Mittelalter* (Leipzig: VEB Deutscher Verlag für Musik, 1969). A pictorial and narrative history of depictions of the hand from the eleventh to the fifteenth century is included. Almost all are left hands, although at least one is a right hand (in Paris, BNF, MS lat. 7203, a twelfth-century manuscript). See also Joseph Smits van Waesberghe, "The Musical Notation of Guido of Arezzo," *Musica Disciplina* 5 (1951):15-53.

2. Andrew Hughes and Edith Gerson-Kiwi, "Solmization," *NGD* 17:458-467. Today's practice of solmization in Hindu music has its roots in the teaching of Vedic chant. A Talmudic treatise states that the right hand is to be kept clean in order to be able to signal the melodic intonations of scripture.

3. Tilden Russell, "A Poetic Key to a Pre-Guidonian Palm and the *Echemata,*" *Journal of the American Musicological Society* 34 (Spring 1981):109-112.

4. Ibid., 112.

5. Ibid., 115. The *echemata* were melody types whose source was Byzantine melodies. These intonation formulas with none-noeane syllables were gradually supplanted by Latin mnemonic verses.

6. Hughes and Gerson-Kiwi 1980, 190-195.

7. Claude Palisca, "Guido d'Arezzo," *NGD* 7:803-807; see also Smits van Waesberghe 1951, 15-53.

Example 1: Guido's Hymn to St. John the Baptist, "Ut queant laxis" from the *Epistola ad Michahelem, Liber usualis* (Tournai, Belgium: Desclée, 1938), p. 1504.

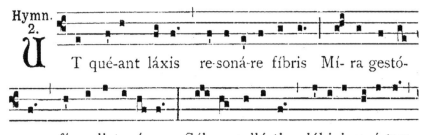

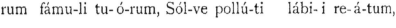

Sáncte Jo-ánnes. 2.

8. The writings of Quintilian, particularly his *Institutio oratoria,* Cicero's *De oratore,* and the anonymous *Ad C. Herennium libri IV* are, according to Frances Yates, the three most important Latin sources for the classical art of memory. See Yates, *The Art of Memory,* 1.

9. Rosemary Killam, "Solmization with the Guidonian Hand: A Historical Introduction to Modal Counterpoint," *Journal of Music Theory Pedagogy* 2/2 (1988):251-273.

10. There are two other examples: one is from a twelfth-century treatise in Paris, see Smits van Waesberghe 1969, 132-133; the other, in Marin Mersenne's *Harmonie universelle* (Paris: Sébastien Cramoisey, 1636), facs. ed., ed. François Lesure (Paris: Éditions du Centre National de la Recherche Scientifique, 1963), 2:144, describes the need for both hands, right and left.

The art of memory *[ars memorativa]* in classical times was related to rhetoric and gave the orator places and images *[loci* and *imagines]* by which he could improve his ability to deliver long speeches with unfailing accuracy.[8] Images of all sorts from trees, ladders, theaters, temples, and hands began to appear in memory guides for all subjects, including rhetoric, grammar, *computus* [calculating], the learning of the ecclesiastical calendar, and music.

In order to appreciate why the hand was needed, the system of hexachords must be explained. Tinctoris, Gaffurius, Ornithoparcus, and other theorists in the fifteenth and sixteenth centuries agreed that to know the hand meant to know all the steps commonly used in music, their relationships to one another, and how to write them down and read them.[9] Tinctoris actually gives several justifications for the use of the hand and explains why the left hand is generally used.[10]

Guido instructed his students to learn the notes of a chant by recalling the pitches and syllables of a six-note segment that later became known as the hexachord. One of the ways this was accomplished was by means of the model song, an easy chant that stays within one hexachord. This natural hexachord (from c to a) was only one of three. To go to a higher range, one could pivot either on g *(sol),* producing a hexachord ("hard") that extended from g to e' and then even higher by pivoting on c' of the g hexachord, producing a natural hexachord an octave above the original. This process of pivoting was called mutation and could be reversed to descend to G by treating c as *fa.* The third hexachord ("soft"), made by mutation from *fa* to *ut,* was necessary not to extend the range, as it only reached from f to d', but to produce a b-flat. Each pitch would be known both by a letter name and a string of hexachord syllables applied to it (see Table 1). For example, the pitches g and a would be G *sol re ut* and a *la mi re,* respectively. The scale's lowest note Γ *[gamma]* would be known as *gamma ut,* shortened to gamut, the name for the entire scale, which extended to e'' or e la. (See Ill. 1 for a diagram of how to navigate from gamma ut [gamut] to e la.)

Table 1

|  |  |  |  | hard |  |  |  |  | ut re | mi | fa sol la |
| natural | soft | hard | natural | soft |  | hard | ut re | mi fa | sol la |

```
                    hard              ut re   mi  fa sol la
            soft            ut re mi fa    sol la
        natural       ut re  mi  fa sol la
      hard        ut re  mi  fa sol la
    soft    ut  re mi fa    sol la`
  natural ut re mi   fa sol la
 hard  ut re mi fa sol la

 ΓA B  c  d  e  f  g  a  b♭ b^nat c' d' e' f' g' a'  b'♭ b'^nat c" d" e"
```

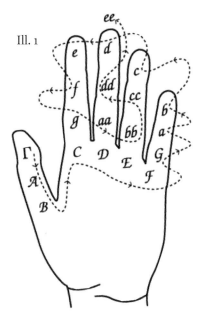

Ill. 1

Graphic by Kim Banister

A steep learning curve was required to remember where each of these notes fit into each hexachord. Guido is credited years after his writings, none of which actually contain the image of the hand, for devising the system by which he pointed to joints in the fingers of the left hand in order to teach solmization. Each joint represented a specific pitch in the scale. All but one hand in the current exhibition are in one or another way exemplars of the so-called Guidonian hand (Cat. 46, 47, 49, and 50). The remaining hand (Cat. 48) points to the hexachord in what appears to be an act of teaching. The principle of solmization, like the use of the hand as a mnemonic, goes back to antiquity and is found in many other cultures where syllables were attached to particular musical notes.[11] Guido's letter to the monk Michael states: "You have therefore a system for learning unheard melody most easily and correctly. . . . For after I began to present this method to choirboys, some of them could easily sing unknown chants before the third day, which by other methods could not happen for many weeks."[12] Guido, who described most of his innovations with pride, never mentions the hand in his extant writings. In the *Epistola* he describes a method designed to help "learn an unknown chant." He describes the older method of sounding pitches on a monochord followed by rote repetition and suggests that this method is good for beginners but very bad for those who continue further. His solution to learning new chants is to "commit to deep memory all descents and

11. Oliver Strunk, *Source Readings in Music History* (New York: Norton, 1950), 184.

12. Dolores Pesce, *Guido d'Arezzo's "Regule Rithmice, Prologus in Antiphonarium" and "Epistola ad Michahelem": A Critical Text and Translation* (Ottawa, Canada: Institute of Medieval Music, 1999), 463. Martin Gerbert, *Scriptores ecclesiastici de musica sacra potissimum* (1784), (Imprint Milan: San Blasianis, 1931), 2:45. "Habebis ergo argumentum ad inveniendum inauditum cantum facillimum et probatissimum. . . . Namque postquam hoc argumentum cepi pueris tradere, ante triduum quidam eorum potuerunt ignotos cantus leviter canere, quod aliis argumentis nec multis hebdomadibus poterat evenire." See Carruthers, *The Book of Memory,* 106.

13. Pesce 1999, 459-463; Oliver Strunk, *Source Readings in Music History* (New York: Norton, 1950), 184.

14. Karol Berger, "The Hand and the Art of Memory," *Musica Disciplina* 35 (1981): 116-117. See also Michel Huglo, "L'auteur du traité de musique dédié à Fulgence d'Affligem," *Revue belge de musicologie* 31 (1977):5-19, and Claude Palisca, *Hucbald, Guido, and John on Music* (New Haven: Yale University Press, 1978), 87-95.

15. Berger 1981, 177-178. He quotes from Siegbertus Gemblacensis, *Liber de scriptoribus ecclesiasticus*, col. 579.

16. Berger 1981, 118-119. See Pesce 1999, 13, and Calvin M. Bower, "The Grammatical Model of Musical Understanding in the Middle Ages," in *Hermeneutics and Medieval Culture,* eds. Patrick J. Gallagher and Helen Damico (Albany: State University of New York Press, 1989), 142-143.

17. Ernest Benz, *Meditation, Musik und Tanz. Uber den "Handpsalter," eine spätmittelalterliche Meditationsform aus den Rosetum des Mauburnus* (Abhandlungen der Geistes–und Sozialwissenschaftlichen Klasse der Akademie der Wissenschaften und der Literatur) (Mainz: Steiner, 1976).

18. Carruthers, *The Book of Memory,* 105-106.

19. Nicholas Orme, "John Holt (d. 1504), Tudor Schoolmaster and Grammarian," *The Library* 18/4 (December 1996):182-305. Phrases set to music were said to aid in memorization. John Holt, an English schoolteacher and tutor of Henry VIII, wrote a book in the late 1400s, *Lac puerorum,* that contains three woodcuts that were visual aids in teaching grammar to young schoolchildren. The first diagram is a left hand that displays the paradigms of the definite article; the second is also a left hand, with five rings for each of the five cases necessary for learning the second declension; the third holds six candles with long wicks threaded by a rope containing the paradigms of all five declensions, singular and plural. This last image could not be represented on a single hand. Another Latin grammar from a slightly later period in the south of Germany is even more elaborate than Holt's in its use of visual aids. Colored pictures, often comic, of humans, animals, and birds are  scattered throughout. A flagged note and an unflagged note represent long and short syllables, another example of the sharing of mnemonic devices between teachers of grammar and music. See Monika Asztalos, Jan Öberg et al., *Die "Seligenstädter Lateinpädagogik,"* (Stockholm: Almqvist and Wiksell International, 1989). The *Summa musice,* written around

ascents and diverse properties of individual sounds."[13] A monk by the name of John Cotton [of Afflighem], writing in or near St. Gall around 1100, connects Guido's method in the *Epistola* with the hand:

> First we enjoin him who wishes to prepare himself for training in music that he zealously master the letters of the monochord and the syllables written above them and not leave off this task before he has them by memory.... It is said that the syllables we use are taken from the hymn that begins: *Ut queant laxis....* So let him who strives for knowledge of music learn to sing a few songs with these syllables until he knows fully and clearly their ascents and descents and their many varieties of intervals. Also, let him diligently accustom himself to measuring off his melody on the joints of the hand, so that presently he can use his hand instead of a monochord whenever he likes, and test, correct, or compose a song. After he has repeated these things for some time, just as we have directed, and has thoroughly memorized them, he will have an easier, unperplexed road to music.[14]

This description not only links Guido's method with the hand, but also highlights the importance of memory, allowing a student to "test, correct, or compose a song" anywhere, without need of the instrument known as the monochord. Writing at the same time as John Cotton, another monk known as Siegbert, credits Guido with enabling children (both boys and girls) to sing directly from a notated page with the aid of syllables and the hand:

> Guido, a monk of Arezzo, was renowned more than almost any church musician. He ought to be esteemed above his predecessors in that boys and girls learn or are taught unknown melodies even more easily by his rule than by the voice of the teacher or by the use of some instrument, provided that, once six letters or syllables have been applied melodically to the six steps which are the content of music and these steps have been distinguished through the joints of the fingers of the left hand through the whole octave, the high and low ascents and descents of these steps offer themselves to the eyes and ears.[15]

That Guido might have learned *ars memorativa*, the art of memory, and *ars rhetorica*, the art of rhetoric, can only be conjectured, but scholars have found cases in which musical treatises of the eleventh and twelfth centuries were copied together with rhetorical ones. Dolores Pesce, Calvin Bower, and others have shown that Guido's education outside music included the study of metrical poetry and rhetoric, and that he applied some of the precepts and rules of grammar to his musical pedagogy.[16] Medieval teachers, such as Hugh of St. Victor in the twelfth century and Robert of Basevorn in the early fourteenth century, devised elaborate memory schemes. The former's rhetorical method is described in his *Tractatulus de oratione.* Hugh's work served as a model for Jan Mombaer (Johannes Mauburnus) whose book of meditation, printed in a second edition of 1510 (Cat. 75), contains a hand whose joints are inscribed with spiritual exercises designed to facilitate memory by linking theological vocabulary to musical instruments and dances.[17] Basevorn's methodology for preaching actually borrows from the Guidonian system of solmization.[18] Latin grammars often rely on principles established by the Guidonian method, particularly the use of the hand.[19]

Five examples in the current exhibition relate to musical learning. They represent a time frame from about 1450 to 1636 and are found in English,

German, and French sources. Only one of the five is from a manuscript source (Cat. 46); the remainder are from printed books, dating from the late fifteenth through the middle of the seventeenth century. The oldest of the printed editions, Hugo's *Flores musicae* (Cat. 47), is actually a copy of a fourteenth-century manuscript. The manuscript source, copied in England during the fifteenth century, is based on Guido's treatise, which was written in the eleventh century. Each one of the hands is influenced not only by time but also by geographical origin.

The first example is closest in content and spirit to the writings of Guido, as it is taken from a copy of his *Micrologus,* made in the fifteenth century by an anonymous English scribe. Although Guido did not include the image of the hand in the original treatise, the scribe includes it in this exemplar from chapter 16 (Cat. 46A). Following immediately on the verso is "Lady Music" (Cat. 46B), holding her monochord. She is pictured above a chart of information on the intervals and hexachords that does appear in the original treatise. The hand includes verbal cues for the lines and spaces above each of the solmization syllables (Cat. 46A).[20] An earlier version of the hand, copied in a twelfth-century manuscript from the Admont monastery in Austria, depicts the hand, its syllables, and no further inscriptions (Fig. 11).[21] The so-called Admont manuscript contains not only the hand along with the extant writings of Guido but also selected works of other medieval music theorists, Odo of Cluny, the anonymous author of the *Dialogus de musica,* Hermannus Contractus, and Berno of Reichenau.

The English continued to depict the hand in sources through the mid-sixteenth century (few remain, owing, in part to Henry VIII's pillages of monasteries in the first part of the century). If the little dialogue between Hortensio and Bianca regarding the old gamut in Shakespeare's *Taming of the Shrew* is any indication, Guido's methods fell into disfavor at the end of the sixteenth century.[22] The gamut was originally designed for use with simple modal melodies, but as tonality and modulation crept into music in the sixteenth century, the modal system proved unreliable and cumbersome. The advantages of solmization outweighed the decision to scrap the device altogether, but theorists and teachers in England and abroad struggled to simplify the hexachordal system (also called the gamut) without losing the benefits of solmization. The first English textbook on music, William Bathe's *Briefe Introduction to the True Art of Musicke* (1584), written while he was a student at Oxford, proposed scrapping the gamut altogether in the early stages of teaching. He referred to it as filled with "manifold, crabbed, confuse[d], and tedious rules."[23] He suggested a new method of sight-singing employing an unchanging sequence of *sol-fa* names permanently related to the notes of the Mixoly-dian scale[24]:

g   a   b   c   d   e   f   g
*ut   re   mi   fa   sol   la   fa   ut*

In this new system, the student had only to identify the position of *ut* on the staff in order to read a tune. Bathe was influenced by Francis Bacon's belief in empirical attitudes and boasted that he could in the space of a month teach

1200, would, like many medieval school texts, have been read aloud, sentence by sentence, by the teacher, who would ask the pupils to take dictation upon a slate. Although the book was designed as a manual for young singers who were learning Gregorian chant, notation, performance, composition, and music theory, the learning was achieved first as an exercise in Latin grammar. See Christopher Page, *The "Summa Musice": A Thirteenth-Century Manual for Singers* (Cambridge: Cambridge University Press, 1991).

20. See Smits van Waesberghe 1969, 138.

21. Leonard Ellinwood, "A Fresh Look at Guido on Polyphony: An English Translation of Excerpts from the *Micrologus* of Guido d'Arezzo Based on a Revision of Gerbert's Edition through Collation with the Admont-Rochester MS, with Explanatory Comment," paper read before the Western New York Chapter of the American Musicological Society at Wells College, Aurora, New York, 11 October 1936.

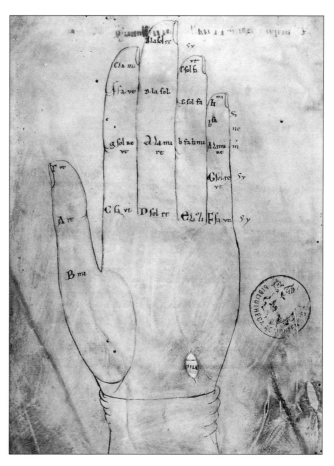

Fig. 11. Anonymous, *Guidonian Hand*, twelfth century. Guido d'Arezzo, *Micrologus.* Rochester, Sibley Music Library, Eastman School of Music, University of Rochester, ML 92 1200

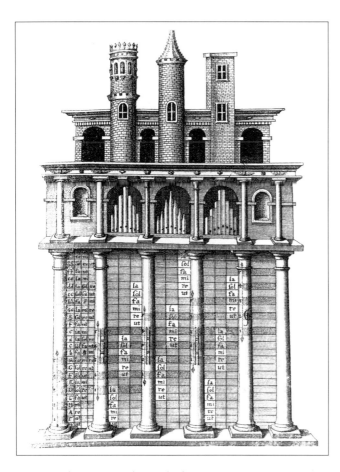

Fig. 12. Matthäus Merian, *The Temple of Music*, engraving, c. 1621. From Robert Fludd, *Utriusque cosmi historia* (Oppenheim: Johann Theodor de Bry, 1617-1621) 1:171. History of Medicine Division, National Library of Medicine, National Institutes of Health, Bethesda, Maryland

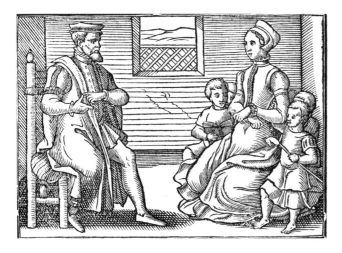

Fig. 13. Anonymous, English ?, *Singing at Home*, woodcut. From *Tenor of the Whole Psalmes in Four Partes* (London: John Day, 1563), frontispiece. The Folger Shakespeare Library, Washington, D.C.

a child of eight to sing difficult "crabbed" songs (referring to pieces with up to three sharps and three flats), to sing at sight, and to read in four clefs (C, F, G, and D). Bathe's work heralds a new era of English texts that offer solutions to the beginner's problems by utilizing the concept of moveable *sol-fa,* among them Anonymous: *Pathway to Musicke* (1596); Thomas Morley: *Plaine & Easie Introduction to Practical Music* (1597); Charles Butler: *The Principles of Musik* (1636); and John Playford: *A Brief Introduction to the Skill of Musick* (1658).

Thomas Morley believed the student still needed to learn the gamut, but once this was known, they could progress to learning *sol-fa* names for the rising major scale:

$$f \quad g \quad a \quad b^\flat \quad c \quad d \quad e \quad f$$
*fa sol la fa sol la mi fa*

This scheme (derived from the sequence in Guido's system), in which the leading note or tone became instantly recognizable through the use of the unduplicated syllable *mi,* the so-called *fasola* system, was to remain popular in England for the next two centuries. Already, by Butler's time, there was concern that the new method was not compatible with that on the continent, specifically mentioning the work of Mersenne in France among others. Mersenne, Butler reported, proposed in his monumental *Harmonie universelle* of 1636 (Cat. 50) the use of *si* as the seventh note of the scale. Despite the controversy over the gamut in England, one still finds books such as Thomas Davidson's *Cantus, Songs . . .,* published in 1682, with an illustration of the hand side–by–side "The Scale of the Gam."[25] Another interesting depiction of the Guidonian system—albeit not the hand itself—is the amazing engraving done by Matthäus Merian entitled *The Temple of Music* in Robert Fludd's seventeenth-century encyclopedia *Utriusque cosmi historia* (Fig. 12).[26] One final image from an English source deserves mention. A woodcut in the tenor partbook of John Day's *Whole Book of Psalms,* printed in 1563, depicts a gentleman pointing with his left hand to the extended thumb of his right apparently instructing a woman, surrounded by young children; one of them is holding a book, possibly "a book of psalms" (Fig. 13).

Similar patterns of acceptance and rejection of the gamut can be observed on the continent from the 1500s to the 1700s. Ample documentation proves the German reverence for the Guidonian system of musical learning throughout the Middle Ages.[27] Images of the hand with descriptions of the method abound in printed sources beginning in the fifteenth century. Hugo von Spechtshart of Reutlingen was a fourteenth-century German musician

and teacher who wrote a musical treatise designed to teach beginning choristers. His *Flores musicae omnis cantus Gregoriani* was so popular that it found its way into numerous printed editions in the late fifteenth century, was used as a resource for generations of German textbooks before and after the Reformation, and was published as late as the nineteenth century with a side-by-side translation into German. One text, printed in 1501 by the German music teacher Nicholaus Wollick, is almost a direct copy of Hugo's *Flores*.[28] One of the reasons for the popularity of Hugo's text following the appearance of the incunable editions published in Strasbourg by the German printer Johann Prüss was its woodcuts. The little book was printed with fairly large type, many images, and musical illustrations. The most famous of these was the full-page Guidonian hand (Cat. 47). Another full-page woodcut represents a compendium of classical, biblical, and medieval legends regarding the origins of music.[29] Unlike the first example from the fifteenth-century English manuscript (Cat. 46), there are no indications above the syllables as to line or space; rather, a staff in the palm contains the notation of an ascending and descending six-note scale (in this case, the hard hexachord on g) above a text explaining the three hexachords, natural (c-a), soft (f-d), and hard (g-e) and the use of the hand beginning at the top of the thumb (at the letter gamma) and proceeding across the palm and up and down the fingers from G to e".[30]

Although German towns had begun to organize schools for children before the Reformation,[31] it was Martin Luther and, in particular, his colleague Philipp Melanchthon who systematically reorganized the curriculum in these institutions. Unlike their monastic counterparts where boys were taught music for the sole purpose of being able to take part in religious services, the public schools taught music as a "valuable intellectual discipline, a religious duty and a social pleasure" to every child, boy or girl. German children studied singing and music in school for at least an hour a day.[32]

The hand survives in a variety of ways in other treatises of the fifteenth and sixteenth centuries. One of these is a little music text by a German music teacher named Balthasar Prasperg, *Clarissimma plane atque choralis musicae interpretatio,* very much in the tradition of Hugo. It was issued in Basel in 1501 and again in 1507 by Michael Furter, who also printed the first manual on musical instruments, Sebastian Virdung's *Musica getutscht* in 1511. The frontispiece contains a woodcut that depicts a banner with the Guidonian syllables *ut re mi fa sol la* above a well-dressed couple; he is gesturing with his left hand toward the banner, while she plucks a small harp (Cat. 48).

A later German example of the Guidonian hand occurs in Adam Gumpelzhaimer's *Compendium musicae latino germanicum* (printed in 1591 and again in 1632), a textbook on the rudiments of music for his students at the church of St. Anna in Augsburg. This church was formerly affiliated with the Carmelite order, and then in 1525 became Lutheran (Fig. 14). The book was based to a large extent on Heinrich Faber's *Compendiolum musicae,* which in 1572 had been translated from French into German. Probably influenced by earlier German texts, including Hugo's, Adam's hand reveals other changes in musical pedagogy. In Adam's hand, one begins at the top of the left thumb and proceeds up each finger in succession instead of going across the palm, up the little finger, across the tops of the other fingers, and up and down and around the joints. In every other way, Adam's hand looks just like Hugo's, even to the depiction of the staff with its ascending and descending hexachord on g (although Adam employs a

22. Act 3, scene 1 of Shakespeare's *Taming of the Shrew,* in *The Complete Plays and Poems of William Shakespeare,* ed. William A. Neilson (Cambridge, Mass.: Houghton Mifflin, 1942), 163.

23. Bernarr Rainbow, *Music in Educational Thought and Practice* (Aberystwyth, Wales: Boethius Press, 1989), 69.

24. Ibid., 69-70.

25. Thomas Davidson, *Cantus, Songs . . . ,* published in 1682, The Folger Shakespeare Library, D 382. I thank Professor Jessie Owens for sharing this source with me.

26. See Cat. 60. Charles Burney, writing in 1740, recalled that when he began to play the organ at Chester, his teacher made him learn the gamut: "The Guidonian syllables were taught at full length to children in my own memory, without explaining their relations to different hexachords" (Rainbow 1989, 102). The gamut lingered on in the eighteenth century in England and elsewhere, and it was particularly favored by antiquarians, although in general it had little effect upon professional practice. It was among amateurs and rural church choristers that it had the greatest appeal. William Tans'ur, in his *Musica sacra* of 1772, still considered the gamut sacrosanct and an indication of musical erudition (Rainbow 1989, 102). By the nineteenth century practical matters overtook intellectual ones. John Curwen, a Congregational minister, in an attempt to revive singing in his church, devised a system that placed solmization initials over pitches, coupled with bar lines, colons, and other symbols to indicate rhythmic duration, and manual signs for each of the syllables. His system, published in 1880 as *Standard Course of Lessons and Exercises in the Tonic Sol-fa Method of Teaching Music,* had its philosophical origins in Guidonian solmization but borrowed from far less orthodox methods aimed at the masses (Bernarr Rainbow, "Tonic Sol-fa," in *NGD* 19:61-65).

27. See Susan Forscher Weiss, "Musical Pedagogy in the German Renaissance," paper read at the Second International Conference, Frühe Neuzeit Interdisziplinär Conference: *Constructing Publics: Cultures of Communication in the Early Modern German Lands,* Duke University, 17 April 1998, forthcoming.

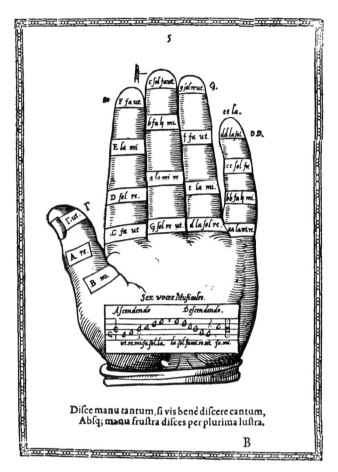

Fig. 14. Anonymous, German ?, *Guidonian Hand*, woodcut. From Adam Gumpelzhaimer, *Compendium musicae latinogermanicum* (Augsburg: Johann Ulrich Schönig, 1632), p. 5. Music Division, Library of Congress, Washington, D.C.

28. In 1501, the same year that Petrucci printed the *Odhecaton* in Venice, Nicholaus Wollick's text *Die Musica Gregoriana* came out in Cologne, looking very much like Hugo's, with its Guidonian hand, diagrams of the intervals, *hufnagel* script, epigram to Tubal, and basic overall structure. It appears to have relied heavily on Hugo, or at least on a source common to both. See K. W. Niemöller, "Nicholaus Wollick," *NGD* 20:512.

29. See Lilian M. C. Randall, "Flores Musicae: A Musical Bouquet," *Walters Art Gallery Bulletin* 29 (December 1976):1–3.

30. The Bb was curved and known as b *mollis* or "soft b" and opposed to b-natural with its square shape, known as b *durum* or "hard b." Hence the names for the two other hexachords, the "soft" on f and the "hard" on g.

31. Henry Raynor, *A Social History of Music* (New York: Schocken Books, 1972), 115.

modern G clef, rests, and mensuration sign [time signature]). The significance of Adam's treatise also lay in his selection of musical examples, which include many of his own works, in particular pieces in canonic form; his canons were included in part for their pedagogical value, for their suitability in teaching beginners, and for those whose voices are of equal range.[33] The syllables on Adam's hand follow a less circuitous path than those on the other hands in the exhibition. Instead of the customary ordering of the solmization syllables proceeding from the tip of the thumb to the base of the palm as pictured in Illustration 1, Adam places the syllables in ascending order on each successive finger (c, d, e, f on the pointer finger, g, a, b, c on the index, etc.). The highest note appears at the tip of the little finger, instead of at the tip of the index as in the other examples. Hands with irregular placement of syllables were rare but seem to coincide with the advent of the diatonic scale.

Although Lutheran Germany continued to emphasize the importance of the ancient traditions of music learning, attempts were always being made to replace the Guidonian syllables and their cumbersome mutations. A system known as *Abcedieren* using chromatic, alphabetical note-names instead of *sol-fa* was introduced by Pancratius Cruger in the sixteenth century.[34] Johann Amos Comenius (Cat. 33), perhaps influenced by Francis Bacon, urged that children needed texts with many pictures and illustrations, in both Latin and vernacular, tomes separate from those used by scholars. Indeed the German interest in illustrations and diagrams as a means of helping students to memorize goes back to the Middle Ages.[35] Birds, animals, comic characters, and musical instruments were often used as mnemonics. The playing of games, such as cards, was another means of developing memory. Comenius argued that music was an important element in the curriculum of all schools but that the parent must reinforce the learning of music by singing hymns and psalms at home each morning before leaving the house.[36]

A notable example appears in perhaps the most artistically splendid of all the musical images in the exhibition. Christofle de Savigny, a Frenchman in the service of Ludovico Gonzaga, Duke of Nevers and Prince of Mantua, together with an artist, possibly the well-known Jean Cousin the Younger, produced a book that was printed by the Gourmont brothers in Paris in 1587 and in at least one other edition in 1619 (Cat. 49).[37] This work, *Tableaux accomplis de tous les arts liberaux contenant brievement et clerement par singuliere methode de doctrine, une generale et sommaire partition des dicts arts, amassez et reduicts en ordre pour le soulacement et profit de la jeunesse,* contains eighteen illustrated tables, each followed by a page of narrative explanation. Savigny's coffee-table book illustrates what were then considered the important features of the liberal arts, mathematics, science, and theology, at least for a beginning student. Savigny's tree, or schematization of knowledge, may well be a precursor of the works of Francis Bacon, published in the early seventeenth century.[38] Bacon's works were said to be the models for later encyclopedias, such as that of

Diderot's *Encyclopédie* to which Jean Jacques Rousseau contributed articles on music. The border of Savigny's music page contains illustrations of numerous musical instruments. Within, one finds a table of the signs and symbols of musical knowledge intended to help a young musician memorize and understand the important concepts of music theory (Cat. 49). In this particular rendition of the Guidonian hand, to facilitate navigation around the joints, the arabic numbers 1-19 are placed above each of the solmization syllables. The hand is only one of many images placed in a specific hierarchy to enable students to learn in a systematic manner. In his narrative on the following page, Savigny links learning about the harmony of the spheres with producing good singers (and instrumentalists). He also makes no differentiation between *gamme* (gamut) and *eschiele* (scale). The practical considerations, a by-product of the reforms undertaken by the Germans and Swiss in the early part of the sixteenth century, are manifest in Savigny's illustration.[39]

The last of the French exemplars in the exhibition is by another writer who was directing his work toward an audience wider than that of the professional musician. Marin Mersenne's *Harmonie universelle* was published in Paris in 1636. In it the hand appears twice. The first is the ordinary harmonic hand of the practitioner, the one used for teaching children.[40] On page 143 he states that there are seven hexachords in the harmonic table. After an explanation of hard and soft he continues with a theoretical discussion. He is not—as had been thought—describing a system that requires a left and right hand, but is referring to the right and left sides of the table.[41]

There is an earlier example of the use of both right and left hands in a twelfth-century manuscript in Paris.[42] Johannes Tinctoris, in his *Expositio manus*, states that the lesson can be taught with either hand, but that

> it is taught rightly, however, in the left by everyone, for the reason that
> the places in the left hand are more easily indicated by the index finger
> on the right, even though some people most aptly indicate the places on
> the thumb of the left hand with the index finger of the same hand and the
> places on the other fingers similarly by the thumb of the same hand;
> wherefore they may use only one hand, that is, the left, in the instruction
> of this kind of lesson.[43]

Later in the same volume Mersenne presents the hand again on page 349f. In this instance the hand functions as a part of the larger picture of music theory, a kind of pictorial summary—not unlike Savigny's—that makes associations between Guido's system, that of the ancient system of tetrachords (on the left), and symbols and rhythmic durations in the surrounding borders (Cat. 50). Above each of the syllable names are two or three notes on lines or in spaces (these cues were made verbally in the fifteenth-century English manuscript discussed earlier [Cat. 46A]). The hand has thus become an icon for both theoretical and practical learning.

Later in the seventeenth century Rameau describes a use of the hand, not to teach the hexachords but as a means of learning to read music: "It will be seen readily enough that the five fingers of the hand are very capable of representing the five lines upon which music is written: for if one contemplates or imagines the hand held well open, the little finger nearest the ground, one may see the five lines with their spaces–which are the gaps separating the lines formed by the fingers."[44] Rameau in his *Code de musique* (1760), published six years before his death, included material based on his lifetime experience as a

32. Many musical textbooks from the Reformation and post-Reformation periods reveal evidence of the change. They contain information on theory, composition, and singing, and although many presuppose a high degree of skill and musical sophistication, they are all practical textbooks *of* music as opposed to theoretical treatises *on* music. The Reformation introduced new pedagogical elements into the study of music, both methodological and curricular, and these were offered to the public, not just to the clergy or the elite. Although the Guidonian principles remained a staple of many texts following the Reformation, several musicians turned away from the method as being far too cumbersome. Georg Rhau's *Enchiridion* was first published in 1517 as a music manual for young schoolboys. In his section on solmization, Rhau, who studied with Luther at Wittenberg, omits reference to the ubiquitous Guidonian hand because he considered it an added complication to an already overburdened system.

33. William F. Hettrick, "Adam Gumpelzhaimer," *NGD* 7:846-847.

34. Rainbow 1989, 358; Yates 1966, 177-178.

35. Sabine Heimann-Seelbach, "Diagrammatik und Gedächtniskunst," in *Schule und Schüler im Mittelalter* (Cologne: Böhlau, 1996), 385-410.

36. Johann Mattheson, in his *Das neueröffnete Orchester* published in 1713, attacked the church modes and the Guidonian system of solmization as "outworn survivals preserved rather as hallowed relics than for their utility." The decline in the art of singing led Frederick the Great in 1746 to issue a decree demanding that all public schools and gymnasiums have singing lessons three times a week (Rainbow 1989, 85, 120).

37. Ambroise Didot, *Étude sur Jean Cousin* (Paris: Didot et frères, 1872), 195-197; Michèle Beaulieu, "Pierre Bontemps et les Cousins Père et Fils: Artistes sénonais de la Renaissance," in *Clio et son regard: Mélanges d'histoire de l'art et d'archéologie offerts à Jacques Stiennon à l'occasion des ses vingt-cinq ans de l'enseignement à l'Université de Liège*, eds. Rita Lejeune and Joseph Deckers (Liège: Pierre Mardaga, 1982), 35-48. Jane Stevens, "Hands, Music, and Meaning in Some Seventeenth-Century Dutch Paintings," *Imago Musicae* 1 (1984):89, states that the book was first published in 1578 in Paris. This is undoubtedly a typographical error.

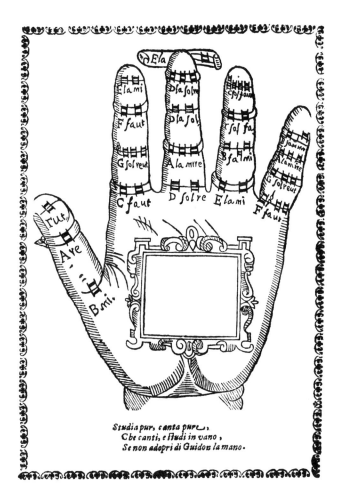

Studia pur, canta pur,
Che canti, e studi in vano,
Se non adopri di Guidon la mano.

Fig. 15. Anonymous, Italian?, *Guidonian Hand*, woodcut. From Orazio Scaletta, *Scala di musica molto necessario per principiati* (Rome: Andrea Fei, 1642), frontispiece. Music Division, Library of Congress, Washington, D.C.

38. Ruth Mortimer, comp. (with Philip Hofer and William A. Jackson), *Harvard College Library, Department of Printing and Graphic Arts, Catalogue of Books and Manuscripts,* in *Part 1: French Sixteenth-Century Books* (Cambridge, Mass.: Harvard University Press, 1964), 2:595.

39. Another important treatise, one of the earliest written in French, *Le droict chemin* by Louis Bourgeois, published in Geneva in 1550, advises singers to abandon the archaic Guidonian hand, the complex Greek names of the scale (*diapason, diapente,* etc.) altogether and advocates printing the *sol fa* names against the notes directly on the staff. Anne Amerson, "Louis Bourgeois, Sixteenth-Century Psalmodist and Theorist, with a translation of *Le droict chemin de musique* (Geneva, 1550)" (master's thesis, University of Hawaii, 1972).

teacher. He taught children by using his own hand, not, as in the older method to teach gamut names, but in the more contemporary manner to depict lines and spaces on a staff.

In Italy the first theoretician to suggest a break with the Guidonian tradition was Bartolomeo Ramos de Pareia, the Spanish music teacher who in his 1482 treatise proposed a set of eight syllables; he was attacked by many of his contemporaries including Niccolo Burtius. Gaffurius and Bermudo in their treatises attempted to link the modes with the hexachord system but not until the end of the sixteenth century were seventh and eighth syllables added.[45] Some Italian textbooks contain the conventional Guidonian approach, including one by the Cremonese composer Orazio Scaletta. The more famous of his two treatises, *Scala di musica molto necessario per principiati,* like Adam Gumpelzhaimer's, was reprinted many times. Scaletta emphasizes practical issues, showing a departure from the Italian treatises such as Zarlino's and other humanist theoreticians of the late fifteenth and sixteenth centuries.[46] The staff lines around the fingers on Scaletta's hand (Fig. 15) contain either two or three breves (shortest notational values), according to where the notes are to be found, as was the case in Mersenne's hand.

Karol Berger claims that "the musical hand belongs to the family of mnemonic devices which have their ultimate source in the classical art of memory."[47] He reminds us of Leo Treitler's work on the function of memory in the oral transmission of chant, while suggesting that the hand also had a role to play in the final stages that transformed the oral to a written tradition, a stage in which Guido was a key figure.[48] Although he cannot prove that the hand and the art of memory are connected, Berger suggests that the inventor of the hand may have copied the idea from the author of *Ad Herennium* or from the writings of Martianus Capella. Others, such as Pesce and Bower, have suggested connections between the learning of rhetoric and grammar and the learning of music. F. Alberto Gallo has shown how a technical rhetorical term—*pronuntiatio*—became a musical term; Joseph Smits van Waesberghe and Michel Hugo have made indirect links between Guido and the rhetorical works of Cicero and others. Berger concludes by saying:

> Whoever first came at the idea of representing the steps of the gamut on the hand, might have been simply adapting an already existing tool to his particular purpose in blissful ignorance of the centuries of tradition behind his invention. . . . Once a device was in common use, a medieval theorist was even less likely to discuss in detail its origin, beyond referring to a Pythagoras, a Boethius, or a Guido as the inventor. [As a matter of fact, all three of these were hailed as the inventors of the hand.][49]

40. Following Mersenne's introduction of the table and the two observations he presents the normal "Guidonian hand." The ordinary harmonic hand of the practitioners, in which you see all the syllables [twenty] which one uses for teaching children, although some reduce it now to the eight which form the octave of C *sol ut fa* in order to abbreviate the method; but whatever ingenuity one brings to it, it all comes back to the same thing.

41. Jane Stevens had suggested in her article "Hands, Music, and Meaning in Some Seventeenth-Century Dutch Paintings," *Imago Musicae*, 1 (1984):91-92, that Mersenne was referring to two hands, but in fact his description has nothing to do with using the left or right hand for picking out the pitches. I would like to thank Leofranc Holford-Strevens for pointing out this error. Mersenne 1963, 2:144. The original passage reads: "Secondement que les demitons des Hexachordes repondent aux demitons Tetrachordes des Anciens, dont les trois conjoints sont a main gauche de la Gamme de Guy Aretin & le disjoint, ou separe est a main droite avec le cinquiesme, auquel il est conjoint." Secondly, one must observe that the half step of the hexachords correspond to the halfsteps of the tetrachords of the ancients, of which the three conjunct tetrachords are on the left side, and the disjunct, or separate, on the right side with the fifth to which it is joined. See also Smits van Waesberghe 1951, 15-53 and his entry in *Die Musik in Geschichte und Gegenwart* (Kassel: Barenreiter, 1956) 5:1453.

42. Joseph Smits van Waesberghe, *De musico-paedagogico et theoretico Guidone Aretino, eiusque vita et moribus* (Florence: L. S. Olschki, 1953), 132-133. The twelfth-century manuscript is found in Paris, BNF, MS lat. 7203, fol. 5v.

43. Albert Seay, "The *Expositio manus* of Johannes Tinctoris," *Journal of Music Theory* 9 (1965):201. Tinctoris is operating from the assumption that most people are right-handed.

44. For the Rameau quotation, see Rainbow 1989, 108 n. 2.

45. On the other hand, the Italians occasionally found their own method of employing the hand. One of these unorthodox hands is in Adriano Banchieri's *Cantorino utile a novizzi,* published in Bologna in 1622. Banchieri pays homage to Guido and to his hymn early in the book, but on p. 26 he depicts a left hand with a thumb curved against the pointer finger,

devoid of letters or numbers. The remaining fingers contain the numbers one through fourteen, utilizing only the twelve joints and two tips above the ring and little fingers. As the range of chant is often with one or two hexachords, it is possible that Adriano needed fewer places in his hand (Adriano Banchieri, *Cantorino utile a novizzi* [Bologna: Heredi di Bartolomeo Cochi, 1622], Forni reprint [Bologna: *Bibliotheca musica Bononiensis,* 1980]).

46. Iain Fenlon, "Orazio Scaletta," *NGD* 16:545-546.

47. Berger 1981, 118. There is a slight paradox inherent in the use of the hand as an aide-mémoire. Guido lamented, in the prologue to his antiphoner *Aliae regulae* (1020-1025), the time young singers spent learning chants by heart. He claimed that his system would permit the students to read by sight, not just learn by rote. Rote repetition, as Mary Carruthers has pointed out, is not "found out" by any heuristic (from the Greek, meaning "to find") or retrieval scheme and is therefore not considered recollection or true memory. Some of these heuristic schemes, like Guido's, take advantage of "hermeneutic" and "iconographic" conventions. It is ironic that many musicians today attribute their inadequacies in memory to an emphasis on note-reading in lieu of greater time spent in aural training (see Carruthers, *The Book of Memory,* 19-21).

48. Leo Treitler, "Homer and Gregory: The Transmission of Epic Poetry and Plainchant," *Musical Quarterly* 60 (1974):333-372, and Berger 1981, 118.

49. Berger 1981, 120; Smits van Waesberghe 1969, 120.

# A Show of Hands
*Brian P. Copenhaver*

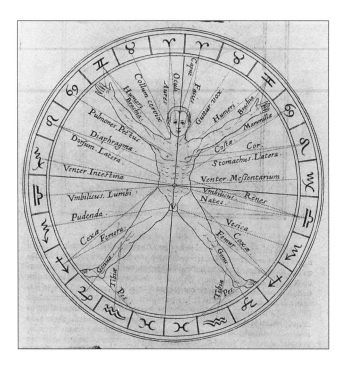

Fig. 16. Matthäus Merian, *Melothesia Representing Zodiacal Influences on the Body*, engraving, c. 1621. From Robert Fludd, *Utriusque cosmi historia* (Oppenheim: Johann Theodor de Bry, 1617-1621), 2/6: 113. Library of the College of Physicians of Philadelphia

1. Tamsyn Barton, *Ancient Astrology* (London: Routledge, 1994), 185-197.

2. The standard, though antiquated, work on ancient divination is A. Bouché-Leclerq, *Histoire de la divination dans l'antiquité* (Paris: Leroux, 1879), still cited by Jerzy Linderski in his summary of the topic: "Divination," *Oxford Classical Dictionary,* eds. S. Hornblower and A. Spawforth (Oxford: Oxford University Press, 1996), 487-488.

3. Aristotle, *PA* 2.27 70<sup>b</sup>6-16; translation from *The Complete Works of Aristotle*, ed. Jonathan Barnes (Princeton: Princeton University Press, 1984), 1:113.

4. Aristotle, *HA* 1.8 491<sup>b</sup>9-14; 1.15 493<sup>b</sup>31-33, 1.15 494<sup>a</sup>16-18; translation from Barnes 1984, 1:782, 786, 787.

5. Aristotle, *Physiognomics* 1.805<sup>a</sup>1-18; translation from Barnes 1984, 1:1237.

Chiromancy, or divination by marks on the human hand, was a popular topic in late medieval and early modern Europe, even for people with enough education to read Latin. Hundreds of books of this period—vernacular as well as Latin—explain the related arts of reading palms, lines on the forehead (metoposcopy), or general features of the human body (physiognomy). These and other parts of the human person, seen as a "little world," or microcosm, were thought to be linked organically to each other and to the parts of the "great world," or macrocosm. In this context of universal sympathies and antipathies, astrological theories about the stars and other macrocosmic bodies informed medical diagnosis of ailments in the lesser human body. Using the convention called *melothesia* (μελοθεσια; μελος "part" + θεσις "arranging"), astrologers and physicians assigned parts of the body to the twelve figures of the zodiac, believing that Aries ruled the head; Taurus, the neck; and so on down to Pisces and the feet (Cat. 57).[1]

A standard if refined *melothesia* with hands ruled by Gemini in the normal way (Fig. 16) appears in the section of Robert Fludd's *Utriusque cosmi historia* that deals with the "supernatural, natural, preternatural and contranatural history of the microcosm." But in other images of the cosmic human that embellish the huge project he started in 1617, Fludd transcended the common iconography. Before he abandoned it, other parts of his enormous encyclopedia appeared through 1626, displaying the intricate plates prepared by Johann Theodor de Bry and Matthäus Merian to fulfill Fludd's aim of re-creating in images what God had established in nature. The same section, for example, displays a human figure (Fig. 17) standing below a fiery cloud that frames God's most sacred name ( יהוה , YHWH). The body stretches from microcosmic day above the head to microcosmic night below the feet. Within these limits the upper half of the body (down to the base of the penis) occupies three concentric circles: head and neck in the empyrean heaven, thorax in the ethereal heaven and belly in the elementary heaven. The right is the only hand visible, palm outward in this lowest elementary circle.

The title page of the next section of the second volume, "On the Technical History of the Microcosm," locates chiromancy within Fludd's special framework for the divinatory arts. In the top segment of a circle divided into eight truncated wedges (Fig. 18), man stands below a blaze of divinity with his feet on a globe containing the ape that symbolizes art—man's imitation of God's natural creatures. Moving clockwise from man's left are seven images displaying types of divination: prophecy, geomancy, the art of memory, judicial astrology, physiognomy, chiromancy, and the science of pyramids—this last a specialty of Fludd's.

What made these lines standard or conventional? For their anatomical basis, we can turn to a much later work, a textbook assigned in today's medical

schools. Clemente's *Anatomy* (Fig. 19) shows a number of features normally seen on the palm and fingers. Starting in the middle of the palm at the wrist and curving around the base of the thumb is (1) the *radial longitudinal palmar crease*. Running from the same origin toward the middle finger is (2) the *medial longitudinal palmar crease*. Crossing line 2 in the center of the palm and extending to the edge opposite the thumb is (3) the *proximal transverse palmar crease*. Roughly parallel to 3, closer to the fingers and reaching between the little and middle fingers is (4) the *distal transverse palmar crease*. The small pads called (5) the *monticuli* of the palm lie between the fingers at their base.

These folds and creases on the hand, like stars and planets in the sky, are natural objects of which people have long made supernatural use by divining with them—treating them as signs of future events. People everywhere, including people who still check their horoscopes every day, have found divination useful. In the ancient Mediterranean world, divination and religion were inseparable, as the Greek evidence from Homer onward shows. In the fourth century BCE, Xenophon classified various types of divination through oracles, dreams, the observation of birds, the inspection of sacrifices, and other means, but three centuries later Cicero used Stoic categories in his influential dialogue *On Divination*. Astrology fell into the group that Cicero called artificial or external because the source of divination is outside the diviner's person and requires technical knowledge. In this sense, astrology and related systems of divination were *technai* (τεχναι) and, therefore, like medicine. Medical prognosis, like divination, was and is a predictive technique.[2]

For an expert to predict changes in a person's life by observing features of the body was normal in ancient medicine and remains so today. In the *Prior Analytics,* one of his logical works, Aristotle extended this proposition from the physical realm to the moral. "It is possible to infer character from physical features," he argues "if it is granted that the body and soul are changed together by the natural affections . . . such . . . as anger and desire . . . [and if] there is one sign for each affection."[3] If large limbs are a sign of courage in the lion, he reasons, the same sign should indicate courage in a human. This passage and a few others in the *History of Animals* attached Aristotle's enormous authority to what became a science of physiognomy. A round forehead signifies a quick temper, and the flat-footed are more apt to be criminals than constables.[4] Such statements in the canonical works made it plausible that Aristotle had written a whole treatise on physiognomy, based on the premise that

> mental character is . . . conditioned by the state of the body . . . [and] the body . . . by the affections of the soul.
>
> . . . But still better instances of the fundamental

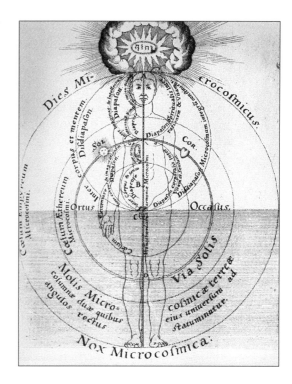

Fig 17. Matthäus Merian, *Man as Microcosm in Day and Night*, engraving, c. 1621. From Robert Fludd, *Utriusque cosmi historia* (Oppenheim: Johann Theodor de Bry, 1617-1621), 2/5: 112. Library of the College of Physicians of Philadelphia

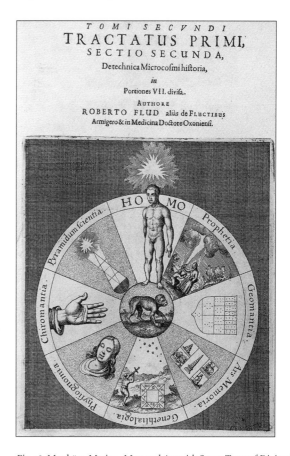

Fig. 18. Matthäus Merian, *Man and Art with Seven Types of Divination*, engraving, c. 1621. From Robert Fludd, *Utriusque cosmi historia* (Oppenheim: Johann Theodor de Bry, 1617-1621), 2/1: frontispiece. Library of the College of Physicians of Philadelphia

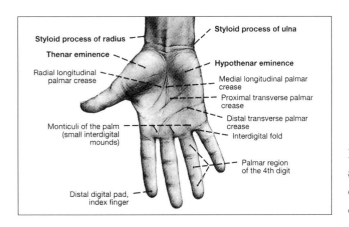

Fig. 19. K. Mozga, *Surface Anatomy of the Right Upper Extremity, Anterior Aspect,* digital print. From Carmine D. Clemente, *Anatomy: A Regional Atlas of the Human Body,* 4th ed. (Baltimore: Lippincott, Williams and Wilkins, 1998), fig. 40. Hershey Medical Center, Hershey, Pennsylvania

6. Aristotle, *Physiognomics* 3.806$^a$22-25; 3.808$^a$5-10, 10-15; translation from Barnes 1984, 1:1238, 1239, 1241.

7. Suetonius, *Tit.* 2; Juvenal 6.583-584.

8. Barton 1994, 13, 138; Michael Baigent, *From the Omens of Babylon: Astrology and Ancient Mesopotamia* (Harmondsworth: Penguin, 1994).

connection of body and soul . . . may be found in the normal products of nature. . . . The soul and body appropriate to the same kind [of animal] always go together, and this shows that a specific body involves a specific mental character. Moreover, experts on the animals are always able to judge of character by bodily form, . . . [and thus] physiognomy must be practicable.[5] Bearing out this theory were concrete connections, such as those between coarse hair and courage or soft hair and cowardice. "Hands long and delicate" show the same trait of cowardice, while "hands . . . carried upturned and flabby" are the mark of an effeminate man.[6]

In this pseudo-Aristotelian work of the third century BCE, hands are no more prominent than other parts of the body. Likewise, while *physiognomonia* (φυσιογνωμια) became a common term, words for specialists in the physiognomy of hands—*cheiromantis* (χειρομάντις: χειρ "hand" + μάντις "diviner") or *cheiroskopos* (χειροσκόπος; χειρ "hand" + σκοπέω "examine")—were rare in ancient Greek. Nonetheless, the place of hands in human culture and their constant visibility to human observers assured a lively future for chiromancy, while the broader practice of physiognomy continued to attract attention and produce other specialties. Suetonius used the technical term *metoposcopus* for a diviner who foretold that Titus would rise to the imperial throne, but when Juvenal attacked women as credulous in his savage sixth satire, the seer who inspects female hands and foreheads is a *vates,* a prophet or diviner in the broadest sense.[7]

The specialty of chiromancy was a division of physiognomy, but it was also dependent on astrology and greatly shaped by it. From antiquity through the early modern period, astrology and astronomy were indistinguishable from one another. The same people who studied the heavens mathematically believed that planets and stars influence earthly phenomena and can be used to predict them. A clear distinction between astronomy as an exact science and astrology as a divinatory superstition is post-Newtonian. Astronomy began in the temples of ancient Mesopotamia, but astrology has the same pedigree. Since the main point of astrology was to predict celestial effects on humans, it was natural to look for some relationship between the heavenly bodies and the human body.[8]

The culminating pictorial expression of that inquiry in the West was Fludd's extravaganza of microcosms and macrocosms, but his fantasies had an ancient pedigree. In the second century CE, when the astronomer Ptolemy described regions and cities with the parts of the sky believed to influence them, he also provided an ethnography, recording the physical appearance of exotic and mythical peoples as well as their customs and character. The Ethiopians who live in a torrid climate cooked by the Sun are generous and clever, says Ptolemy, but also voluptuous and dishonest. The heavens shape souls as well as bodies. A man with a hairy chest has high spirits, but hairy legs are a sign of lust. According to the physician Galen, Ptolemy's eminent contemporary, such outer signs are clues to the inner physiology that causes them, and physiology is influenced by the stars. Galen therefore took it for granted that a physician must know and use astrology. Unsurprisingly, some of his admirers found it difficult to tell his medical prognostications apart from

divination. Both were predictive sciences well grounded in the natural philosophy of the time.[9]

The philosopher Aristotle, the astronomer Ptolemy, the physician Galen, and scores of other ancient authorities, actual and mythical, gave learned approval to the belief in divination of which chiromancy was part. As Europe became Christian, however, that belief became dangerous. Because of its ritual character, any divination threatened the ministers of the new religion by competing with their own rites. Astrological divination was especially risky because ancient pagans had treated the stars and planets as gods, now demoted to evil demons.[10] Despite these perils, one could find support for chiromancy in the holiest text of all, the pages of Scripture, where the metaphorical range of Hebrew, Greek, and Latin words for "hand" invites exegesis. Giving the law to Moses in Exodus 13:9, the Lord was surely not thinking of palmistry when he said "it shall be a sign unto thee upon thine hand," yet this biblical passage and others would be used to sanctify chiromancy.

The Hebrew Bible approves some kinds of divination, though the methods are obscure. The mysterious *urim* and *thummim* may have been stones, sticks, or dice for a priest to cast and learn God's will. But Joseph and Moses had shamed Pharaoh's sorcerers, and Ezekiel followed suit by denouncing "foolish prophets . . . and lying divination."[11] Built on these laws of ancient Israel, Christian anti-occultism was even more exclusive, reserving all the Gospel's wonders for Jesus, the good angels, or evil spirits. Early Christian loathing of occultism was so fierce that its success in the Middle Ages and after was itself a miracle of human desire, showing that the official faith had failed a whole range of needs for health, love, power, wealth, and security in this world and the next. This last compulsion kept Christian clients coming to the diviners, including chiromancers, who would help them see the future.

Moslems rather than Christians first harvested the fruits of ancient learning in the early Middle Ages, and physiognomy was part of the crop. In the early tenth century, for example, the physician called Rasis in Latin included the topic in his *Liber Almansoris,* which medical students in Renaissance universities still studied. Even before Rasis wrote, however, Christian preachers were warning the faithful not to have their palms read, but chiromancy survived to flourish in the later medieval centuries. Major thinkers of that age—Michael Scot, Albertus Magnus, Peter of Abano, and others—had works of chiromancy ascribed to them, sometimes accurately, and Aristotle enjoyed the same vicarious honor even more often.[12] Medieval manuscripts preserve six different chiromancies naming Aristotle as author, though their sources are Arabic and Greek. One of these, known from its first words as *Lineae naturales tres sunt in planitie omnis ciros* (Every hand has three natural lines on its surface), appears to be the first independent chiromancy in Latin. If the attribution of this translation to Adelard of Bath is correct, it belongs to the twelfth century, when John of Seville may also have turned an Arabic chiromancy into Latin.[13]

Even though one of them cites Avicenna and Albertus Magnus, two of these half-dozen medieval chiromancies attributed to Aristotle were printed together under his name in 1490. Fifteenth- and sixteenth-century presses eventually issued more than a dozen other books containing pseudo-Aristotelian guides to palmistry.[14] Printing, having started in Europe around 1450, would strengthen the occultist tradition by amplifying its visual power. Of all magical images, the best known were the signs of the seven planets and

9. Barton 1994, 180-191.

10. Richard Kieckhefer, *Magic in the Middle Ages* (Cambridge: Cambridge University Press, 1990), 56-58, 85-90, 116-131; Valerie Flint, *The Rise of Magic in Early Medieval Europe* (Princeton: Princeton University Press, 1991), 18-21, 88-108, 128-146.

11. Genesis 41:8-44; Exodus 7:8-25, 28:30; Howard C. Kee, "Magic and Divination," *The Oxford Companion to the Bible,* eds. B. M. Metzger and M. D. Coogan (New York: Oxford University Press, 1993), 483-484.

12. Thorndike, *A History of Magic and Experimental Science,* 1:668; 2:166, 266, 331, 575; Kieckhefer 1990, 87.

13. Charles B. Schmitt and Dilwyn Knox, *Pseudo-Aristoteles Latinus: A Guide to Latin Works Falsely Attributed to Aristotle before 1500* (Warburg Institute Surveys and Texts, XII) (London: Warburg Institute, University of London, 1985), 21-24.

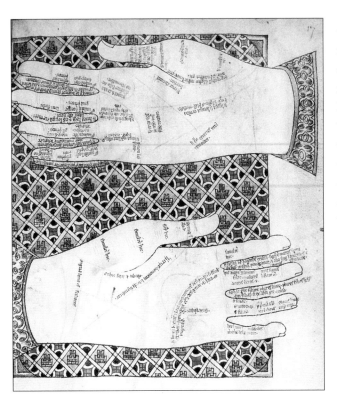

Fig. 20. *Two Chiromantic Hands,* thirteenth century. Oxford, Bodleian Library, MS Ashmole, 399, fol. 17

14. Thorndike, *A History of Magic and Experimental Science,* 5:672-678.

15. Schmitt and Knox 1985, 22-23.

16. Thorndike, *A History of Magic and Experimental Science,* 2:702; 3:19, 421, 515; 4:117, 143, 278, 492.

17. D. P. Walker, *Spiritual and Demonic Magic from Ficino to Campanella* (London: Warburg Institute, University of London, 1958); Brian P. Copenhaver, "Astrology and Magic," in *Cambridge History of Renaissance Philosophy,* ed. Charles B. Schmitt et al. (Cambridge: Cambridge University Press, 1988), 264-300.

18. Heinrich Cornelius Agrippa von Nettesheim, *Opera,* reprint ed. (Hildesheim: Olms, 1970), 1:95-96; Charles G. Nauert, *Agrippa and the Crisis of the Renaissance* (Urbana: University of Illinois Press, 1965), 32-33, 98, 106, 111-113, 192-193.

19. Agrippa 1970, 1:235-248.

twelve zodiacal constellations, painted on the night sky millennia before by the imagination. Since late antiquity, alchemists had been accumulating an even more profuse iconography. As the astrologer watches the lights of the heavens and the alchemist observes the colors of metals, so the diviner looks for the flight of a bird, the shape of entrails, the shudder of a sacrificed ox or—in the art of chiromancy—marks on a hand. It became easier to read such marks methodically when printed manuals of palmistry disseminated chiromantic images widely and kept them stable, illustrating the diviner's experience and explaining his theories in (sometimes) clear pictures.

One medieval chiromancy that made it to print was the earliest Latin treatise, the translation connected with Adelard of Bath.[15] Two hands drawn for a thirteenth-century manuscript of this work (Fig. 20) are filled with nothing but tiny words, strings of meaning to tie the page to the reader's eye. Some of these wispy threads follow the chiromantic lines, but the illustrator's effort shows that manuscript transmission of images left much hanging on accidents of talent, invention, or brute physical change. Compared to images in printed books, these schematic hands are less effective as carriers of chiromantic technique, even if reinforced by oral tradition.

Around the time that printing created new possibilities for technical illustration, scholars looked to the past for a theory to justify occult practices, whose efficacy and morality were still under attack in the later Middle Ages. The *Speculum astronomiae,* ascribed to Albertus Magnus, questions the legitimacy of chiromancy but justifies it by linking it with physiognomy and astrology. A few centuries later, by contrast, astrology would make chiromancy disreputable. Meanwhile, some of the most outspoken critics of medieval occultism were reluctant to deny all credence to chiromancy. A theologian of Paris might complain that the art was demonic, but his medical colleagues would go on using it. Yet even an archbishop could face legal charges for having his palm read. Chiromancy—like any magic—was vulnerable to moral critics who claimed that all divination is the devil's work.[16]

The opposing theory of natural magic aimed to preserve some occult beliefs and practices on the grounds that the causes of the effects involved were natural objects rather than spiritual persons. This key distinction between natural and demonic magic was known to medieval authorities, but Marsilio Ficino and other Renaissance thinkers strengthened the philosophical foundations and cultural authority of natural magic. Ficino recovered, translated, and interpreted the ancient Neoplatonic philosophers who had first worked out a coherent theory of magic, and he combined their ideas with those of the Scholastics. Giovanni Pico della Mirandola publicized and extended Ficino's views, even adding Cabala to the mix. Pietro Pomponazzi's approach was more traditional in sticking closer to Peripatetic sources but also more radical in denying demons any role at all in the world that natural philosophy could explain. By the early sixteenth century, the result was that occultism—including astrology and divination—reached its apex as a required and respectable topic of intellectual discourse among educated Europeans.[17]

Although "occultism" is a nineteenth-century coinage, its use to refer to certain beliefs and practices of early modern Europeans—magic, astrology, Cabala, demonology, divination, witchcraft, and so on—is justified by a book published in 1510 (issued in complete form only in 1533) and covering the same range of items under the title *De occulta philosophia*. This exposition and defense of "occult philosophy" was the work of Henry Cornelius Agrippa von Nettesheim (1486-1535), who expanded and vulgarized the shorter, subtler, and—in some ways—less readable contributions of Ficino and Pico. In the first book of his work, Agrippa proposed a theoretical basis for chiromancy and related arts, as follows:

> The body's expression, gesture, motion, position and figure . . . enable us to capture gifts from the heavens, expose us to higher powers and produce various effects in us. . . . Cheerful, open expressions and polite gestures . . . relate to Jupiter, . . . harsh, fierce, cruel, angry, savage gestures and expressions of the same kind to Mars. . . . Saturn indicates a person between black and yellow in color, thin, crooked, with rough skin, . . . clever, gifted, a seducer and a killer. . . . On these figures and gestures, then, physiognomy, metoposcopy and the arts of divination depend, and so does chiromancy, predicting future events . . .[in a way] not to be scorned or condemned, seeing that they are predicted not by superstition but by a harmonic correspondence of all the parts of the body. One who better imitates the celestial bodies . . . will be equipped to receive more of their gifts insofar as he is more like those powers above.[18]

Stars and planets, argues Agrippa, are single causes of multiple, related effects that signify one another because they are so related as effects of the same cause. The star that causes some physical or mental effect in a person also causes in the same person some bodily figure—in the case of chiromancy, a mark on the hand—that can be read as a sign of the related physical or mental effect because it flows from the same celestial cause. The magus who recognizes these occult harmonies can prepare himself or another to receive more of heaven's gifts, as Agrippa explains in the chapter of his second book "On the Proportion, Harmony, and Measure of the Human Body."

> Since man is God's most beautiful and finished work, his image and a lesser world,[he] contains and sustains in himself all numbers, measures, weights, motions, elements and other components of his nature. . . . Hence, all the ancients used to . . . show numbers by fingers, seeming to prove that all numbers, measures, proportions and harmonies were invented from the joints of the human body. . . . The common measures of all the body's parts are proportionate and consonant, thereby conforming to the parts of the cosmos and to the measures of the Archetype, so that no part of the human body lacks correspondence to some sign, some star, some intelligence or some divine name in the Archetype, God himself.[19]

Following this introduction are six astrological figures of the whole human body, variants on themes of *melothesia*, microcosm, macrocosm, and horoscopic astrology. Next comes a long section on proportion among various body parts, and in the middle of this a figure of a hand with planetary signs (Fig. 21), followed by more description of bodily proportions. These include those of the hand, which show the "measures found everywhere that agree with the . . . heavenly bodies themselves in length, breadth, height and circumference, . . . from which a manifold harmony arises."[20] Because Agrippa's book was so popular,

20. Ibid., 1:247.

21. Thorndike, *A History of Magic and Experimental Science,* 5:36-68; Paola Zambelli, "Aut Diabolus aut Achillinus: Fisionomia, astrologia e demonologia nel metodo di un Aristotelico," *Rinascimento* 18 (1978):59-86.

22. Johannes ab Indagine, *Brief Introductions Both Naturell and Pleasaunte. . . unto the Art of Chiromancy* (London: John Day, 1558), fol. 5; Thorndike, *A History of Magic and Experimental Science,* 5:65-66.

23. Among the many manuals of chiromancy in print, see the following, which follow essentially the same scheme used in early modern books: William G. Benham, *The Benham Book of Palmistry: A Practical Scientific Treatise on the Laws of Scientific Hand Reading* (North Hollywood: Newcastle Publishing, 1988); Cheiro the Palmist, *Palmistry: The Language of the Hand* (New York: Gramercy Books, 1999); for a collection of traditional illustrations, see also Grillot de Givry, *Witchcraft, Magic, and Alchemy,* trans. J. C. Locke (New York: Bonanza Books, n.d.), 262-279.

his picture of the chiromantic hand is one of the most famous, but not the simplest. For the basics of the practice about which Agrippa theorized, we should turn to earlier printed treatments of chiromancy.

The most notorious of these is the *Chyromantie ac physionomie anastasis cum approbatione magistri Alexandri de Achillinis,* published in 1504 by Bartolomeo della Rocca, better known as Cocles and infamous for predicting the deaths of forty-five people. His *Resurrection of Chiromancy and Physiognomy* is most remarkable for its author, murdered by an angry client in the year his book went to press. Cocles had a famous friend, however, in Alessandro Achillini, an eminent physician and philosopher of Bologna. Achillini's most reprinted work was the methodological preface that he wrote for Cocles, maintaining that physiognomy and chiromancy are valid forms of knowledge, *scientiae speculativae,* or theoretical sciences in Aristotelian terms. From this high philosophical ground, Cocles descended to an abundance of chiromantic detail and many pages of nasty gossip about the high and mighty as well as the low and titillating. People read the racy *Resurrection* in Latin and vernacular versions through the seventeenth century.[21]

A northern challenge to the best-selling Cocles arrived nearly two decades later with the *Introductiones apotelesmaticae* of Johannes ab Indagine (von Hagen), first published in 1522. This Indagine was a priest of the Frankfurt region and an employee of the archbishop of Mainz, to whom he dedicated his work. The book sold very well for the better part of two centuries. Hostile to scholastic philosophy, Indagine defended some uses of astrology, preferring what he called the "natural" kind that uses only the sun and moon, without the other planets of the "artificial" astrologers. An English translation of 1558 explains how to identify "a libidinouse and an unshamfast woman" by looking in her hand for "a cross . . . about the upper corner, procedinge oute of the line of life" (Cat. 62).[22] Finding this "line of life" is chiromancy at its simplest.

What Indagine called the "line of life" is the "radial longitudinal palmar crease" to a contemporary anatomist. Both phrases are terms of art, well defined and widely recognized, and both have moral force since both express authority. On the face of it, the modern anatomical term is the more artificial and less intelligible, meant mainly to communicate among physicians, not to patients. The older chiromantic term, used by the client as well as the diviner, stays closer to ordinary language. A woodcut (Cat. 61) from the *Antropologium de hominis dignitate natura et proprietatibus,* published by Magnus Hundt the Elder in 1501, shows how the older terminology was deployed. Beginning at the upper left of the palm, below the little finger is the *linea mensalis,* or table-line, that rules fortune or destiny. Next below the table-line and roughly parallel to it is the *linea media naturalis,* or middle line, that shows the course of a profession or career. The *linea cordis et vitae,* or life-line, emerges from the same area above the base of the thumb *(pollex).* The *percussio manus,* or striking part, on the opposite edge of the hand has to do with imagination and procreation. The *linea restricta,* or bracelet, at the base of the palm, if well formed, signifies happiness and longevity. Since the total length of the life-line, starting above the base of the thumb, is reckoned at about eighty years, breaks or cuts at various points on the way predict a shorter life.[23]

Such prediction needs a little calculation, but not much compared to the labor of casting a horoscope. The simple, visual appeal of chiromancy helps explain its enduring popularity. But its real power came from astrology, whose

symbolic allure draws us to the stunning *melothesia* (Cat. 57) in the 1522 edition of the *Fasciculus medicinae* by Johannes de Ketham. Like the Ram or the Bull or the Twins on this zodiacal man, planetary signs can also be placed on the little mounds of the hand and below its fingers, as in the chiromantic image (Fig. 21) from Agrippa's *Occult Philosophy*.

The hand mapped crudely (Cat. 66) by Girolamo Cardano in the 1557 *De rerum varietate* is relatively clear but, like most of Cardano's work, unconventional. The fingers with their usual names are divided anatomically rather than chiromantically, and we are meant to be impressed by the Greek terminology. In any language, any mark on a hand might mean something to a chiromancer. Spots on the fingernails could be signals from the stars. One of Cardano's special gifts, so he claimed, was to see his future through his fingernails. His credentials in physiognomy were impressive enough, and he also published a *Metoposcopia*, despite the claim in his autobiography that he avoided "any doctrine, evil, pernicious or vain, such as chiromancy, the science of compounding poisons, or alchemy." In fact, he was greatly interested in divination as an analogue to medical prognosis and as proof that he was a true prophet. He admitted as much elsewhere in the autobiography, where he also recalled that he had not been expected to survive childhood because his "life-line was very brief, irregular, interrupted and branching, and . . . there were stars which threatened."[24]

Another innovator in chiromancy and an even more flamboyant character was Paracelsus, whose original doctrine of signatures blended botanical, geological, medical, and zoological morphology with astrology and theology. To help us discover their inner forces, the Creator equipped all things with outward marks or signatures, and with physiognomy and chiromancy we can read this divine writing. Although the author of this doctrine had a traditional medical education, the normal curriculum could not support his grand project for an anthropological, cosmological, and theological medicine.[25] One product of his novel program was the *Astronomia magna* of 1537 to 1539, in which we learn that

> men discover everything that lies hidden in the mountains by external signs and correspondences, and thus also . . . find all the properties of herbs and . . . stones. . . . For each fruit is a sign, and through it we discover what is contained in that from which it stems. Similarly there is nothing in man that is not marked in his exterior. . . . There are four ways by which the nature of man and of all living things can be discovered. . . . First, chiromancy; it concerns the . . . hands and feet. . . . Second, physiognomics, it concerns the face and the whole head. . . . Third, the *substantina*, which refers to the whole shape of the body. . . . And fourth, the customs and usages, . . . manners and gestures in which man . . . shows himself. . . . These four . . . provide us with a complete knowledge of the hidden, inward man.[26]

Chiromancy comes first among these four convergent routes to exploring the human person from the outside in, and it applies to all of nature. "There are many kinds of chiromancy," according to Paracelsus, "not only the chiromancy

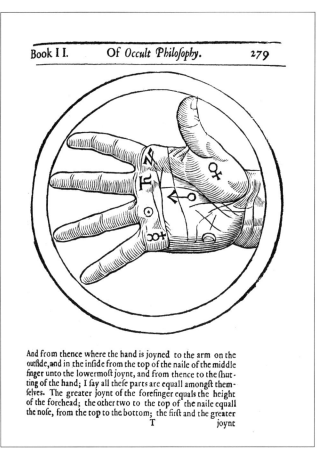

And from thence where the hand is joyned to the arm on the outſide, and in the inſide from the top of the naile of the middle finger unto the lowermoſt joynt, and from thence to the ſhutting of the hand; I ſay all theſe parts are equall amongſt themſelves. The greater joynt of the forefinger equals the height of the forehead; the other two to the top of the naile equall the noſe, from the top to the bottom; the firſt and the greater
T joynt

Fig. 21. Anonymous, *Chiromantic Hand with Planetary Symbols*, woodcut. From Agrippa of Nettesheim, *Three Books of Occult Philosophy* (London: Gregory Moule, 1651), p. 279. The Folger Shakespeare Library, Washington, D.C.

24. Girolamo Cardano, *The Book of My Life (De vita propria liber)*, trans. Jean Stoner (New York: Dover, 1962), 168-169, 196, 229; Nancy G. Siraisi, *The Clock and the Mirror: Girolamo Cardano and Renaissance Medicine* (Princeton: Princeton University Press, 1997), 5, 18, 93-94, 119-120, 128, 225-226, 268.

25. Walter Pagel, *Paracelsus: An Introduction to Philosophical Medicine in the Era of the Renaissance* (Basel: Karger, 1958), 50-55, 82-95, 137-141, 144-152, 203-210, 218-227; Charles Webster, *From Paracelsus to Newton: Magic and the Making of Modern Science* (Cambridge: Cambridge University Press, 1982), 1-6, 15-30, 48-59, 77-85.

26. Selections from the *Sämtliche Werke* of Paracelsus, eds. Karl Sudhoff and Wilhelm Matthiessen, are available in English translation in *Paracelsus: Selected Writings*, ed. J. Jacobi, trans. N. Guterman (Princeton: Princeton University Press, 1951); for this selection from the *Astronomia Magna*, see p. 121.

Fig. 22. Anonymous, German ?, *The Hand of Fate*, woodcut. From Paracelsus, *Prognosticatio ad vigesimum quartum usque annum duratura . . . conscripta. Anno xxvi* [Augsburg? 1536?], fig. 8. Library of the College of Physicians of Philadelphia

27. *Paracelsus: Selected Writings*, 125 (from the *Liber de imaginibus,* date uncertain).

28. Ibid., 125 (from the *Liber artis praesagae,* spurious).

29. *Andreae Vesalii Bruxellensis scholae medicorum Patavinae professoris suorum de humani corporis fabrica librorum epitome* (Basel: Oporinus, 1543), fol. L.

of man's hands, from which it is possible . . . to ascertain what good or evil will befall him, [but also] . . . that of herbs, of tree leaves, of wood, of rocks, of mines, or the chiromancy of landscapes, of their roads and rivers, and so on."[27] The lines of the human hand also mark all the objects of nature that surround and sustain mankind. The expert healer will look everywhere for these signatures and make medicine from everything the cosmos has to show and to give. In the end, however, every creature has its natural term, allotted by God, and no medicine can stay the hand of fate (Fig. 22). Knowing that "death is the harvester of the human fruit," the physician learns his craft by observing (according to a pseudo-Paracelsan text) "the outward characteristics which nature gives a man by shaping him in a certain way. For nature shapes the anatomy of a pear in such a way that the pear develops into a pear tree, . . . and the same is true of silver and gold. Nature also forges man, now a gold man, now a silver man, now a fig man, now a bean man."[28] Metals, plants, animals and humans are effects of the same divine causes. Outward forms declare inner forces through the same visible patterns. The fig man and the bean man are not monsters but manifestations of nature, human resonances of natural harmonies. But the scope of Paracelsan chiromancy was far greater than any divination known to his contemporaries. It was cosmic divination, a premonition of what the seventeenth century would call theosophy.

By contemporary standards, Paracelsus and Cardano were great physicians. History has recognized them as men of genius, but personal eccentricity and occultist habits of mind put them outside the main annals of medicine, in which Andreas Vesalius was the leading hero of the day. The portrait (Cat. 5) of the great anatomist from *De humani corporis fabrica* shows the basis of this discrimination. With his left hand Vesalius grasps the right arm of a front-facing cadaver at the elbow, while his right hand holds a dissected muscle just below the cadaver's right hand, also partly dissected. Unlike Agrippa, Cardano, Paracelsus, or the lesser chiromancers, Vesalius does not interpret the hand or search it for signs. He disassembles it, reducing it to parts that will tell their own story. The gesture of the dissector's right hand is as laconic as the text of the *Epitome* of the *Fabrica* in describing the hand: "At the end of the forearm begins the top of the hand. . . . The part below the wrist . . . is called the palm by some, and its inner area is concave and bordered by a number of little mounds and crisscrossed by many lines."[29] In the complete *Fabrica,* we learn a little more, that one of these lines belongs to life and the heart, for example, but the tone is the same. Some anatomists of the period were warmer to chiromancy, others as cool as Vesalius.

As Catholic reaction to the Protestant challenge gathered force after mid-century, learned Europeans discovered that a cooler attitude toward the occult sciences would be prudent. In Cardano's case, however, family turmoil as much as institutional threats explain his cagey and contradictory statements on such matters late in life, when a bureaucracy of religious repression was making ideas as original as his more and more dangerous. When Pope Paul IV first authorized

the *Index of Forbidden Books* in 1559, Cocles, Indagine, and other physiognomists made the list. Sixtus V focused the church's scrutiny more closely on occultism in 1586 by issuing a papal bull against astrology and other divinatory arts, and Urban VIII confirmed these restrictions in 1631 with another encyclical letter.[30]

The title of this document, *Inscrutabilis,* is ironic (unintentionally): this same Urban kept a file of horoscopes on his cardinals, and hired Tommaso Campanella in 1628 to help him work astrological magic. Until Campanella's magic found a papal customer, ecclesiastical jailers had kept the renegade Dominican in prison for nearly thirty years, during which time Giordano Bruno went to the stake in 1600 and Giulio Cesare Vanini followed him in 1619. By 1632, when Galileo was condemned, Urban was pope and personally involved in the controversy. But even at the Vatican, the early phases of the baroque also saw the final efflorescence of occultism into the dazzling pictorial fantasies and world-renewing schemes of early theosophy—a new word when Johann Kepler used it to belittle Fludd. These were the decades when Fludd was designing his splendid diagrams of macrocosm and microcosm, when Michael Maier did the same for alchemy and emblems in his *Atalanta fugiens,* when the Rosicrucians were rumored to be planning cosmic reform, and the polymath Jesuit Athanasius Kircher blended geology, magnetism, hieroglyphics, and universal linguistics with the height of the tower of Babel and the plan of Noah's ark in a succession of copiously illustrated guides. After Fludd, Maier, and Kircher, what Agrippa had named "the occult philosophy" lost the respect of the European world of learning. The fantastic universes imagined by the early theosophists finally became too arcane, their language too private to hold the attention of the republic of letters. This loss never controlled popular culture, however, nor was it universal among the learned, though by the early eighteenth century it became their normal reflex.[31]

Long before the magical arts had lost their credibility, Giambattista Della Porta had published *Four Books of Natural Magic* in 1558 and expanded them to twenty in 1589, even though Jean Bodin had already implicated him in witchcraft and the Inquisition had cautioned him about astrology. Braving these dangers or ignoring them, in 1586 Della Porta issued the first of his several physiognomies, *On Human Physiognomy,* without a license. Venetian inquisitors prohibited an Italian version of this Latin work in 1592. The third of the physiognomies to appear in the author's lifetime, the *Celestial Physiognomy* of 1603, is a smooth piece of sophistry that claims to support divination solely on the basis of anatomical features, while emphatically repudiating astrology. But the same work, whose title brazenly declares its true purpose, repeats in comprehensive detail the techniques of astrological physiognomy that it purports to abandon. Della Porta died in 1615, leaving unpublished his *Chirofisionomia,* a new name for the old art designed to detach its author from the astrological chiromancies of Cocles and Indagine. In a spirit often called "Baconian"—though Della Porta had it first—this work bases itself in large part on personal observation. Equally impressive were several pages of imprimaturs backing up Della Porta's evasions, while laying out the seven planets with the seven regions of the hand for all to see.[32]

Michelangelo Merisi da Caravaggio (1571-1610) was a younger contemporary of Della Porta and influenced by him. Born near Milan, he spent the last half of his brief, turbulent life in Rome, arriving around 1592 when Sixtus V had been the last pope to hold Peter's throne for very long. Despite the sensuality of his

30. Thorndike, *A History of Magic and Experimental Science,* 6:147, 156, 169-171, 507; see n. 23 above.

31. Brian P. Copenhaver, "The Occultist Tradition and Its Critics," in *The Cambridge History of Seventeenth-Century Philosophy,* eds. D. Garber and M. Ayers (Cambridge: Cambridge University Press, 1998), 454-465; Walker 1958, 203-236.

32. Luisa Muraro, *Giambattista Della Porta, mago e scienziato* (Milan: Feltrinelli, 1978), 15-19; Thorndike, *A History of Magic and Experimental Science,* 7:155-164; 8:449.

33. *Polydori Vergilii Urbinatis de rerum inventoribus libri octo* (Lyons: Gryphius, 1546), 74.

art, Caravaggio was soon in demand for ecclesiastical and other commissions. In most of his paintings, which are full of physical and psychological movement and charged with theatrical energy, hands are busy everywhere. Two hands recoil when a lizard bites a pretty boy. One hand holds Jerome's pen like a distracted scholar's afterthought. Strong hands belong to an old Abraham about to cut Isaac's throat. Old, gentle hands point the prayers of peasants toward a Madonna. The crucified Peter looks heavily at a hand spiked to a cross. As Jesus takes the Judas kiss, he folds his hands in tense acquiescence. One painting alone, the *Madonna del Rosario* of 1607, shows sixteen hands—posing, pointing, supplicating.

Anyone who has not thought much about hands may start with Caravaggio, who painted them like no one else. He also opened a new chapter in the history of genre painting, the pictorial art that puts anonymous people in distinctive social situations meant to evoke a moral response. Caravaggio did not invent this form, but in only three works (two of the same subject) he raised it to new heights of genius. One is *The Cardsharps,* painted shortly before 1600, which shares one of its types with the other two, the Louvre and Capitoline versions of *The Fortune-Teller,* the first of which belongs to the same period. The shared type is a nattily dressed young man caught in the act of being cheated by his social inferiors. Five hands are at work in *The Cardsharps.* They belong to the young dupe, an artful dodger across the table, and his partner in crime standing behind their victim.

For his dramas of hands and faces playing and deceiving, Caravaggio had to go no farther than Roman streets and taverns or Roman churches and their sermons. Nor did he need creativity to connect a homily on deceit with the secret sins of occultism. Plautus, Lucian, Chaucer, and the Italian dramatists of Caravaggio's day and earlier had long since exploited the comedy of false magic and the spectacle of the mark anxious to be fleeced by spooks or superstition. Juvenal had singled women out as easy victims of such fraud and as its perpetrators. When Polydore Vergil summarized the ancient categories of divination in his widely read manual *On Discoveries,* his additions to the classical list were necromancy and chiromancy, the latter introduced by a line from the caustic satirist:

> Divination by examining lines in the hand is chiromancy. Juvenal in *Satire* 6: "She'll offer the soothsayer hand and forehead." All these arts are superstitious and completely ridiculous, for poverty always rules those who use such things, as Cicero says . . . *On Divination*: "They lose the path and show others the road; they promise riches to those whom they beg for pennies." Therefore let us shun them as people of wicked superstition.[33]

Conventional, upper-class morality, here grounded by Polydore in classical precedent, put chiromancy in its place and women in theirs. The superstitious are gullible and greedy, ripe for the picking by smarter villains.

Caravaggio could take this moral context for granted. In his Louvre *Fortune-Teller* (Fig. 23), the young man is identical in type with the victim of *The Cardsharps,* but darker, plumper, perhaps a bit older. A young woman holds his right hand softly between her two. She might be his age, but her experience is timeless. Her turban and the rest of her costume make her a gypsy. The young man's left hand is handsomely gloved and holds a matching glove on his hip, inside the well-worked hilt of the sword that announces his readiness for the world. His posture is confident, but his expression is rapt, less by his seducer's craft than by her charms. She points silently to his ungloved

palm between middle and ring fingers, between Saturn and the Sun, the place that chiromancers call the *cingulum Veneris,* or "belt of Venus." She shows him his soft spot, but his eyes are elsewhere, and more is at risk than the ring on his *digitus annularis.*

If Caravaggio's great skills were in light and color, drama and movement, Jacques de Gheyn's (1556-1629) were in detail and delicate lines, in draftsmanship and precise representation. Constantijn Huygens believed that de Gheyn's "finer pencil" would have captured the new world revealed by microscopy had he lived longer. But the meticulous observer who could render a hermit crab in exacting detail also put a witches' Sabbath on the same sheet, its uncanny figures drawn from Bosch's universe, not nature's.[34] This older, darker world of mountebanks and misguided victims was also de Gheyn's subject in *The Fortune-Teller and the Lady* (Cat. 63), engraved by Andries Stock, of roughly the same period as Caravaggio's *Fortune-Teller.* It tells the same story of fraud and gullibility that Caravaggio told, except that swindlers and swindled are all women. It is a finely dressed lady whose eagerness to know her fate sets her up for trickery. As her duenna waits behind, she looks demurely away from the gypsy hag in front of her or perhaps distractedly down at the toy dog by her feet. Other gypsies (one may be male) lurk behind the diviner, who already has the young woman in hand.

If de Gheyn's *Fortune-Teller* is macabre, the detailed chiromantic map (Cat. 4) in the 1671 *Physiognomie and Chiromancie* of Richard Saunders is merely grotesque, a labyrinth of lines, marks, signs, and places, a dense puzzle compared to the plain figures of the title page (Fig. 24). The untutored reader will be lost in this maze, where bad luck and wayward sex are the main prospects. Saunders foresees chastity, lechery, sodomy, incest, barrenness, illegitimate children, and several wives. That such worries might keep seventeenth-century readers anxious to learn the skills of astrological chiromancy was George Wharton's hope when he turned the work of a sixteenth-century physician, Johann Rothmann, into an English *Keipomantia, or the Art of Divining* (1652; Cat. 67).[35]

Rothmann's approach had been to lay out the basics of chiromancy in cases and problems, the same route later followed by Johann Praetorius in his *Ludicrum chiromanticum. . .seu thesaurus chiromantiae* (1661).[36] But Praetorius was oblique in his approach, as his title warns us. A *ludicrum* is funny, witty, playful, diverting, entertaining, or histrionic—a show in the theatrical sense. But what are we meant to see in this show of hands? Its treasure may be a trap. Johann-Baptist Paravicini's ludic but ponderous engraving (Cat. 68) shows chiromancy to be either an honorable practice or a criminal perversion, depending on what one makes of it. This ornate advertisement for *Chiromantic Diversion* diverts the reader from the author's liability as false prophet and sinner against religion. While serving notice that Praetorius is aware of the moral ambiguity of his topic, it makes a game of the problem. The distinction put in play was the magician's age-old plea: my art is good, unlike the bad art that others practice.

Ever since Indagine, chiromancers and their critics had adopted the term "natural" as a touchstone, but later authorities used it to relegate Indagine and

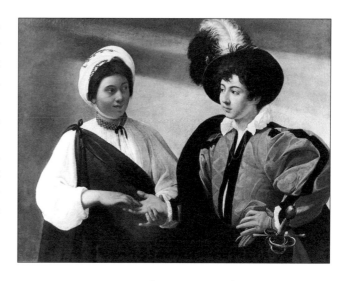

Fig. 23. Caravaggio, *The Fortune Teller*, oil on canvas, c. 1598-1599. Paris, Musée du Louvre

Fig. 24. Anonymous, *Metoposcopic Head and a Chiromantic Hand Bearing a Lullian Wheel.* woodcut. From Richard Saunders, *Physiognomie and Chiromancie* (London: Nathaniel Brooke, 1671), title page. The Folger Shakespeare Library, Washington, D.C.

34. Svetlana Alpers, *The Art of Describing: Dutch Art in the Seventeenth Century* (Chicago: University of Chicago Press, 1983), 1-13, 85-91.

35. Thorndike, *A History of Magic and Experimental Science*, 6:506-507; 8:331, 462-463.

36. Ibid., 8:490-491.

37. Ibid., 7:83, 281, 359, 422, 440, 472, 509, 603-604, 643, 647; 8:341, 449, 461, 484, 561, 608-609.

38. *Encyclopedia Britannica or a Dictionary of Arts and Sciences* . . . (Edinburgh: Bell and MacFarquhar, 1771), 1:145-310; 2:66-180, 193, 770.

39. *The Columbia Encyclopedia,* eds. B. A. Chernow and G. A. Vallasi, 5th ed. (New York: Houghton Mifflin, 1993), 115, 493, 676; Oswei Temkin, "Gall and the Phrenological Movement," *Bulletin of the History of Medicine* 21 (1947):275-321.

40. *The Idea Pages: West Los Angeles, GTE* (Los Angeles: GTE, 1999), 9, 11, 766, 854.

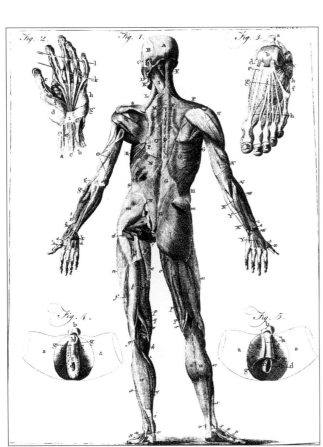

Fig. 25. Alexander Bell, *Male Nude, Rear View, with Details of the Right Hand and Left Foot, Plate,* engraving. From *Encyclopedia Britannica or a Dictionary of Arts and Sciences* . . . . (Edinburgh: Bell and MacFarquhar, 1771), 1:pl. XVI. Lehigh University Library, Bethlehem, Pennsylvania

Cocles to a disreputable past, putting physiognomy on one side of a line dividing the natural from the fake, chiromancy on the other. Another option was to distinguish a natural chiromancy based only on anatomical features from the astrological kind. For Roman Catholics anxious about papal edicts, this was a favored choice, though Protestants used it too. On this basis, but without enthusiasm, the learned Caspar Schott permitted palmistry when he wrote *Natural Magic* and *Physical Curiosities,* at a time when Aristotle's venerable authority still kept his brother Jesuits convinced that some kind of chiromancy must be worth rescuing. Others in this reforming age looked to the future, hoping that chiromancy might be rehabilitated and rise to the standards of the new philosophies. For a time, even astrology held the hopes of reformers, but when these hopes eroded and astrology lost its grip on educated people, chiromancy still had two advantages: simplicity and a plausible physical basis in the familiar surface-anatomy of the hand. Meanwhile, as late as 1668 a Franciscan exorcist could still argue for a natural astrological chiromancy because he had more to fear from the demons than the stars. The truth of the art was still suitable as a dissertation topic at Regensburg in 1691.[37]

During the eighteenth century chiromancy drifted farther toward the margins of learned culture, as evidenced by the first edition of the *Encyclopedia Britannica* (1771). The entry for "hand" says only "see: Anatomy, Part i, ii, &c." Among several illustrations in that article of 175 pages, plate 16 (Fig. 25) gives most attention to the hand—a flayed left hand displaying "the palm . . . after the common teguments are removed." These "common teguments" had been center-stage in the theater of chiromancy, but now they are written out of the reductive scientific action. A few pages after the 114 given to "chemistry," the first *Britannica* finds only a small place for "chiromancy, a species of divination, drawn from the different lines and lineaments of a person's hand; by which means, it is pretended, the inclinations may be discovered."[38]

In the early nineteenth century the old art of physiognomy became the new science of phrenology, based on the colorable notion that faculties of mind working inside the skull ought to show themselves on bumps outside. A little later, when early anthropologists measured the heads of "primitive" people and compared them to norms idealized in Greco-Roman sculpture, the more pernicious delusion of craniology piled up data that would eventually make the case for racism. The short entry for "cranial index" in a recent encyclopedia points to another brief entry on "anthropometry . . . once the standard approach to racial classification . . . [but] now used for deciding the range of clothing sizes . . . and . . . nutritional status."[39]

From the Greeks to the garment district, from astrology to agrobusiness, physiognomy has come a long way, at least in the high culture. In another contemporary work of reference, *The Idea Pages,* GTE's 1999 telephone book for West Los Angeles, the index entry for "Palm Readers" refers to another on "Spiritual Consultants," but Sofia, a psychic spiritualist, occupies the only space under this heading. In the busier category of "Psychics," which comes

just before "Psychoanalysis," she and ten other seers have paid to list their numbers. Sofia's ad is the most conspicuous, its red border punctuated with zodiacal signs and its copy promising "various readings including Tarot cards, psychic, palm, aura, past life readings and regressions." Sofia's advice is "never failing . . . on Love, Money & Career." Otherwise, although chiropractic doctors fill nearly four pages of *Idea Pages,* the term "chiromancy" is nowhere to be seen.[40]

Fig. 26. Brian and Kathleen Copenhaver, *Psychic Boutique,* photograph, Los Angeles, 1999

Under other names the art is easy to find on the West Side, where tourists buy star maps on Sunset Boulevard and celebrity Cabala can be had in Santa Monica. Four palm-readers do business within two miles of one another. Olga, psychic to the stars, offers five-dollar specials in Westwood Village, the shopping district nearest to UCLA (University of California at Los Angeles). Brentwood Psychic, not far away, shares high-rent space with an animal clinic. Here in O.J. Simpson country, just blocks from the ill-starred Mezzaluna restaurant, the signage is subdued. No hands are painted on the wall. Only a tasteful awning flaps its come-on in the breeze: Palm & Tarot Card Reading. Downscale and ten minutes south on Sepulveda just off Olympic is the Psychic Boutique, two blocks up from Barbeques Galore, purveyor of backyard grills to the stars. Two white hearts state the boutique's business—Specializing in Love—and a sandwich board out front shows a hand on a field of stars (Fig. 26). Charge a reading on MasterCard or Visa.

Fig. 27. Brian and Kathleen Copenhaver, "*Readings by Sophia,*" photograph, Los Angeles, 1999

Farther south on Overland is the wise Sofia's establishment, a tidy, gray frame house tucked under a glass-box Citibank and heralded by an imposing sign (Fig. 27): "Psychic Reading," it says, and then "Palmistry," over a hand circled by the zodiac, its palm pierced by a door open to the starry depths. Sofia practices across the way from Lida's Westside Plaza, where Indonesian food is on offer at Bali Place and Chinese at Seasons. At Lida's, passing pilgrims can escape with Freedom Travel or clean their clothes and get a Nu-Life. Graceful hands beckon under Facials & Waxing on the window of Helen's Nails, and the banner at Le Beach Club testifies that "We Carry Heliotherapy." The microtemples of cyberspace lie waiting in Aztek Computers. What chance has Sofia's ancient art in this L.A. phantasmagoria? Chiromancy has survived the centuries that brought it to Sofia's place. It will survive some more.

# Writing on Hands: Catalogue

Authors of Entries

BPC=Brian P. Copenhaver
CRS=Claire Richter Sherman
SK=Sachiko Kusukawa
SFW=Susan Forscher Weiss

Complete references to works cited in the notes will be found in frequently cited sources, 268-269.

The order of information for catalogue entries is: The title of the images and date; the medium and dimensions; the author and title of the book; the place, publisher, date of publication, and page; inscriptions and signatures; and lenders to the exhibition.

All dates for images in illustrated books correspond to the date(s) of publication for works exhibited rather than to that of the first editions.

Measurements of images are provided for all works exhibited; sheet sizes are provided only for prints and disbound illustrations. In all cases, height precedes width; inches are followed by centimeters.

Inscriptions in the entries are limited to words written on or around the image that relate to content, otherwise they are explained in the text. Underscored characters represent missing or abbreviated letters in the original inscription.

Honours

Dishonours

Death in prisson

Riches

Pouvertey

Death in prisson

Venus girdle

Riches by learning

Confusion of Science

Sordid and ueneiall achons

The table line

Contempt

Sadnes

Sister of the line of liue

plurality of Wiues

The line of life or of the heart

Affronts Receiued

Victory for loue

Assasinate

Line of the liver or of Saturne

Hurt in duell

Kild in duell

Enemies

Couardise

Malady of minde

Sickne

The middle natural line

Via lactea

Victory for honour

Via percussion

barremes

The Wrist the age

of the variz According

# 1. Reading the Writing on Hands

*Mentor, Metaphor, and Map: Cat. 1-4*
*Identity, Intelligence, and Creativity: Cat. 5-10*

# The Hand as the Mirror of Salvation

*The Hand as the Mirror of Salvation,*
1466
Anonymous, Netherlandish (?)
Handcolored woodcut

Image: 15¹⁵⁄₁₆ x 10⁹⁄₁₆" (38.9 x 26.8 cm)
Inscribed: see below
National Gallery of Art, Washington,
D.C., Rosenwald Collection, 1943

1. For another woodcut made in the same year, see Cat. 41.

2. Arthur M. Hind, *An Introduction to a History of Woodcut with a Detailed Survey of Work Done in the Fifteenth Century* (London: Constable, 1935) 1:111; Elizabeth Mongan and Carl O. Schniewind, *The First Century of Printmaking, 1400-1500,* exh. cat. (Chicago: Art Institute of Chicago, 1941), cat. no. 19; Richard S. Field, *Fifteenth-Century Woodcuts and Metalcuts from the National Gallery of Art* (Washington: National Gallery of Art, 1965), no. 269.

3. For the biblical citations, see Brückner, "Hand und Heil," 86.

4. For the idea of "mapping," see Linda C. Hults, *An Introductory History of the Print in the Western World* (Madison: University of Wisconsin Press, 1996), 31.

THIS RARE WOODCUT, ONE OF FIVE KNOWN EXAMPLES, bears the date of 1466.[1] Like other fifteenth-century woodcuts, the print was handcolored to emulate the bright tones of manuscript illumination. Here rose, green, yellow, and gray enliven the dark tones of the brown ink and beige paper. Red strokes emphasize the first letters and important words of the lengthy Latin texts printed from the same block as the image of the hand, as is the case with blockbooks.

The image represents the palm side of the left hand. The accepted terminology of the fingers is crucial to identifying each of the five stages of meditation, a subject explored in Part VI of the exhibition. Semiotic connections are made between each finger and its function in the sequence of spiritual stages. As seen in the identifying inscriptions, the thumb, the master digit, signifies God's will; the index, examination; the middle finger, repentance; the ring or medical finger, confession; the smallest or ear finger, satisfaction. Further words written on the joints of each finger break down the series of steps necessary to reach each of the five states. The seven lines below the hand reiterate the significance of the fingers and their relationship to these stages in terms of their anatomical and etymological properties.

The extensive inscriptions also follow a sequence, beginning with New Testament verses that enjoin the intended reader/spectator, probably a cleric or learned layman, to undergo spiritual examination. For example, the verses on the left of the hand specify the five stages:

> When thou knowest the will of the Lord, then own the faults in order
> to avoid them. When thou hast done evil, then repent of it. When
> thou verily repentest, then confess it. When thou has confessed, then
> do penance.[2]

The words written on the upper band of the wrist define the search for salvation as a burning light; that of the lower one, as the rock of faith.[3]

The figure of Mary Magdalen on the left is associated with contrition and penitence; that of Mary Martha on the right, with prayer, elimination of greed, and charity. In terms of Christian iconography, the former with her vessel of salvation, the pyx, stands for the contemplative life; the latter, stamping on a dragon, with the active life.

In short, the image of the hand stands for the whole person, in relation to spiritual and moral values. It also serves as a cognitive map on which the inscribed words form a series of memory places based on the anatomy of the hand and the nomenclature of the fingers.[4]

CRS

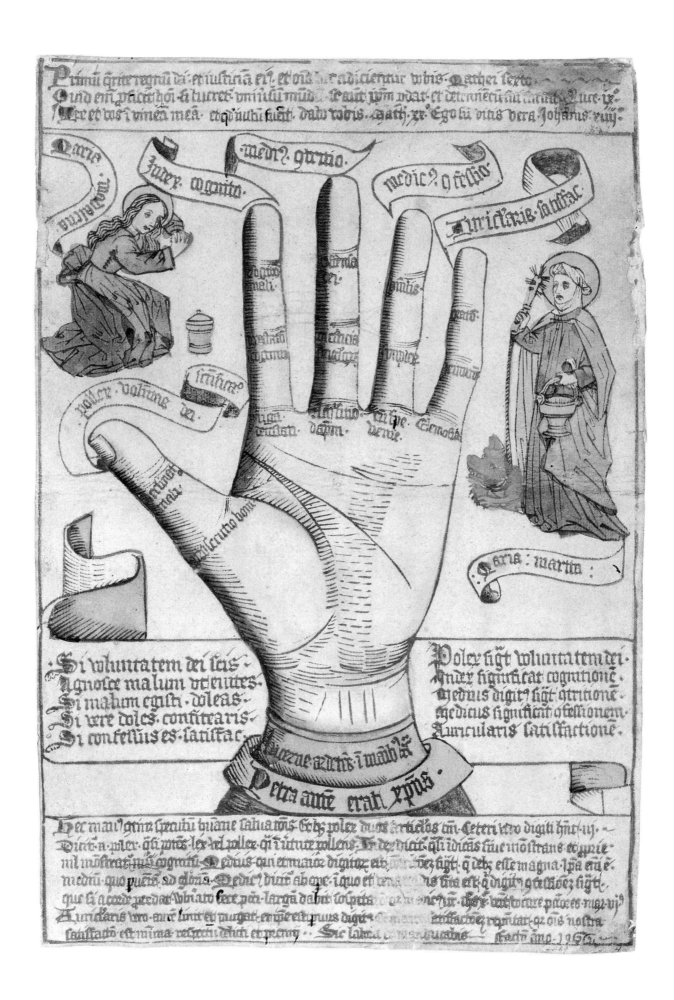

# The Hands as Bodily Mnemonics

*The Hands as Bodily Mnemonics*, 1491
Shop of Michael Wolgemut (1434 to
1437-1519) and Wilhelm Pleydenwurff
(c. 1460-1494)
Woodcuts
Images: 9¹⁵⁄₁₆ x 6⅞" (25.3 x 17.6 cm)
Stephan Fridolin (c. 1430-1498)
*Schatzbehalter der wahren Reichtümer
des Heils*

Nuremberg: Anton Koberger, 8
November 1491, fols. e6v. and 7r.
Inscribed:
*Die linck hand* (The left hand);
*Die recht hand* (The right hand)
The Walters Art Gallery,
Baltimore, Maryland

1. For the contents of the book, see *The Illustrated Bartsch*, pt. 8, no. 8791, 277-278 [B. 87]. For the discussion of two other images of hands from this book, see Cat. 37; for hands as "Defenders of Faith," see Part VI of the exhibition, "Guiding Hands."

2. Richard Bellm, *Der Schatzbehalter*, facsimile ed. (Wiesbaden: Guido Pressler, 1962), 1:38.

3. The analysis of the numerical organization, and other important features of the woodcuts, derives from Brückner, "Hand und Heil," 64-65.

4. Ibid., 64.

5. For Fridolin, see Hermann Tüchle, "Stephan Fridolin," *NDB* 5:440. Jeffrey Chipps Smith, *Nuremberg: A Renaissance City: 1500-1618*, exh. cat. (Austin: University of Texas Press, 1983), 6.

6. Bellm 1962, 3-4.

THESE HANDS BEGIN THE SEQUENCE OF NINETY-SIX WOODCUTS in a folio volume of mystical meditations on Christ's sufferings.[1] The translation of the title as "The Treasure Chest of Salvation" refers to the book as the metaphorical container of these truths. The hands, as privileged parts of the body linked to the soul, act as metaphors for a bodily shrine, holding, grasping, and perceiving the inner wisdom revealed in the text and images of the book.[2] In addition, the hands function as tables of contents geared to the hundred meditations of the text and as cognitive maps of the routes to salvation. Each number acts as a separate drawer of the treasure chest.

Like *The Hand as the Mirror of Salvation* (Cat. 1), as spiritual guides and figures of the whole person, these images have even more specific functions as bodily mnemonics. Using the decimal structure of the five digits, plus a flexible count of fifteen joints and their roots per finger, each hand has fifty places on which to organize and associate the same number of meditations. The first group of fifty follows a chronological sequence, ending with Good Friday; the second ends with the Resurrection. The left hand carries the Roman numerals for one to fifty; the right, fifty-one to a hundred. The counting begins below at the left thumb and continues on the bases of the four other fingers, proceeding from left to right. The series continues in the same way, culminating in fifty on the tip of the smallest finger. On the right hand, the method of counting is reversed, going from right to left, beginning with the tip of the thumb, and ending at the base of the smallest finger.[3] In the text, the author proposes even more complex ways of counting, including grouping meditations by color, but suggests that the reader/hearer might prefer Rosary beads. Realizing that the numbers on the hands might form inadequate references, the author enjoins his audience to make large hands out of paper and then to place on the rings of the hands title words of the meditations with which they can associate visual images.[4]

Stephan Fridolin was a Franciscan who preached to the convent of Poor Clares in Nuremberg, "a major center of learning, and under Abbess Caritas Pirckheimer (1467-1532), one of the last bastions of Roman Catholicism."[5] The meditations in the *Schatzbehalter* were based on his sermons and directed to the laity who could also hear them. The production of the *Schatzbehalter* is a landmark in the history of the book.[6] The dimensions and large number of folios are a forerunner of Anton Koberger's achievement of 1494 in producing the famous *Nuremberg Chronicle*. The woodcuts by the shop of Michael Wolgemut and Wilhelm Pleydenwurff mark a great refinement in technique that herald the achievement of Koberger's godson Albrecht Dürer (Cat. 26 and 28) in the Apocalypse series of 1498. The physical structure of the book reinforces the close connection between text and images mandated by Fridolin as part of the cognitive process of the hearer/reader. Indeed, Fridolin may well have participated in setting the program of the woodcut cycle, in particular the selection of the hands as its opening and closing images.
CRS

A

B

*The Learned Man*, 1511
Anonymous, French
Woodcut
Image: 7⁹⁄₁₆ x 4¾" (19.2 x 12.1 cm)
Charles de Bovelles (Charles de
Bouelles, Carolus Bovillus) (1479-1553)
*Liber de sensibus* in *Que hoc volumine
continentur*
Paris: Henri Estienne, 1511, fol. 60v.

Inscribed:
*Studiosus Palestrites* (The Active
Scholar); *Imaginatio* (Imagination);
*Auditio* (Hearing); *Locutio* (Speaking);
*Scriptio* (Writing); *Lectio* (Reading)
History of Medicine Division, National
Library of Medicine, National
Institutes of Health, Bethesda,
Maryland

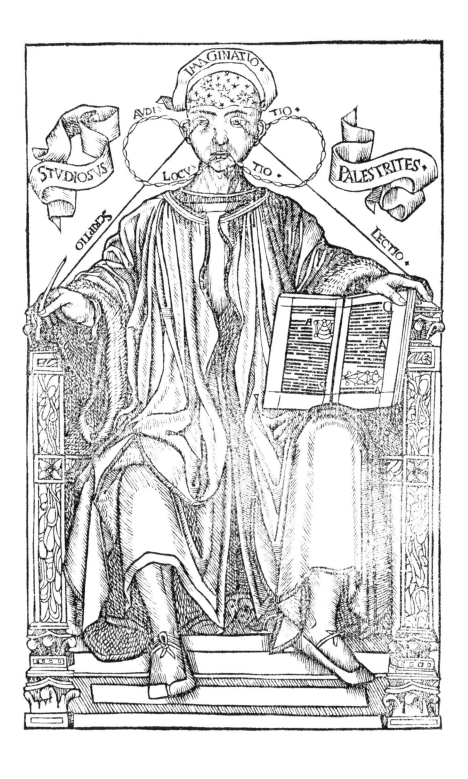

THIS WOODCUT, THE LAST ILLUSTRATION IN A RICH SERIES OF DIAGRAMS, appears in a treatise on the senses, one of twelve shorter works by the French philosopher Charles de Bovelles (known also as Charles de Bouelles and Carolus Bovillus).[1] Bovelles, born in the northern French town of Saint-Quentin, was a disciple of the early French humanist and reformer, Jacques Lefèvre d'Étaples, with whom he studied philosophy at the college of Cardinal Lemoine at the University of Paris. Bovelles, who traveled widely in Europe, wrote on many theological and philosophical topics including metaphysics, epistemology, and mystical numerology, as well as mathematics, and the French language. Bovelles came from a generation still heavily influenced by medieval monastic culture but also inspired by Italian humanism, particularly Neoplatonism.[2]

By its position at the end of the treatise, which was completed in 1509 and dedicated to Charles de Hangest de Genlis, bishop of Noyon, the image of *The Learned Man* presents a pictorial summary of Bovelles' ideas on the paths to the acquisition of knowledge. The five lines at the top of the page attempt to explain the cognitive process. The words apparently come from the representation of the student striving to become a learned man. Speaking collectively, he says that we read and write, speak and meditate on what enters through our ears. Through the five senses, man learns everything. He receives stimulation which reaches the mind through the ears, mouth, eyes, and hands. The student becomes the learned man by seeking out the poles on which the heavenly spheres revolve.[3]

By five words connected to two straight and two curving lines, the image attempts to represent the learning process. *Auditio* issuing from the ears is tied to *Locutio*, coming from the tongue. The emphasis on hearing and speaking as the essential method of learning derives from Bovelles' unusual ranking of hearing over vision. He believed that man can learn from observation of nature, but does so more effectively from listening to and discussing the teaching of learned men.[4] Connected with vision are writing, represented by the pen held in the right hand, and reading, by the book in the left: the processes by which information received orally are recorded and read. *Imaginatio* represents the faculties in the brain, especially *mens* (mind), which receives the data transmitted by the external senses and converts them to the highest good achievable only by the learned man: contemplation of God and the divine realm.[5]

The immobile figure, clad in a fur-trimmed academic robe, sits in a richly decorated elevated chair in a frontal position, totally absorbed in the learning process. His large book shows two geometric diagrams possibly derived from one of Bovelles' own writings on mathematics, the discipline he believed offered a model and method for attaining universal knowledge.[6] As a whole, the figure recalls the type of the inspired writer, so prevalent in medieval portraits of Evangelists. Yet, the striking representation, one of many in the volume, probably indicates the collaboration of the author in setting the program of visual images and specifying their content and placement.

CRS

1. For a facsimile of these treatises, see Carolus Bovillus, *Que hoc volumine continentur* (Stuttgart-Bad Cannstatt: Friedrich Frommann Verlag/Günther Holzboog, 1970). The volume was published by Henri Estienne, a distinguished member of the famous printing family. See Fred Schreiber, *The Estiennes* (New York: E.K. Schreiber, 1982). For a French translation and introductory essay of one treatise, the *Liber de sapiente*, see Pierre Magnard, *Le livre du sage* (Paris: J. Vrin, 1982).

2. For a full account of these currents, see Joseph M. Victor, *Charles de Bovelles, 1479-1553: An Intellectual Biography* (Geneva: Droz, 1978).

3. The Latin lines read:
   Quid agat studiosus palestrites
   Scribimus & legimus: loquimur/
     meditamur in aures
   Quod cadit: His quinis omnia discit
     homo.
   Auribus: ore/oculis/manibus/
     cerebroque cietur.
   Qui cupit ethereos doctus adire polos.
I wish to thank Mary Martin McLaughlin, who helped with the translation that appears in the text.

4. For a detailed, informative presentation of these ideas, see Thomas Frangenberg, "*Auditus visu prestantior*: Comparisons of Hearing and Vision in Charles de Bovelles's *Liber de sensibus*," in *The Second Sense: Studies in Hearing and Musical Judgement from Antiquity to the Seventeenth Century*, ed. Charles Burnett et al. (London: The Warburg Institute, University of London, 1991), 71-94. For further discussion of the hierarchy of the senses, see Cat. 30-31.

5. Frangenberg 1991, 80-81.

6. Bovelles published several works on geometry in 1503, while five treatises, including one on mystical numerology, are included in *Que hoc volumine continentur*. See Victor 1978, 13.

# The Hand as a Cognitive Map

*The Hand as a Cognitive Map*, 1671
Anonymous
Woodcut
Image: $8^{15}/_{16}$ x 6½" (22.6 x 16.5 cm)
Richard Saunders (1613-1687)
*Physiognomie and Chiromancie*

London: Nathaniel Brooke, 1671, p. 51
Inscribed (in part):
*North, South, East, West*
The Folger Shakespeare Library,
Washington, D.C.

1. See Jean Belot, *Les oeuvres de M. Jean Belot* (Lyons: Claude de la Rivière, 1649). The woodcut is inserted between pp. 98-99. For Saunders' work, see Andrew Fitzherbert, *The Palmist's Companion* (Metuchen, N.J.: Scarecrow Press, 1992), 85-86; Fred Gettings, *The Book of the Hand: An Illustrated History of Palmistry* (London: Paul Hamlyn, 1965), 189-190; and Thorndike, *A History of Magic and Experimental Science,* 8:462-463.

2. Kurt Seligmann, *The History of Magic and the Occult* reprint ed. (New York: Gramercy Books, 1997), 266. For further discussion of the microcosm analogy, see the essay by Brian P. Copenhaver in this volume, 46-49.

3. Seligmann 1997, 191.

4. For a contemporary work of similar range by Johann Praetorius, see Cat. 68.

5. The present work is an expanded version of the first edition, which was published by Nathaniel Brooke in 1653. Saunders published a separate book entitled *Palmistry: The Secrets Thereof Disclosed* (London: Sawbridge, 1664).

6. For further information on Saunders, see *DNB* 27:817-818.

THIS WOODCUT, AN ENGLISH TRANSLATION of an identical illustration copied from an earlier work by Jean Belot, combines astrology and chiromancy, known also as palmistry, to interpret outward, bodily marks of the hand as signs of the interior life and fate of the individual.[1] The hand again stands as a symbol or figure of the whole person. As a privileged part of the body, the hand is a "mediator between the above and below, between the intellectual microcosm, residing in the head, and the material microcosm, which dwells in the body."[2] In addition to the natural lines of the hand, artificial symbols drawn from astrology indicate the signs of the planets on each finger and zodiacal symbols on the joints as marks indicating forces that determine fate, personality, and moral character as defined in words or phrases. For example, the index finger, assigned to the planet Jupiter, bears on its joints the symbols of the zodiacal signs of Aries the Ram, Taurus the Bull, and Gemini the Twins. The first is associated with leadership; the second with reliable, dogmatic, and possessive traits; the third with active and wideranging interests.[3] Numbers and compass directions are other graphic symbols that contribute to reading the anatomical parts of the hand, broken down into separate regions, as a map that converts knowledge of invisible, immaterial relationships into a visually legible and reliable format.

Richard Saunders' book is one of only five written in English during the sixteenth and seventeenth centuries. His subjects are chiromancy and the allied subjects of physiognomy and metoposcopy, the art of reading character from the face, and the lines of the forehead respectively.[4] His work, comprising a hundred pages and forty-eight figures of the hand, combines theory and practice in his extended verbal and visual discussion of chiromancy.[5] In some respects, the book is an anthology of earlier texts, from which ideas and specific images are borrowed. Ambitious in scope and production, the work is dedicated to the prominent antiquarian and alchemist Elias Ashmole (see Cat. 67) and contains prefatory praises from noted contemporary practitioners of astrology.[6]
CRS

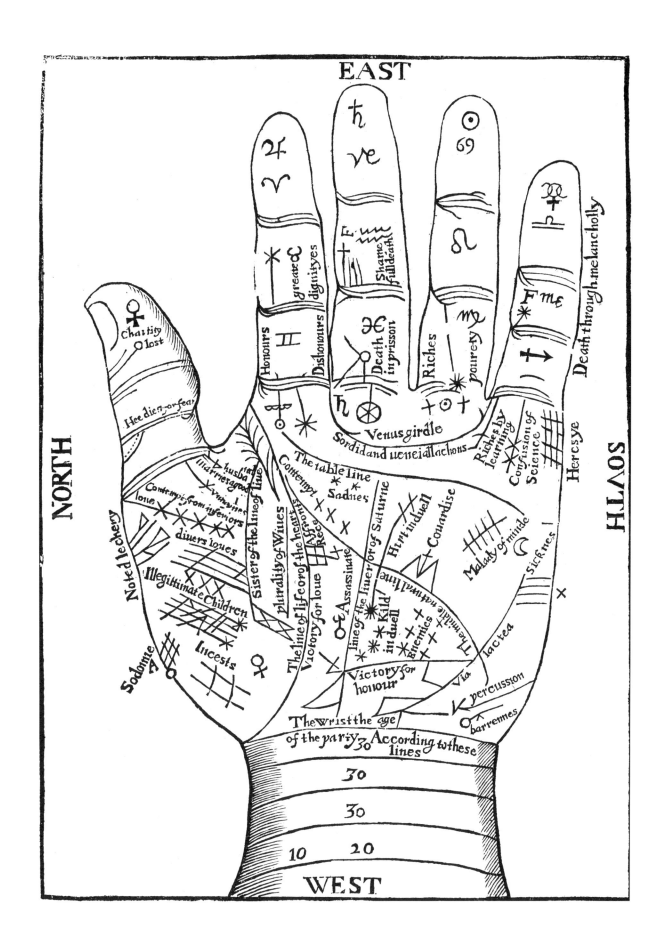

EAST

NORTH

SOVTH

WEST

# Portrait of Andreas Vesalius

*Portrait of Andreas Vesalius,* 1542
Anonymous, Venetian School;
attributed to Jan Stephen van Calcar
(c. 1499-1550)
Woodcut
Image: 7⅝ x 3⅝" (19.3 x 14.6 cm)
From Andreas Vesalius (1514-1564)
*De humani corporis fabrica libri septem*
Basel: Johann Oporinus, 1543

Inscribed:
*An. aet. XXVIII M.D.XLII*
(Age 28, 1542);  *Ocyus, iuncunde et tuto*
(Swiftly, pleasantly, and safely)
Philadelphia Museum of Art:
SmithKline Beecham (formerly
SmithKline Beckman) Corp. Fund for
the Ars Medica Collection, 1949-47-41B

1. Saunders and O'Malley, *The Illustrations from the Works of Andreas Vesalius,* 41. See also David Rosand and Michelangelo Muraro, *Titian and the Venetian Woodcut,* exh. cat. (Washington: International Exhibitions Foundation, 1976-1977), pl. 50, 216.

2. Saunders and O'Malley, *The Illustrations from the Works of Andreas Vesalius,* pl. 2, 42.

3. See Richard N. Wegner, *Das Anatomenbildnis: Seine Entwicklung im Zusammenhang mit der anatomischen Abbildung* (Basel: Schwabe, 1939), 33-40.

4. For a summary of Vesalius' later career, see Saunders and O'Malley, *The Illustrations from the Works of Andreas Vesalius,* 29-40.

STANDING IN FRONT OF A CURTAIN, A RICHLY DRESSED VESALIUS glances at the viewer while he holds the dissected forearm and hand of a larger than lifesize figure placed next to a column. On the table next to the dissected arm are a pen and inkpot, inscription, and a dissecting tool. Although scholars generally agree on the portrait's Venetian origin, the attribution to a specific artist is still contested (see Cat. 13). The lack of consistency in naturalistic depiction of Vesalius' hand and head are further puzzling features of this striking image of the young and confident Vesalius, who gazes defiantly at the viewer. The incorrect reference to the chapter number in the text (not 30, but 43) that discusses the digital muscles is also surprising.[1] What is equally remarkable is the emphasis on the dissected forearm and hand of the heroic figure next to Vesalius. This choice is deliberate, because the prominently depicted flexor-muscles of the fingers are considered the anatomically complex feature associated with human identity and intelligence. The focus on Vesalius' own hand as writer and recorder shows his intellectual prowess as scholar, while the dissected hand demonstrates his manual skill as an anatomist. The latter feature accords with Vesalius' insistence that direct involvement with the process of dissection is essential to medical practice: a daring allusion at a time when manual labor was still associated with barber-surgeons and not academically trained physicians. The famous title page of the *Fabrica,* as the book is known, makes the point more clearly, as Vesalius, unaided by the customary barber-surgeon or demonstrator, performs the dissection himself.[2]

While the author portrait is not a novel genre, the depiction of an anatomist exhibiting his skill in the frontispiece of his text inaugurates a new tradition (Cat. 6 and 7).[3] In this respect, as in so many others, Vesalius stands at the forefront of developments linking art and science.

For the rest of his life, Vesalius devoted most of his energies to serving as military surgeon and physician to the Emperor Charles V and his son and successor, Philip II. Although in 1555 he published a second edition of the *Fabrica* (Cat. 19), his fame rested on the remarkable qualities of this publication, which, widely copied, became the model for anatomical illustration for half a century.[4]
CRS

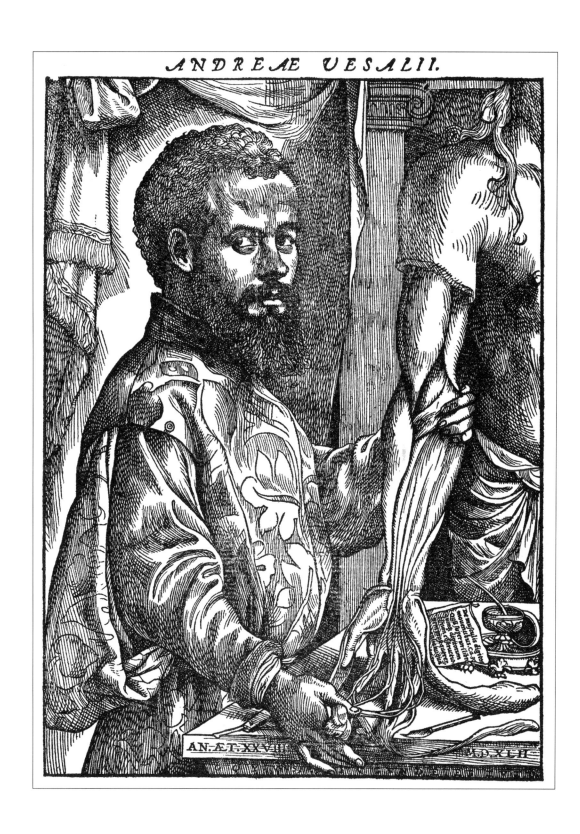

*ANDREAE VESALII.*

## Portrait of Giulio Casserio

*Portrait of Giulio Casserio*, c. 1600
Attributed to Josias Murer II (1564-1630)
Engraving
Plate mark: 14³⁄₁₆ x 9⁷⁄₁₆" (36.3 x 24 cm)
Giulio Casserio (Julius Casserius)
(1561?-1616)
*De vocis auditusque organis historia anatomica*
Ferrara: Vittorio Baldini, 1601, fol. b1
Inscribed:
*Iulius Casserius Placentinus Philosophus Medicus Anatomicus Natus Annos XXXIX*
(Julius Casserius of Piacenza, medical philosopher and anatomist at the age of 39); *Rimatur manus apta manum: mens erue mentem*
(The skilled hand scrutinizes the hand, the mind [of the viewer] draws out the mind [of Casserius])
History of Medicine Division,
National Library of Medicine,
National Institutes of Health,
Bethesda, Maryland

1. For an analysis of the portrait and the title page of this volume, see Mimi Cazort, "On Dissected Putti and Combustible Chameleons," *Print Collector's Newsletter* 17/6 (1987):198-201.

2. Loris Premuda, "Giulio Casserio," DSB 3:98-100; Premuda, *Storia dell'iconografia anatomica* (Milan: Aldo Martello, 1957), 161-162. For further discussion of the date of Casserio's birth, see Giuseppe Sterzi, *Giulio Casseri anatomico e chirurgo (c. 1552-1616)* (Venice: Istituto veneto di arti graphiche, 1909), 8-9.

3. For Casserio's citation of Murer, see Choulant, *History and Bibliography of Anatomic Illustration*, 243. See also G. Wolf Heidegger and Anna Maria Cetto, *Die anatomische Sektion in bildlicher Darstellung* (Basel: S. Karger, 1967), 303-304. For Murer and his family, see Thieme-Becker, 25:283. See also Roberts and Tomlinson, *The Fabric of the Body*, 259-261; and Richard Wegner, *Das Anatomenbildnis: Seine Entwicklung im Zusammenhang mit der anatomischen Abbildung* (Basel: Benno Schwabe, 1939), 51-52, fig. 20.

THE PORTRAIT OF THE DISTINGUISHED SURGEON and anatomist Giulio Casserio continues the theme of the connection between the hand and mind established in the image of Andreas Vesalius (Cat. 5). Like his illustrious predecessor at the University of Padua, Casserio shows his skill as anatomist and surgeon, wielding a scalpel and a hooklike device by which he has dissected the disembodied right hand placed prominently in the foreground. The inscription surrounding the portrait again emphasizes the connections between the hand and the mind, although this time the fingers' extensor muscles are featured.

Casserio's image is striking in the naturalistic depiction of the homely anatomist, including his long nose, receding hair, and wart on his forehead. Casserio, pictured in three-quarter, half-length format presents himself directly to the spectator with a forthright gaze. The portrait deserves attention, too, in revealing a marked increase in the social status of the surgeon anatomist. Among these signs are the rich costume, coat of arms, the honorific oval frame with inscriptions, and the classical allusions to fame in the two allegorical figures above and the winged putti below.[1] In addition, the light area behind his head stresses the activity and distinction of his mind. Casserio, who came from a humble background, made his way into the medical world by association with the famous Girolamo Fabrici, public lecturer in anatomy and surgery at the University of Padua. Fabrici encouraged Casserio, who studied the classics before receiving his medical degree around 1580. As an established surgeon in private practice, Casserio's wealth grew. His reputation as an anatomist increased also, as did the jealousy of his mentor Fabrici, whose position as public lecturer he filled when the latter suffered from poor health.[2]

Casserio's intellectual and social ambition are evident in this full-page portrait, surrounded in the folios preceding and following it by numerous tributes to his erudition and scientific reputation. Indeed, the folio-sized book, dedicated to Ranuccio Farnese, Duke of Parma and Piacenza, honored suitably in a dedication portrait, is a superb and expensive example of printing and illustration. Provided with thirty-four engravings on the comparative anatomy of the voice and hearing, this volume—the first of Casserio's three published volumes on anatomy (Cat. 21 and 22)—demanded considerable resources. Casserio insisted on the scientific accuracy of the illustrations and to this end exerted considerable influence on their program and structure. The second edition of the *De vocis* mentions that Josias Murer, the artist of Casserio's portrait, lived in the anatomist's house in order to work on the engravings.[3]

CRS

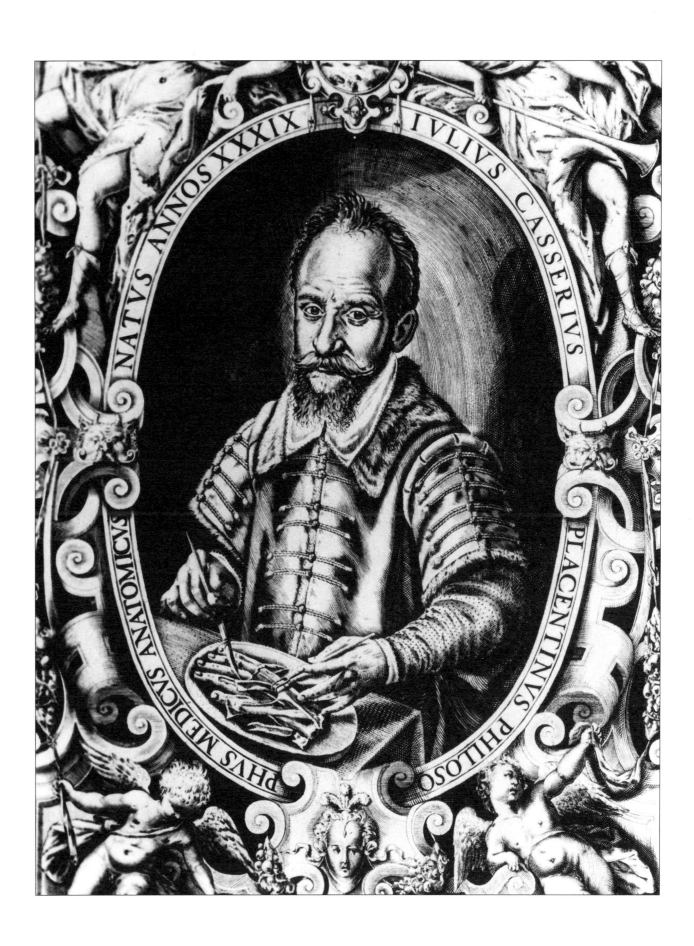

# The Anatomy Lesson of Dr. Tulp

*The Anatomy Lesson of Dr. Tulp,*
after Rembrandt, 1876
Léopold Flameng (1831-1911)
Etching (44th of edition)
Plate mark: 11¹⁄₁₆ x 15" (28.1 x 38.1 cm)

Sheet: 15³⁄₁₆ x 17¹⁵⁄₁₆" (38.5 x 45.5 cm)
Signed lower right
Philadelphia Museum of Art: Gift of
Mrs. Robert M. Hogue, 1943-50-25

1. For a detailed and informative analysis of Rembrandt's work, with extensive references to earlier literature, see Schupbach, *The Paradox of Rembrandt's "Anatomy of Dr. Tulp."* For a critique of Schupbach's and other art-historical interpretations of the painting, see Norbert Middelkoop et al., *Rembrandt under the Scalpel: The Anatomy Lesson of Dr. Nicolaes Tulp Dissected,* exh. cat. (The Hague: Mauritshuis, 1998), 17-24.

2. See Martin Kemp's essay in this volume, 22-27, for further explication of these ideas.

3. Schupbach, *The Paradox of Rembrandt's "Anatomy of Dr. Tulp,"* 17.

4. Ibid. For a collection of valuable texts in Schupbach's work, appendix 2, 57-65, "The Special Significance of the Hand."

5. Thieme-Becker, 12:69-70; E. Bénézit, *Dictionnaire critique et documentaire des peintres, sculpteurs, dessinateurs, et graveurs,* rev. ed. (Paris: Librairie Gründ, 1976), 4:391; Henri Béraldi, *Les graveurs du XIX<sup>e</sup> siècle* (Paris: Librairie L. Conquet, 1887), 101-134. The present etching is no. 220 of Béraldi's list of Flameng's work and is dated 1876 in Bibliothèque Nationale, Département des Estampes, *Inventaire du fonds français après 1800* (Paris: Bibliothèque Nationale, 1954), 7:582, no. 219.

6. Peter S. Samis, "*Aemulatio Rembrandti*: The Nineteenth-Century Printmaker Flameng and His *Prises/Crises de Conscience,*" GBA 116 (December 1990): 243-258.

7. For the connection between Flameng's political views and the iconography of his early works, see ibid., 244-251.

THIS ETCHING IS A FAITHFUL COPY AFTER REMBRANDT'S famous painting of 1632, *The Anatomy Lesson of Dr. Tulp* (The Hague, Mauritshuis).[1] Like the portraits of Vesalius (Cat. 5) and Casserio (Cat. 6), the etching focuses on the dissected muscles of the forearm to connect the hand and human intelligence. Rembrandt's work creates a brilliant fusion of a group portrait with an anatomical demonstration by Dr. Nicolaes Tulp. As the lecturer speaks to a group of Amsterdam surgeons, holding up his own bent left hand as an example of its flexibility, with his right he points his scalpel at the dissected left arm of the corpse spread out on the table. The emphasis on the flexor muscles and tendons of the hand echoes the example in Vesalius' portrait and underlines their special status.[2] The canonic works of Aristotle and Galen diffused the idea that the hand, particularly the muscles and tendons of the forearm that flex the fingers, is the instrument whose versatility permits human mastery over nature. As William Schupbach puts it: "In this respect the human hand was the physical counterpart of the human psyche, which, by performing rational thought over an unrestricted range of subjects, was also an instrument for using other instruments."[3] In their complex design, the prehensile capacities of the hand, concentrated in the flexor muscles and tendons of the fingers, demonstrated "the wisdom and goodness of God in the creation of man."[4]

In his fictive historical representation, Rembrandt's concern for the portrait of the group shows the rise in the social and professional status of the surgeons. A century earlier this group was deemed unworthy because of their association with manual, practical work devoid of theoretical knowledge. Rembrandt's depiction shows that the surgeons' work is informed by both scientific knowledge, here set in the anatomical theater of Amsterdam, and practical skill.

Léopold Flameng was one of the most illustrious etchers and engravers of his time.[5] In the early part of his career, he took part in the revival of etching in France, emblematic of the artist's freedom from the constraints of reproductive engraving favored by the Academy.[6] Flameng's devotion to Rembrandt is shown in the former's original etchings of the 1860s and 1870s. Flameng was Charles Blanc's choice as the printmaker for his 1859 edition of Rembrandt's etchings. Flameng's bust-length portrait of Rembrandt, a *remarque,* next to his signature at the bottom of the present etching substantiates his artistic identification with the earlier artist.[7] Later in his career Flameng became very successful as a reproductive engraver, producing versions of some of Rembrandt's most famous paintings, such as *The Night Watch.*

CRS

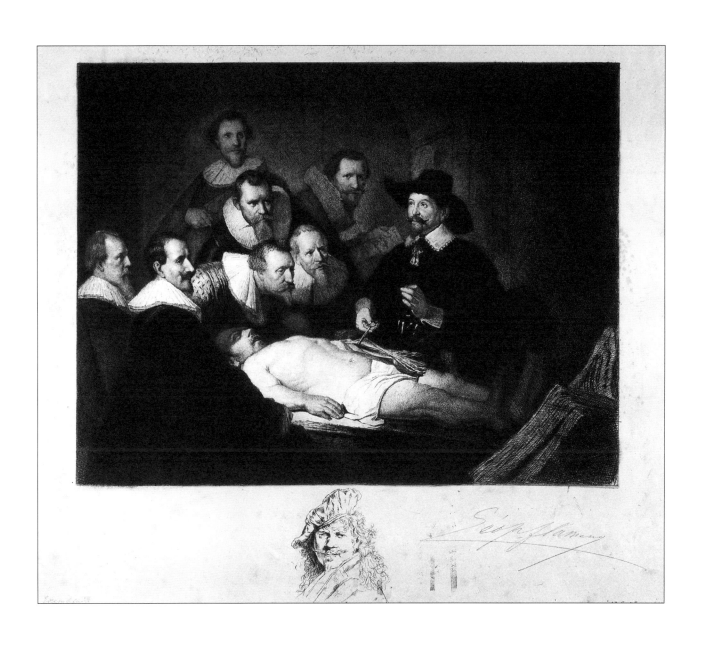

## Self-Portrait
## (Esther Inglis)

*Self-Portrait (Esther Inglis)*, 1624
Esther Inglis (1571-1624)
Drawing in black pen and ink
Image: 1¾ x 1¼" (4.5 x 3.2 cm)
Antoine de la Roche Chandieu
(1534-1591)
*Octonaries upon the Vanitie
and Inconstancie of the World*
1 January 1600

Reverse title page
Inscribed:
*ESTHER INGLIS; De Dieu le Bien,
de moy le mal, ou rien, 1624*
(Esther Inglis; Good comes from
God, from me, nothing or evil, 1624)
The Folger Shakespeare Library,
Washington, D.C. (MS V.a.91)

THIS SELF-PORTRAIT, the only one in the exhibition, like the images of Vesalius, Casserio, and Hollar (Cat. 5, 6, and 9), stresses the connection between personal and professional identity and the hand. Inglis presents herself not only as an artist but also in a double sense as a writer, holding pen, ink, and book as emblems of her handiwork. An example is visible on the opposite page: an English translation of a French text penned in her exquisite handwriting and decorated with a pink rose. Inglis' professional identity was founded on her reputation as a calligrapher well versed in many writing styles. Inglis' inscription of her name on either side of her portrait first establishes her personal identity, but the words on the book show that her gift comes from God, a view consonant with the traditional belief that writing was the result of divine inspiration.[1] She acts as God's handmaiden, her writing an instrument for recording and preserving divine wisdom inscribed in the texts that she copies. At the same time as the aesthetic quality of her handwriting is prized as a sign of individual identity, it is recognized as a manual skill that is also a divine gift. Writing, then, is an activity that unites in the hand mental and manual qualities fundamental to human generic and personal identity.

The small size of Inglis' portrait distinguishes it from much larger male images in the exhibition, as well as from the greater scale of her elegant calligraphy on the opposite folio. Her contemporary reputation partially rested on her ability to write different scripts in a very small hand.[2] The association of feminine virtuosity with miniature scale is a timeless gender stereotype. The embroidered velvet bookbindings covering some of Inglis' gift books, also executed by her, connect her further with needlework, another woman's craft.[3] Yet in Inglis' self-portraits inserted in her manuscripts, she wears fashionable dress and asserts her professional status as writer and artist.[4] The portrait type in the Folger manuscript is based upon the image of another French woman, Georgette de Montenay, author of an early book of Protestant religious emblems (Cat. 76 and Fig. 37).[5]

Inglis was the child of Huguenot immigrants who came to Scotland about 1569 to escape religious persecution. In 1580, after the family had for a few years received public assistance for poor persons, Esther's father, Nicholas Langlois, became head of a French school in Edinburgh. Her mother, Marie Presot, was an excellent calligrapher, from whom the daughter learned her craft.[6]

Despite the advent of printing, writing by hand was essential for commercial, political, and legal documents. Although restricted to the domestic sphere, some women became calligraphers and writers of documents, often by association with male relatives. Inglis, who anglicized her family name, and kept it after her marriage to Bartholomew Kello, diplomat and clergyman, helped her husband in transcribing documents. Her manuscripts were, however, gift books generally written in the hope of securing employment in the households of prominent persons, including royalty and nobility.[7] Her efforts to direct her works to a public sphere showed great courage and self-recognition of her ability as a calligrapher. Her texts were generally derived from the Bible or Protestant religious treatises and addressed to powerful partisans of the cause.[8]

The present work, authored by a prominent sixteenth-century French Protestant religious reformer, had facing English translations perhaps supplied by Inglis herself or, more likely, by her husband. A discrepancy exists between Inglis' date of 1600 for the text and that of 1624 for the portrait. A convincing explanation is that Inglis kept this version of the *Octonaries* as a model for later copies and glued in the portrait during the last year of her life.[9]

CRS

1. Georgianna Ziegler, "Hand Ma[i]de Books: The Manuscripts of Esther Inglis, Early-Modern Precursors of the Artists' Book," forthcoming, *English Manuscript Studies*. See also Dorothy Judd Jackson, *Esther Inglis, Calligrapher* (New York: Spiral Press, 1937).

2. Jonathan Goldberg, *Writing Matter: From the Hands of the English Renaissance* (Stanford, Calif.: Stanford University Press, 1990), 147.

3. Ziegler forthcoming.

4. Goldberg 1990, 150, states that the broad-brimmed hat and ruff worn by Inglis are borrowed from male dress.

5. A. H. Scott-Elliot and Elspeth Yeo, "Calligraphic Manuscripts of Esther Inglis (1571-1624): A Catalogue," *Papers of the Bibliographical Society of America* 84/1 (1990):18.

6. Ibid., 12-13. For Marie Presot, see Robert Williams, "A Moon to Their Sun: Writing Mistresses of the Sixteenth and Seventeenth Centuries," *Fine Print* 11/2 (1985):89-90.

7. Scott-Elliot and Yeo 1990, 14-15; Goldberg 1990, 147.

8. Ziegler forthcoming.

9. Elliot and Yeo 1990, 41-42.

# Portrait of Wenceslas Hollar

*Portrait of Wenceslaus Hollar, c. 1649*
Wenceslaus Hollar (1607-1677), after
the painting by Jean Meyssens
Etching
Plate mark: 6¼ x 4½" (16 x 11.3 cm)
Jean Meyssens (1612-1670)
*Images de divers hommes d'esprit sublime*
Antwerp: Jean Meyssens, 1649, n.p.
Inscribed:
*WENCESLAUS HOLLAR Gentilhomme né à Prage l'an 1607, a esté de nature fort inclin pour l'art de meniature principalment pour esclaircir, mais beaucoup retardé par son père, l'an 1627, il est party de Prage ayant demeuré en divers lieux en Allemaigne, il c'est addoné pour peu de temps à esclaircir et aplicquer l'eau forte, estant party de Coloigne avec le Comte d'Arondel vers Vienne et dillec par Prage vers l'Angleterre, ou ayant esté serviteur domestique du Duc de Yorck,*
*il s'est retiré de là à cause de la guerre à Anvers où il reside encore. Ie. Meyssens pinxit et excudit.* (Wenceslaus Hollar. Gentleman born in Prague in 1607, naturally inclined to the miniature art, principally to portraiture. But kept back greatly by his father, in 1627 he left Prague. Having lived in various places in Germany, for a short while he devoted himself to portraiture and etching, having left Cologne with the Count [Earl] of Arundel for Vienna and from there, by way of Prague to England, where having been in the domestic service of the Duke of York, he withdrew from there because of the war, to Antwerp, where he still resides. Jean Meyssens painted and printed it.)
The Folger Shakespeare Library, Washington, D.C.

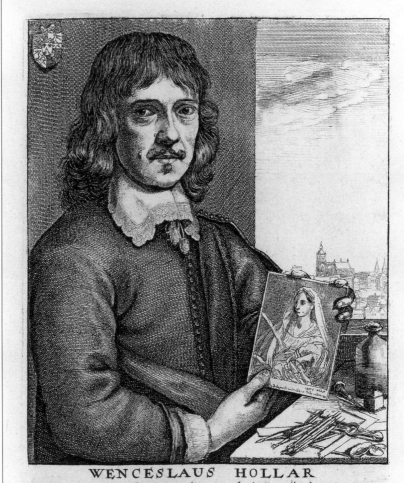

WENCESLAUS HOLLAR

*Gentilhomme ne a Prage l'an 1607, a esté de nature fort inclin pr l'art de meniature principalement pour esclaircir, mais beaucoup retardé par son pere, l'an 1627, il est party de Prage aijant demeure en divers lieux en Allemaigne, il c est addonne pour peu de temps a esclaircir et aplicquer leau forte, estant party de Coloigne avec le Comte d'Arondel vers Vienne et dillee par Prage vers l'Angleterre, ou aijant esté serviteur domesticque du Duc de Iorck, il s'est retire de la a cause de la guerre a Anvers ou il reside encores.*
*Ie. Meyssens pinxit et excudit.*

LIKE THE PORTRAITS OF ANDREAS VESALIUS (Cat. 5), Giulio Casserio (Cat. 6), and Esther Inglis (Cat. 8), the image of Wenceslaus Hollar demonstrates the connections between personal and professional identity and the hand. In this case, the artist exhibits his handiwork, the product of intelligence, creativity, and manual skill. Next to his right hand Hollar, who gained fame as an etcher known for his rendition of topographic views, costumes, and portraits, exhibits the tools of his trade as an etcher.[1] The work that he holds is his own etching of a now-lost painting by Raphael of St. Catherine from the Arundel collection.[2] The portrait thus pays tribute not only to Hollar's skill as an artist, but also to that of Raphael, one of the most highly regarded creative geniuses of the Italian Renaissance renowned for his command of artistic theory and practice. Hollar also acts as guardian of a shared artistic tradition.

The portrait, like the others in this section of the exhibition, demonstrates the social and professional status of the subject. Posed in half-length format, Hollar looks straight out at the viewer with an intense expression. Again details of costume, such as the elegant lace collar and doublet, play an important role in establishing the artist's elevated rank, as does the family coat of arms on the upper left. Reference to Hollar's skill as a topographical artist, as well as a biographical element, is the city view and building on the upper right visible through a window opening, sometimes identified with St. Vitus, the cathedral of Prague, Hollar's birthplace. The lengthy inscription below the image contributes further information about Hollar's life.[3] Despite the fact that Hollar himself made the etching, the image is not a true self-portrait, as it is a replica of a painting by Jean Meyssens.[4] The latter was a painter, printmaker, and publisher who collected sixty-two engraved and etched portraits of well-known contemporary artists after paintings and drawings made by various printmakers. In 1649 Meyssens published this group.[5] The model for such collections goes back to sixteenth-century Italian precedents, which later spread to northern Europe.[6] The most recent and influential example was Anthony Van Dyck's project for a series of portraits of famous artists, collectors, and other prominent men, known as the *Iconographie*.[7]

Hollar's career, deeply affected by the upheavals of the civil war in England and the Thirty Years' War in Europe, was marked by a search for a stable environment capable of fostering sustained and secure artistic patronage. From 1636 to 1642, after he left Prague and Cologne, Hollar briefly enjoyed such a situation in London, where he was attached to the household of the Earl of Arundel, England's greatest collector.[8] The etching he shows of Raphael's painting of St. Catherine also honors the collector and Hollar's happy years in his employment.

CRS

1. Richard Pennington, *A Descriptive Catalogue of the Etched Work of Wenceslaus Hollar, 1607-1677* (Cambridge and New York: Cambridge University Press, 1982), no. 1149, 245.

2. Ibid., no. 177, 22. See David Jaffé et al., *The Earl and Countess of Arundel: Renaissance Collectors,* exh. cat. (London: Apollo, 1995), fig. 15 and n. 119. See also Richard T. Godfrey, *Wenceslaus Hollar: Bohemian Artist in England,* exh. cat. (New Haven and London: Yale University Press, 1994), no. 75, 110.

3. For biographical information, see Pennington 1982, xix-xxiv; George Gordon, "Wenceslaus Hollar," *DOA* 14: 682-685.

4. For Hollar's self-portraits, see Godfrey 1994, no. 13, 48.

5. For biographical information, see Alfred von Wurzbach, *Niederländisches Künstler-Lexikon* (Vienna and Leipzig: Verlag von Halm und Goldmann, 1910) 2:159; Thieme-Becker, 24:502.

6. For this tradition, see Susan J. Barnes, "The *Uomini Illustri,* Humanist Culture, and the Development of a Portrait Tradition in Early Seventeenth-Century Italy," in *Cultural Differentiation and Cultural Identity in the Visual Arts* (Studies in the History of Art, 27; Center for Advanced Study in the Visual Arts, Symposium Papers, 12), eds. Susan J. Barnes and Walter S. Melion (Washington: National Gallery of Art, 1989), 81-94.

7. See Marie Mauquoy-Hendrickx, *L'iconographie d'Antoine Van Dyck,* 2 vols., 2d ed. rev. (Brussels: Bibliothèque Royale Albert Iᵉʳ, 1991).

8. For Hollar's relationship with the Arundel circle, see Pennington 1982, xxii-xxix; Rachel Doggett et al., *Impressions of Wenceslaus Hollar,* exh. cat. (Washington, D.C.: The Folger Shakespeare Library, 1996), 17; Jaffé 1995, 20-32.

# Thumbmark of Thomas Bewick

*Thumbmark of Thomas Bewick*, 1824
Thomas Bewick (1753-1828)
Wood engraving
Image: 8⅛ x 4⅞" (20.6 x 12.4 cm)
Size of thumbmark: 2⅝ x 4"
(6.8 x 10.2 cm)

Thomas Bewick (1753-1828)
*The Fables of Aesop and Others*
Newcastle: E. Walker, 1824, fol. A1
Rare Book and Special Collections
Division, Library of Congress,
Washington, D.C.

WHILE THE HAND IS A SYMBOL OF GENERIC HUMAN IDENTITY, the imprints of a person's palm and fingers hold clues to his or her individuality. In Asian societies, such imprints made with ink were for many centuries recognized in legal documents as marks of authenticity.[1] In Europe such usage of fingerprints, as well as for identification of criminals, did not develop until the nineteenth century. Scientific connections between individual identity and distinctive patterns of the fingertips emerged in the seventeenth century.[2]

Thomas Bewick, naturalist, illustrator, author, and printmaker, used the mark of his thumb as a receipt to assure the authenticity of the editions of *The Fables of Aesop and Others* and to prevent the "loss of copies from printing house and warehouse."[3] Bewick may have chosen the thumb over other fingers not only for ease of imprint, but also because it represented the master digit, symbol of the artist's handiwork.[4] Other devices used for identifying the copies were the signatures of Bewick and his son, Robert Elliot Bewick, the name of the purchaser (in some cases), and the number of the copy. In addition, Bewick printed from a copper plate a landscape scene above the thumbmark in a wood engraving, a technique that he revived and popularized.[5] Bewick apparently did not add these signatures or distinctive sprays of seaweed, placed over the landscape, until the books "were needed for copies sold by him or issued to authorized booksellers."[6] The whole procedure of authentication involved six different printing operations.

The Library of Congress copy bears the number 729, one of a thousand copies issued in a demy paper format. Bewick's thumbmark is one of two types he devised, the short kind that appeared in the second edition.[7] Neither version of this collection of fables, based largely on Croxall's eighteenth-century English translation, met with the success of Bewick's earlier works on natural history, landmarks in the history of book illustration.[8] His partiality for fables as a means of moral instruction of the young, a goal that long engaged him, connects Bewick with such influential educators as Jan Amos Comenius (Cat. 33), who saw the important role of visual images in the pedagogical process.[9]
CRS

1. For a brief summary of developments, see Gerald Lambourne, *The Fingerprint Story* (London: Harrap, 1984), 22-25.

2. Ibid., 25.

3. Iain Bain, *Thomas Bewick: An Illustrated Record of His Life and Works* (Newcastle upon Tyne: Tyne and Wear County Council Museums, 1979), 63. Bewick had used the device earlier in his *History of British Birds,* published in 1809. See Lambourne 1984, 26.

4. A fingerprint expert states that while it is not possible to confirm that the thumbprints were Bewick's own, "they could only have been engraved by a man with a considerable understanding of the ridge formation of the fingers, and the ridge characteristics within these formations." Lambourne 1984, 26.

5. See Leo. John de Freitas, "Wood Engraving," *DOA* 33:367-370.

6. For a detailed account of the printing procedures in the first and second editions of the book, see S. Roscoe, *Thomas Bewick: A Bibliography Raisonné of Editions of "The General History of Quadrupeds," "The History of British Birds," and "The Fables of Aesop" Issued in His Lifetime* (London: Geoffrey Cumberlege, Oxford University Press, 1953), 152-169.

7. Ibid., 163.

8. Ibid., 167-169.

9. For Bewick's long-standing interest in the *Fables* as a source of moral instruction, as well as his account of his pleasure in designing the illustrations and the difficulties encountered in printing his edition, see *A Memoir of Thomas Bewick Written by Himself,* ed. and intro. Iain Bain (London and New York: Oxford University Press, 1975), 131-133. For a short summary of Bewick's career, see Colin Campbell, "Thomas Bewick," *DOA* 3:896-898.

To Thomas Bewick & Son D.[r]

To a Demy Copy of Esop's Fables £ s d

"18"

Received the above with thanks

Thomas Bewick,    Robert Elliot Bewick

Thomas Bewick

his    Mark

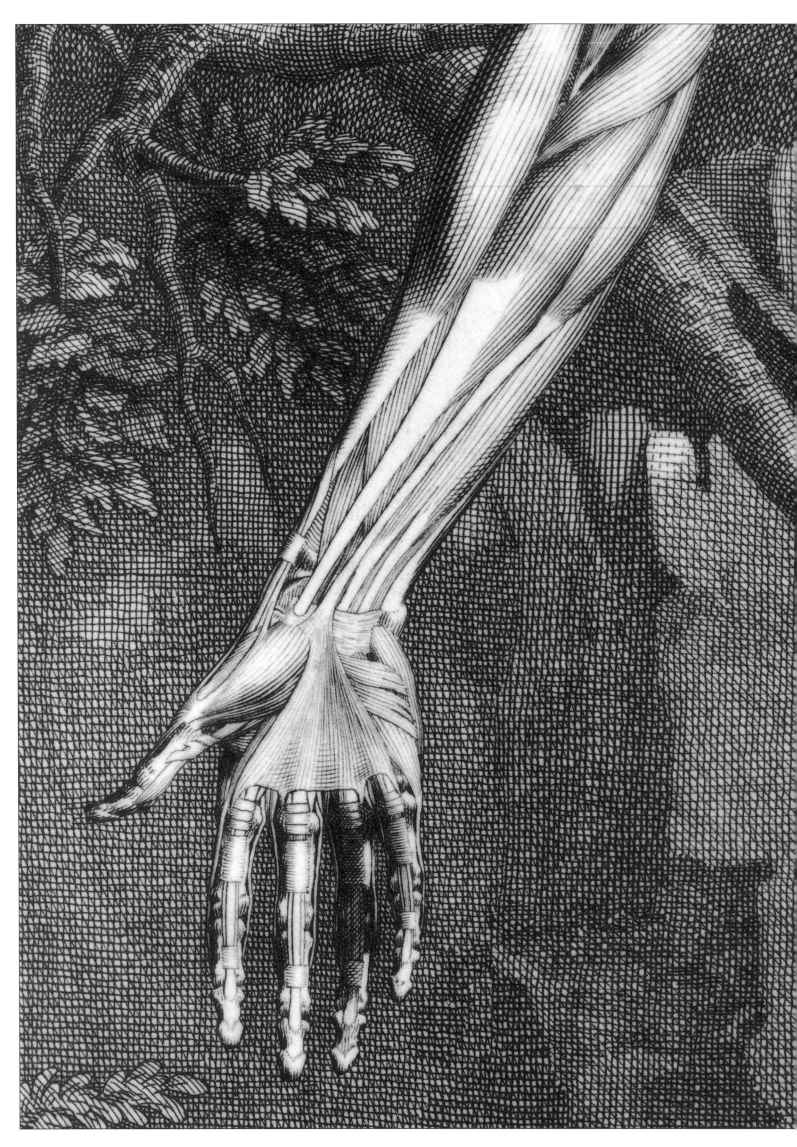

# II. The Handiwork of the Creator

*Wound Manikin*, 1540
Anonymous, German; attributed to
Hans Wechtlin (c.1480-1485; d.after 1526)
Handcolored woodcut
Image: 10¼ x 7⅜" (26.3 x 18.3 cm)
Hans von Gersdorff (d. 1529)
*Feldtbuch der Wundartzney*
Strasbourg: Johann Schott, 1540, fol. 44
Inscribed:
*Spiegel der Wundartzney. Der
Landsknecht Ebenbyld ich binn/Und
trag auch dissen Sold im synn. Ich wags*

*uff/Gerat wol/Brüder Veit/Bitz dz das
haubtgüt gar erleit.* (I represent the
lansquenets [mercenary soldiers]. I
dare to do whatever happens, Brother
Veit [Death]. Until the main part of
the body will die [of the wounds]).
Philadelphia Museum of Art:
SmithKline Beecham (formerly
SmithKline Beckman) Corporation
Fund for the Ars Medica Collection,
1949-97-11m

1. Ernest Wickersheimer, "Hans von Gersdorff," *NDB* 6:322-323.

2. See Hans von Gersdorff, *Feldtbuch der Wundartzney,* facs. ed. (Weiler im Allgäu: Editions Medicina Rara, 1968), fols. c6v.-9r. The inscription above the woodcut says: "Doch hoff ich gott/kunstlich artzney/ Schylans der werd mir helfen frey." In the foreword to the second treatise on surgery, the author refers to his sobriquet and mentions the "handtwürckunge der wundartzney." A small woodcut represents the author writing under the guidance of an angel. (For further references to divinely inspired writing, see Cat. 8.)

3. John L. Thornton, *Medical Book Illustration* (Cambridge and New York: Oleander Press, 1983), 53; Richard A. Leonardo, *History of Surgery* (New York: Frozen Press, 1943), 130.

4. Leonardo 1943, 130.

5. Diane R. Karp, "Wound Manikin" in *Ars Medica*, no. 4a, 155. She explains that while the woodcut is copied from the 1517 edition, it may have been recut to fit the size of the later edition. The inscription is not the same as in the 1517 edition. For the possible attribution of the original woodcuts to Hans Wechtlin, "a Basel artist and pupil of Hans Holbein the Elder," see Cazort, *Ingenious Machine of Nature,* cat. nos. 11-12, 119-120; and Hans J. van Miegroet, "Hans Wechtlin," *DOA* 33:18-19.

6. I am grateful to Prof. Albrecht Classen for his translation of the inscription.

A REFERENCE TO THE SKILLED HAND arises in a medical context in this brightly handcolored woodcut from a portable textbook for surgeons by Hans von Gersdorff, first published in 1517.[1] The author, known also by the family name of Schylhans (skilled hand), was a well-established surgeon in Strasbourg, who in the course of his career performed two hundred amputations. In the first edition, the author openly alludes to his sobriquet as emblematic of the surgeon's profession, which greatly depended on manual skill.[2] This heavily illustrated book, one of the earliest printed in this field, featuring numerous full-page woodcuts of surgical instruments and operations, enjoyed great success; it was published in many later editions and translated into other languages.[3] The emphasis on visual demonstration, as well as its replication in printed works, becomes increasingly important in medical books of the sixteenth century. Although von Gersdorff's book begins with a treatise on anatomy by the fourteenth-century French surgeon Guy de Chauliac, his emphasis is more practical than theoretical. The use of the vernacular indicates that it was addressed to surgical practitioners rather than academically trained physicians versed in Latin, who enjoyed a higher social status. A historical landmark in the development of military surgery is the first woodcut of an amputation seen later in Gersdorff's treatise.[4]

Standing at the head of the second (and last) treatise, the image serves as a visual paradigm for the military surgeon confronted with an array of possible battle wounds suffered by a foot soldier.[5] The inscription above the image comes from the soldier himself, who stoically says he will fight to the bitter end, oblivious of the consequences, until severely afflicted by his wounds.[6] His body is cruelly pierced by various weapons: arrows, clubs, swords, spears, gunshot, and a hammer. The illustration serves as a catalogue of weapons and a source of information about locations for binding wounds. Such woodcuts were often printed as single sheets to hang in the bathhouses or other locations where barber-surgeons worked.

The type of the "wound man" had its roots in medieval anatomical illustrations.[7] An earlier version occurred in the first printed medical text illustrated with woodcuts, published in Venice in 1491: the *Fasciculus medicinae* of Johannes de Ketham (see Cat. 57).[8] The present image offers a far more detailed array of weapons and their sites, of which two clearly affect the hands. Against all odds, the wound man stands erect in a contrapposto pose, his feet placed on a strip of grass and plants. As a martyr to his profession, the wound man recalls St. Sebastian, who is traditionally represented as a standing figure pierced by arrows.[9] The connection with religious iconography is apt, as in Christian thought the body was viewed as the noble creation of God. This

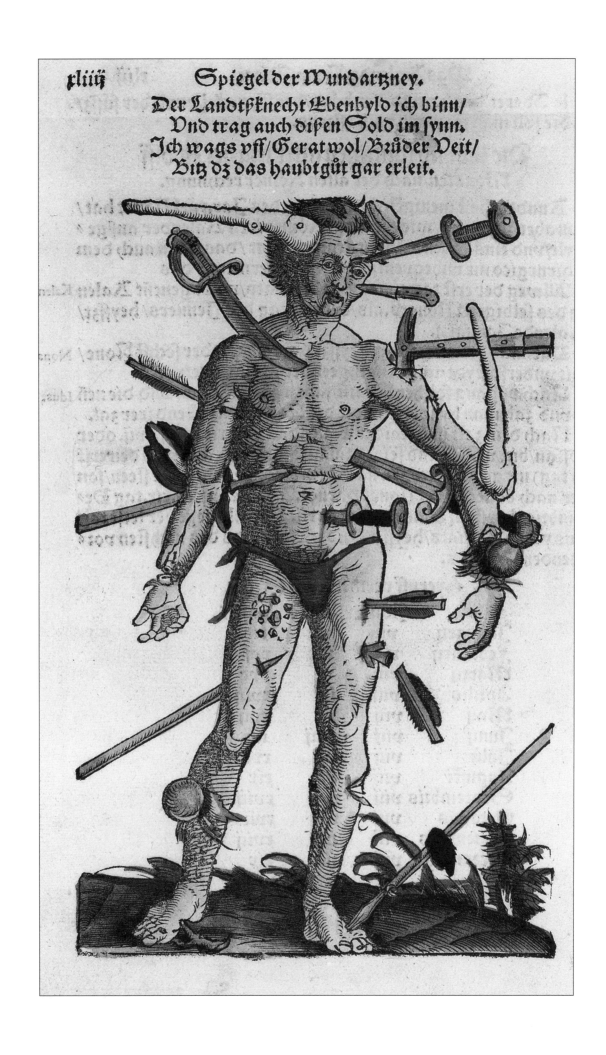

Spiegel der Wundartzney.

Der Landtßknecht Ebenbyld ich binn/
Vnd trag auch diſen Sold im ſynn.
Ich wags vſſ/Gerat wol/Brüder Veit/
Biß dz das haubtgůt gar erleit.

7. For a series of wound men in medieval manuscripts and early printed books, see Elizabeth Matthew Lewis, *An Exhibition of Selected Landmark Books and Articles in the History of Military Medicine together with a Graphic Display of the Wound Man through History,* exh. cat. (West Point, N.Y.: United States Military Academy, 1976), 2-21.

8. For a wound man in the 1493 edition of the *Fasciculo de medicina,* see Valentina Lindon, *Les siècles d'or de la médecine: Padoue XV$^e$-XVIII$^e$ siècles* (Milan: Electa, 1992), no. 39, 98. For a discussion of the Ketham, see Karl Sudhoff, "Der 'Wundenmann' in Frühdruck und Handschrift und sein erklärender Text," *Archiv für Geschichte der Medizin* 1 (1908):351-361.

9. See Peter Assion, "Sebastian," in *Lexikon der christlichen Ikonographie,* ed. Wolfgang Braunfels (Rome and Freiburg: Herder, 1976) 8:cols. 318-324.

10. For a classically inspired nude, Dürer's influential engraving of 1504, the *Adam and Eve,* see Cazort, *The Ingenious Machine of Nature,* cat. no. 10, 116-118.

idea in part underlies the persistent convention of picturing dissected bodies as alive and heroic (Cat. 12-16). Another consideration is the role that the artist who executed the illustration played in representing the body as an idealized, naturalistic form unblemished by his wounds. The figure shows the influence of Italian Renaissance artistic currents of classicism and naturalism diffused north of the Alps in the graphic work of Albrecht Dürer (Cat. 28).[10] While the type began as a simplified diagram showing sites of wounds, the more naturalistic style of this image, as well as his speaking role, evokes in the modern viewer an uneasy recognition of a dissonance between its practical goals and the method of representation.

CRS

## 12 Écorché with Exterior Muscles of the Front of the Body

*Écorché with Exterior Muscles of the Front of the Body*, 1521
Attributed to Amico Aspertini
(c. 1474-1552)
Woodcut
Image: 5³⁄₁₆ x 3⁵⁄₈" (13.2 x 9.3 cm)
Jacopo Berengario da Carpi
(c. 1460-1530)

*Carpi commentaria cum amplissimis additionibus super anatomia Mundini*
Bologna: Girolamo Benedetti, 1521, fol. 519
Rare Book and Special Collections Division, Library of Congress, Washington, D.C., Lessing J. Rosenwald Collection

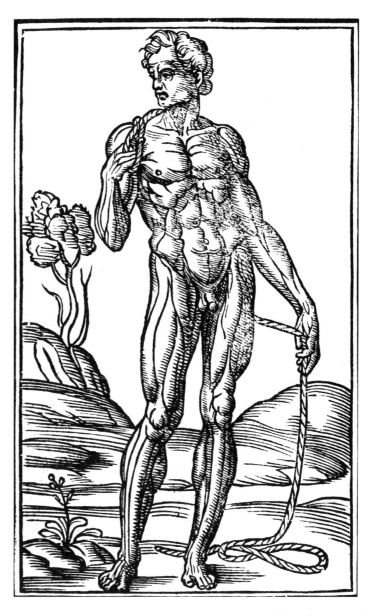

LIKE HIS CONTEMPORARY HANS VON GERSDORFF (Cat. 11), Jacopo Berengario da Carpi was a surgeon. He was trained from childhood in the profession by his father. Berengario received elements of a humanistic education from Aldo Manuzio (Aldus Manutius). Later a famous Venetian publisher, Manutius was employed during the 1470s as tutor to the children of the rulers of Carpi, Berengario's birthplace, a north Italian town near Modena. In the 1480s Berengario received a master's degree in arts and medicine from the University of Bologna, then the leading Italian center of medical and philosophical education, where in 1502 he became a professor.[1] Although he (unlike von Gersdorff) had thus entered the world of academic medicine, Berengario

1. For a biography, see Charles D. O'Malley, "Giacomo Berengario da Carpi," *DSB* 1:617-621; and Vittorio Putti, *Berengario da Carpi: Saggio biografico e bibliografico seguito della traduzione del "De fractura calvei sive cranei"* (Bologna: L. Cappelli, 1937).

2. For Berengario's career as a surgeon and the social status of the profession within the academy, see Roger K. French, "Berengario da Carpi and the Use of Commentary in Anatomical Teaching," in *The Medical Renaissance in the Sixteenth Century,* ed. A. Wear et al. (Cambridge and New York: Cambridge University Press, 1985), 44-48.

3. For a discussion of the anatomical commentary, Berengario's method, and the role of illustration in his work, see ibid., 49-62.

4. See Cazort and Kornell, *The Ingenious Machine of Nature,* 38-39, 44; Roberts and Tomlinson, *The Fabric of the Body,* 69-83; Roslynne V. Wilson, "Collaborations in Art and Medicine, 1491-1543: The Development of Anatomical Studies in Italian Medical Treatises" (Ph.D. diss., Case Western Reserve University, 1988), chap. 2.

5. For the prototype of the *écorché,* see Roberts and Tomlinson, *The Fabric of the Body,* 71 and fig. 3.3.

6. See Katharine Park, "The Criminal and the Saintly Body: Autopsy and Dissection in Renaissance Italy," *Renaissance Quarterly* 47/1 (1994): 1-33.

7. Kornell, *The Ingenious Machine of Nature,* 44, n. 3.

8. Ibid., 17-19; 43-49.

9. For the connection between Leonardo and Berengario, see Roberts and Tomlinson, *The Fabric of the Body,* 77; for the relationship between the Michelango sculpture and Berengario's *écorché,* see Wilson 1988, 108. See also Charles Seymour Jr., *Michelangelo's David: A Search for Identity* (Pittsburgh: University of Pittsburgh Press, 1967), fig. 15.

10. See Cazort, *The Ingenious Machine of Nature,* 38; Marzia Faietti and Daniela Scaglietti Kelescian, *Amico Aspertini* (Modena: Artioli, 1995), 60-61, and no. 3, 339-341.

11. Choulant, *History and Bibliography of Anatomic Illustration,* 136; French 1985, 48-49.

enjoyed a lucrative career as a surgeon, ministering to (among others of high rank) the Medici family. Based on his practical experience, in his writing he emphasized the craft and manual skills required of the anatomist.[2]

Berengario's *Commentaria,* dedicated to Cardinal Giuliano de' Medici, was an anatomical reference book of a thousand pages partly addressed to an academic audience. His work was based on his fourteenth-century predecessor at the University of Bologna, Mondino dei Luzzi. The commentary form was a feature of medieval scholarly texts that allowed for ordered explication and disputation, as well as new interpretations of authoritative works. Berengario's *Commentaria* presented a historically informed account and wide knowledge of works by classical, medieval, and Arabic writers. While respectful of great medical authorities like Galen, Berengario did not hesitate to contradict them, based on his extensive dissections of the body. Instead of relying on traditional verbal opinion, he stressed the role of sight and touch founded on practical experience in his explanations of anatomical structures.[3]

Berengario's emphasis on demonstration grounded in visual experience is evident in the twenty-one illustrations grouped at the end of the book. The woodcuts in the *Commentaria,* although somewhat crude and simplified, are significant for the history of anatomical illustration because they are the first to appear in printed books that offer such extensive visual material.[4] Most focus on the muscular system of the body, seen in different views. Individual woodcuts generally favor the representational mode of an idealized male nude with his outer layer of skin removed in order to reveal the underlying structure. This type, known as an *écorché,* became a lasting convention of anatomical illustration.[5]

Like the *Wound Manikin* (Cat. 11), the *écorché* holding a rope in Berengario's *Commentaria* is represented as alive. This convention has various explanations. The heroic nature of the form confirms the belief that the human body was a divine creation. Here the rope can allude to an emblem of martyrdom in Christian iconography. Another possible reference is to the rope by which the body was held during the dissection procedure. Since at this time such bodies were frequently those of criminals executed by hanging, an additional (perhaps ironic) connection exists.[6] The idealized figure standing at ease in a landscape setting removes the unpleasant realities underlying dissection and fuses aesthetic concerns with demonstration of the body's superficial muscular structure.

Another level of meaning appears in Berengario's statement that the illustrations could be useful to artists.[7] By the early sixteenth century knowledge of anatomy, particularly of muscular structure, was a prerequisite for artists' naturalistic representations of the human figure based on observation, study of existing works, or dissection.[8] Both Leonardo (Cat. 17) and Michelangelo, whose colossal sculpture of David may underlie the depiction of the rope-holding *écorché,* practiced dissection.[9] Amico Aspertini, the artist to whom the Berengario illustrations are now attributed, previously worked for the publisher of the *Commentaria* and is known for his knowledge of ancient and contemporary Roman art as painter, sculptor, and draftsman.[10] Although no evidence exists, Berengario may have collaborated with the artist in fashioning the program of illustration.

Berengario himself was a collector of antiquities and accepted payment for his services as a surgeon by receiving works of art, including a painting by Raphael. Among Berengario's commissions was a pair of silver vases from Benevenuto Cellini, who praised him for his knowledge of art and literature.[11] Thus Berengario's emphasis on visual experience based on cognitive and aesthetic values provided an important precedent for future developments linking art and anatomy, most notably Vesalius' *Fabrica* (Cat. 5 and 13). In both areas, the work of the hand was essential in uniting manual skill with the description, acquisition, and teaching of scientific knowledge.

CRS

# The Ninth Plate
# of the Muscles

*The Ninth Plate of the Muscles*, 1543
Anonymous, Venetian School; attributed to Jan Stephen van Calcar
(c. 1499-1550)
Woodcut
Image: 14 x 8¼" (35.5 x 21 cm)
Sheet: 16 x 10½" (40.6 x 26.7 cm)
Andreas Vesalius (1514-1564)
*De humani corporis fabrica libri septem*

Basel: Johann Oporinus, 1543
Inscribed:
*Nona musculorum tabula* (Ninth plate of the muscles)
Philadelphia Museum of Art:
SmithKline Beecham (formerly SmithKline Beckman) Corporation
Fund for the Ars Medica Collection,
1949-97-41d

1. For a full-length biography of Vesalius, see Charles D. O'Malley, *Andreas Vesalius of Brussels, 1514-1564* (Berkeley and Los Angeles: University of California Press, 1964). A briefer account occurs in Saunders and O'Malley, *The Illustrations from the Works of Andreas Vesalius*, 9-42.

2. For the English translation of the letter, see O'Malley 1964, 317-327.

3. Andrew Cunningham, *The Anatomical Renaissance: The Resurrection of the Anatomical Projects of the Ancients* (Aldershot: Scolar Press, 1997), 121-122; Glenn Harcourt, "Andreas Vesalius and the Anatomy of Antique Sculpture," *Representations* (Winter 1987): 52.

4. For the dissection scene in the *Fabrica,* see Cazort, *The Ingenious Machine of Nature,* cat. no. 19, 130-132; for the traditional type, see ibid., cat. no. 1, 115-116.

5. For the letter to Oporinus, with precise directions for the printing of the illustrations, see Saunders and O'Malley, *The Illustrations from the Works of Andreas Vesalius,* 46-48.

6. For an explanation of the complex philosophical and religious context in which Vesalius wrote about the body as reflecting the design of nature and God, see Nancy G. Siraisi, "Vesalius and the Reading of Galen's Teleology," *Renaissance Quarterly* 1/1 (1997):25-33.

7. Ibid., 21, citing Schupbach, *The Paradox of Rembrandt's "Anatomy of Dr. Tulp,"* 41-49.

8. Mimi Cazort in *Ars Medica*, ed. Diane R. Karp, cat. no. 8c, 159-161.

9. Saunders and O'Malley, *The Illustrations from the Works of Andreas Vesalius,* pl. 32, 108. The explanation concludes with the information that these transverse ligaments "were clearly to be seen in the first and second plates and denoted by numerals."

LIKE BERENGARIO DA CARPI (Cat. 12 and 18), Andreas Vesalius (Cat. 5 and 19) stressed the importance of the "hands-on" approach of the surgeon-anatomist. Both emphasized direct observation based on practical experience obtained from numerous dissections of the human body. Advocates of visual recording of anatomical structure as essential to the descriptive and demonstrative process, they took anatomy on new paths that diverged from traditional medical texts without illustrations. Like Berengario, Vesalius received a humanistic education and studied authoritative classical texts, even contributing to the new edition of Galen's *On the Usefulness of the Parts*. Vesalius (Andries Vesal) came from a Brussels medical family attached to the imperial court. After medical training at the universities of Paris and Louvain, Vesalius became, like Berengario, a lecturer in surgery and anatomy. Vesalius received his medical degree from and joined the faculty of the University of Padua, which succeeded Bologna as the preeminent center of Italian medical education. He quickly achieved notice as a dynamic demonstrator of university-sponsored dissections.[1]

Vesalius' portrait (Cat. 5) not only proudly exhibits his practical, manual skill but also points to his mastery of theory as author of his great textbook on anatomy, known as the *Fabrica*. In his dedication of the magnificent volume to the Emperor Charles v, Vesalius pleads for the revival in medical practice of the work of the hand, which should be entrusted to the trained anatomist.[2] Vesalius points to the physicians of ancient Alexandria as exemplars who combined knowledge of internal medicine, pharmacy, and manual practice of surgery.[3] The famous frontispiece on the title page of the *Fabrica* shows Vesalius himself performing a dissection, unlike the traditional practice of entrusting the actual work of dissection to an academically untrained barber-surgeon, while the academic physician seated in a chair above reads from a text.[4]

The *Fabrica* is equally bold as an ambitious undertaking for a young man of twenty-eight: Vesalius attempted to present a textbook of the entire anatomical structure of the human body. Produced in a few years, the *Fabrica* consists of seven hundred pages featuring 243 woodcuts. The result is a masterpiece seamlessly blending art, science, and printing. Although the illustrations are closely tied to the text by a system of numbers and letters identified in nearby indices, the superb woodcuts account in large measure for the book's fame. Vesalius, who supervised every detail of the *Fabrica*'s production, instructed the printer, the humanist Johannes Oporinus of Basel, to favor the illustrations over the text.[5] The woodcuts served as the primary component of a comprehensive anatomical atlas unveiling in an ordered sequence the body's underlying structure. While based on his systematic scientific inquiry, Vesalius' text also referred to the body as the handiwork of man's creator, designer, and master craftsman.[6]

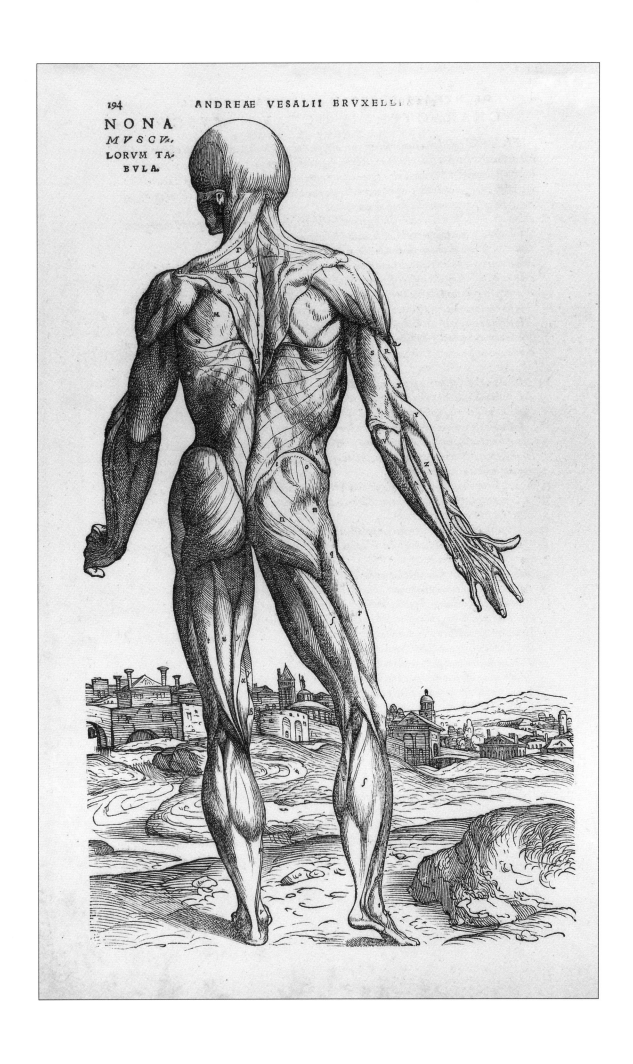

NONA
*MVSCV-*
*LORVM TA-*
*BVLA.*

Fig. 28. Anonymous, Venetian School, attributed to Jan Stephen van Calcar, *Full-length, Side View of a Skeleton Contemplating a Skull*, woodcut. From Andreas Vesalius, *De humani corporis fabrica libri septem* (Basel: Johann Oporinus, 1543), book 1, p. 264. History of Medicine Division, National Library of Medicine, National Institutes of Health, Bethesda, Maryland

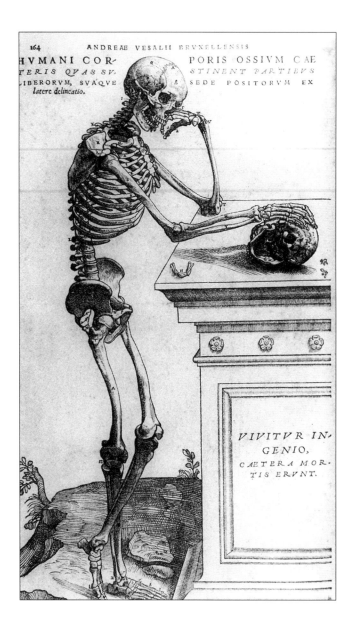

10. For a re-creation of the sequence of the muscle figures printed in reverse to form a continuous landscape, see Cazort, *The Ingenious Machine of Nature,* fig. 59, 133. See G. S. Terence Cavanagh, *The Panorama of Vesalius: A "Lost" Design from Titian's Studio* (Athens, Ga.: Sacrum Press, 1996). The book includes "The Back Views," as well as "The Front Views."

11. Kemp, "'The Mark of Truth,'" 101.

12. Roberts and Tomlinson, *The Fabric of the Body,* 208-210.

13. See ibid., 204-227.

14. Ibid., 233-242.

15. For a summary of recent opinion on the attribution controversy, see Cazort, *The Ingenious Machine of Nature,* 134-135.

Following Galen's scheme, Vesalius divided the *Fabrica* into seven parts, beginning with the skeletal and myological structures. The representational modes follow those of Berengario (Cat. 12 and 18). Expressing a negative and moralizing attitude related to the disintegration of the body after death, the skeletons, seen from different points of view, are movingly depicted standing in a landscape and showing different kinds of emotion (Fig. 28).[7] The fourteen muscle figures are similarly shown as alive, capable of different kinds of motion and feeling appropriate to the stage of dissection. Heroic in stature, they mirror the influence on contemporary Italian artists of antique sculpture in the proportions, as well as naturalistic representation of the body's three-dimensional structure. The ninth plate of the muscles is the first of the sequence to show the posterior view of the flayed body.[8] Although the figure's face is invisible, the turn of his head and outspread hands, together with the contrasting positions of legs and feet, convey a muted resistance to his plight. At this stage, the muscles remain intact except for "the transverse ligaments lying on the outer aspect of the forearm near the wrist."[9] The astonishing development of the woodcut technique in the twenty-two years since the illustration of Berengario's woodcuts (Cat. 12 and 18) is evident here: the use of

cross-hatching distinguishes muscles from contour lines and contributes to the three-dimensionality of the figure, who dominates the surrounding friezelike cityscape.[10] The small size of the inscribed letters and numbers, keyed to the text's explanatory indices on the facing folio, hardly disrupts the impression of visual unity.

Many aspects of the production of this magnificent volume remain enigmatic. Its lavish size, an imitation of medieval luxury manuscripts, involved Vesalius' search for patronage, as well as the advancement of the professional status of anatomy.[11] Vesalius presented a handcolored copy to the Emperor Charles v, whose physician he became. Vesalius, like Berengario, knew that the illustrations of the skeletal and muscular structures would be useful to artists. But the book's expense, size, scholarly method, and language limited its audience.[12] More popular was a reduced version entitled the *Epitome*, also published by Oporinus in 1543, directed to beginning medical students.[13]

No question about the *Fabrica* remains more controversial than the attribution of the woodcuts to a specific artist or group of them. A compatriot, Jan Stephen van Calcar, who worked in Titian's workshop, was named by Vesalius himself as the artist who contributed three plates to the latter's earlier publication, the *Tabulae sex*.[14] Although Vesalius does not mention any of the designers or woodcutters involved in the production of the *Fabrica*'s illustrations, many scholars attribute them to van Calcar. Because of the Venetian origin and extremely high quality of the illustrations, others opt for Titian or members of his workshop. Late twentieth-century research contends that the question cannot be resolved beyond attributing the works to a group of Venetian master craftsmen.[15] From close collaboration with Vesalius and the publisher, the resulting production remained for a very long time a widely copied and imitated model for anatomical treatises in which illustration served as a primary vehicle for attaining scientific knowledge.

CRS

*Pregnant Female Nude*, 1560
Nicolas Beatrizet (1507 or 1515-c. 1565)
after Gaspar Becerra (c. 1520-1568)
Engraving
Plate mark: 9⅜ x 6⅛" (23.9 x 15.6 cm)
Juan Valverde de Hamusco (c. 1525-1587)

*Anatomica del corpo humano*
Rome: Antonio Salamanca and
Antonio Lafreri, 1560, fol. 101
(pl. 6 of book 3)
The Folger Shakespeare Library,
Washington, D.C.

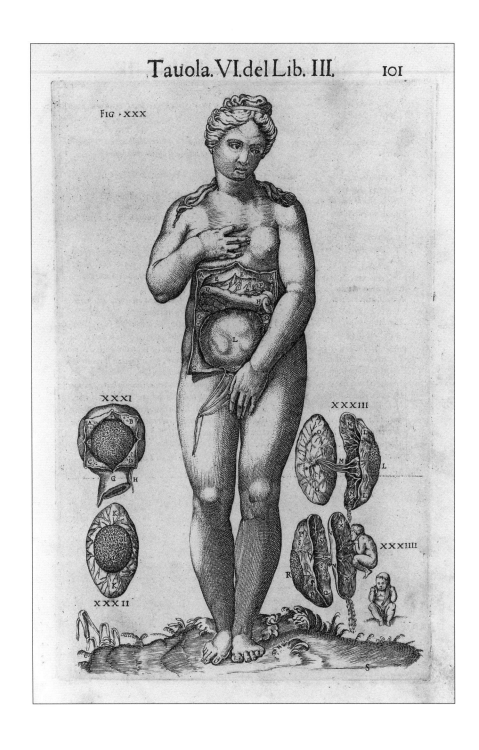

ALTHOUGH THE CANON OF WESTERN anatomical representations is traditionally male gendered, the exceptions are illustrations of the female genital organs and pregnancy.[1] Examples occur in early sixteenth-century printed books, including a series in Berengario's *Commentaria.*[2] While relying on a Vesalian representation of a fragmented female body in the *Fabrica* for anatomical information, the female pregnant nude here is shown full length.[3] The designer, Gaspar Becerra, invokes dual iconographic models for this innovative representation.[4] The first is the Venus pudica type, drawn from classical sculpture, in which the figure conceals one breast with one hand and, with the other, covers her genital region. The second derives from images of the naked Eve, usually depicted with Adam in scenes of the creation and fall of man. In Becerra's design, carried out by the engraver Nicolas Beatrizet, the sturdy proportions of the nude recall those of Eve in Michelangelo's fresco on the Sistine ceiling.[5] Becerra may have worked with the latter and was certainly familiar with his style.

With head slightly turned and legs placed close together, the figure stands at ease, her hands and arms taking the pose of the Venus pudica. The skin of the abdominal region is pulled back to reveal the pregnant uterus and stomach with transverse mesocolon. The four symmetrically placed smaller figures represent, in different stages, human placentae, culminating in the independent newborn male with the umbilical cord on his neck sitting discreetly on a rock.[6] The female nude adheres to the convention of representing the dead and dissected figure as alive and standing in a landscape. Her submissive and resigned expression associates her with feminine stereotypes of her maternal and sexual roles.

The text and illustrations of Valverde's *Anatomica* are notable in several respects. Valverde, a Spaniard who studied medicine at the University of Padua with Vesalius' successor Realdo Colombo, was the first to copy in 1556 large segments of the *Fabrica,* including two hundred of the illustrations.[7] Valverde acknowledged his indebtedness to Vesalius, but the latter bitterly resented these appropriations. Valverde, however, corrected some errors in the earlier work and added fifteen new illustrations, of which the female pregnant nude is an important example, while replacing Vesalius' animal placentae with human ones.[8] Valverde also showed visual sensitivity in engraving the Vesalian images which were originally created as woodblocks. The first large-scale use of copper engraving in anatomical illustration permitted a much finer delineation of detail than did woodcuts.[9] Several engravings showing flayed men holding up their skin or carrying on dissections are extremely arresting.[10]

Valverde's work, of which the Folger example is an Italian translation by Antonio Tabo de Albengo, enjoyed great success. Extremely well organized and clearly presented, a separate index, keyed to the illustrations, follows each book. Much shorter than the *Fabrica,* Valverde's book was written in vernacular languages, was smaller in size, and thus less expensive. Proof of its popularity lies in the numerous translations and printing in many editions by well-known publishers.[11]

CRS

1. For a discussion of the representation of the female form in anatomy books, see Londa Schiebinger, "Skeletons in the Closet: The First Illustrations of the Female Skeleton in Eighteenth-Century Anatomy," in *The Making of the Modern Body: Sexuality and Society in the Nineteenth Century,* eds. Catherine Gallagher and Thomas Laqueur (Berkeley and Los Angeles: University of California Press, 1987), 42-51; and Deanna Petherbridge and Ludmilla Jordanova, *The Quick and the Dead: Artists and Anatomy,* exh. cat. (London: South Bank Centre, 1997), 54.

2. See Cazort, *The Ingenious Machine of Nature,* 36-40, figs. 13 and 16. For the Vesalian figures of Adam and Eve in the *Epitome,* see ibid., cat. nos. 27-28, 133-134.

3. Roberts and Tomlinson, *The Fabric of the Body,* 218.

4. For the artists, see J. J. Martin Gonzalez, "Gaspar Becerra," *DOA* 3:470-471; and Marianne Grivel, "Nicolas Beatrizet," *DOA* 3:448.

5. Frederick Hartt, *History of Italian Renaissance Art* (Englewood Cliffs, N.J., and New York: Prentice-Hall and Harry N. Abrams, 1974), 448-449, figs. 527 and 530.

6. Roberts and Tomlinson, *The Fabric of the Body,* 218.

7. See Francisco Guerra, "Juan de Valverde," *DSB* 13:568-569; Guerra, "Juan de Valverde de Amusco," *Clio medica* 2 (1967):339-362.

8. Roberts and Tomlinson, *The Fabric of the Body,* 211-217.

9. Kemp, "'The Mark of Truth,'" 101.

10. Ibid., figs. 6.2-6.5.

11. Choulant, *History and Bibliography of Anatomic Illustration,* 205-206.

# Male Nude Showing Nerves and Tendons with Details of the Hand and Neck

*Male Nude Showing Nerves and Tendons with Details of the Hand and Neck,* 1788
Luca Ciamberlano (c. 1570-1580; active till 1641)
Engraving after Pietro Berrettini (Pietro da Cortona) (1596-1669)
Plate mark: 14¾ x 10" (37.6 x 25.5 cm)
Pietro Berrettini (1596-1669) and

Francesco Petraglia (fl. 1788)
*Tabulae anatomicae ex archetypis egregi pictoris Petri Berrettini Cortonensis*
Rome: Venantio Monaldini, 1788, pl. 3
History of Medicine Division,
National Library of Medicine,
National Institutes of Health,
Bethesda, Maryland

1. The drawings, bound together in a single album, are in the University of Glasgow Library, Special Collections, MS Hunter 653 (D1.1.29). See Cazort, *The Ingenious Machine of Nature,* cat. no. 67, 181-183; Roberts and Tomlinson, *The Fabric of the Body,* 272-279. For the engraver, whose initials appear on pls. 1 and 4 of the published editions, see Eckhard Leuschner, "Luca Ciamberlano," Saur 19:129-130.

2. The most complete discussion of this series is found in Lüdike Duhme, *Die Tabulae Anatomicae des Pietro Berrettini da Cortona* (Arbeiten der Forschungstelle des Instituts für Geschichte der Medizin der Universität zu Köln, 18) (Cologne: F. Hansen, 1980). For a discussion of Berrettini's sources, see Jörg Martin Merz, *Pietro da Cortona: Der Aufstieg zum führenden Maler im barocken Rom* (Tübingen: Wasmuth, 1991), 28-30. For the use of panels in the woodcuts of Charles Estienne and Estienne de la Rivière, *La dissection des parties du corps humain* (Paris: Simon de Colines, 1546), see Cazort, *The Ingenious Machine of Nature,* cat. nos. 30-32, 138-139.

3. Merz 1991, 26.

4. Jeremy M. Norman, *The Anatomical Plates of Pietro da Cortona* (New York: Dover Publications, 1986), introduction, [2].

5. Martin Kemp, "Dr. William Hunter on the Windsor Leonardos and His Volume of Drawings Attributed to Pietro da Cortona," *Burlington Magazine* 118 (1976):144-148. Professor Kemp acknowledges the help of Dr. Helen Brock in bringing these works to his attention and assisting him with their documentation. For a short biography of Berrettini, also known as Pietro da Cortona, see Jörg Martin Merz, "Pietro Berrettini," Saur 10:1-8.

6. Roberts and Tomlinson, *The Fabric of the Body,* 273-276.

7. For the corresponding plate in the first edition, see Norman 1986, pl. 3.

DETAILS OF THE HEAD AND HAND, two interrelated parts of the body that testify to the creator's own handiwork, are singled out in this illustration of the male nude. Following the strategies of anatomical illustration in the sixteenth century (Cat. 11-14), the baroque period saw a continuation of the convention of depicting the dissected body as alive, whole, and inhabiting a manmade or natural environment. The twenty drawings by Pietro Berrettini dating from about 1618, now in the University of Glasgow Library, which were engraved about the same time by Luca Ciamberlano, show an intensification of expression, a more marked classical influence, and an elaboration of design.[1] Although many of Berrettini's drawings of the nude derive from Italian sources, including Michelangelo's paintings and drawings, the Vesalian woodcuts, and contemporary studies for academic artistic training, by contrast the striking feature of the rectangular panels derives from French sixteenth-century designs.[2]

The heroic and gracefully posed *écorché,* whose ease of movement and relaxed pose belie the artfully displayed flaps of skin, stands facing left. At knee level, fragments of a classical colonnade appear. Directly below it darker crosshatchings cast a contrasting pattern of shadows. His outstretched right arm supports a blank panel. On the other side, the figure's upraised left arm holds a second panel. There a detail of the head and neck seen from the left is depicted on the top half, and on the bottom, a detached right hand. Further complexity of meaning arises from the *écorché's* display on the panel of these two body fragments. The elaborate engraving technique permits subtle tonal and linear contrasts in defining relationships of muscular and organic structures. Networks of thin white lines running through the body and the two fragments highlight paths of the nervous system related to the muscular structure.[3] This emphasis, continued throughout the original series of drawings, points to their didactic function in a possible neurological textbook for anatomists.[4]

The historical context of Berrettini's drawings and their delayed publication present many enigmas. Discovered as recently as 1976, the drawings were only then, based on documentary evidence, recognized as youthful works by the great baroque artist.[5] The fate of the drawings is unknown from their execution around 1618 until their gift in 1772 by Sir William Hamilton, the English diplomat and archaeologist, to the anatomist and collector William Hunter. The contemporary engravings by Ciamberlano from c. 1618-1629, which lacked a text, were not published until 1741. Added by the author Gaetano Petrioli in this first edition were anatomical details, borrowed from Vesalius and other anatomical texts, yet absent from the drawings and the original plates. The second edition of 1788, with another explanation and a historical introduction by Francesco Petraglia, removed from the plates the accessories in the first published version.[6] These alterations account in the present engraving for the blank panel on the left, where in Berrettini's corresponding drawing (Fig. 29), the hand was

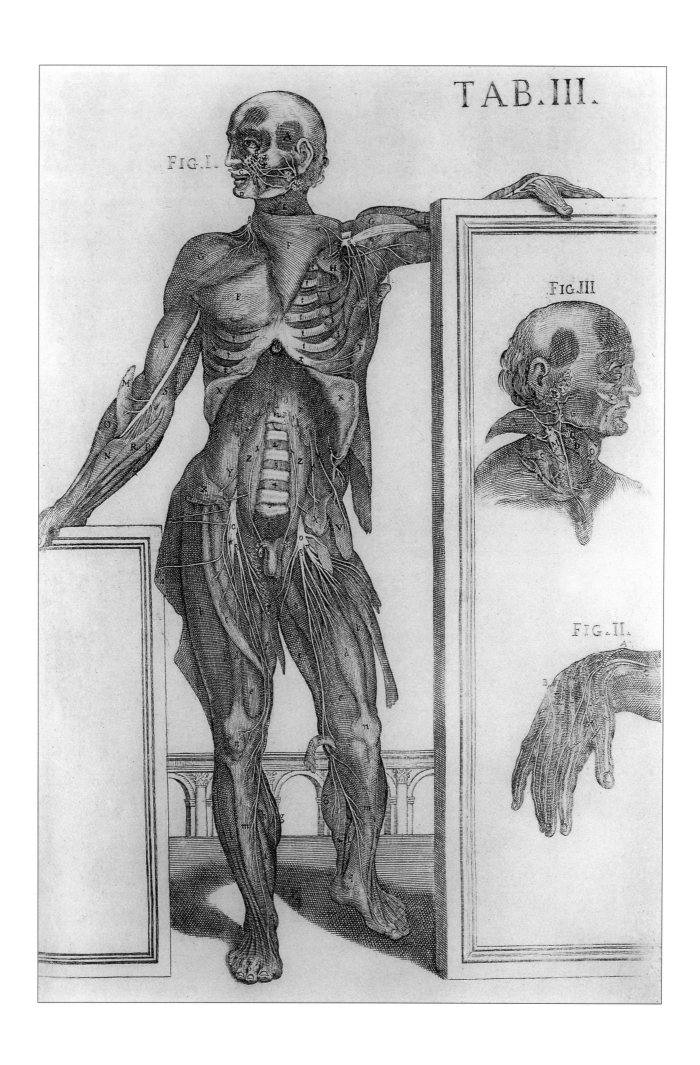

placed.[7] The long delay in publication was not unusual in anatomical atlases, which were very expensive to produce and required lengthy collaboration between artists and anatomists. In this case, the identity of the anatomist remains a matter of dispute. Recent research contends that the presumed source of Berrettini's commission was Giovanni Maria Castellani, head of the hospital of Santo Spirito in Rome, where the artist supposedly made the drawings under the supervision of an anatomist.[8] Castellani was planning an anatomical textbook, in which Berrettini's drawings would have figured.[9]

The arresting character of Berrettini's representation and its translation by Ciamberlano reveals not only the increasingly sophisticated nature of anatomical illustration but also its conservative tradition in still presenting the fragmented body as God's perfect handiwork.

CRS

Fig. 29. Pietro Berrettini (Pietro da Cortona), *Male Nude Showing Nerves and Tendons with Details of the Hand and Neck,* pen and ink drawing, with sepia wash and white heightening, 1618. From a bound volume of anatomical drawings, Glasgow University Library, MS Hunter 653 (D1.1.29), pl. 3. Glasgow University Library, Department of Special Collections

8. Kemp 1976, 147. In earlier documents the anatomist was identified as Nicolò Lache (Nicolas Larché). See Merz 1991, 25.

9. For discussion of the identity of the anatomist and documentation in favor of Castellani, see Merz 1991, 32.

# The Front View of the Outermost Layer of Muscles

*The Front View of the Outermost Layer of Muscles*, 1747
Jan Wandelaar (1690-1759)
Engraving and etching
Plate mark: 22⅛ x 16⁵⁄₁₆" (56.2 x 41.4 cm)
Sheet: 22¾ x 16⁵⁄₁₆" (57.8 x 41.4 cm)
Bernhard Siegfried Albinus (1697-1770)
*Tabulae sceleti et musculorum corporis humani*
Signed: Jan Wandelaar

Leiden: Johannes and Hermannus Verbeek, 1747
Inscribed:
*Bern. Siegf. Albini Tabulae Anatomicae Musculorum Hominis* (Bernhard Siegfried Albinus *Anatomical Plates of Man's Muscles*)
Philadelphia Museum of Art, Gift of Dr. Richard H. Chamberlain, 1973-83-1

THIS REPRESENTATION OF A "MUSCLEMAN" CULMINATES the series inaugurated by Berengario and Vesalius (Cat. 11 and 12). The entire work by the noted Dutch anatomist Bernhard Siegfried Albinus and his artist, Jan Wandelaar, opens a new era in the history of anatomical illustration from the standpoints of detailed scientific accuracy and visual depiction. Albinus, a member of a prominent medical dynasty, continued the reputation of the University of Leiden, established in the seventeenth century, as a center of scientific and medical research. Trained as surgeon and anatomist at Leiden and Paris, Albinus carried on a distinguished career as teacher, scholar, author, and editor of previous texts by his great predecessors. A man of wide philosophical and literary interests and notable tenacity, Albinus had ambitious professional goals.[1]

The present volume constitutes the first of four parts of a challenging undertaking to publish a complete anatomical atlas of the human body. The product of many years of detailed anatomical research and experimentation in solving problems of accurate visual representation, the elephant folio volume required of Albinus great expenditure of time and money. The book had enormous and long-lasting influence, serving as a model for both anatomists and artists.[2]

Albinus' search for perfection in anatomical description involves an unusually well-documented account of the collaboration between anatomist and artist.[3] In his prefatory account of the work, Albinus explains that he employed Wandelaar because of his skill in drawing and engraving, and his knowledge of anatomical illustration. For at least twelve of the more than twenty years necessary for the completion of this book, Wandelaar lived in Albinus' house, where the author undertook the artist's instruction and correction in every aspect of the work. While the anatomist testified to Wandelaar's skill, he referred to him as his "tool" and did not identify him by name. After the artist's death, Albinus grieved for him, suffering lasting depression at his loss.[4]

Together both men resolved problems underlying previous anatomical representation. To achieve consistency in the proportional relationships of individual body parts to the whole and avoid distortions of perspective and foreshortening, they set up two net grids for viewing the cadaver from two distance points. Using paper squared off in matching dimensions, Wandelaar transferred the figure's outlines to his drawings.[5] Another innovation was using outline drawings of the engraved and etched form provided with a system of letters, numbers, and other graphic symbols, keyed to explanations in the neighboring text. The accompanying plate remained free of marks that would mar the overall aesthetic effect.[6]

Albinus solved another anatomical dilemma by selecting the ideal forms of the body's structure, ranging from the whole cadaver to specimens of individual

1. Roberts and Tomlinson, *The Fabric of the Body,* 320-322; Peter W. van der Pas, "Bernard Siegfried Albinus," *DSB* 1:4-5.

2. For the influence of the work, see Cazort, *The Ingenious Machine of Nature,* cat. nos. 78-88, 194-200; Roberts and Tomlinson, *The Fabric of the Body,* 327-328.

3. For an account of this relationship, see Hendrik Punt, *Bernard Siegfried Albinus (1697-1770) on "Human Nature": Anatomical and Physiological Ideas in Eighteenth-Century Leiden* (Amsterdam: B. M. Israël, 1983), 15-16; Cazort, *The Ingenious Machine of Nature,* 195-198. For citations by Albinus, see Choulant, *History and Bibliography of Anatomic Illustration,* 279-280.

4. Roberts and Tomlinson, *The Fabric of the Body,* 327.

5. For a detailed description of this procedure, see Punt 1983, 20-33.

6. Roberts and Tomlinson, *The Fabric of the Body,* 327.

7. Albinus wished to avoid representing the individual, possibly idiosyncratic, characteristics of a single body as typical of universal traits.

8. Punt 1983, 17-18; Cazort, *The Ingenious Machine of Nature,* 198-199.

9. The unchanging expressions of skeletons and musclemen represent a departure from the tradition inaugurated in the Vesalian series, where the figures grow increasingly distraught as the dissection progresses. Instead, in the Wandelaar plates, the surrounding landscape grows starker. See Cazort, *The Ingenious Machine of Nature,* 199.

10. Roberts and Tomlinson, *The Fabric of the Body,* 326-327; Punt 1983, 53-54.

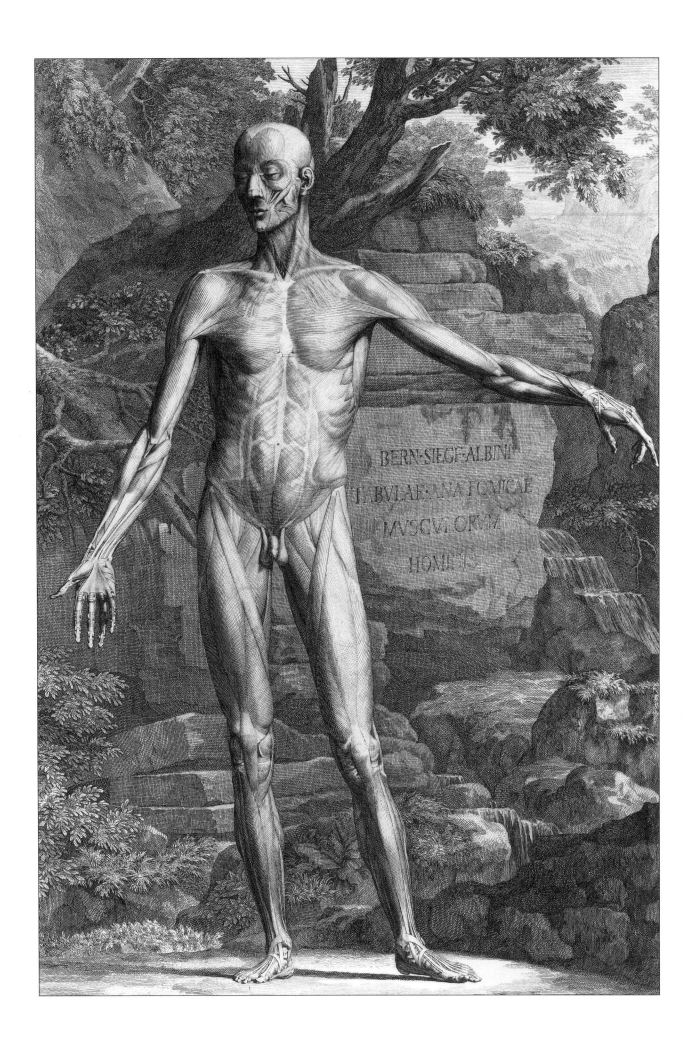

BERN·SIEGF·ALBINI
TABVLAE·ANATOMICAE
MVSCVLORVM
HOMINIS

parts gathered over time.[7] Reflecting Enlightenment ideas of rationality and classicism, Albinus sought perfection of form embodied in objectivity, proportionality, and symmetry. The underlying aesthetic expressed in the figures' gestures and movements stresses the grace and vitality of the body and nature.[8] To this end the author chose the body of an ideally formed young man, supplemented by a live model who took the same pose. In Wandelaar's drawings and plates, for the sequential front, back, and side views of the skeletons and muscles, the same careful poses are repeated and the figures remain serene.[9] While Albinus sought objectivity and disliked pictorialism in anatomical representation, he allowed Wandelaar freedom to delineate the landscape backgrounds, because the artist's subtle use of light and shade brought out the figures' three-dimensional qualities and expressed notions of the vitality of nature.[10]

The first of the musclemen stands easily, weight on the right foot, with arms extended to reveal both exterior and interior surfaces. Wandelaar's expert use of line and subtle modeling reveals the distinction between larger and smaller muscles without disturbing the unity of the whole. Consistent with conventions of anatomical representation, the heroic, nobly proportioned muscleman exhibits perfect poise, although deprived of his skin. The figure is integrated with the varied landscape of flowers, rocks, trees, and water. These features are beautifully modeled by subtle variations of light and shade conveyed by varied systems of graphic delineation. The muscleman's left arm touches the fragment of rock inscribed with Albinus' name and the title of the muscle series. Introducing the notion of the manmade artifact into the harmonious relationship between figure and landscape, the inscription pays homage not only to the creative role of Albinus as writer, but also as equal collaborator with the artist whose identity he shares.

Albinus' search for *homo perfectus* (the perfect man) in anatomical and visual form reflects contemporary philosophical and scientific ideals. Yet his concepts remain within the traditional framework of anatomical illustration in which the human body is viewed as the perfected handiwork of a higher authority, identified elsewhere by Albinus as "Nature, the arch workman."[11]

CRS

11. Choulant, *History and Bibliography of Anatomic Illustration,* 277, citing Albinus' publication *Academicarum annotationum libri I-VIII* (Leiden: Johannes and Hermannus Verbeek, 1754-1768).

**Studies of the Skeleton, Bones, and Muscles of the Right Hand**

*Studies of the Skeleton, Bones, and Muscles of the Right Hand*, c. 1510-1511
Leonardo da Vinci (1452-1519)
Drawings: Brown pen and ink with wash, over traces of black chalk
Sheet: 11⅜ x 7⁵⁄₁₆" (28.8 x 20.2 cm)
(here reproduced)

Originals: Windsor Castle, Royal Library, MS A, fols. 19009r.-19009v. Photographs copyright Her Majesty Queen Elizabeth II

1. For a recent summary of Leonardo's biography, career, and a select bibliography, see Martin Kemp, "Leonardo da Vinci," *DOA* 19:180-199. For a full-length treatment of relevant issues, see Kemp, *Leonardo da Vinci: The Marvellous Works of Nature and Man* (Cambridge, Mass.: Harvard University Press, 1981).

2. Charles D. O'Malley and J. B. de C. M. Saunders, *Leonardo da Vinci on the Human Body* (New York: Henry Schumann, 1952), no. 10, 58.

3. Kenneth D. Keele, *Leonardo da Vinci and the Art of Science* (Hove, Sussex: Wayland, 1977), 63 and 65. For Leonardo's dissections, see Katharine Park, "The Criminal and the Saintly Body: Autopsy and Dissection in Renaissance Italy," *Renaissance Quarterly* 47/1 (1994):16.

4. For a discussion of artistic training, see Bernard Schultz, *Art and Anatomy in Renaissance Italy* (Ann Arbor, Mich.: UMI Research Press, 1985).

5. For a short account of the complex history of Leonardo's notebooks, see Roberts and Tomlinson, *The Fabric of the Body*, 98-104. For Leonardo's anatomical methods, see ibid., 104-111; and Kenneth D. Keele, *Leonardo da Vinci: Anatomical Drawings from the Royal Library, Windsor Castle*, exh. cat. (New York, Metropolitan Museum of Art, 1983), 10-14.

6. Kemp, "'The Mark of Truth,'" 90-94.

7. Ibid., 90; Roberts and Tomlinson, *The Fabric of the Body*, 107-111.

8. For the possible connection between Leonardo's drawing of the bones of the hand and a woodcut in Berengario da Carpi's *Commentaria* of 1521 (Cat. 12 and 18), see Roberts and Tomlinson, *The Fabric of the Body*, 77, and fig. 3.8.

THESE DRAWINGS BY LEONARDO DA VINCI recall previous discussion of the hand as emblem of creativity, intelligence, and manual skill (Cat. 5-9).[1] Combining his search for scientific knowledge and his unparalleled skill as a draftsman, Leonardo's drawings are milestones in the history of anatomical representation. For example, on the verso of this folio, Leonardo for the first time correctly depicts the bones of the hand from interior and exterior views.[2] Leonardo's drawings, founded on experience of human and animal dissections, form part of an ambitious but unfulfilled program of a complete study of the structure of the human body from conception until death.[3] Uniting in a seamless web scientific exploration and artistic expression, Leonardo's faith in visual description of anatomy and biology over verbal explanation conflicted with the methods of contemporary academic medicine. As a young man his training in the Florentine workshop of Verrocchio in the late 1470s contributed to his study of anatomy as essential to the three-dimensional representation of the body on a planar surface. The development of linear perspective, along with mathematical modes of achieving proportional relationships among body parts, formed a basic method of artistic training in fifteenth-century Florence.[4] Leonardo's astonishingly fluid drawing technique became a means of translating his increasingly complex studies of the structures and mechanics of natural phenomena into visual form.

This folio belongs to one of many manuscript notebooks that reveal Leonardo's lifelong fascination with visual recording of the laws and mechanics of the macrocosm and their reflection in the microcosm, man's body.[5] In order to describe accurately and in detail the ordered structure of the body, Leonardo introduced many modes of anatomical representation, including sequential front, back, and side views, cross-sections, and a range of diagrammatic techniques.[6] Indeed, Leonardo's search for completeness of description made his program for a complete anatomical textbook intellectually, as well as economically, impossible to realize in printed form.[7] Although isolated drawings may have circulated among artists, Leonardo's largely unpublished work prevented diffusion of his astounding achievement both as an artist and anatomist of unparalleled distinction.[8]

Executed during the second phase of Leonardo's anatomical studies while he lived in Milan from 1508 until 1513, these drawings show his focus on the mechanics and movement of the hand. This preoccupation was part of a larger inquiry into the mechanisms underlying the movements of the limbs, face, and internal organs.[9] Both sides of the folios, where extended verbal notes in Leonardo's mirror handwriting accompany the dissections on the recto and the bones on the verso, speak of a sequence of demonstrations of the bones and muscles of the hand. Various stages of the dissections show the muscular structure "rising up the page in a series finishing in the upper right corner."[10] The details of single movements of the fingers underlie Leonardo's interest in the mechanism of their movements.[11] On the verso, studies of the fingers on the upper right

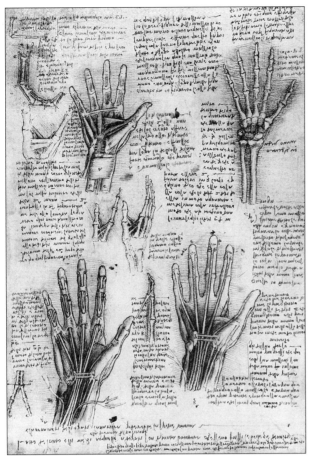

A

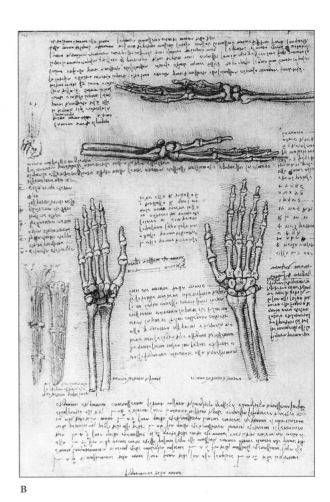

B

show the joints, "tendons, arteries, and nerves."[12] The two vertical figures of the bones of the hands and wrist are followed by two side views of the wrist and hands. The clenched fist further shows the effect of movement on muscles and tendons. Leonardo's use of line for contours, modeling in light and shade, as well as of contrasting tonal highlights, differentiates individual parts and details, but at the same time it unifies the total structure and brings out its three-dimensional character.

Martin Kemp believes that around 1510 Leonardo focused on the teachings of the great anatomist Galen, who, in his influential writings, characterized the hand as the supreme instrument in the divinely created human body. Perhaps as a result of discussions with the anatomist Marcantonio della Torre, who taught at the nearby University of Pavia, Leonardo in these drawings realized the "miracle of form and function in the human hand."[13]

CRS

9. On the upper central figure of the recto, Leonardo writes: "Make the book on the elements and practice of mechanics precede the demonstration of the movement and force of man and other animals, by means of which you will be able to prove all your propositions." Kenneth D. Keele and Carlo Pedretti, *Leonardo da Vinci: Corpus of the Anatomical Studies in the Collection of Her Majesty the Queen at Windsor Castle* (London and New York: Johnson Reprints/ Harcourt Brace Jovanovich, 1979-1980) 2:no. 143r., 530.

10. Ibid., 2:534.

11. Ibid.

12. Ibid., 2:538.

13. See Martin Kemp's essay "The Handyworke of the Incomprehensible Creator" in this volume, 27; and Kemp, "Dissection and Divinity in Leonardo's Late Anatomies" *JWCI* 35 (1972):213-216.

18   Bones of the Interior
of the Right Hand
and Left Foot

*Bones of the Interior of the Right Hand and Left Foot*, 1521
Attributed to Amico Aspertini
(c.1474-1552)
Woodcut
Images: 6⅛ x 3¹¹⁄₁₆" (15.6 x 9.5 cm)
Jacopo Berengario da Carpi (c.1460-1530)
*Carpi commentaria cum amplissimis additionibus super anatomia Mundini*
Bologna: Girolamo Benedetti, 1521, fol. 522
Inscriptions surrounding the hand:
*Above:* Primu̱m os indicis; Primu̱m os policis; Unu̱m ex octo ossibu̱s rasette; Focile maius. *Below:* ultimu̱m os medii; ultimum os a̱nnuularis; u̱ltimu̱m os auricularis; 2 (*secundu*) m os auricularis; Unu̱m ex quattuor ossibu̱s pectinis; Focile minus. (*Above:* First bone of the index finger; first bone of the thumb; one of the eight bones of the wrist; the larger bone of the forearm. *Below:* The last bone of the middle finger; the last bone of the ring finger; the second bone of the little finger; one of four bones of the metacarpus; the smaller bone of the forearm)
History of Medicine Division, National Library of Medicine, National Institutes of Health, Bethesda, Maryland

OPPOSITE THE FOLIO DEPICTING A SKELETON seen from the back, the woodcuts of the bones of the interior of the right hand *(above)* and the left foot *(below)* are the last of the illustrations in Berengario da Carpi's important *Commentaria*. (For a previous discussion of this work, see Cat. 12.) These images of the bones of the hand and foot are the only body parts singled out for representation following the impressive group of musclemen and skeletons. The woodcuts are among the earliest published illustrations of the bones of the hand and feet that are considered generally accurate.[1] Perhaps Berengario considered that correct rendition of the hand and foot would have particular value for artists, one group of readers addressed by the author.[2]

Leonardo's drawings (Cat. 17) may have served as the models for Berengario's woodcuts, although how the former's notebooks circulated is unclear. Although the rather crude woodcuts lack the subtlety of Leonardo's modeling and draftsmanship, they nevertheless emulate in the background the use of light and shade to achieve a three-dimensional effect. Also similar are the proportional relationships among the bones of the hand and foot.[3] While Berengario discusses these structures in the text (fols. 507-512v.), verbal explanations of the bones linked by connecting lines occur next to the woodcuts in order to identify them. A certain awkwardness in printing the identifying inscriptions on the lower left upside down from those on the right indicates haste, or a lack of experience in coordinating the visual and verbal components, or both. The two summary explanations in the right margin, however, follow the folio's vertical orientation.[4] The possibility exists that Amico Aspertini did not execute these representations or that of the skeleton on the opposite folio.[5]

CRS

1. Roberts and Tomlinson, *The Fabric of the Body*, 82, and pl. 17.

2. Berengario, *Commentaria*, fol. 520v.

3. Roberts and Tomlinson, *The Fabric of the Body*, 77.

4. Each paragraph notes that both woodcuts identify the names and sites of the bones of the hand and foot and the numbers of the bones of each part.

5. Vittorio Putti, *Berengario da Carpi: Saggio biografico e bibliografico seguito della traduzione del "De fractura calve sive cranei"* (Bologna: L. Cappelli, 1937), 194-195.

19    Two Views of the Bones
of the Hand and Four
Details of the Bones of
the Wrist

*Two Views of the Bones of the Hand and
Four Details of the Bones of the Wrist*,
1555
Anonymous, Venetian School;
attributed to Jan Stephen van Calcar
(c. 1499-1550)
Woodcut
Image: 12¼ x 6⅞" (31 x 17.2 cm)

Andreas Vesalius (1514-1564)
*De humani corporis fabrica libri septem*
2d ed., Basel: Johann Oporinus, 1555,
book 1, chapter 25, p. 141
Inscribed with figure numbers
The Folger Shakespeare Library,
Washington, D.C.

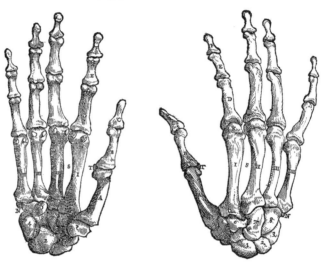

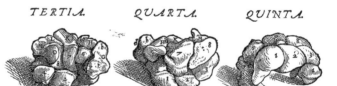

IN TECHNIQUE, COMPOSITION, AND RELATIONSHIP TO THE TEXT, these woodcuts of the second edition of the *Fabrica* show a tremendous advance in representation over those in Berengario's *Commentaria* (Cat. 18). The Vesalian images are more complete, since they present both the interior (palmar or posterior) and exterior (anterior) views of the right hand. Also included are four details depicting the eight bones of the wrist, seen from the same aspects, as well as from their upper and lower ends.[1] The three-dimensional characters of both Figures 1 and 2, as well as of the details of Figures 3-6, result from subtle modeling. On the surface of the first two figures, darker and lighter areas obtain effects of relief, revealing areas of greater and lesser complexity of structure. The casting of shadows below and at the sides of the bones of the wrist contribute to their solidity and sequential differentiation. Instead of sharing a depiction of the bones of the foot, as in the Berengario page, the Vesalian image devotes a whole very large sheet to the bones of the hand. The layout is also more elegant, as the figures are shown vertically and frontally instead of horizontally. The symmetrical and hierarchical arrangement of the composition also contributes to the graceful overall page design. Unlike the obtrusive identifying inscriptions on the Berengario woodcut, a refined system of letters and numbers, explained in an index on the following page, ties text and image together in a clear system. On the following page roman and arabic numerals and upper- and lowercase letters identify bones of the hands and wrists in the order of the figures. This arrangement describes all these parts and their relationships to discussions in other chapters. In sum, the writing on these hands permits reading of them as cognitive maps leading to acquisition and retention of anatomical knowledge.

These representations in the second edition show an improvement of design over those in the first one, where the intrusion of text above and below the figures detracts from the visual focus. Greatly contributing to the greater elegance of the 1555 page is the explanatory paragraph written in smaller, lowercase letters that gives a general description of the figures. Indeed, in this second edition published after the first was out of print, Oporinus created a masterpiece in opting for a larger folio size, choice of paper, and adaptation of the newly developed Garamond type. The author also took the opportunity to make corrections in the text, primarily in the preface, where Vesalius eliminated potentially objectionable references to friends and to his practice of obtaining in irregular manner bones and skeletons for dissections.[2]

These woodcuts belong to book 1 of the *Fabrica*, devoted to the exposition of the skeletal structure of the body. Like the supporting structure of a building, the bones perform the analogous function in the architecture of the body. Because the discussion begins with the head and ends with the feet, the bones of the arms and hand fall midway in the book. Although the author portrait of Vesalius in the *Fabrica* (Cat. 5) seems to accord with Galen's praise of the hand as "the instrument of instruments," that image singles out the muscles, not the bones. As Nancy Siraisi points out, Vesalius abandons Galen's order of discussion of anatomical structure, which begins with the hand.[3] Still, Vesalius devotes many chapters of book 2 on the muscles to those of the hand. In his very scholarly review of classical medical sources, revived by knowledge of humanistic editions of these texts, Vesalius points out Galen's errors and corrects them on the basis of his own experience. Yet he continues to view the body as Nature's supreme design.

CRS

1. Saunders and O'Malley, *The Illustrations from the Works of Andreas Vesalius*, pl. 16, 74; Andreas Vesalius, *On the Fabric of the Human Body*, book 1: *The Bones and Cartilages*, trans. William Frank Richardson and John Burd Carman (San Francisco: Norman Publishing, 1998), 172.

2. For discussions of the second edition, see Saunders and O'Malley, *The Illustrations from the Works of Andreas Vesalius*, 36. See also Gerrit A. Lindeboom, *Andreas Vesalius and His Opus Magnum: A Biographical Sketch and an Introduction to the Fabrica* (Nieuwendijk: De Forel, 1975), 9-10.

3. Nancy G. Siraisi, "Vesalius and the Reading of Galen's Teleology," *Renaissance Quarterly* 50/1 (1997):4-10.

# An Artificial Hand Made of Iron

*An Artificial Hand Made of Iron*, 1634
Anonymous, French
Woodcut
Image: 9⅛ x 5³⁄₁₆" (23.3 x 13.2 cm)
Ambroise Paré (1510-1590)
*The Workes of That Famous Chirurgion Ambrose Parey*
London: Th. Cotes and R. Young, 1634, book 23, p. 881

Inscribed:
*The forme of an hand made artificially of iron; This figure following sheweth the back-side of an hand artificially made, and so that it may be tyed to the arm or sleeve.*
The Folger Shakespeare Library, Washington, D.C.

1. Wallace B. Hamby, "Ambroise Paré," *DSB* 10:316. For a complete biography, see Hamby, *Ambroise Paré: Surgeon of the Renaissance* (St. Louis: Warren H. Green, 1967). Also useful is the short account by Ira M. Rutkow, *Surgery: An Illustrated History* (St. Louis: Mosby, 1993), 168-171.

2. For a print by Jean Perrisin depicting the attendance of Paré and Vesalius at Henry II's deathbed, see Rutkow 1993, fig. 109, 171.

3. Stephen Paget, *Ambroise Paré and His Times, 1510-1590* (New York and London: G. P. Putnam's Sons, 1897), 27.

4. For the context of the opposition to Paré and his strategy for combating it, see Laurence Brockliss and Colin Jones, *The Medical World of Early Modern France* (Oxford: Clarendon Press, 1997), 104-106.

5. Paré had earlier written a short version for surgeons of Vesalius' *Fabrica*. The latter's influence is evident in Paré's *Anatomie universelle du corps humain* of 1561. See Rutkow 1993, 169. For a description of the 1575 edition of the collected works, see Janet Doe, *A Bibliography, 1545-1940, of the Works of Ambroise Paré, 1510-1590,* reprint ed. (Amsterdam: Gérard Th. Van Heusden, 1976), 101-108.

6. Doe 1976, 166-181.

7. Vittorio Putti, *Historic Artificial Limbs* (New York: Paul Hoeber, 1930), 11.

8. Paré 1634, 880.

9. Ibid.

10. See his essay in this volume, 22-23.

LIKE HANS VON GERSDORFF (Cat. 11), Ambroise Paré was a military surgeon whose works, derived from his experience on the battlefield, were written in the vernacular. Trained as a barber-surgeon with no humanistic education, Paré had to fight the opposition of the conservative medical faculty of the University of Paris. He had, however, a knowledge of anatomy by dissection achieved during his stint as a house surgeon at the Hôtel-Dieu. Beginning in 1536 he entered army service and throughout the rest of his life served as a military surgeon, traveling widely on many campaigns. Paré's great success in changing established methods of dealing with wounds is a landmark in the history of surgery. For example, he revolutionized the treatment of gunshot wounds, rejecting the use of hot oil in favor of a compound featuring turpentine and other natural materials. Paré also "advocated the ligature of blood vessels to control hemorrhage during amputation." His first publication in 1542 on the treatment of battle wounds made his reputation. Paré became surgeon to three French kings and had "a flourishing practice at court and in Paris."[1] In 1559 he was called to the bedside of the mortally wounded King Henry II, where he met Vesalius (Cat. 5, 13, and 19), who had been summoned to serve as special consultant shortly before the monarch's death.[2]

Throughout his career, Paré, a man of wide intellectual interests and humanitarian concerns, wrote constantly as a means of deflecting professional opposition from the University of Paris medical faculty. In his *Apologie* of 1580, rebutting an attack on his surgical methods as counter to historical authority, Paré emphasizes the importance of experience and practice over academic theory, stating that "the operations of Surgery are learned by the eye, and by the hand."[3] This work, which also included an account of his travels, is an interesting autobiographical memoir, testifying to Paré's individual achievement and triumph over his original status as a barber-surgeon.

Written in French, the first edition of Paré's collected works dating from 1575 was published in Paris. Paré's use of the vernacular instead of Latin drew tremendous criticism from the Paris medical faculty, which tried to stop its publication.[4] A huge folio volume richly illustrated with 295 woodcuts, the book encompassed a history of anatomy (with lavish borrowings from Vesalius' text and illustrations), as well as a study of marvels and prodigies.[5] The book was immensely popular, and Paré himself oversaw four revised editions. In addition, the volume was translated into other vernacular languages, and most unusually, into Latin. The present edition, translated into elegant English by Thomas Johnson, was made from the Latin version of 1582.[6]

The present woodcuts occur in chapter 12 of book 23 entitled *Of the Meanes and Manner To Repair or Supply The Naturall or Accidentall Defects or Wants in Man's Body.* The representations of the palm side of an artificial hand above, and the opposite view showing a method of attachment to the arm or

*The forme of an hand made artificially of iron.*

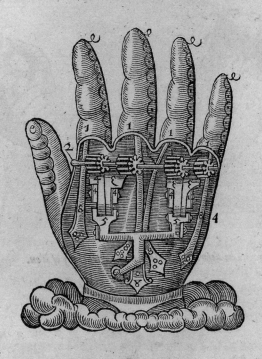

*This figure following sheweth the back-side of an hand artificially made, and so that it may be tyed to the arme or sleeve.*

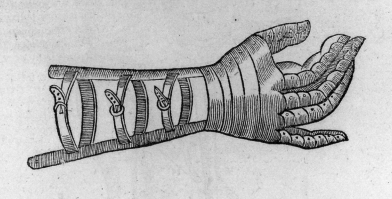

Eeee 3                                              *The*

sleeve, derive from the woodcuts of the original edition. In the process, the images have been reversed, so that the depictions show the left hand instead of the right. In one case, because of the reversal, the number nine placed at the sides of the fingers to identify thin metal reinforcements, functions only as unreadable decoration. Furthermore, the identifications of the parts of the hand, featured at the right of the original edition are lacking. Nevertheless, the images continue to show an ingenious system of mechanical inventions to replicate the complex operations of the hand. Vittorio Putti describes its mechanisms: "The hand, which on the dorsum has the form of a steel gauntlet, is attached to the forearm by two metal rods and leather straps. The thumb is rigid and the fingers are kept extended by four springs fixed in the palm. When they are flexed, they are kept so by [ratchets] worked by metal levers."[7]

In the paragraph preceding the woodcuts, Paré describes the process by which he had the artificial hand made at his "great cost and charges" by

> a most ingenious and excellent Smith dwelling at Paris, who is called of those that know him, and also of strangers, by no other name than the little Loraine, and here I have caused them to bee portrayed or set downe, that those that stand in neede of such things, after the example of them, may cause some Smith, or such like workman to serve them in the like case.[8]

Unfortunately, Paré does not reveal the name of the draftsman who translated the model into two dimensions. Even in the less accurate images in the 1634 edition, the intricate mechanical devices of the originals survive in the carefully interwoven and overlapping networks drawn to scale and depicted in perspective. Whether Paré's model ever saw production is unclear. Nonetheless the artificial hand retains its appeal as a humanitarian, rational, and aesthetic device. As Paré himself stated: "They [the artificial limbs] are not only profitable for the necessity of the body, but also for the decency and comeliness thereof."[9] Martin Kemp points out that the form of the artificial limb attempts to re-create the divinely created design of the hand as the "instrument of instruments."[10]

CRS

## 21 Three Palmar Views of the Nerves of the Left Hand and Wrist

*Three Palmar Views of the Nerves of the Left Hand and Wrist,* 1609
Anonymous
Engraving
Plate mark: 13 x 8⅝" (33 x 22 cm)
Giulio Casserio (Julius Casserius)
(1561?-1616)
*Pentaestheseion hoc est de quinque sensibus liber*

Venice: Nicolò Missserini, 1609, pl. 2, p. 24 (photographic reproduction)
Inscribed with figure numbers
History of Medicine Division, National Library of Medicine, National Institutes of Health, Bethesda, Maryland

1. For the discussion of the five senses, see Part III of the exhibition (Cat. 26-33).

2. See John L. Thornton and Carole Reeves, *Medical Book Illustration: A Short History* (Cambridge and New York: Oleander Press, 1983), 66.

3. Choulant, referring to Josias Murer (see Cat. 6), states that the plates are "all from the hands of the artists who drew and engraved the plates of the preceding work" (*History and Bibliography of Anatomic Illustration,* 224). It is possible that the *Pentaestheseion* plates, although separately published, might have been included in the more extensive *Tabulae anatomicae.*

4. Giuseppe Sterzi, *Giulio Casseri: Anatomico e chirurgo, c. 1552-1616* (Venice: Istituto veneto di arti grafiche, 1909), 96.

5. Lüdige Duhme, *Die Tabulae Anatomicae des Pietro Berrettini da Cortona* (Arbeiten der Forschungsstelle des Instituts für Geschichte der Medizin der Universität zu Köln, 18) (Cologne: Institut für Geschichte der Medizin der Universität zu Köln, 1980), 48.

6. Taste follows, with six figures, followed by smell with seven, hearing with twelve, and vision, also with six.

7. The hierarchy of the senses is discussed in Cat. 30-31.

8. Choulant, *History and Bibliography of Anatomic Illustration,* 223.

IN THE SECOND OF HIS THREE ANATOMICAL WORKS, Giulio Casserio investigates the anatomical structures and functions of the five senses.[1] This folio volume, dedicated to Count Maximilian of Bavaria, includes thirty-seven plates. Twelve of them, relating to the ear, had been published in his first book *De vocis auditusque organis historia anatomicae,* dated 1601 (Cat. 6). The remaining twenty-one were commissioned for this volume.[2] Although the plates have not received much art-historical attention, their size and modeling techniques are very close to those designed by Odoardo Fialetti and engraved by Francesco Valesio for Casserio's last and posthumously published work, the *Tabulae anatomicae* (Cat. 22).[3]

While more modest in size and scope than his other books, the *Pentaestheseion* is clearly organized and extremely thorough in its system of both verbal and visual demonstration. After a scholarly review of the five senses as elements of perception as a whole, including classical authorities on the subject, Casserio proceeds to analyze each of them. Although the subject had a formidable literature, Casserio's treatment was novel in his attempt to explain in detail the underlying neural and physiological structures of perception.[4] Indeed, examination of neurological functions is characteristic of medical investigations of the seventeenth century, as noted in the engravings made after Pietro Berrettini's drawings (Cat. 15).[5]

Casserio's discussion begins with touch, the most fundamental of the senses. The mechanisms of touch, however, are demonstrated in only two plates, whereas the other four senses receive a minimum of six illustrations each.[6] In his introduction, Casserio follows the familiar teleological proposition that the body reflects design by a divine craftsman. Following Aristotle, Casserio acknowledges that touch is the most basic sense in nature, necessary for life. Perhaps for this reason, he discusses it first.[7] The argument from design follows (p. 25) in Casserio's analysis of the hand, particularly the palm, as exquisitely equipped with the skin, nerves, and muscles to receive the impulses necessary for perception of sensory data from the external world and transmit them to the whole body.

While praise of the hand thus follows traditional philosophical and medical lines of reasoning, the three figures of the second plate demonstrate Casserio's observations based on dissection. On the pages following the plate, his clear explanation of the hand's neural and myological structure is apparent in the general introductory paragraph, followed by one for each of the three figures. In them, visual forms and their inscribed letters, following alphabetical order, receive concise and consistent description.

Verbal description depends upon a similarly precise visual translation of the successive views of the hand's neural and myological structures. Here Casserio, who is known to have worked closely with his collaborating artists,

# FIGVRA PRIMA

# FIGVRA SECVNDA

# FIGVRA TERTIA

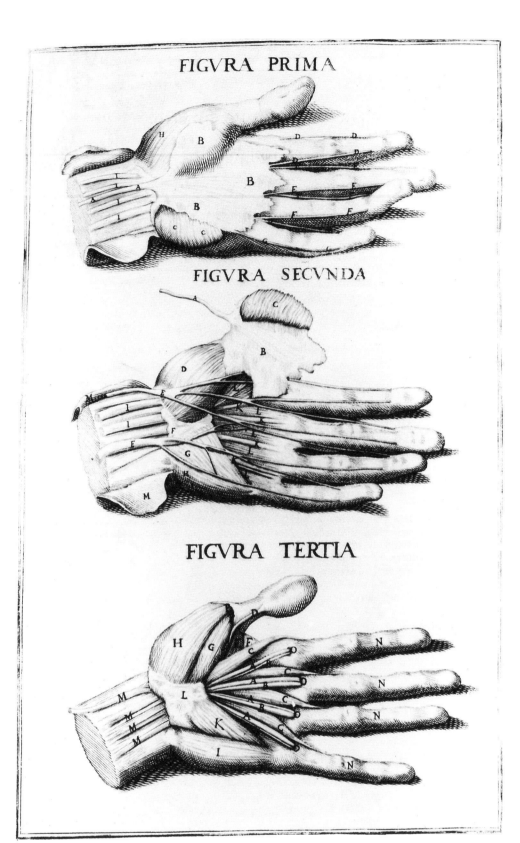

could well have played an authoritative role in laying out the requirements for the modes of visual representation.[8] In the engraving, each of the three hands, in palmar views, is seen from the side, as though it rests on a surface. A remarkable range of modeling techniques distinguishes skin, nerves, and muscles. Linear variations, from the thin diagonals marking the cross-sections of the wrists to the heavy diamond-like patterns casting shadows below the hand and between the fingers, describe and differentiate individual structures, as well as marking their relationship with others. In the second figure, as the skin of the upper part of the thumb is cut back, the face of the wide tendon is revealed in a delicate, leaf shape. A contrasting effect occurs in a forceful, radiating pattern created in the third figure by the dark lines of the tendons and muscles of the four fingers radiating in a spreading, symmetrical, and repeated pattern.

Combining aesthetic and scientific consistency, the image of the hand serves again as a cognitive map. By exploring concealed, inner structures, the anatomist confirms the explanations of the workings of the hand designed by the creator as the "instrument of instruments."

CRS

Successive Palmar
Views of the Muscles
and Tendons of the
Left Hand

*Successive Palmar Views of the Muscles
and Tendons of the Left Hand*, 1645
Francesco Valesio, engraver (1560-1648)
after Odoardo Fialetti, (1537-1638)
Engraving
Plate mark: 13³⁄₁₆ x 8⅛" (33.5 x 21 cm)
Giulio Casserio (Julius Casserius)
(1561?-1616)
*Tabulae anatomicae LXXVIII* in

Adriaan van den Spieghel (Adrianus
Spigelius) *Opera quae extant omnia*
Amsterdam: Joan Blaeu, 1645, pl. 25,
book 4, p. 79
Inscribed with plate and figure numbers
Philadelphia Museum of Art: Purchased
with the SmithKline Beecham (formerly
SmithKline Beckman) Corporation Fund
for the Ars Medica collection, 1982-41-1

Fig. 30. Francesco Valesio after Odoardo
Fialetti, *Seated Écorché in a Landscape*,
engraving. From Giulio Casserio,
*Tabulae anatomicae LXXVIII* in Adriaan
van den Spieghel, *Opera quae extant
omnia* (Amsterdam: Joan Blaeu, 1645),
pl. 15. Philadelphia Museum of Art,
SmithKline Beecham (formerly SmithKline
Beckman) Corporation Fund for the Ars
Medica Collection

1. Cazort, *The Ingenious Machine of Nature*,
cat. no. 53, 167.

2. Previously woodcut illustrations and
text could be printed "at one pull of the
press." Roberts and Tomlinson, *The Fabric
of the Body*, 263.

3. For a detailed account of the editions,
see ibid., 262-263.

4. Cazort, *The Ingenious Machine of Nature*,
cat. no. 53, 167.

5. Ibid., cat. no. 53, 167-168.

THE THREE FIGURES OF THE PALMAR VIEWS of the dissected left hand are shown in the same positions as those of the nerves, tendons, and muscles in Casserio's second work, the *Pentaestheseion* (Cat. 21). Progressively deeper stages of dissection also are repeated, as is a similar system of identification on the opposite page in separate paragraphs for each figure and its individual units. Similar modeling techniques depict with great sensitivity in each figure the comparative location, movement, and interpenetration of muscles and tendons. Great care is taken with such details as the shadows cast by the thumb, as successive layers of skin are removed in each figure.

Unlike the *Pentaestheseion*, the text of the *Tabulae anatomicae* was not written by Casserio (Cat. 6), who, before 1600 had envisioned a complete anatomical atlas of all parts of the body. Although eighty-six engravings were ready for printing by 1613, the accompanying text was not ready before his death three years later.[1] The time-consuming process of printing copper plates separately from the text sometimes delayed the production of anatomical atlases.[2] Casserio's successor as professor of surgery and anatomy at the University of Padua, Adriaan van den Spieghel, had written an unillustrated book on anatomy that was coordinated with Casserio's plates, when they were first published in Venice in 1627 by van den Spieghel's successor at Padua, Daniel Rindfleisch (Danieles Bucretius). In his will, van den Spieghel, instructed Rindfleisch to publish two of his own works. Rindfleisch had obtained Casserio's plates from his heirs and added twenty others by the original artists. The Amsterdam edition of 1645 contains two works by van den Spieghel, Casserio's *Tabulae anatomicae*, as well as two other texts, including Harvey's on the circulation of the blood (see Cat. 23).[3]

The engravings in the 1627 edition of Casserio's *Tabulae anatomicae*, as well as those reprinted in the 1645 edition, are considered to usher in a new era of anatomical illustration following a period of Vesalius' domination. Cazort singles out the originality and inventiveness of the illustrations, as in the *écorché* figure of a peasant jauntily seated in a landscape in a graceful pose (Fig. 30).[4] The artists responsible are the engraver Francesco Valesio working from the designs of Odoardo Fialetti. The latter had produced an anatomical manual for artists, while Valesio had previously executed the engravings of a distinguished anatomical text book by Guido Guidi.[5] It is not clear whether all the Casserian anatomical plates were the work of Fialetti and Valesio or were entrusted to other unnamed artists.

The representations of the muscles and tendons of the hand, while lacking the dramatic quality of Fig. 30, give ample opportunity to demonstrate its intricate structure. Again, the potential for bending, grasping, and other movements that make possible the intricate work of the hand, realized in the engraving itself, repeats the theme of the "instrument of instruments."

CRS

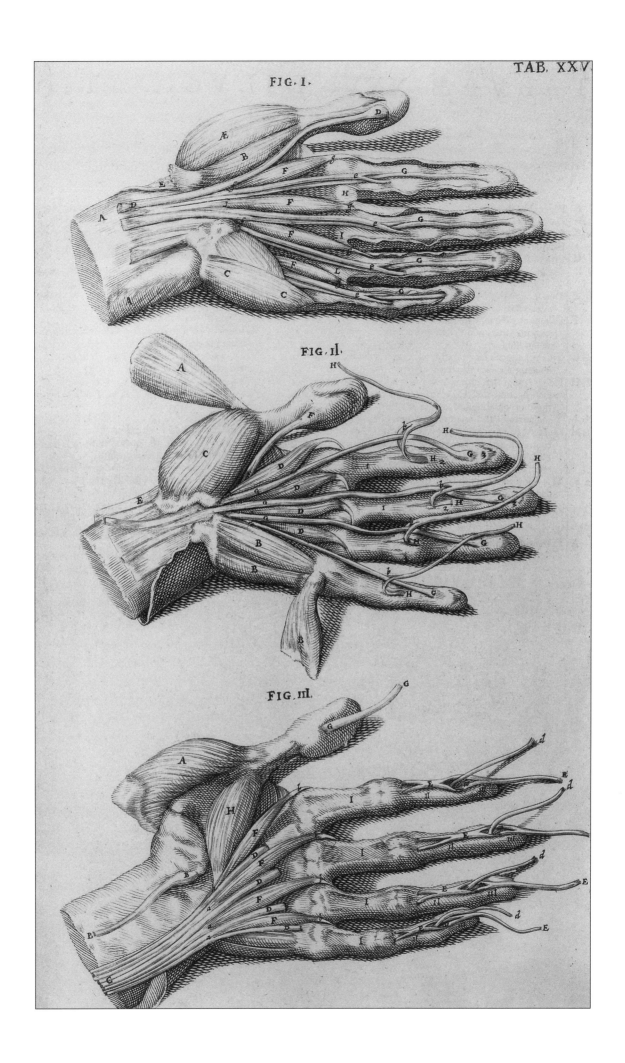

# A Demonstration of the One-Way Flow of Blood through the Veins

*A Demonstration of the One-Way Flow of Blood through the Veins*, 1639
Anonymous
Engraving
Plate mark for Figures 1-2 and
Figures 3-4: 4¼ x 6⁵⁄₁₆" (10.7 x 16 cm)
William Harvey (1578-1657)
*De motu cordis et sanguinis in*

*animalibus anatomica exercitatio*
Leiden: Joannes Maire, 1639, Figs. 1-4
inserted between pp. 184 and 185
Inscribed with figure numbers
History of Medicine Division, National
Library of Medicine, National
Institutes of Health, Bethesda,
Maryland

1. For the diploma, see Kenneth D. Keele, *William Harvey: The Man, the Physician, and the Scientist* (London and Edinburgh: Nelson, 1965), 21-22, and pls. 4 and 5. For a portrait of Harvey in the Hunterian Collection, University of Glasgow, showing him examining an illustration in the 1645 treatise containing Casserio's *Tabulae anatomicae* and his own *De motu cordis*, see Geoffrey Keynes, *The Portraiture of William Harvey* (London: Royal College of Surgeons of England, 1949), pl. 13 and cat. no. 3, 32-33.

2. For a concise and illuminating biography with an excellent bibliography, see Jerome J. Bylebyl, "William Harvey," *DSB* 6:150-162. For a full-length and sympathetic account of Harvey's personality and career, see Keele 1965, and Geoffrey Keynes, *The Life of William Harvey* (Oxford: Clarendon Press, 1966). For a detailed account of Harvey's journey in 1636 and 1637, including his meeting with Wenceslaus Hollar, see Keynes 1966, 229-263.

3. The book was published in Frankfurt, then the center of the continental book trade, by William Fitzer, who took over the firm of Johann Theodor de Bry, publisher of Robert Fludd (Cat. 60 and 83). Fludd, who was a friend of Harvey and the first to accept his theories of the circulation of the blood (Cat. 83), may have recommended Fitzer.

4. Whitteridge's translation (Oxford and London: Blackwell Scientific Publications, 1976), with the same title she recommended, includes a very helpful introduction. The first section (xiii-xxvi) explains the structure of *De motu cordis*.

WHEN WILLIAM HARVEY RECEIVED HIS MEDICAL DIPLOMA in 1602 from the University of Padua, among the faculty signatories were those of his mentor, Giovanni Fabrici (Hieronymus Fabricius of Aquapendente), and Giulio Casserio (Cat. 6, 21, and 22).[1] An Englishman, Harvey had studied at Caius College of the University of Cambridge before going to Padua, still the leading European center of medical education. Upon his return to England, Harvey practiced medicine and in 1607 became a member of the Royal College of Physicians, an institution to which he contributed greatly. From 1618 to 1647 Harvey was physician first to King James I and then to Charles I, with whom he enjoyed a long and fruitful relationship. He remained loyal to the latter until the disastrous end of his rule. A man of wide interests, Harvey had counted among his friends and colleagues leading thinkers and writers of his time, including Robert Fludd (Cat. 60 and 83). In 1636 Harvey joined the diplomatic mission of the Earl of Arundel, when he met Wenceslaus Hollar (Cat. 9). The next year Harvey journeyed to Italy to search for works of art for Charles I's collection. As a consequence of his loyalty to the king, Harvey lost many of his notes and manuscripts when his apartment was ransacked by antiroyalist forces. After 1647 Harvey lived in London until his death ten years later following a stroke. Harvey was described by contemporaries as a man of intense energy, benevolence, and affability, if sometimes of quick temper.[2]

Like Vesalius, Harvey published few books. His revolutionary work on the circulation of the blood, known as *De motu cordis*, was first printed in 1628.[3] As Gweneth Whitteridge points out in the introduction to her translation of the text, the correct English title should read: *An Anatomical Disputation Concerning the Movement of the Heart and Blood in Living Creatures*.[4] The idea of disputation according to strict rules, which permitted an exchange of views following arguments based on forms of logic, was fundamental to academic discourse. Indeed, in the present edition from the collections of the National Library of Medicine, the views of two opponents of Harvey's arguments are interposed with those of the author.[5]

Before publication of the book, Harvey had devoted many years to observations from human dissections and studies of comparative anatomy of animals, which he had recorded in his lecture notes. Although he built upon the previous discoveries on the subject by his sixteenth-century predecessors and contemporaries, the book is considered a landmark in the history of science and medicine.[6] Harvey introduced in his work a scientific method in the modern sense: substantiating his ideas based on definition of the problem, direct observation, qualitative analysis, demonstration, and validation of the results.[7] Many scholars have recognized that although Harvey practiced demonstration of his theories founded on experience, independent of previous authority and verifiable by experiments, he was at the same time greatly influenced by Aristotelian modes of thought and a teleological orientation.[8]

A

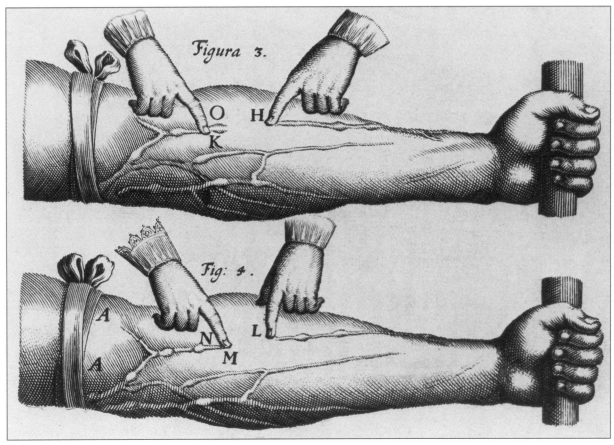

B

5. For a discussion of the 1639 Leiden edition, see Geoffrey Keynes, *A Bibliography of the Writings of Dr. William Harvey, 1573-1657* (Cambridge: Cambridge University Press, 1953), 9. Harvey's opponents were James Primrose, a London physician, and Emilio Parigano of Venice. See Keynes 1966, 243, 320, and 449. For an account of the reception of, and controversy about, *De motu cordis* from 1629 to 1648, see Gweneth Whitteridge, *William Harvey and the Circulation of the Blood* (London: MacDonald, 1971), chap. 7, 149-161.

6. For previous work in the field, see Keele 1965, chap. 8.

7. For Harvey's account of his research methods see ibid., 103-108.

8. See Walter Pagel, *New Light on William Harvey* (Basel: S. Karger, 1976), chap. 4; and Roger French, *William Harvey's Natural Philosophy* (Cambridge and New York: Cambridge University Press, 1994).

9. The following citations and explanation of Harvey's figures are drawn from I. Bernard Cohen, *Album of Science, From Leonardo to Lavoisier, 1450-1800* (New York: Charles Scribner's Sons, 1980), pl. 203. See also French 1994, 107-110.

Although the dedication of *De motu cordis,* addressed to Charles I, stresses validation of ideas by ocular demonstration, the book was unlike Vesalius' *Fabrica* in its scope and modest size. For one thing, *De motu cordis* was not an anatomical atlas but was focused on a demonstration of crucial physiological functions. Furthermore, except for the present engravings, the book, like Harvey's later works, did not include illustrations. Indeed, these engravings by an anonymous artist were adapted from one that appeared in the 1603 *De venarum ostiolis* [On the Valves of the Veins] by Harvey's mentor, Giovanni Fabrici. The single figure from Fabrici's much larger treatise was reversed and augmented by three others in the illustrations of *De motu cordis.*

The two engravings, divided into four figures, are inserted into chapter 13 of *De motu cordis,* where Harvey explains their meaning as a visual demonstration of the principle of the circulation of the blood. The illustrations form part of a system of proof in an experiment the reader could carry out personally. Harvey's directions are given in the pages immediately following the engravings. Both plates, containing two figures each, depict the interior surface of a left arm and hand. The arm, separated from the body above the elbow, has a tourniquet tied to it, while the hand, making a fist, grasps a segment of a barber's pole, then used in bloodletting. The general purpose of the visual demonstration is to "show that blood passes through the valves of the veins only in one direction, from the extremities toward the heart."9 When the flow of blood is interrupted by the tourniquet, one sees "nodes or swellings (*B, C, D, D, E, F* in Figure 1) at each valve in the veins." Then, if one "can rub his finger along a vein (as from *O* to *H* in Figure 2)," the experimenter will see that "the valve (at *O*) prevents the blood from flowing backwards, away from the heart." With a finger of his right hand placed at points *O* to *H* to keep the blood from being withdrawn, the "experimenter next takes a finger of his left hand and tries (Figure 3) to press blood *(K* to *O)* through the valve (toward *H*)." He will find that the blood will not go beyond the valve "in a direction away from the heart." In Figure 4, "two fingers, one of each hand, are placed together at a point in a vein below a valve *(N).* Keeping the finger of his left hand in place (at *L*), the finger of his right hand strokes the vein in a direction toward the valve, and toward the heart. The blood passes easily through the valve, toward the heart, leaving a stretch of vein empty, since the blood cannot get back into the vein through the valve." Harvey's demonstration proves that the "blood passes through valves in the veins toward the heart, but not in the other direction. Hence there is no ebb and flow of blood in the veins, but only a one-way flow toward the heart."

The representational mode, closer to a diagram than to a fully naturalistic depiction of the structures of the arm and hand, is consistent with the demonstrative purpose of the illustration. Here the hand gripping the barber's pole is a passive part of the experiment's visual proof. But the disembodied hands in Figures 2, 3, and 4 are performers and agents, enablers of the successive stages of the experiments. Fittingly, the index fingers, traditionally denoting the desire for knowledge, are singled out to establish the precise cognitive value of the experiments.

CRS

*Muscles of the Arm and Hand*, 1677
Giovanni Georgi (Giorgio)
(fl. 1600-1650)
Engraving
Plate mark: 8 x 5¾" (20.3 x 14.5 cm)
Johann Vesling (1598-1649)
*Syntagma anatomicum*

Padua: Pietro Maria Frambotto, 1677,
p. 264
Inscribed with numbers and letters
Signed lower left *G.G.*
Rare Book and Special Collections
Division, Library of Congress,
Washington, D.C.

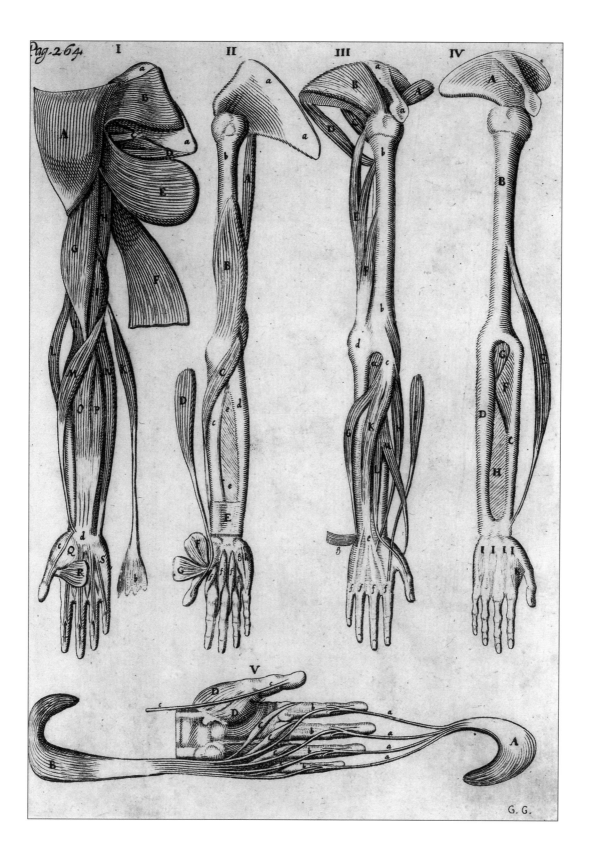

1. Erich Hintzsche, "Johann Vesling," *DSB* 14:12-13.

2. Geoffrey Keynes, *The Life of William Harvey* (Oxford: Clarendon Press, 1965), 270-271.

3. Thieme-Becker 13:426-427; and Rosetta Pizzo, *Dizionario enciclopedico Bolaffi dei pittori e degli incisori italiani* (Turin: G. Bolaffi, 1972-1976), 5:339.

4. Roberts and Tomlinson, *The Fabric of the Body*, 239.

5. Ibid., 236.

6. Ibid., pl. 21, 94-96; Choulant, *History and Bibliography of Anatomic Illustration*, 150-151; and Roslynne Valerie Wilson, "Collaborations in Art and Medicine, 1491-1543: The Development of Anatomical Studies in Italian Medical Treatises" (Ph.D. diss., Case Western Reserve University, 1988), chap. 3. For a facsimile of the rare edition of 1541, see *Musculorum humani corporis picturata dissectio per Ioannem Baptistam Cananum,* ed. Giulio Muratori (Florence: Sansoni, 1962).

JOHANN VESLING, A GERMAN ANATOMIST AND BOTANIST, studied medicine in Venice and Leiden.[1] After many travels, including journeys to the Near East, Vesling was appointed professor of anatomy and surgery at the University of Padua in 1632. Two letters to William Harvey (Cat. 23) dated 1637, when they appear to have met, indicate that Vesling accepted Harvey's theories on the functions of the heart and lungs.[2] A popular teacher, Vesling made drawings during his lectures, which became the basis for his textbook entitled *Syntagma anatomicum* first published in 1641 with engravings by Giovanni Georgi (Giorgio).[3]

The *Syntagma anatomicum*, which was extremely popular as a textbook, lives up to its meaning in English as a systematically arranged treatise. The Library of Congress copy is one of many Latin editions; translations into German, Dutch, and English followed.[4] Its practical function distinguishes it in size and length from the monumental anatomical atlases of Vesalius (Cat. 5, 13, and 19) or of Casserio (Cat. 6, 21, and 22). Preceding the illustrations, the text features short definitions of the terminology and functions of the relevant parts of the body. Vesling begins with praise of the muscles of the hand. Opposite the illustration itself comes the description of its anatomical contents in general and the identification in each numbered figure of every anatomical element arranged in alphabetical order.

The economy of verbal arrangement, suited to the book's purpose as a succinct, easily consulted manual for students, is echoed in the illustrations. Their stripped-down character, free of any background or other descriptive elements, makes them easier to consult and correlate with the textual identification.[5] The figures' quasi-diagrammatic quality is reinforced by their two-dimensional character, although the modeling permits differentiation of bones from muscles and tendons. The vertical orientation of the first four figures seen straight on echoes body orientation while presenting only oddly detached fragments. These representations recall those in the first engravings used in anatomical illustrations, Giovanni Battista Canano's *Musculorum corporis picturata dissectio* of 1541.[6] The repeated vertical composition, permitting comparison of similar but varied structures, is abruptly shifted in the fifth figure, depicting the muscles of the palmar view of the left hand. Once again, the abstract shapes and patterns of muscles extending on either side of the hand lend a rather surreal effect to an otherwise factual anatomical description.

As in other anatomical illustrations, these representations of the muscles of the arms and hand serve as containers or vessels of systematically organized information about themselves. The letters inscribed on them are readily related to easily retrieved verbal data nearby. Both verbal and visual elements unite to construct simplified and organized forms appropriate for the learning and memorizing functions of an anatomical textbook.

CRS

**25A,B** Two Views of the Muscles and Tendons of the Forearm and Back of the Left Hand

*Two Views of the Muscles and Tendons of the Forearm and Back of the Left Hand*, 1685
Attributed to Abraham Blooteling (Bloteling) (1640-1690), after drawings by Gérard de Lairesse (1640-1711)
Engraving and etching
Plate mark: 18⅝ x 13" (47.3 x 33 cm)

Sheet: 20½ x 14¹¹⁄₁₆" (52.1 x 37.3 cm)
From Govard Bidloo (1649-1713)
*Anatomi humani corporis centum et quinque tabulis*
Amsterdam: Joannes van Someren, 1685
The Trout Gallery, Dickinson College, Gift of Dr. Kenneth B. Roberts, 2000.1.3/4

THESE VIEWS OF SUCCESSIVE DISSECTIONS OF THE MUSCLES and tendons of the exterior of the forearm and the back of the hand are the most dramatic anatomical representations in the exhibition. Originally part of an elephant folio, the engravings almost exceed the boundaries of anatomical illustration in employing a theatrical visual rhetoric. The anatomical views form part of a coordinated fabric of props reminiscent of a stage set or still-life painting.

Plate 69 (Cat. 25A) represents the relationship between the muscles of the forearm and those of the flexed fingers. The artist emphasizes the independence of the arm as a living structure, limiting the visibility of the supporting post and rope. On the right, the fleecelike texture of the cutaway layers of skin denies the underlying reality of the dissection process. The lengthy, almost three-dimensional pattern of cast shadow on the left again stresses the lifelike character of the arm and hand. Only the knife and other tools on the lower right, painstakingly depicted, bear witness to the operation.

In Plate 70 (Cat. 25B), the arm and hand are supported by a series of pins resting on a board. The arm, with drapery drawn back to reveal its structure, ends in a series of fluttering folds. The diagonal placement, as well as the contrast between the dark tones of the upper arm and the light ones of the hand, lend a dynamic character to the representation. Even the parallel placement of the pins and the strands of the muscles make elegant linear patterns. In both engravings, inscribed letters of the alphabet identify the respective muscles, tendons, and bones keyed to the very brief legends on the volume's facing page. Aesthetic values seem to outweigh communication of scientific information.

The theatrical cast of these representations constitutes a fitting praise of the hand as the "instrument of instruments."[1] Moreover, both the anatomist, Govard Bidloo, and the designer of the plates, Gérard de Lairesse, were actively involved with the stage. The former was a playwright and poet; the latter, not only a painter but also a designer of stage sets.[2] The fruits of their collaboration, brilliantly realized by the engraver, usually—but not universally—identified as Blooteling, bear the hallmarks of a dynamic style, in which naturalistic effects are employed to yield maximum expression.[3] Here the denial of death in anatomical illustrations reaches a climax.

The author, Govard Bidloo, is another in the series of gifted surgeon-anatomists of wide interests and colorful personality encountered in the exhibition (Cat. 5, 16, 20, and 24).[4] In 1690 he was named superintendent of military hospitals in the Netherlands; four years later he was appointed professor of medicine and surgery at the University of Leiden, then the center of European medical education. His work there was frequently interrupted by his service as physician to William III of England. After the latter's death, Bidloo enjoyed popularity as a lecturer at Leiden and a prosperous private practice. He was, however, involved in controversy regarding his major work, from which the present engravings derive. This large-scale anatomical atlas of 105 plates

1. See the essay by Martin Kemp in this volume, 22.

2. For Bidloo and the theater, see Roberts and Tomlinson, *The Fabric of the Body*, 309; for Lairesse, see Lyckle de Vries, *Gérard de Lairesse, An Artist between Stage and Studio* (Amsterdam: Amsterdam University Press, 1998).

3. For a summary of the controversy over the attribution of the engravings to Blooteling, who signed the portrait of Bidloo on the title page of the anatomical atlas, and those favoring the reproductive engraver Pieter van Gunst and his brother Philippe, see Cazort, *The Ingenious Machine of Nature*, cat. nos. 68-71, 186. For Blooteling's career, see Gregor M. Lechner, "Abraham Bloteling," Saur 2:607; and Richard Jeffree, "Abraham Blooteling," *DOA* 4:169-170.

4. See Peter W. van der Pas, "Govard Bidloo," *DSB* 15, Supplement 1:28-30.

5. Roberts and Tomlinson, *The Fabric of the Body*, 310-318; Cazort, *The Ingenious Machine of Nature*, cat. nos. 68-71, 183-186.

6. For an account of the controversy with Ruysch and Cowper's plagiarism, see van der Pas, *DSB* 15, Supplement 1:29; Roberts and Tomlinson, *The Fabric of the Body*, 412-414.

7. De Vries 1998, 122-124.

8. For a discussion of Lairesse's drawings for the Bidloo volume in a biography of the artist, see Alain Roy, *Gérard de Lairesse (1640-1711)* (Paris: Arthena, 1992), 394-399.

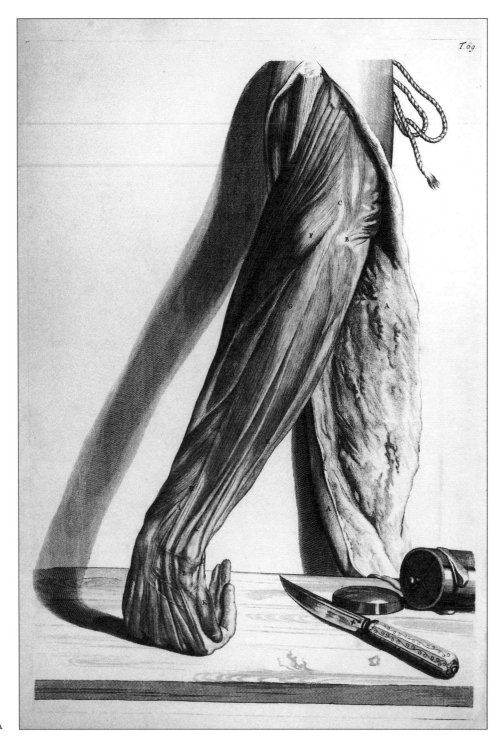

designed by Lairesse, for which the drawings survive, was an ambitious enterprise that took thirteen years to complete. In his introduction to the volume, Bidloo explained that the illustrations had no precedent and that the drawings were made by Lairesse as the dissections were taking place.[5] Although the artistic values of the plates received early recognition, various authorities criticized the brief anatomical explanations Bidloo furnished, including his teacher, Frederick Ruysch, to whom Bidloo replied in a bitter satire. More infuriating was the appropriation of the atlas by the English anatomist William Cowper, who represented the work as his own. Despite Bidloo's protests about the fraud to the Royal Society, of which he was a member, he failed to gain satisfaction in the matter.[6]

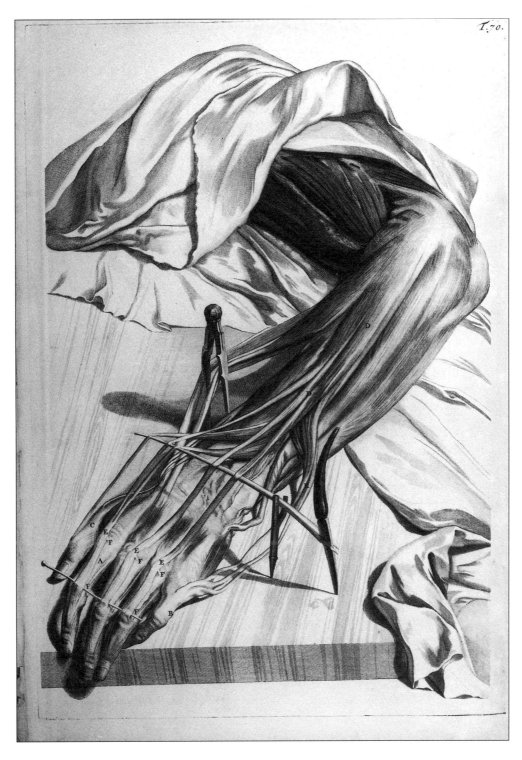

B

    Bidloo's collaboration with Lairesse strikes a happier note. His acknowledg-
ment of indebtedness to the artist, whom he called the leading painter of his
age in his preface to the anatomical atlas, is unusual given the lack of recognition
suffered by previous artists of similar enterprises (Cat. 5, 13, and 15).[7] Lairesse
was recognized as a preeminent painter of his age, bringing classical elements
into Dutch art.[8] Known as the Dutch Poussin, Lairesse was also active as a
printmaker, stage designer, and art theorist. Aided by Blooteling, an outstanding
engraver, Bidloo and Lairesse brought anatomical representation to new levels
of artistic excellence.

CRS

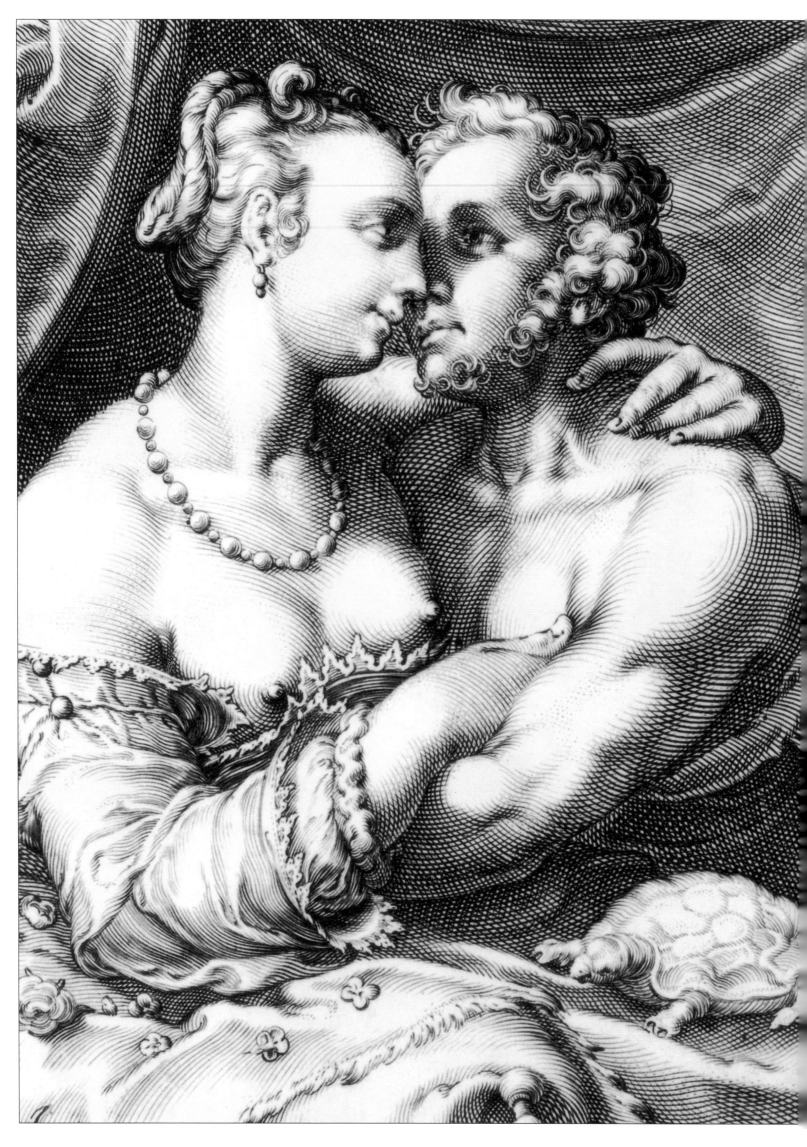

# III. Messengers of the World

*The Sense of Touch: Cat. 26-33*
*Inscribing Memory: Cat. 34-39*

Willibald Pirckheimer
as the Caput Physicum

Willibald Pirckheimer as the Caput
Physicum, 1498
Albrecht Dürer (1471-1528)
Woodcut
Image: 2⅞ x 2¹⁄₁₆" (7.4 x 5.2 cm)
Ludovicus Pruthenus (Ludwig of
Prussia) (fl. 1456-1494)
Trilogium animae

Nuremberg: Anton Koberger, 10 March
1498, fol. E
Inscribed:
Caput physicum (The material head)
with the letters A-F
The Walters Art Gallery, Baltimore,
Maryland

1. For a detailed account of the author,
circumstances of publication, and the
contents of the volume, see P. Bonaventura
Kruitwagen, "Bio-bibliographisches zu
Ludovicus de Prussia und seinem Trilogium
animae," Franziskanische Studien 12
(1925):347-363.

2. For an explanation of medieval faculty
psychology, see Clarke and Dewhurst, An
Illustrated History of Brain Function, chap. 3.

3. This account depends heavily on Walter
Pagel, "Medieval and Renaissance
Contributions to Knowledge of the Brain
and Its Functions," in The History
and Philosophy of Knowledge of the Brain
and Its Functions (An Anglo-American
Symposium, London, 15-17 July 1957), ed.
Frederick N. L. Poynter (Springfield, Ill.:
Charles C. Thomas, 1959), 100-107.

4. The Caput physicum as a portrait of
Pirckheimer by Dürer is accepted by
various authorities. For citations of the
attributions by individual authors,
see Germanisches Nationalmuseum, exh.
cat. Albrecht Dürer, 1471-1971 (Munich:
Prestel-Verlag, 1971), cat. no. 292, 165; and
Albrecht Dürer: Woodcuts and Wood Blocks,
ed. Walter L. Strauss (New York: Abaris
Books, 1980), no. 56.

THIS IMAGE COMBINES A DIAGRAMMATIC MODE OF REPRESENTATION with an
individualized portrait. This strange mixture occurs in a book by Ludovicus
Pruthenus (Ludwig of Prussia), printed by the famous Nuremberg publisher
Anton Koberger (Cat. 2 and 37). The Trilogium animae [Three Parts of the Soul]
is a scholarly, meticulously organized treatise addressed to fellow clergy and
students. The author, a member of the Observantine branch of the Franciscan
order, is a fairly obscure figure. Yet after his death the head of his community
commissioned the printing of this didactic treatise on philosophy and psychol-
ogy. Except for the title page (adapted by Koberger from another volume), the
illustrations consist only of two simple diagrams and the present image.[1]

The brain and the senses, of which touch is the most fundamental, are
intimately linked. As a diagram showing how sense perceptions are transmitted
and converted to knowledge within the brain, this image is unexceptional.[2]
The explanation of the separate parts, coordinated with the inscribed letters,
appears opposite the woodcut in the right margin. The letter A depicts the
whole brain (Cerebrum per totum); B contains the meeting place of the
senses (sensus co[mun]is); C, imaginatio (image-making faculty); D, fantasia
(imagination), E, Estimativa (judgmental faculty) and F, Memoria (memory). As
a whole, the diagram corresponds generally to medieval theories of faculty
psychology, in which different parts of the brain, divided into cells or ventricles, are
assigned certain functions. In short, the five external senses, sources of perception
from the external world and the basis of thinking, transmit impressions to a
central place in the anterior or front ventricle of the brain. There specific objects
of separate sensation are composed into fleeting visual images of things perceived.
These impressions are then communicated to the preliminary faculties of reason

and judgment in the central ventricle and thence to memory in the posterior one.[3] The author defines and describes these separate parts in five chapters and summarizes the figure in a sixth one opposite the image.

Although the verbal and visual explanations are models of clarity, what remains puzzling is the combination of a diagram with an individualized portrait. The image is now generally accepted as the likeness of Willibald Pirckheimer, the Nuremberg patrician scholar and humanist. Pirckheimer was also the best friend of Albrecht Dürer, the greatest German artist of his time.[4] In 1498, although only twenty-seven when the *Trilogium animae* was published, Dürer already had extensive experience in book illustration. He had trained with Michael Wolgemut, whose shop had produced the technically innovative and rich cycle of woodcuts in the *Schatzbehalter* (Cat. 2 and 37).[5] The publisher of these two books was Anton Koberger, who was Dürer's godfather. Koberger may have requested Dürer, then engaged in making the blocks, printing, and publishing the inventive prints of the *Apocalypse* series, to contribute the single image of the brain diagram to the *Trilogium animae* volume.

Dürer's purpose in creating the unusual hybrid of portrait-diagram is unclear. Perhaps the young artist, always original in his approach to artistic problems, thought the allusion to Pirckheimer's mental abilities was a compliment and perhaps something of a joke or puzzle as well. In a letter to Pirckheimer, Dürer refers to his friend's boundless mental capacities, particularly his capacious memory.[6] Whatever Dürer's motive, Pirckheimer's distinctive features, particularly his irregularly shaped nose and heavily lidded eyes, familiar from other portraits by the artist, emerge in a novel context.[7] The image has art-historical significance both as Dürer's first woodcut portrait and his initial image of Pirckheimer,[8] thereby realizing his quest for a three-dimensional, veristic style in this medium.

CRS

5. For a short biography with extensive bibliography, see Peter Strieder, *DOA* 9:427-445. A classic full-length study is Erwin Panofsky, *The Life and Art of Albrecht Dürer* (Princeton, N.J.: Princeton University Press, 1955).

6. See Jean Michel Massing, "Dürer's Dreams," *JWCI* 49 (1986):238-244; and Massing, "From Manuscript to Engravings: Late Medieval Mnemonic Bibles," in *Ars memorativa: Zur kulturgeschichtlichen Bedeutung der Gedächtniskunst 1400-1750*, eds. Jörg Jochen Berns and Wolfgang Neuberg (Tübingen: Max Niemeyer Verlag, 1993), 101-103, esp., n. 1.

7. For another portrait of Pirckheimer by Dürer, see Germanisches Nationalmuseum 1971, cat. no. 293, 165; see also Willehad Paul Eckert and Christoph von Imhoff, *Willibald Pirckheimer: Dürers Freund* (Cologne: Wienand Verlag, 1971), esp., 80-85.

8. Strauss 1980, no. 56.

*The Inner Senses of the Brain*, 1503
Anonymous, German
Woodcut
Image: 6 x 4" (15.1 x 10 cm)
Gregor Reisch (d. 1515)
*Margarita philosophica*
Freiburg im Breisgau: Johann Schott,
1503, fol. H2
Inscribed:
*Animae sensitivae* (sensitive soul)*;
sensus communis, fantasia, imaginativa,* (common sensorium, image-making
faculty), left ventricle; *cogitatiṿa,
estimatiṿa,* (rational and judgmental
faculty), central ventricle; *memorativa*
(memory faculty), right ventricle;
*vermis* (narrow canals, connecting
the first, second, and third ventricles);
*olfactuṣ* (smell), nose; *gustuṣ* (taste),
tongue
The Folger Shakespeare Library,
Washington, D.C.

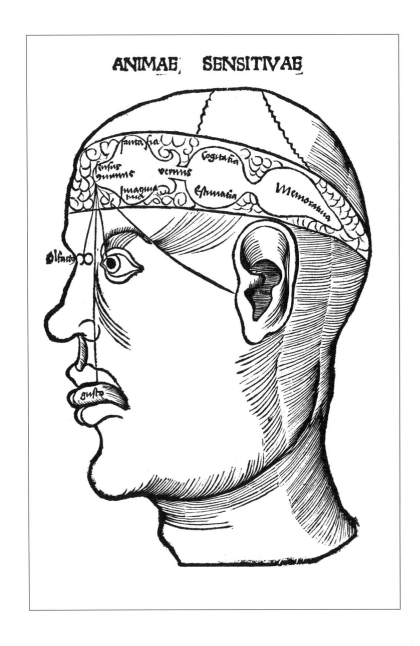

THIS WOODCUT REPRESENTS CONNECTIONS between four of the five exterior senses and the brain. Lines connect the four with a location within the first ventricle, establishing a clear relationship between them. While these indications point to the eye and ear as the sites of vision and hearing, two inscriptions specifically identify the locations in the nose and tongue of smell and taste. Touch alone is missing, an absence explicable by describing the exterior senses located in the head and neck only.

Like the Dürer image of Willibald Pirckheimer (Cat. 26), the present woodcut also depicts the inner senses localized in the brain. The upper portion shows the dissection of the "cranial cavity."[1] Yet in several respects this representation is clearer than Dürer's. First, the diagrammatic mode offers a clear way of isolating the principal features by omitting the dimension of a portrait reference. Second, the larger size of this full-page woodcut permits fuller description. Finally, the profile view with the head facing left, a pose widely copied in later illustrations, establishes a clearer way of localizing brain functions without the intrusive letters requiring marginal amplification. Identification of the three ventricles by interior inscriptions is a clearer solution. Another advantage of this representation is that the three ventricles are seen as "three freely communicating cells." The meaning of the term *vermis*, placed between the first and second ventricles, is less certain, although the term may connote the narrow canal separating the three units.[2]

The illustration occurs in the first printed encyclopedia, the *Margarita philosophica* (The Philosophic Pearl) by the Carthusian prior Gregor Reisch, a friend of Erasmus and other humanists.[3] Reisch organized his encyclopedia, designed for university students, around the seven liberal arts, beginning with grammar. Divided into two main headings, "theoretical" and "practical" philosophy, the book was "a pedagogical *summa*" linked to "the subdisciplines forming in the universities of the day."[4] Reisch made the wealth of information, carefully organized according to late scholastic philosophic systems, more approachable by adopting a dialogue format presenting an interchange between master and pupil. The present woodcut occurs in the tenth of twelve books covering the broader rubric of natural philosophy. Chapter twenty-one discusses the faculties of the second part of the soul. The diagram, cited as a separate element in the table of contents, occupies a position between the folios devoted to this topic.[5] The close relationship between text and image may account in part for the popularity of this diagram, which was reproduced in many subsequent treatises.

The Strasbourg printer Johann Schott moved his presses to Freiburg im Breisgau, the location of Reisch's priory, especially to print the book, which is very well illustrated, both with full-length allegorical woodcuts and an assortment of diagrams. The author may well have played an important part in designing the program of illustration and coordinating it with the text.[6] The book was extremely successful, with ten editions published during the sixteenth century.[7] Once again, the prominent role of images in aiding the cognitive processes of students probably contributed to the popularity of the *Margarita philosophica*.

CRS

1. Choulant, *History and Bibliography of Anatomic Illustration*, 128. The two lines of the upper part suggest "the coronal suture, occipital suture, and the cerebral convolutions" (ibid., 128).

2. An allied interpretation states that the term indicates "thinking is arrested when it blocks the passage and begins again when it unblocks" and that "the patterning around the cells may conceivably be intended to portray cerebral convolutions." Clarke and Dewhurst, *An Illustrated History of Brain Function*, fig. 48, 34.

3. M. J. Dorcy, "Gregor Reisch," *NCE* 12:215. For a lengthier account and extensive biographical references, see *Gregor Reisch, Margarita philosophica*, ed. and intro. Lutz Geldsetzer, facs. ed. (Düsseldorf: Stern-Verlag Janssen, 1973), vi-vii.

4. Anna Sigridur Arnar, *Encyclopedism from Pliny to Borges*, exh. cat. (Chicago: University of Chicago Library, 1990), cat. no. 8, 7. See also Geldsetzer 1973, i-v.

5. The illustration is identified as "Imago: Typus organorum sensitivorum."

6. S. H. Scott, "The Schotts of Strassburg and Their Press," *Transactions of the Bibliographical Society* 11 (Oct. 1909-March 1911):165-176.

7. For a discussion of the editions and explanation of their contents, see John Ferguson, "The *Margarita philosophica* of Gregorius Reisch: A Bibliography," *The Library* 10 (1930):194-216.

*Doubting Thomas,* c. 1510
Albrecht Dürer (1471-1528)
Woodcut
Sheet (trimmed to image): 5 x 3¹³⁄₁₆"
(12.7 x 9.7 cm)

Inscribed with monogram AD
National Gallery of Art, Washington,
D.C., Rosenwald Collection, 1943

1. For the history of the representation, see Gertrud Schiller, *Ikonographie der christlichen Kunst: Die Auferstehung und Erhöhung Christi* (Gütersloh: Gütersloher Verlagshaus Gerd Mohn, 1971), 3:108-114.

2. See Anthony Synnott, "Puzzling over the Senses: From Plato to Marx," in *The Varieties of Sensory Experience: A Sourcebook in the Anthropology of the Senses,* ed. David Howes (Toronto: University of Toronto Press, 1971), 64-69.

3. *Dürer in America: His Graphic Work,* ed. Charles W. Talbot, with notes by Gaillard F. Ravenel and Jay A. Levenson, exh. cat. (National Gallery of Art: Washington, D.C., 1971), cat. nos. 156-193, 183-184. The *Doubting Thomas* is cat. no. 90. See also Walter L. Strauss, *Albrecht Dürer: Woodcuts and Wood Blocks* (New York: Abaris Books, 1980, no. 133, 396 [B. 49]).

4. Rudolf Berliner, "Zu Dürers kleiner Passion," *Die christliche Kunst* 25 (1928-1929):314-318.

5. Peter Strieder, "Albrecht Dürer," *DOA* 9:435.

6. Schäufelein's woodcut appeared in Ulrich Pinder's *Speculum passionis,* published in Nuremberg in 1507 (*Dürer in America,* 184). For this image, see Friedrich Winkler, "Dürers kleine Holzschnittpassion und Schäufeleins Speculum-Holzschnitte," *Zeitschrift des deutschen Vereins für Kunstwissenschaft* 8 (1941):205-206, fig. 12.

7. For Dürer's style in the *Small Passion,* see Heinrich Wölfflin, *The Art of Albrecht Dürer,* trans. Alastair Grieve and Heide Grieve (New York: Phaidon Press, 1971), 175-195; Erwin Panofsky, *Albrecht Dürer* (Princeton: Princeton University Press, 1948), 1:139-145; and *Albrecht Dürer Master Printmaker,* exh. cat. (Boston: Museum of Fine Arts, 1971), xix-xxii.

THIS IMAGE REPRESENTS TOUCH AS AN ACTION that probes and verifies. Here the Apostle Thomas attempts to confirm the Resurrection by placing two fingers in the wound in Christ's side.[1] By gripping Thomas's hand with his right arm, Christ aids the Apostle by encouraging and guiding his exploration. Thus touch is an interactive operation that involves two agents and two actions. In the following interchange (John 20:27-29), Christ addresses Thomas: "Reach hither thy finger, and behold my hands, and reach hither thy hand, and thrust it into my side: and be not faithless, but believing." After Thomas performs the action, he says: "My Lord and my God." Christ responds: "Thomas, because thou hast seen me, thou hast believed: blessed are they that have not seen, and yet have believed." In other words, Christ states that by requiring tangible, visual proof, the Apostle's affirmation is less valuable than faith based on incorporeal belief. Touch is particularly suspect, because it relies on bodily contact. According to philosophical and religious tradition, touch is therefore inferior to the senses of seeing and hearing because they stimulate spiritual and intellectual development.[2]

This scene is one of thirty-seven illustrations by Albrecht Dürer known as the *Small Passion.* Published in Nuremberg in 1511, the series was printed as a book with Latin verses for each plate commissioned by the artist from a Benedictine monk, Benedictus Chelidonius (Schwalbe).[3] Intended to inspire medtiation and piety, the woodcuts were the volume's dominating element.[4] The book sought a more popular audience than the engraved volume of similar content that Dürer published in the same year with comparable but fewer plates and that was directed to collectors and connoisseurs.[5]

Encompassing the history of mankind's salvation, the *Small Passion* begins with Adam and Eve and ends with the Last Judgment. Following the Passion and Resurrection, the *Doubting Thomas* is Christ's fourth and last appearance to his disciples before the Ascension. This episode, whose composition is derived from a woodcut by Dürer's pupil Hans Schäufelein, is highly dramatic.[6] After his second trip to Venice in 1505-1507, Dürer's style changed from a linear approach (Cat. 26) to a highly refined system of tonal modeling. By now an established artist of great reputation, Dürer displays in the *Small Passion* a mastery of the woodcut medium.[7] The compression of the Apostles in the shallow space focuses attention on the three main figures. Framed by a central arch, the light suggesting the Trinity radiates in three directions from Christ's head and illuminates the figures of Thomas on his right and Peter on his left. Their bulky mantles contrast sharply with the seminude body of Christ, who stands in a graceful contrapposto position. With an expression of resignation, Christ turns toward Thomas. The light shining on his arms and hands, bent in opposite directions, focuses attention on his wounds. Unlike this sharp definition of Christ's body, Thomas's head seen in profile view, remains in shadow. His probing hand, less visible and forceful than Christ's guiding arm and hand, demonstrates the inferiority and separation of the earthly from the heavenly realm.

CRS

*The Dentist*, 1523
Lucas van Leyden (1494-1533)
Engraving
Sheet (trimmed to plate mark):

4⁹⁄₁₆ x 2⁵⁄₁₆" (11.6 x 5.9 cm)
Inscribed with initial L and date 1523
National Gallery of Art, Washington,
D.C., Rosenwald Collection, 1943

1. For a discussion of the history of philosophical and medical theories on this subject, including the relationship between pain and touch, see Kenneth D. Keele, *Anatomies of Pain* (Oxford: Blackwell Scientific Publications, 1957), esp. 34-40.

2. Jan Piet Filedt Kok, *Lucas van Leyden: Grafiek,* exh. cat. (Amsterdam: Rijksprentenkabinet/Rijksmuseum, 1978), fig. 113, 72. Filedt Kok believes that an engraving of two musicians dated 1524 (ibid., fig. 114, 72) may exemplify hearing. For a related print, entitled *The Surgeon* also dated 1524, see Ellen S. Jacobowitz, "Lucas van Leyden: Engravings and Etchings," in *The Illustrated Bartsch* 12:290 [B.156]; Jan Piet Filedt Kok, compiler, *Lucas van Leyden, The New Hollstein, Dutch and Flemish Etchings, Engravings, and Wood-cuts, 1450-1700,* ed. Ger Luitjen (Rotterdam: Sound and Vision Interactive, 1996), 145 [B.157].

3. Filedt Kok 1978, 72. For a discussion of the profession in this period, see Jens J. Pindborg and L. Marvitz, *The Dentist in Art* (Chicago: Quadrangle Books, 1960), 9.

4. Pindborg and Marvitz 1960, 22.

5. Filedt Kok 1978, 72.

6. For a discussion of the artist's biography and career, see Jan Piet Filedt Kok, "Lucas van Leyden," *DOA* 19:756-762. See also *Lucas van Leyden Studies, Nederlands Kunsthistorisch Jaarboek* 28 (1978).

7. Giorgio Vasari, *Lives of the Most Eminent Painters, Sculptors, and Architects,* trans. Gaston Du C. de Vere (New York: Harry N. Abrams, Inc., 1979) 2:1247.

8. For an examination of Lucas' style see Ellen S. Jacobowitz and Stephanie Loeb Stepanek, *The Prints of Lucas van Leyden and His Contemporaries,* exh. cat. (Washington, D.C.: National Gallery of Art, 1983), 19-25.

9. For other Dutch artists who represented dental themes, see Pindborg and Marvitz 1960, 9; Maria Elisabeth Wasserfuhr, *Der Zahnartz in der niederländischen Malerei des 17. Jahrhunderts* (Arbeiten der Forschungsstelle des Instituts für Geschichte der Medizin der Universität Köln, 1) (Cologne: F. Hansen, 1977); and Heinz E. Lässig and Rainer A. Müller, *Die Zahnheilkunde in Kunst- und Kulturgeschichte* (Cologne: DuMont, 1987).

THIS ENGRAVING COMMUNICATES HOW THE SENSE OF TOUCH can result in pain.[1] Indeed, this print, signifying touch, may have formed part of a series on the five senses.[2] But unlike Dürer's woodcut of the *Doubting Thomas,* in which touch enables a process of probing and verification of a spiritual metamorphosis, the present image is entirely secular in character. Moreover, the depiction of pain is represented humorously and satirically. A peasant, the central and largest figure, is the sufferer. The cause of his pain is the extraction of a tooth, here performed by the figure at the left. Called a "tooth puller," this man holds the tool lodged in the patient's mouth.[3] So engrossed is the sufferer in his painful sensation that he does not realize that the female accomplice behind him is lifting a purse from his back pocket. Once again touch involves interaction, but this time among three figures. Two of them cause pain—conscious and unconscious—to the third, unwitting victim of quackery and theft.

The artist focuses attention on the patient, who occupies the foreground of the engraving. Staring out at the viewer, the man shows by the jerky movement of his upturned left arm and hand, as well as his left leg, his reaction to pain. Below an apparent trade sign, the richly clad "dentist" stands before a table containing the tools of his trade. As an advertisement for his expertise, a series of teeth decorate the upturned brim of his hat.[4] The quack's expression shows intense absorption in performing his painful task. Similarly engrossed in her task is the dentist's accomplice. Lucas thus successfully differentiates the psychological reactions of the three main characters as they act and react to the immediate effects of a single event.

The satirical treatment of the subject emerges clearly as the viewer confronts the homely, disheveled central character. His stocky body clad in torn clothes identifies him as a crude, lower-class person. His pain lacks dignity, as it results from a lack of judgment about the choice of practitioner, who exemplifies the quack traveling from place to place and setting up shop on the street. The print carries a moral message, as the patient/victim has ignored warnings, common in contemporary literature, about such charlatans.[5]

Lucas van Leyden had an international reputation as engraver and painter.[6] Indeed, in his contemporary account of famous artists, Vasari praises "the beauty" of *The Dentist* in his discussion of Lucas' career.[7] Something of a child prodigy, Lucas mastered engraving techniques at an early age.[8] He was greatly influenced by the graphic work of Dürer (Cat. 26 and 28), whom he met on the latter's 1521 voyage to the Netherlands. Lucas was a prosperous citizen of Leiden, and his work capitalized on his observations of ordinary events from life's daily round. In his pungent observations about human behavior evident in *The Dentist* and other prints, he foreshadows many later representations of this theme by Dutch artists.[9]

CRS

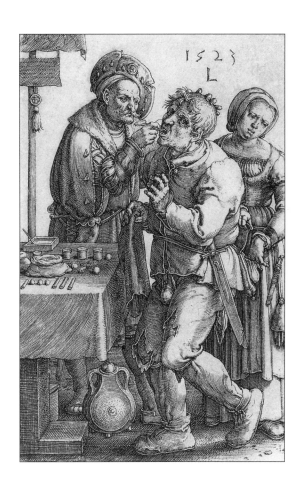

Touch, c. 1596
Jan Pietersz. Saenredam (1565-1607),
after Hendrick Goltzius (1558-1617)
Sheet (trimmed to plate mark):
6⅞ x 4⁵⁄₁₆" (17.5 x 12.5 cm)
Inscribed:
Left, 5

Below, *Que conspecta nocent, manibus
contingere noli, Ne mox corripiare peiori
malo* (Don't touch with your hands
what you have seen, for fear that worse
evils will soon debase you)
National Gallery of Art, Washington,
D.C., Rosenwald Collection, 1943

1. *The Illustrated Bartsch* 4:95-99 [B. 99];
G. S. Keyes, *Hollstein* 23:105.

2. See Sander Gilman, "Touch, Sexuality,
and Disease," in *Medicine and the Five
Senses,* 198-215.

3. Carl Nordenfalk, "The Five Senses in
Flemish Art before 1600," in *Netherlandish
Mannerism* (Papers Given at a Symposium
in the Nationalmuseum, Stockholm,
21-22 September 1984), ed. Görel Cavalli-
Björkman (Stockholm: Nationalmuseum,
1985), 137.

4. Goltzius commissioned the verses for
the five senses series from Schonaeus, a
learned schoolmaster in Haarlem with
whom Goltzius studied. See E. K. J.
Reznicek, "Hendrick Goltzius," *DOA* 12:879;
for the complete article, see ibid., 879-884.

5. See Jodocus Badius Ascensius, *Stultiferae
naves* (Paris: Thielman Kerver, 1500).
The book was published as a supplement
to Sebastian Brant's Latin best-seller of
1494, translated as *The Ship of Fools.*
For the relevant plate and the entry by
Lubomir Konecny, see *I cinque sensi
nell'arte: Immagini del sentire,* ed. Sylvia
Ferino-Pagden, exh. cat. (Milan: Leonardo
Arte, 1996), 99.

6. See Carl Nordenfalk, "The Five Senses in
Late Medieval and Renaissance Art," *JWCI*
48 (1985):1-22; Nordenfalk, "The Sense of
Touch in Art," in *The Verbal and the Visual:
Essays in Honor of William Sebastian
Heckscher* (New York: Italica Press, 1990),
109-120.

7. For a thorough discussion of Goltzius'
treatments of this theme, see Ilja Veldman,
"Goltzius' Zintuigen, Seizoenen, Elementen,
Planeten en vier Tijden van de Tag: Van
Allegorie naar genre Voorstelling,"
*Nederlands Kunsthistorisch Jaarboek* 42-43
(1991-1992): 308-314.

8. For reproductions of the series,
see Veldman 1991-1992, 310-311. *Touch* is
the most classicizing of the five images.

UNLIKE THE IMAGES BY DÜRER (Cat. 28) and Lucas van Leyden (Cat. 29), this engraving of a couple embracing conveys the notion of touch as a pleasurable sensation achieved by bodily contact.[1] Here the two half-dressed protagonists embrace one another as a preliminary stage in lovemaking. Since the couple's hands, the primary instruments of touch, are only partially depicted, in this case their overlapping bodies provide the main area of physical contact.[2] The two figures fill the entire picture space. Accessories are limited to a large cushion, the curtain setting, suggestive of a bedchamber, and the tortoise, an appropriate symbol for touch because its shell is so responsive to sensation.[3] Despite the visual representation of touch as an action that results in pleasurable feelings, the inscription by Cornelius Schonaeus conveys a negative message that this sensation can lead to immoral acts.[4] An early example of such moralizing appears in a woodcut of 1500 from the *Female Ship of Fools.*[5]

Although the five senses became a popular subject in sixteenth-century prints, along with similar series like the four seasons, the seven planets, and four elements, they were first depicted as female personifications and later expanded to allegories.[6] Instead of using a single figure of classical origin, Goltzius significantly expanded the theme by representing couples engaged in activities associated with the senses.[7] Although the woman's rich dress may be contemporary, the couple's facial types still show a classical, ideal quality. *Touch* is the last in Goltzius' series of the five senses, following sight, hearing, smell, and taste.[8] This order accords generally with the traditional hierarchy of the senses, in which the first two, located in the head and connected with cognitive and spiritual values, received a privileged status. Although the positions of taste and touch are sometimes inverted, both share the stigma of association with bodily appetites.

Jan Pietersz. Saenredam is well known as an engraver of the works of Hendrik Goltzius, the most gifted and successful graphic artist of his generation in Holland.[9] An immigrant from Germany during the first decades of Dutch independence, in 1577 Goltzius settled in Haarlem, then an important intellectual and artistic center. With Cornelis Cornelisz. van Haarlem and the painter, biographer, and art theorist Karel Van Mander, Goltzius introduced mannerist elements into Dutch art during the 1580s and 1590s.[10] After executing commissions for the Antwerp publisher Phillip Galle (Cat. 69), Goltzius opened his own graphic printing house in 1582, and as a result his own works, executed in a variety of media, circulated widely. Among Goltzius' pupils was Jacques de Gheyn II (Cat. 63). Saenredam and other graphic artists worked in Goltzius' studio during the year Goltzius traveled to Italy (1590-1591). Due to Goltzius' firsthand knowledge of antique and Renaissance works of art, his style became more academic and classicizing. Saenredam's engraving of *Touch* and the other senses reflect Goltzius' own search in his drawings for three-dimensional modeling and surface textures. Saenredam made his engraving from Goltzius'

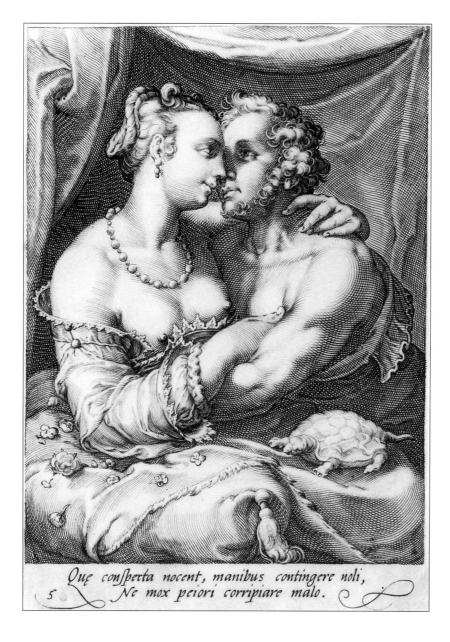

*Que consperta nocent, manibus contingere noli,*
*Ne mox peiori corripiare malo.*
5

9. See Dorothy Limouze, "Jan (Pietersz.) Saenredam," *DOA* 27:507. For a discussion of Saenredam's collaboration with Goltzius in the 1590s, see Jan Piet Filedt Kok, "Hendrick Goltzius—Engraver, Designer, and Publisher, 1582-1600," *Nederlands Kunsthistorisch Jaarboek* 42-43 (1991-1992):187-195.

10. See Pieter van Thiel, "Late Dutch Mannerism," in *Gods, Saints, and Heroes: Dutch Painting in the Age of Rembrandt,* exh. cat. (Washington, D.C.: National Gallery of Art, 1980), 77-79.

11. E. K. J. Reznicek, *Die Zeichnungen von Hendrick Goltzius* (Utrecht: Haentjens Dekke and Gumbert, 1961) 1:cat. no. 171, 308; 2:pl. 309. In 1961 the drawing of *Touch* was in the collection of P. de Beur in Amsterdam.

still-extant drawing, employing the latter's richly varied tonal engraving style to achieve a three-dimensional, sculptural effect.[11] The representation of *Touch* is a landmark in transforming its frame of reference from an abstract medical or classicizing personification to the concrete experience of sexual gratification.
CRS

*The Portal of Touch*, 1609
Attributed to Thomas de Leu
(fl. 1576-1614)
Engraving
Plate mark: 7½ x 5¾" (19 x 14.5 cm)
Bartolomeo Delbene (Del Bene),
b. 1514
*Civitas veri, sive morum*
Paris: Ambroise and Jérôme Drouart,
1609, p. 19
Inscribed:

*A. Porta contactus sive tangendi, operta hederis, quibus nomen ipsum ab herendo & tangendo. In hyperthyro autem Mars & Venus irretiti à Vulcano* (The gate of contact or touch, covered with ivy, whose very name [signifies] clinging and touching. And on the lintel, Mars and Venus caught in a net by Vulcan); *P. del Tatto* (Portal of Touch)
The Folger Shakespeare Library, Washington, D.C.

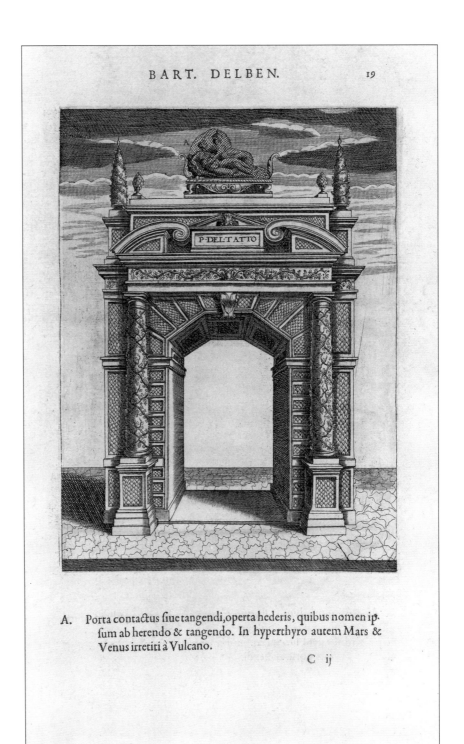

BART. DELBEN.    *19*

P·DEL·TATTO

A.    Porta contactus ſiue tangendi, operta hederis, quibus nomen ipſum ab herendo & tangendo. In hyperthyro autem Mars & Venus irretiti à Vulcano.

C ij

VIEWED BY ITSELF, THE REPRESENTATION OF TOUCH as a gateway or portal is puzzling. An explanation requires reference to the title of the work, translated as the City of Truth or Morals. Based on Aristotle's *Nicomachean Ethics,* the work is an allegorical epic poem and dream journey with an instructive prose commentary by Theodore Marcile.[1] The key illustration (Fig. 31) depicts the soul as a city, entered by five gateways, identified with the external senses (*B.* on the legend below the engraving). Touch is located on the upper right (northeastern quadrant) of this city view.[2] There follows a representation of each gateway as an architectural feature in a late sixteenth-century adaptation of classical forms. While the language of the text, including the explanation below the image is Latin, the inscription *P. del Tatto* on the pediment reveals that the architecture, like the language, is probably of Italian derivation. Specific decorative details exemplify the characteristic of each sense, as do the sculptural groups surmounting the gateway.[3]

As the fourth of the series, touch occupies a familiar place among the hierarchy of the senses, following sight, smell, and taste.[4] The negative evaluation of touch, related to the promotion of sexual activity (Cat. 30), continues in the symbolism of the ivy-covered engaged columns. As the legend below the image specifies, ivy is a plant connected with clinging and touching, thus emblematic of immoral bodily contact. The sculptural group of Mars and Venus, entangled in a net by the latter's husband Vulcan, refers to a mythical—and humorous—example of adulterous conduct.

The didactic tone of the representations, with clarifying inscriptions and legends, continues throughout the heavily illustrated volume.[5] Its author is Bartolomeo Delbene (Del Bene), a Florentine whose family came to France with Catherine de' Medici on her marriage to King Henry II.[6] A diplomat and poet, Delbene, who dedicated the *Civitas veri* to Catherine's son Henry III, became a member of the court academy, and enjoyed close ties with the poets of the Pléiade. The present work, in the tradition of the Mirror of Princesses genre, was originally intended as a memorial book of moral instruction for Delbene's patron, Marguerite of France, daughter of King Francis I and Duchess of Savoy, who died in 1574. For twenty years Delbene had served as Marguerite's secretary at both the French and Savoy courts.[7] Although the dedication of the book is dated 1585, the volume was not published until twenty-four years later on the initiative of Bartolomeo's son, Alphonse Delbene, bishop of Albi.

The image of the mind as a city or soul has many roots in medieval didactic literature, including Augustine's *City of God,* as does the idea of a central, fortified space that protects and encloses the virtues.[8] In a fifteenth-century illustrated manuscript of the *Nicomachean Ethics* produced in Naples, individual virtues stand in elaborate gateways.[9] Another application of the circular city divided into segments occurs in memory treatises, such as Cosimo Rosselli's *Thesaurus artificiosae memoriae* (Cat. 36 and 52), localizing images of Hell and Paradise.[10] A specific connection with the senses as gateways is found in a fourteenth-century French manuscript of Richard of Fournival's *Li bestiaires d'amour,* where Lady Memory stands at the doors of sight and hearing, signified by an eye and ear respectively (Fig. 32).[11] The senses as architectural gateways relate to notions of images as cognitive maps (Cat. 4), as well as to allegorical modes of representation that belong to long-standing literary, iconographic, and philosophical traditions in Western culture.

CRS

1. For discussion of the text, see Frances A. Yates, *The French Academies of the Sixteenth Century* (London: Warburg Institute, University of London, 1947), 111-116; Louise Vinge, *The Five Senses: Studies in a Literary Tradition* (Lund: Berlingska Boktryckeriert, 1975), 79-84; and Roger Paultre, *Les images du livre: Emblèmes et devises* (Paris: Hermann, Éditeurs des sciences et des arts, 1991), 147-149.

2. For the symbolic topography of the city, see Yates 1947, 112-114; Vinge 1975, 83.

3. For descriptions, see Vinge 1975, 81-82.

4. Most exceptionally, hearing is the last, instead of the second, external sense pictured. The reason for this unusual placement is that the commentary to the text calls for the entrance to the city by the respective parties through the gateway of hearing, by which learning is transmitted through the vehicle of speech (Vinge 1975, 83). For a similar treatment of hearing, see Bovelles' *Liber de sensibus* (Cat. 3).

5. The illustrations have been attributed to Thomas de Leu, who signed the engraving of the volume's title page. It is possible, however, that the engravings were executed by a group including de Leu, Jaspar Isac, and Léonard Gaultier. See Yates 1947, 111 n. 4, citing Jeanne Duportal, *Étude sur les livres à figures édités en France de 1601 à 1660* (Paris: Librairie Ancienne Honoré Champion, 1914), 155.

6. For an account of Delbene's career, see P. Procaccioli, "Bartolomeo Del Bene," *DBI* 36:330-333.

7. For references to Marguerite of Savoy, see Yates 1947, 111 nn. 2-3.

8. For references to the *City of God* illustrations, see ibid., 116 n. 2; for a stronghold of the virtues, see Claire Richter Sherman, *Imaging Aristotle: Verbal and Visual Representation in Fourteenth-Century France* (Berkeley and Los Angeles: University of California Press, 1995), 78.

9. See Jonathan J. G. Alexander, *Italian Renaissance Illuminations* (New York: George Braziller, 1977), 33, and pls. 35, 37, 108, and 113. The manuscript, executed for Duke Andrea Matteo Acquaviva of Atri, is now in Vienna, Österreichische Nationalbibliothek, Cod. Phil. Gr. 4.

10. Yates, *The Art of Memory,* pls. 8a-8b.

11. See Carl Nordenfalk, "Les cinq sens dans l'art du moyen âge," *Revue de l'art* 34 (1976):22-23; Elizabeth Sears, "Sensory Perception and Its Metaphors in the Time of Richard de Fournival," in *Medicine and the Five Senses,* 18-20.

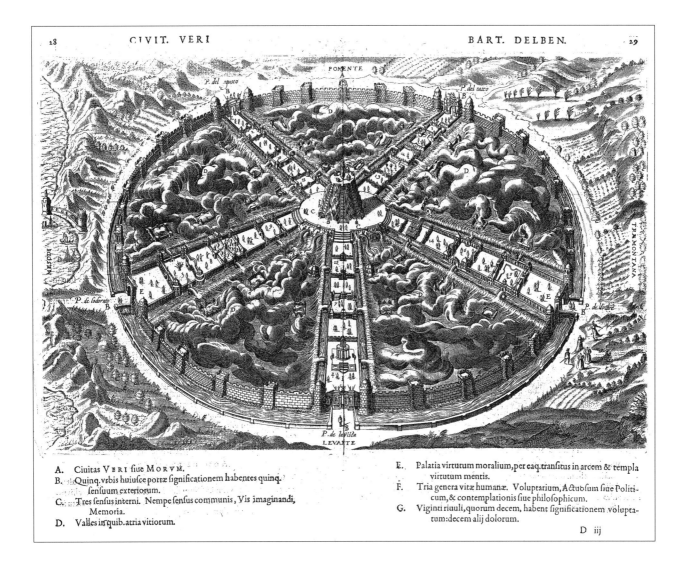

A.    Ciuitas VERI fiue MORVM.
B.    Quinq. vrbis huiufce portæ fignificationem habentes quinq.
        fenfuum exteriorum.
C.    Tres fenfus interni. Nempe fenfus communis, Vis imaginandi,
        Memoria.
D.    Valles in quib. atria vitiorum.

E.    Palatia virtutum moralium, per eaq. tranfitus in arcem & templa
        virtutum mentis.
F.    Tria genera vitæ humanæ. Voluptarium, A&uofum fiue Politi-
        cum, & contemplationis fiue philofophicum.
G.    Viginti riuuli, quorum decem, habent fignificationem volupta-
        tum: decem alij dolorum.

D iij

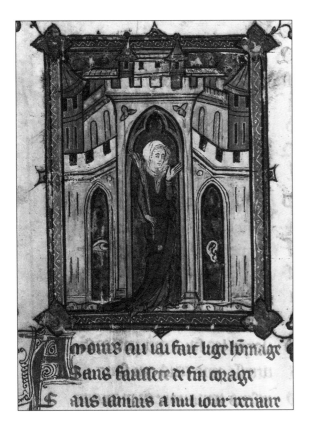

Fig. 31. *(above)* Attributed to Thomas de Leu, *The City of the Soul*, engraving. From Bartolomeo Delbene (Del Bene), *Civitas veri, sive morum* (Paris: Ambroise and Jêrome Drouart, 1609), pp. 28-29. The Folger Shakespeare Library, Washington, D.C.

Fig. 32. *(left)* French, early 14th century, *Lady Memory and the Doors of Sight and Hearing*. Richard de Fournival, *Li bestiaires d'amour*. Paris, Bibliothèque Nationale de France, MS fr. 1951, fol. 1

## 32 The Sensation of Heat

*The Sensation of Heat*, 1664
Louis de la Forge (fl. 1632-1666?) and
Gérard van Gutschoven (1615-1668)
Woodcut
Image: 4⁵⁄₁₆ x 3⅜" (12.6 x 8.6 cm)
René Descartes (1596-1650)
*L'homme . . . et un traité de la*

*formation du foetus du mesme autheur.*
*Avec les remarques de Louys de la Forge . . .*
Paris: Charles Angot, 1664, p. 97
History of Medicine Division,
National Library of Medicine,
National Institutes of Health,
Bethesda, Maryland

THIS STRIKING IMAGE occurs in the first textbook on physiology. The treatise by the great French philosopher René Descartes marks a turning point in viewing man "as a purely material and mechanical being." His work detaches the study of the body from "religious and cultural constraints," thus legitimizing "a clinical and experimental approach to anatomy and physiology."[1] Completed early in his career, the treatise was based on his experiments and dissections of animals.[2] Descartes' views on physiology formed part of his vision of a unified system of knowledge embracing philosophy, cosmology, mathematics, medicine, astronomy, psychology, and physics.[3] His revolutionary contribution to the history of science and philosophy also involved "the creation of an analytical body of reasoning" applicable to all spheres of thought.[4]

Descartes originally envisaged three related texts collectively called *Le monde* (The World), of which only two volumes, *The Treatise on Light* and the present treatise, were published.[5] Descartes withheld these treatises because his views on the physical nature of the world and the mechanical nature of the body might offend the church. His caution arose after the trial in 1633 of Galileo, who endorsed Copernicus' heliocentric views of the universe. As a result, *The Treatise on Man* (the title of the text in English) has a complicated history. During Descartes' lifetime, the work circulated in manuscript

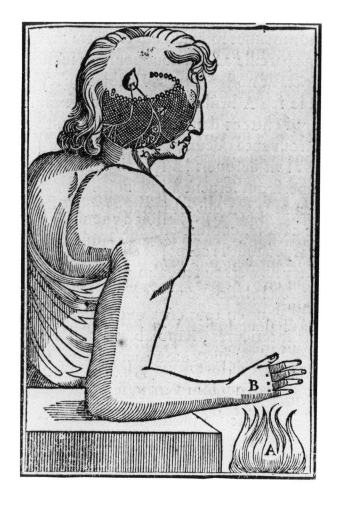

form in the author's original French version. But a Latin translation was published in Leiden in 1662 by Florentius Schuyl. Schuyl also undertook the commission of an elaborate series of engravings to accompany his translation. Two years later the present French edition, edited by Descartes' literary executor, Claude Clerselier, was published from the author's original manuscripts. Clerselier added an extensive commentary by Louis de la Forge, as well as Descartes' treatise on the formation of the fetus.[6] Critical of Schuyl's translation and the engravings in his edition, Clerselier commissioned new illustrations from both Gérard van Gutschoven, an anatomist who had worked with Descartes, and the commentator Louis de la Forge.[7]

In this illustration, the hand serves as a performer of an action initiated by the brain. Paramount here is the ability of the hand to respond to sensations of heat in order to avoid pain, a crucial attribute of touch. This woodcut demonstrates the way in which heat brings about the movement of "spirits" situated in the nerve tubes of the brain, connected to the crucial pineal gland, where the faculties of common sense, imagination, and memory are located.[8]

1. See "René Descartes," in *One Hundred Books Famous in Medicine* (New York: Grolier Club, 1995), no. 31, 117. For the French text and English translation, with excellent commentary and annotations, see Thomas Steele Hall, *Treatise of Man: René Descartes* (Cambridge, Mass.: Harvard University Press, 1972).

2. For accounts of Descartes' career from the points of view of the history of science and philosophy, respectively, see A. C. Crombie, Michael S. Mahoney, and Theodore M. Brown, "René du Perron Descartes" *DSB* 4:51-65; and Bernard Williams, "René Descartes," in *Encyclopedia of Philosophy* (New York and London: Macmillan Publications, 1967) 2:344-354. For a brief article on biographical sources on Descartes, see Barbara Whitehead,

"René Descartes, 1596-1660," in *Research Guide to European Historical Biography, 1450 to the Present* (Washington, D.C.: Beacham Publishing, 1993) 5:2797-2806. A full-scale work, with extensive bibliography, is Stephen Gaukroger, *Descartes: An Intellectual Biography* (Oxford: Clarendon Press, 1995).

3. I. Bernard Cohen, preface to Hall 1972, xv.

4. Whitehead 1993, 2798. Descartes knew personally or studied the works of various authors in this exhibition. For example, Marin Mersenne (Cat. 50) was his best friend. Descartes was an early supporter of Harvey (Cat. 23), and in Holland he met Comenius (Cat. 33).

5. The third treatise, possibly entitled *On the Soul,* was planned but was not among his papers when he died (introduction, Hall 1972, xxiv).

6. The treatise on the fetus is described as "an attempt to explain reproductive generation in mechanistic physiological terms." See Diana H. Hook and Jeremy M. Norman, *The Haskell F. Norman Library of Science and Medicine* (San Francisco: Jeremy Norman, 1991) 1:no. 628, 227.

7. Renato G. Mazzolini, in *The Mill of Thought,* entry for pl. 2, 12a, 92.

8. Gerrit Arie Lindeboom, *Descartes and Medicine* (Amsterdam: Rodopi, 1979), 80-81.

9. Clarke and Dewhurst, *An Illustrated History of Brain Function,* 68.

10. I. Bernard Cohen, *Album of Science: From Leonardo to Lavoisier, 1450-1800* (New York: Charles Scribner's Sons, 1980), pl. 307, 226.

11. Descartes is here dealing with two of the three parts of the soul (the vegetative and sensitive) in mechanistic terms. Yet various strands of his thought, such as the animal spirits, derive from traditional sources such as Galen. See Lindeboom 1979, 75-77; Gaukroger 1995, 270.

12. For the explanation of the diagrams in the text (fig. 37), see Hall 1972, 102-108.

13. For a detailed description of the brain in this diagram, see Clarke and Dewhurst, *An Illustrated History of Brain Function,* figs. 92-95, 68-70. For an English translation of the text, see Hall 1972, 102-108.

14. Hall 1972, 102-104 nn. 148-150.

In Descartes' view, the pineal gland was "the seat of the soul and the governing center of the human body, whose functions he explained in purely mechanical terms."[9] Elsewhere, Descartes states: "The pineal gland then puts into motion the fluid that makes the muscles draw the hand away from the fire."[10] In the woodcut the pineal gland appears in the upper part of the head as an isolated pear-shaped entity.[11]

The woodcut is an identical copy of one shown two pages earlier. In both, the representational mode is the diagram, familiar from an earlier woodcut of the brain (Cat. 27).[12] Again, clarity determines the choice of a profile view, showing a half-length male, leaning on a table, with his right hand, labeled *B,* over the flame, labeled *A.* In smaller letters and numbers, various locations in the brain (somewhat obscured by the netlike surface) are given in the adjoining pages of text.[13] Altogether the diagram attempts to explain how stimuli are received and cause different responses in the brain, a kind of cellular circuitry, which affects bodily action and movement in a mechanical explanation of behavior.[14]

CRS

## 33　The Mental Faculties

*The Mental Faculties* (Five External
and Three Internal Senses), 1685
Anonymous, German?
Woodcut
Image: 1³⁄₁₆ x 2¹¹⁄₁₆" (3.1 x 6.8 cm)
Johann Amos Comenius (Jan Amos
Komensky) (1592-1670)
*The World Seen through Pictures,*

English translation of the *Orbis
sensualium pictus* by Charles Hoole
London: Charles Murne, 1685, p. 86, pl. 42
Inscribed:
*The outward and Inward Senses/Sensus
externi et interni, etc.*
The Folger Shakespeare Library,
Washington, D.C.

THE *ORBIS SENSUALIUM PICTUS,* TRANSLATED INTO ENGLISH by the schoolmaster Charles Hoole a year after its original publication of 1658 in Nuremberg, combines features of an encyclopedia and a dictionary.[1] A landmark in the history of education, the work is the first illustrated textbook intended to teach children Latin. The title page makes clear its aim: "A picture and nomenclature of all things that are in the world; and of men's employments therein." This woodcut, selected from 151 illustrations, expresses the author's conviction that nothing exists without the evidence of the senses.[2] The difference between things must be rightly perceived and distinguished. In this cognitive process, visual images clarify such differences when tied to verbal elements of nomenclature and description. "Seeing is believing" expresses the philosophy governing the organization of the book, especially the idea that pictures form a particular manifestation of language.[3]

The illustration of the mental faculties, composed of the five external senses and three internal processes, is particularly appropriate to demonstrate within the book's structure the relationship between text and image.[4] First "the nomenclatures are the inscriptions, or titles, set every one over their own pictures, expressing the whole thing by its own general term." The second element is composed of the pictures, "the representations of all visible things," while the third consists of "the descriptions" which are "the explications of the parts of the picture, so expressed by their own proper terms."[5] Here the title "The outward and Inward Senses" is first given in English and then translated into Latin as "Sensus externi & interni." Next comes the picture, comprising six numbered main forms. The most extensive feature, the description, follows (with one exception) the order of these numbered figures. This part of the text is divided into two columns. In the left one English (the vernacular mother tongue) appears first in bold type. The second is Latin (the language to be learned), which corresponds line-for-line to the specific English term.

The illustration occurs in the second section of the book devoted to a description of the origins, ages, and parts of man in general.[6] Presented against a suspended curtain or drapery, five of the numbered figures depict the individual organs associated with the external senses in their customary order. Sight, signified by an eye, is first on the upper left; hearing, second on the lower left, by an ear; smell, by the nose on the upper right; taste, by the tongue hanging vertically; and touch, by a hand on the lower right. The properties of touch are described this way (p. 87): "The hand by touching discerneth the quantity and quality of things, the hot and cold, the moist and dry, the smooth and rough, the heavy and light." This example conveys Comenius' method of linking the

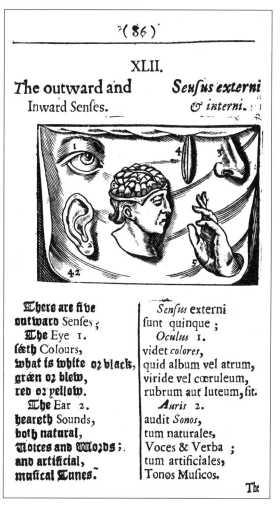

1. Ulrich Dierse, *Enzyklopädie: Zur Geschichte eines philosophischen und wissenchaftstheoretischen Begriffs* (Archiv für Begriffsgeschichte, Supplementheft 2), (Bonn: Bouvier Verlag Herbert Grundmann, 1977), 20-23. The edition included here dates to 1685.

2. The phrase is translated as: "Now there is nothing in the understanding which was not before in the senses."

3. Svetlana Alpers, *The Art of Describing* (Chicago: University of Chicago Press, 1983), 94.

4. For a detailed analysis of text-image relationships, see Janos S. Petofi, "*Orbis sensualium pictus:* Aus der Sicht der semiotischen Textologie," in *Johannes Amos Comenius, 1592-1992* (Atti del Convegno internazionale di Studi Macerata, 2-5 Dicembre 1992), ed. Clara Ferranti (Macerata: Quodlibet, 1998), 141-163.

5. Fol. A3v.

6. The first section is devoted to the parts of the world; the third, to how man makes a living by crafts and trade.

7. The citations come from p. 86 of the present edition.

8. See Yates, *The Art of Memory,* 362-364; Lina Bolzoni, "The Play of Images: The Art of Memory from Its Origins to the Seicento," in *The Mill of Thought,* 51-56; Lubomir Konecny, "Johannes Amos Comenius (Jan Amos Komensky)" in *I Cinque sensi nell'arte: Immagini del sentire,* ed. Sylvia Ferino-Pagden, exh. cat. (Milan: Leonardo Arte, 1996), 84-85.

9. For a biography in English, see Matthew Spinka, *John Amos Comenius: That Incomparable Moravian* (Chicago: University of Chicago Press, 1943). See also Anna Heyberger, *Jean Amos Comenius (Komensky): Sa vie et son oeuvre d'éducateur* (Paris: Librairie Ancienne Honoré Champion, 1928). For an interesting account of the Bohemian intellectual and historical milieu on Comenius' development, see Yates, *The Rosicrucian Enlightenment,* 197-210, 215-221.

10. J. L. Paton, "Comenius as a Pioneer of Education," in *The Teacher of Nations: Addresses and Essays in Commemoration of the Visit to England of the Great Czech Educationalist Jan Amos Komensky, Comenius, 1641-1941,* ed. Joseph Needham (Cambridge: Cambridge University Press, 1942), 10-17. See also Klaus Schaller, *Die Pädagogik des Johann Amos Comenius und die Anfänge des pädagogischen Realismus im 17. Jahrhundert,* 2d. ed. (Heidelberg: Quelle and Meyer, 1967).

11. For discussion of the editions, see John Edward Sadler, *J. A. Comenius and the Concept of Universal Education* (London: George Allen and Unwin, 1966), 268.

objects to be learned with everyday life and the environment. The individual images function sequentially as the equivalents of the verbal definitions to which they are linked.

The inward senses are depicted by a single head opened on top to show the brain. Although somewhat simplified, the tripartite scheme resembles those of the Dürer and Reisch woodcuts (Cat. 26 and 27). Depicted in profile facing right, this figure is divided into three sections. The familiar common sense (labeled *7*), which occupies the front of the brain, "apprehendeth things taken from the outward senses." Then number *6* "phantasie under the crown of the head judgeth of those things, thinketh and dreameth." Memory, labeled *8,* "under the hinder part of the head laeth up every thing and fetcheth them out: it loseth some, and this is forgetfulness."[7] Here numerical order of the parts corresponds to the physical location of the inner senses within the brain, so that the figure forms a cognitive map. As a whole, in their ordered structure and patterns associating image, word, and number the representations recall the methods of memory training, a tradition explored in the following section of the exhibition.[8]

The pedagogical process was of central concern to the author, Johann Amos Comenius (Jan Amos Komensky), one of the great thinkers of seventeenth-century Europe.[9] Born in Moravia, Comenius belonged to the Protestant sect of the Unity of Brethren or Bohemian Brethren, later known as the Moravians, of which he was the last bishop. Because of the upheavals caused by the Thirty Years' War and other strife, his life was one of wandering and exile. While one part of his prolific writings centered on a mystical quest for peace through acquisition of universal wisdom, his modern fame rests more on his reputation as a liberal reformer, particularly in the field of education. Not only a theoretician of pedagogy but also an experienced practitioner as administrator and teacher, Comenius received requests from various European countries to initiate programs of educational reform.[10] As a foundation of his search for universal wisdom, he believed in universal education for both genders and all social classes. The *Orbis sensualium pictus* was one in a series of textbooks written by Comenius linked to various stages of his educational program for the teaching of foreign languages through the vernacular. His humane approach to the education of children extended to recognition of their delight in pictures, as well as of their cognitive value. Comenius was also aware of the power of printing and well informed on its graphic and technical powers. Indeed, the combination of the small size, comprehensive but concise coverage, ingenious use of illustrations, and clarity of organization led to the enormous success of the *Orbis sensualium pictus.* Over the next three hundred years more than a hundred editions in many languages, including nine in the twentieth century, continued to be published.[11]

CRS

## 34 The Third Figure from the Gospel of Saint John

*The Third Figure from the Gospel of Saint John,* 1507
Anonymous
Woodcut
Image: 5⅝ x 3¹¹⁄₁₆" (14.2 x 9.5 cm)
Peter Wiechs von Rosenheim
(Petrus von Rosenheim) (c. 1380-1433)
*Rationarium evangelistarum, omnia in se evangelia prosa, versu, imaginibusque quam mirifice complectens*

Pforzheim: Thomas Anshelm, 1507, fol. a5
Inscribed:
*Figura Ioannis tertia* (The Third Figure from the Gospel of Saint John)
Rare Book and Special Collections Division, Library of Congress, Washington, D.C.,
Rosenwald Collection

PREVIOUS DISCUSSION HAS FOCUSED ON MEMORY as a site in the rear of the brain after external sense impressions have been converted and digested by various faculties (Cat. 26, 27, and 33). The present image introduces the ancient theme of cultivating memory as a means of improving the skill of a speaker in verbal communication. A staple of rhetorical texts inherited from Greece and Rome, such as the *Ad Herennium,* is the use of striking visual images arranged in a definite order to associate with and recollect the parts of a speech or argument. Such theories often invoke a spatial model involving places *(loci)* in an imaginary building in which the speaker or reader would place striking mental images *(imagines)* in order to imprint in the mind ideas or words for access and retrieval.[1] During the Middle Ages various channels transmitted these ideas for practical use by students, preachers of sermons, or for monastic meditation.[2]

The present image illustrates the practice of demonstrating by actual imagery the cultivation of artificial memory *(ars memorandi).* Here such notions are applied to the study of the Bible, particularly the contents of the New Testament's four Gospels.[3] One of a series of fifteen woodcuts, descended first from manuscripts and later from blockbooks, this illustration is the third in this work devoted to the Gospel of Saint John.[4] To facilitate the reader's recollection of each segment, both text and images break this Gospel into smaller parts, a procedure advocated in memory treatises. The units are the Gospel's twenty chapters, divided among the three woodcuts. The heading of each illustration identifies its number and sequence in the series. On the page opposite, short Latin titles associated with roman numerals briefly summarize the contents of each chapter. Below these a series of two-line verses (distichs), arranged in chapter order, reinforce the prose titles.[5] This arrangement coordinates verbal information with the illustration opposite.

The scaffolding of this striking image consists of the traditional symbol of the Gospel. This choice corresponds to the practice in mnemonic treatises of assigning a distinctive image a primary place in facilitating cognitive processes. Here the eagle of St. John, with feathered wings, outspread legs, and claws, predominates in size and frontal position. Attached to the bird's body are smaller numbered units, each providing a visual summary or emblem of the topics of chapters 13 to 20. Their content embraces the events of Christ's Passion and post-Passion appearances.[6] To make the reader more easily recall these subjects by associating them, the visual summaries follow narrative and chronological order.[7] For example, the depiction of chapter 13, the first in the sequence, places atop the eagle's head a shallow basin in which a hand touches a foot resting in the water. Employing a rhetorical figure, metonymy, in which a part refers to the whole of an entity, this image signifies the action of Christ washing the feet of his disciples. This episode occurred the night before the

1. See the Introduction in this volume, 14-15; 18-19, 20.

2. For an illuminating discussion of such practices, see Peter Parshall, "The Art of Memory and the Passion," *Art Bulletin* 81/3 (1999):456-463.

3. See *The Lessing J. Rosenwald Collection: A Catalog of the Gifts of Lessing J. Rosenwald to the Library of Congress, 1943-1975* (Washington, D.C.: Library of Congress, 1977), 116, no. 606.

4. For a detailed account of the transmission from manuscripts to blockbooks and printed editions, see Franz Thoma, "Die Beziehungen des Petrus von Rosenehim zu den Xylographa der *Ars memorandi* und zu den Frühdrucken des *Rationarium Evangelistarum,*" *Zentralblatt für Bibliothekswesen* 46 (November 1929): 533-546; Jean Michel Massing, "From Manuscripts to Engravings: Late Medieval Mnemonic Bibles," in *Ars memorativa: Zur kulturgeschichtlichen Bedeutung der Gedächtniskunst 1400-1750,* eds. Jörg Jochen Berns and Wolfgang Neuber (Tübingen: Max Niemeyer Verlag, 1993), 101-115.

5. See *Ars memorandi: A Facsimile of the Text and Woodcuts Printed by Thomas Anshelm at Pforzheim in 1502* (Cambridge, Mass.: Houghton Library, Department of Printing and Graphic Arts, 1981), fol. a4v.

6. For thorough analyses of the relationships between texts and images for mnemonic study of the Bible, see Hans Rost, *Die Bibel im Mittelalter* (Augsburg: Kommissions-Verlag M. Seitz, 1939), 141-149; and Massimiliano Rossi, "Gedächtnis und Andacht: Über die Mnemotechnik biblischer Texte im 15. Jahrhundert," in *Mnemosyne: Formen und Funktionen der kulturellen Erinnerung,* eds. Aleida Assmann and Dietrich Harth (Frankfurt am Main: Fischer Taschenbuch Verlag, 1991), 177-199.

7. The fundamental article on this series of images is Volkmann, "Ars memorativa," 121-126.

8. See Hellmut Rosenfeld, "Petrus Wiechs von Rosenheim," in *Lexikon für Theologie und Kirche* (Freiburg: Verlag Herder, 1963) 8:379; Massing 1993, 106-107.

feast of Passover, an event recounted in the first verse of this chapter. In a descending pattern along the illustration's central axis formed by the eagle's body, the next image is a heart. The reference is to Christ's advice to the disciples in chapter 14: "Let not your heart be troubled." Below this symbol there follow a leaf and cluster of grapes, an allusion to the first verse of chapter 15, in which Christ says: "I am the true vine and my Father is the husband man." Next comes a pointed hat, a costume accessory associated with the Jews that recalls Christ's warning in chapter 16 that the disciples would be chased from the synagogues.

The numerical sequence now shifts to the upper left, where a large circular form signifies the passages in chapter 17 where Christ refers to the world, which he is leaving, and where the Apostles remain. Opposite on the upper right, associated with the events in chapter 18, three cedar trees and a fence symbolize the garden of Gethsemane, where the events of Christ's betrayal and denial take place. For chapter 19 the image on the lower left depicts Christ's flagellation by Pilate, who holds a scourge in his left hand. The pendant image on the lower right stands for the Resurrection of Christ recounted in chapter 20. The witness to this event was Mary Magdalen, symbolized by the three pyxes. For the final image in chapter 21, the central axis again becomes the focus, as the Apostle Thomas (see Cat. 28), doubting the Resurrection, probes Christ's wound. Arranged in chronological and narrative sequence a symmetrical

arrangement of individual visual units facilitates the reader's cognitive processes. Also noteworthy is the location of the beginning and concluding chapters (13 and 21) at the top and bottom of the image's central axis. In both, hands play a prominent role in expressing human and divine agency.

The nine sixteenth-century printed editions of the *Rationalarium evangelistarum* attest to its popularity as a learning and preaching aid. One component of the text is the series of verses from the *Roseum memoriale* encompassing the Bible's entire contents by Peter Wiechs von Rosenheim, a Benedictine monk and educational reformer.[8] Separated into the appropriate sequences of Gospel chapters assigned to each woodcut, their inclusion in the present text, forms part of a familiar strategy (Cat. 42 and 47) in which oral or silent repetition of mnemonic verses is coordinated with nearby images to foster the reader's cognitive processes. The initial letters of the first line of each distich follow a sequence arranged in alphabetical order. In this case, initial letters of the nine verses, from *N* to *V* and then concluding with *A*, describe the same number and arrangement of chapters. The importance of images in learning and memory receives recognition in the short prefaces to the volume by Sebastian Brant and by the editor, George Simler, who refers to the *Ad Herennium,* which sets out fundamental principles of mnemonic theory.

CRS

# A Memory Tour of a City Street

*A Memory Tour of a City Street,* 1533
Anonymous
Woodcut
Image: 4½ x 3" (11.2 x 7.6 cm)
Johannes Host von Romberch
(c. 1480-1532 or 1533)
*Congestorium artificiose memorie*
Venice: Melchior Stessa, 1533, fol. 35v.

Inscribed:
*Abatia* (Abbey); *Barbi Tonsor*
(Barbershop); *Bellator* (Armorer);
*Bibliopola* (Bookshop); *Bovicida*
(Slaughterhouse); *Bubulcus*
(Swineherd)
The Folger Shakespeare Library,
Washington, D.C.

1. *The Art of Memory,* 115-116. For other
analyses of this and the subsequent related
images, see Volkmann, "Ars memorativa,"
167-170; and Lina Bolzoni, "The Play of
Images," in *The Mill of Thought,* pls. 8a and
8b, 33-34.

2. For a short biography, see Gundolfs
Gieraths, O.P., "Host, Johannes," *NDB*
9:653-654.

3. For Romberch's debt to Pietro da
Ravenna in particular, see Paolo Rossi,
*Clavis universalis: Arti mnemoniche e logica
combinatoria da Lullo à Leibniz (*Milan
and Naples: Riccardo Ricciardi, 1960),
27-31; Yates, *The Art of Memory,* 119-122.

WHILE LESS FANTASTIC THAN THE COMPOSITE IMAGE from the *Rationarium
evangeslistarum* (Cat. 34), the present illustration is also founded on the rules
of treatises on artificial memory. To aid in the recollection of an ordered series
of arguments or parts of a speech, the reader had to construct a series of places
on which to impose striking images. Here the illustration presents as the main
place an imaginary architectural and spatial model based on a walled town
familiar to contemporary readers. Frances Yates believes the origin of this col-
lection of buildings is a simple list of familiar objects to be memorized and
inscribed on groups of places.[1] Onto this configuration, the buildings act as
such separate places, arranged in a favorite memory device: alphabetical order.
Here there is one example for the letter *A,* and five for *B.* The reader/speaker
thus enters a city gate, beginning the sequence (using the Latin words) with
the abbey structures, proceeds upward to the barbershop, then to the
neighboring establishment of the armorer, followed by the bookshop, and
continuing forward to the slaughterhouse and the swineherd. All the places
have doors or openings for the reader/speaker to enter. The images, tied to the

nearby verbal labels, further distinguish, but also link, the individual sites. The complex of abbey buildings culminates in the cross of the church tower, while the other imaginary structures feature implements associated with their trades, such as the books displayed in the bookshop. Furthermore in order to reinforce the memorable quality of the images, the last two places, the slaughterhouse and the swineherd's pen, feature specific figurative examples of activities taking place there. The woodcut, appearing in the second treatise on places, demonstrates an apparently simple, but quite sophisticated, application of the rules governing artificial memory.

The author, Johannes Host von Romberch, was a German member of the Dominican order, long identified with preaching as a key element of its mission.[2] For such an activity in which oral presentation is paramount, memory is a vital element. It is therefore appropriate that the author of the present treatise identifies as an essential source of memory theory the work of the great Dominican theologian Thomas Aquinas. In turn, Aquinas' writing was based on his commentary on Aristotle's *De memoria et reminiscentia,* as well as on the *Ad Herennium.* During a long stay in Italy, Romberch became familiar with humanistic currents of thought. The first edition of the *Congestorium artificose memorie,* dating from 1520, was written during his residence in Venice and published there. Although small in size, perhaps a "pocket book" for portable reference, the volume is elaborately illustrated with a series of woodcuts that clarify various aspects of mnemonic theory, including visual alphabets (Cat. 38). Whereas Romberch's work relies on earlier printed *ars memorandi* treatises as well as manuscript sources, the book became widely diffused throughout Europe after the publication of an Italian translation by Ludovico Dolce.[3] The woodcuts, too, were copied in later texts (Cat. 38). The author addressed the book to a wide audience including not only theologians and preachers but also physicians, jurists, lawyers and notaries, philosophers, and professors of the liberal arts. Once again the value of visual imagery in cognitive processes receives full acknowledgment.

CRS

*A Visual Alphabet,* 1579
Anonymous
Woodcuts
Images: 5³⁄₁₆ x 3⁵⁄₁₆" (13.2 x 8.5 cm)
Cosimo Rosselli (Cosmas Rossellius)
(d. 1578)

*Thesaurus artificiosae memoriae*
Venice: Antonio Padovani, 1579, fols.
95v.-96r.
Library of the College
of Physicians of Philadelphia

A

B

1. Yates, *The Art of Memory,* 124.

2. Ibid., 125. For a survey of illustrations and texts, see Volkmann, "Ars memorativa," 146-173.

3. Volkmann, "Ars memorativa," fig. 179, 168. Romberch was following the illustration in the earliest printed artificial memory treatise (Venice: Erhard Ratdolt, 1482) the *Oratoriae artis epitome* by Jacopo Publico (Jacobus Publicius).

4. Yates, *The Art of Memory,* 128-129.

5. See Ludwig Volkmann, *Bilderschriften der Renaissance: Hieroglyphik und Emblematik in ihren Beziehungen und Fortwirkungen,* reprint ed. (Nieuwkoop: B. de Graaf, 1969).

AMONG THE VARIOUS VISUAL DEVICES WITH MNEMONIC FUNCTIONS, the use of visual alphabets is widespread. The term indicates "ways of representing letters of the alphabet by images."[1] For children beginning to read, remembering the individual letters by association with images (*A* by an apple, etc.) is a useful aid. Mnemonic treatises include alphabets consisting of animals or birds whose names are "arranged in the order of the first letter of their names."[2] The purpose of such alphabets is to provide an ordered sequence of striking images to inscribe on the chosen places of a particular memory system. In this example, the letters are suggested by instruments or objects with similar shapes (fols. 95v.-97v.). On folio 95v., in the third row *F* takes the form of a scythe *(falce)* in the first of four illustrations; a scimitar, in the last. The letter *I*, on the last row of fol. 95v. is suggested by a hook for picking fruit; a column, by an upright fish, or a rod. Another example, the letter *A* on the top row of fol. 96 is associated with a T-square and compass, instruments of measurements of an analogous shape. Each letter is placed within a rectangular grid of twenty–four individual, framed places formed by six vertical rows divided into four horizontal sections. Although the sequence as printed does not follow alphabetical order, the woodcuts attempt to isolate each image in a pattern that fosters association of objects with a particular letter. The verbal explanation of each object (fols. 94r.-94v.), sometimes difficult for the modern observer to recognize, appears on the preceding folio. Interestingly enough, although the language of the text is Latin, the verbal explanation is in Italian. This change came about both to arrive at terms for which no ancient word exists and, as the author states (fol. 93v.), to make the memorization process easier in the vernacular.

Cosimo Rosselli, another Dominican (but of Florentine origin), expanded the artificial memory treatise beyond that of his predecessor Romberch (Cat. 35). The title of his work again refers to the idea of memory as a treasure house. Although an alphabet of mechanical instruments appears in Romberch's work,[3] Rosselli greatly increased the number of such lists and associated objects to encompass stones and gems, minerals, snakes and serpents, and herbs and fruits. Also included are alphabets of ancient foreign languages, such as Hebrew, Persian, Turkish, Arabic, and Chaldean. Of particular interest is a manual alphabet forming letters for a sign language (Cat. 52).

Rosselli thus seems to aim at an encyclopedic type of memory treatise encompassing all types of knowledge. So detailed are many of his devices that their application to specific tasks of forming memory structures of places and images becomes problematic. Memory, as Frances Yates puts it, has "degenerated into a kind of cross-word puzzle to beguile the long hours in the cloister; much of their advice can have had no practical utility; letters and images are turning into childish games."[4] Yet visual puzzles are part of contemporary taste as evident in related developments in hieroglyphics and emblem books (Cat. 80-83).[5]

CRS

**37A,B**  The Apostles, Christ, and the Virgin, *left hand;* Saints, Christ, and the Virgin, *right hand*

*The Apostles, Christ, and the Virgin,* left hand; *Saints, Christ, and the Virgin,* right hand, 1491
Shop of Michael Wolgemut (1434 to 1437-1519) and Wilhelm Pleydenwurff (c. 1460-1494)
Handcolored woodcuts, red, blue, and green
Images: 9⅞ x 6⅞" (25.1 x 17.5 cm)
Stephan Fridolin (c. 1430-1498)
*Schatzbehalter der wahren Reichtümer des Heils*

Nuremberg: Anton Koberger, 8 November 1491, fols. v3v. and v4r.
Inscribed:
*Die linck hand* (The left hand), with profuse information following numbers II-XII; *Die recht hand* (The right hand), inscribed with saints' names
Rare Book and Special Collections Division, Library of Congress, Washington, D.C.

THIS PAIR OF HANDS CONCLUDES THE EXTENSIVE IMAGERY of the *Schatzbehalter,* which begins with two other hands inscribed with the numbers from one to a hundred (Cat. 2).[1] The Library of Congress copy is handcolored in red, blue, and green.[2] Instead of numbers, half-length figures of Apostles, Christ and the Virgin, as well as other saints, occupy the fourteen joints of the fingers and thumbs of each hand. Central to mnemonic theory is the notion of imprinting striking images on a carefully chosen system of places arranged in a structured order, whether a symbolic animal, a city street, or a human body (Cat. 34, 35, and 36). In these woodcuts, the shape and anatomical structure of the palms of the facing left and right hands provide the main places; the joints, the specific sites.

Even more than the numbered hands (Cat. 2), this pair follows intricate sequences developing complex structures of meaning that unite text and images. The verbal information located on the right part of the left hand (Cat. 37A) creates the scaffolding of this association. Beginning at the top, each item of the text, the Apostles' Creed, which summarizes essential articles of the Christian faith, carries a roman numeral (except for the first) from two to twelve.[3] Since every identifying image bears a corresponding number, an association is forged between the image of the saint and his words located to the right of the hand. The sequence begins with St. Peter on the lowest joint of the index finger, then passes to the second labeled figure above, St. John the Evangelist. The figures numbered three to five, Saints James the Great, Andrew, and Philip, all occupy the lowest joint of the middle, ring, and smallest fingers respectively. Then, in a reverse pattern starting with the second joint of the smallest finger, figures six to eight identify Saints Thomas, Bartholomew, and Matthew. The remaining figures, nine to twelve, depict Saints James the Less, Simeon, Jude, and Matthias, who occupy the top joints running from the index to the smallest finger. Not only are the Apostles distinguished by age, physiognomy, and the presence or absence of a beard, but also by their traditional attributes. The alternation of blue, green, and red is another device to aid in fixing in the mind the images of the individual personages. All the saints face left toward the figures placed on the thumb. Christ as the Man of Sorrows and the Virgin complete the sacred company, who serve as objects of devotion or meditation.

While the figures on the right hand (Cat. 37B) are not numbered and do not refer to the Apostles' Creed, a complex iconographic scheme relates them as "princes of faith" to the saints on the left hand. For example, St. Paul, traditionally associated with St. Peter, occupies the same site (the lowest joint of the index finger), while above the first two, St. John the Evangelist is paired with St. John the Baptist on the second joint of the same digit. The former group embodies the virtue of knowledge; the latter, humility. All face right in

1. For fuller discussion of the importance of the *Schatzbehalter,* see Cat. 2.

2. To compensate for damage to the palm of the left hand, a piece of paper with lines drawn in brown ink, to imitate those of the right, has been pasted in.

3. For the text and table of the iconographic structure, see Brückner, "Hand und Heil," 66.

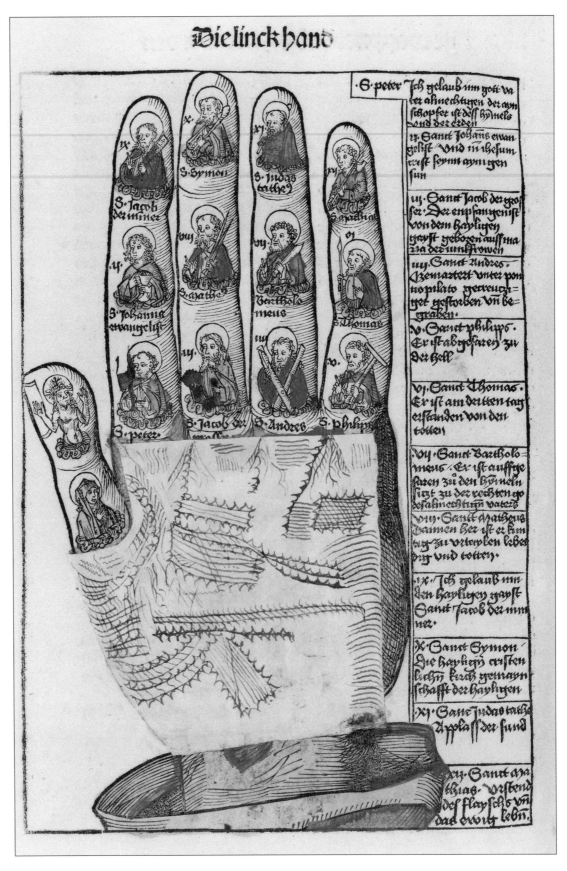

A

the direction of the nimbed Christ and Mary, transformed by faith from their earthly suffering to enjoyment of heavenly glory.

These images not only serve mnemonic purposes but also function as cognitive maps based on the anatomy and structure of the hands. By providing

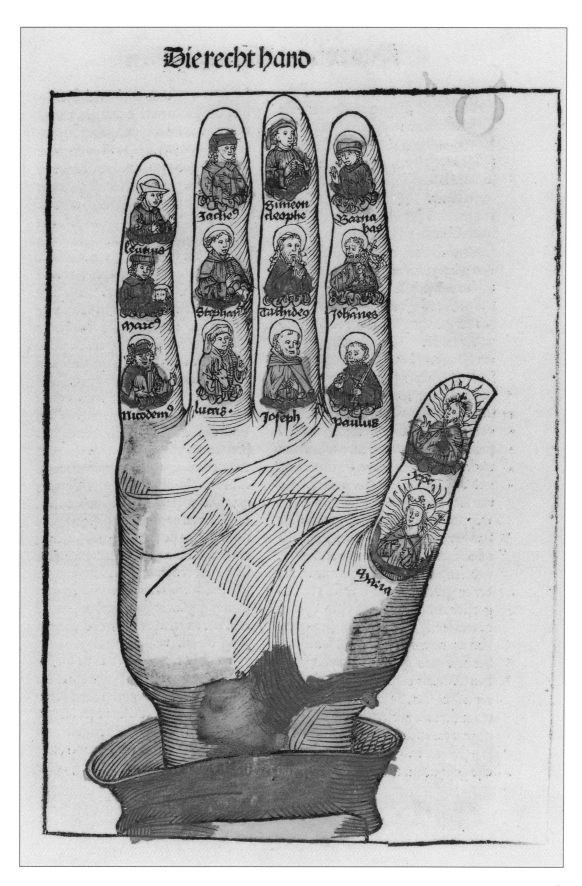

models of complex iconographic relationships capable of mental and actual recreation on the reader's own hands, these images offer lasting paradigms for meditation and contemplation of basic articles of faith connected with Fridolin's sermons.

CRS

B

# The Body as a Series of Memory Places

*The Body as a Series of Memory Places,*
1592
Anonymous
Woodcut
Image: 7⁹⁄₁₆ x 5" (19.2 x 12.7 cm)

Filippo Gesualdo (1550-1619)
*Plutosofia*
Padua: Paolo Megietti, 1592, p. 27
The Folger Shakespeare Library,
Washington, D.C.

1. Lina Bolzoni, "The Play of Images," in *The Mill of Thought,* pl. 1. 10, 36.

2. Ibid.

3. For a short biographical account of Gesualdo (using an alternative spelling of his name), including his birth date, see Lorenzo di Fonzo, "Gesualdi, Filippo," *EC* 6:222. For the Neoplatonic influences, see Yates, *The Art of Memory,* 167-168.

4. Volkmann, "Ars memorativa," figs. 186 and 189.

ALTHOUGH THE APPROACH TO CONSTRUCTING STRIKING IMAGES upon an imaginary place varies greatly between the fantastic composite image of the Gospel of St. John (Cat. 34) and a mundane city street in the Romberch (Cat. 35), another method emerges in the sole figurative illustration of Filippo Gesualdo's *Plutosofia* [Treasure of Wisdom]. Despite its Greek etymology, the title employs a familiar trope of memory as a treasure chest. The text, clearly organized in twenty lessons, devotes the eighth of them to the use of numbers in memory exercises. A specific application is the representation of the human body as the main mnemonic place. Instead of using words or letters of the alphabet, the author proposes a series of forty-two numbers attached to individual parts of the body. The arrangement starts at the bottom of the right toe and extends up that side of the body to the head. From that point the sequence is repeated in descending order, culminating in the left foot. This system is based on the body's symmetry "so that the Places are marked one laterally opposite the other, the way we see one ear with the other ear."[1] The author chose this number (fols. 26-26v.) as a means of enabling the reader to remember in chronological order, the forty-two ancestors of Christ, beginning with Abraham, cited in the first chapter of the Gospel of St. Matthew. Thus this system enables learning and recollecting this information "on one side, on the opposite side, and on both sides alternately."[2] As a mnemonic model, the body has an advantage over imaginary structures as a site always available for reference in uniting numbers with places.

Although in many respects the vernacular text repeats the methods of late medieval *ars memorativa* texts associated with his Dominican predecessors Romberch and Rosselli (Cat. 36 and 38), Gesualdo—a Franciscan—refers to Ficino and thus Neoplatonic currents in memory theory.[3] Gesualdo names his sixteenth-century predecessors, among whom figures Cosimo Rosselli (Cat. 36 and 52). Rosselli's work provided models for employing the human body as a series of memory sites for learning grammatical and anatomical information.[4]

The influence of humanistic and classical sources is evident in the choice of a seminude, heroic male figure with classical proportions. Perhaps copied from an antique or contemporary model of a deity or an orator, the figure is rendered in heavy, exterior contours and schematic interior shading. To permit the clearest exposure of the numbered body sites, the full frontal view of the body is chosen. Particularly interesting are the outstretched arms and hands. In contrast to the feet, where the toes are undifferentiated, all five fingers are numbered separately on the left (28-32) and right (11-15). Each sequence follows the same order beginning with the thumb. Although the representation is intended to serve a diagrammatic function, the prominence of the outspread hands gives them an expressive character in keeping with the sober dignity of the head. Indeed, hands and head are the only parts of the body Gesualdo numbered so extensively.

CRS

# A Hand with Memory Symbols

*A Hand with Memory Symbols*, 1602
Anonymous
Woodcut
Image: 4⅝ x 2¼" (11.8 x 5.7 cm)
Girolamo Marafioti
(Hieronymous Marafiotus)
(16th-17th Century)
*De arte reminiscentiae per loca,
& imagines, ac per notas,*

*& figuras in manibus positas*
Venice: Giovanni Battista Bertoni, 1602,
fol. 9
Inscribed:
*Sinistra in interiore parte* (Palm side of
the left hand)
The Folger Shakespeare Library,
Washington, D.C.

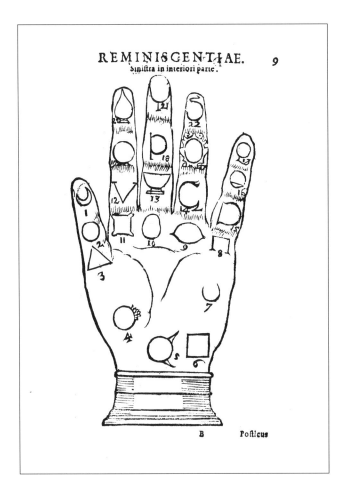

**IN HIS SHORT TREATISE ON THE ART OF MEMORY,** the Franciscan historian of his native Calabria, Girolamo Marafioti, substitutes for the architectural system of places (Cat. 36) a series of four hands.[1] Marafioti carefully explains his method of creating a total of ninety-two places divided between the palm and exterior sides of two pairs of left and right hands. By using the joints of the fingers and other sites on the palms, Marafioti assigns each hand twenty-three individual places, corresponding to the number of letters in the Latin alphabet. The author recognizes the utility of the hands for the reader's ready reference and reliability in constructing an ordered sequence of associations necessary for retrieving information required for speaking and preaching.

The present woodcut inaugurates the series of mnemonic hands: Marafioti (fol. 7) carefully instructs the reader on forming the memory route. In the present instance, a representation of the palm side of the left hand, begins the sequence with the nail level of the thumb (sites *1-3*) and continues on the mounts of the palm in a left to right direction (sites *4-7*). Then the sequence continues, but in a right to left direction (sites *8-11*) beginning with the bases of the smallest, ring, middle, and index fingers. The lowest joint of the index begins the following group of four (sites *12-15*). The next stage (sites *16-19*) reverses direction, starting with the second joint of the smallest finger. The final four (sites *20-23*) resume at the nail level, traveling from the index to the smallest finger. Marafioti also explains how on the next illustration (Fig. 33), depicting the exterior surface, the sequence is reversed, this time beginning with the nail level of the smallest finger.

The author does not neglect to explain the visual symbols on the first hand connected with the numbers. Inaugurating a strange mixture of images is a half moon (*1*), followed by two geometric shapes, a circle and triangle (*2* and *3*). Next on the palm come a ring, horned circle, square, and a semicircle (*4, 5, 6,* and *7*). Other parts of the ensemble include letters (*V, G,* and *D*), separated by a vase (*12, 13, 14,* and *15*).[2] Many of the symbols reappear in Figure 33, although in different positions. The next step requires the reader to construct upon these symbols an individually selected system of images to encourage recollection of them in an ordered sequence. For example, among types of material or spiritual entities to be recalled, Marafioti (fol. 7v.) suggests arranging a list of persons according to gender, age, social status, office, and character. Then the reader

1. "Marafioti (Jeronimo)," in *Nouvelle biographie générale depuis les temps les plus reculés jusqu'à nos jours* (Paris: Firmin Didot Frères, 1860), 33:346-347.

2. For the complete sequence, see Volkmann, "Ars memorativa," 171.

3. Ibid., 172.

4. Ibid., 171.

could position such a group on the hand in the places established by number and symbols. In another process, like Rosselli's (Cat. 36), he mentions the usefulness of a visual alphabet associated with instruments of a similar shape as the letters.

Marafioti's system of using the hands as places is far more abstract than that of the *Schatzbehalter* (Cat. 37), where visual images of sacred persons, placed on the joints of the fingers and closely connected with the adjoining text passage, provide a direct system of reference to the association and recollection of ideas. As in Rosselli's visual alphabet of instruments (Cat. 36), Volkmann observes that the method of the earlier *ars memorativa* genre (Cat. 34 and 35) is here moving toward a symbolic or emblematic mode of representation related to hieroglyphics.[3] Despite the complexity of Marafioti's recommendations, the book's modest size, and the sparse, crudely drawn woodcuts, his work enjoyed contemporary popularity. Addressed to a wide range of readers, including students, scholars, and orators, Marafioti's book soon came out in three subsequent editions and a later anthology.[4]

CRS

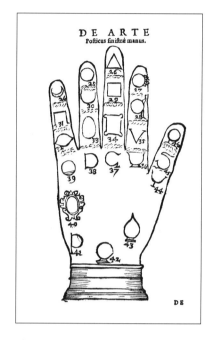

Fig. 33. Anonymous, *Memory Symbols on the Exterior of the Left Hand*, woodcut. From Girolamo Marafioti, *De arte reminiscentiae per loca, & imagines, ac per notas & figuras in manibus positas* (Venice: Giovanni Battista Bertoni, 1602), fol. 9v. The Folger Shakespeare Library, Washington, D.C.

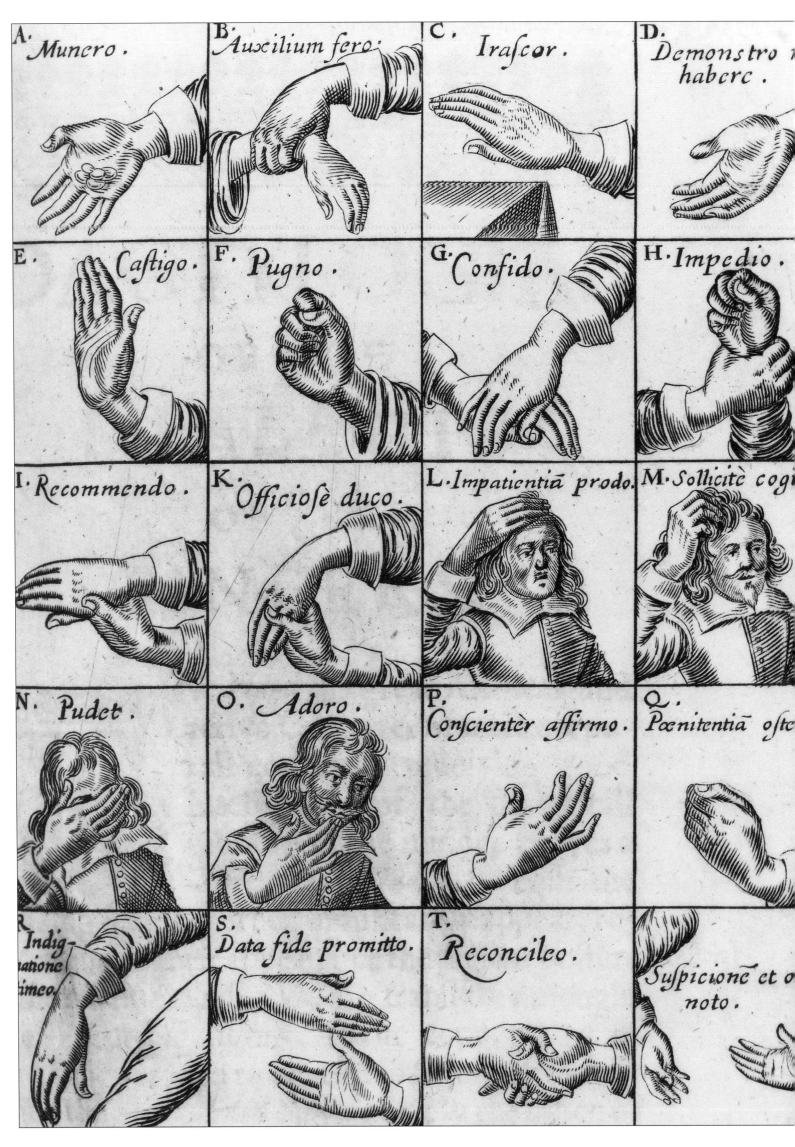

A. *Munero.*

B. *Auxilium fero.*

C. *Irascor.*

D. *Demonstro* *habere.*

E. *Castigo.*

F. *Pugno.*

G. *Confido.*

H. *Impedio.*

I. *Recommendo.*

K. *Officiosè duco.*

L. *Impatientiā prodo.*

M. *Sollicitè cog*

N. *Pudet.*

O. *Adoro.*

P. *Conscientèr affirmo.*

Q. *Pœnitentiā oste*

R. *Indig-* *natione* *timeo.*

S. *Data fide promitto.*

T. *Reconcileo.*

*Suspicione et o* *noto.*

# iv. Knowledge on Hand

*Manipulating Time: Cat. 40-45*
*Steps to Singing: Cat. 46-50*
*Companion of Eloquence: Cat. 51-56*

Bede's Finger Gestures
for 50-60,000; *and*
Bede's Finger Gestures
for 70,000-1,000,000

*Bede's Finger Gestures for 50-60,000*
(40A); *Bede's Finger Gestures for*
*70,000-1,000,000,* (40B),
Eleventh century
Anonymous
Pen and colored inks on vellum
Page: 8⁷⁄₁₆ x 5¾" (21.8 x 14.7 cm)

The Venerable Bede (c. 673-735),
fols. 38v. and 39r.
"De computo et loquela digitorum"
from *The Tegrimi Computus*
The Pierpont Morgan Library, M.925
New York City

1. Elisabeth Alföldi-Rosenbaum, "The Finger Calculus in Antiquity and in the Middle Ages, Studies on Roman Game Counters I," *Frühmittelalterliche Studien* 5 (1971):8. For additional information, see Charles W. Jones, *Bedae Opera de Temporibus* (Cambridge, Mass.: Medieval Academy of America, 1943), 179-181; Burma P. Williams and Richard S. Williams, "Finger Numbers in the Greco-Roman World and the Early Middle Ages," *Isis* 86 (1995):607-608; and Karl-August Wirth, "Fingerzahlen," *Reallexikon zur deutschen Kunstgeschichte* (Munich: C. H. Beck'schen Verlagsbuchandlung, 1987), 8:cols. 1279-1283.

THE FIRST CHAPTER of Bede's *De temporum ratione liber* (725) entitled "De computo et loquela digitorum" (On computing and speaking with fingers) was the most systematic and influential writing on finger-reckoning in western Europe. It was frequently copied out separately, as was the case with this manuscript, composed during the eleventh century. It is part of a collection of medieval manuscripts on the *computus* (time-reckoning methods for establishing the date of Easter) and astronomy, which once belonged to the collection at Casa Minutoli Tegrimi at Lucca, founded in the fifteenth century. With some variants, the text of this manuscript stays very close to the original text of "De computo et loquela digitorum."

On fol. 38v., the first five pictures in the left-hand column are for the numbers 50, 60, 70, 80, and 90, using the left hand. This is followed by three figures for 100, 200, and 300, using the right hand, whose gestures in fact correspond to those used for the 10s on the left hand. The 1,000s are expressed by gestures on the right hand, which in turn correspond to those for 1 to 9 on the left hand. The first and third figures at the top of the right-hand column show the numbers 1,000 and 3,000 respectively. From 10,000 onward, larger gestures are needed, and are shown here in the half-figures in roundels, a convention possibly of classical origin.[1]

The artists seem to have had some difficulty fitting the illustrations around the text. Moreover, they seem to have had little appreciation of what they were drawing or copying, as the figures for 60, 70, 80, and 200 do not exactly correspond to the description Bede gave (compare the gestures with the descriptions above, fol. 38v.); the figures for 100 and 300 are virtually indistinguishable from one another; the second and fourth figures at the top of the right-hand column show the numbers 200 and 900 respectively, where one would expect figures for 2,000 and 9,000.

On fol. 39r., Bede's explanation of finger-reckoning continues from the previous page. For 70,000, the left hand was placed over the thigh, palm outward. For 80,000, the left hand, palm down, was placed over the thigh. For 90,000, the left hand was placed on the loin with the thumb turned to the groin. For 100,000 to 900,000, the same gestures for the 10,000s are used for the right side of the body. In this image, the figures of 100,000 and 200,000 are shown at the bottom of the left-hand column. For a million, both hands are clasped together over the head with the fingers interlaced. The figure for a million was frequently depicted full-length, as it is here, in striking Roman dress.

Again, it seems that the artists may not have fully understood the significance of the gestures of a particular hand, as they confused the visual message by adding gestures to the other hand or exaggerated the irrelevant hand with objects such as a book (see also previous folio). After remarking on the numbers, Bede also refers to using fingers for representing letters.

SK

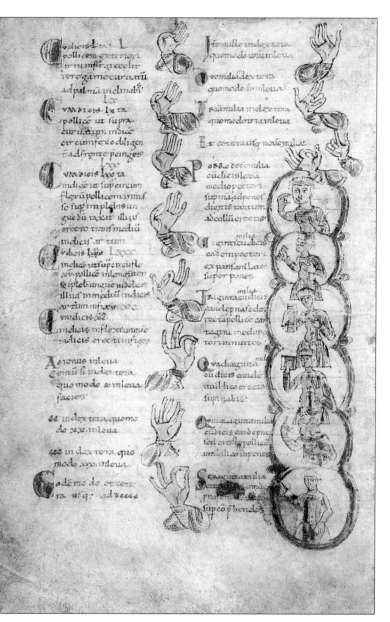

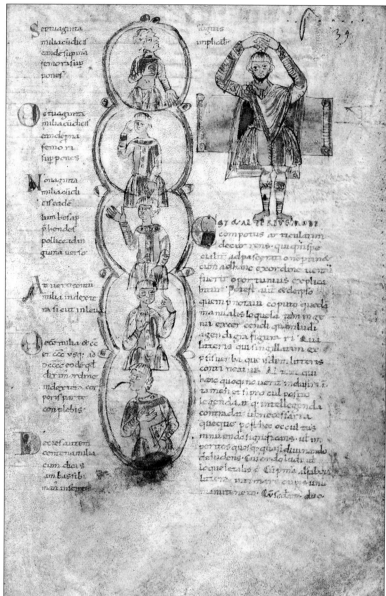

# An Easter Calendar Beginning with the Year 1466

*An Easter Calendar Beginning with the Year 1466*, 1466
Anonymous, German or Swiss
Handcolored woodcut
Image: 7⅜ x 5⁷⁄₁₆" (18.7 x 13.7 cm)
Inscribed:
*Rota . pasche . menses . dies . aureus . numerus* (Wheel of Easter, months, days, the golden number); inside the volvelle: *do . pede . preteritum . digiito [sic] . noto . Pasca . futurum . quae . numerum . aureum al +* (I offer with my feet Passover, with my finger, the future Easter and golden number); on the banderole of the angel: *alleluya . alleluya* (backward); inside the bottom left wheel: *litterae dominicales/ et bi— ectiles /m . c . lxvi* (Dominical and [bissextile] letters, 1466); inside the bottom right wheel: *Rota . aurei / . numeri / . m cccc lxvi . . .* (Wheel of the golden number, 1466)
National Gallery of Art, Washington, D.C., Rosenwald Collection, 1944

1. For further details, see the author's essay, 28-34. See also Wilhelm L. Schreiber, *Handbuch der Holz- und Metallschnitte des XV. Jahrhunderts*, 3d ed. (Stuttgart: Anton Hiersemann and Nendeln: Kraus Reprint, 1969) 4:69 no. 1904p; and R. Dean Ware, "Medieval Chronology," ed. James M. Powell, in *Medieval Studies: An Introduction* (New York: Syracuse University Press, 1976), 213-237.

2. The instruction to begin at the golden number ten would imply that the base year was 1472. See the description of calculating the liturgical calendar in the author's essay, 31-32.

THIS IS A CHART TO LOCATE THE DATE OF EASTER, which falls on the first Sunday after the full moon that occurs on or after the spring equinox. This definition, which involves both the lunar and solar parameters, may well be the reason why both the sun and the moon are pictured in the top corners. The central circle indicates the date of Easter, which derives from the "golden number."[1] The inner row shows the golden numbers from one to nineteen in roman numerals. The middle and outermost circles denote the date (month and day) of Easter corresponding to each golden number. The angel on the volvelle points with its hand (in green) and foot (in red) to the golden numbers for two consecutive years. Here, the foot points to the golden number one, indicating that Easter will fall on 7 April, and the hand points to the golden number two, the following year, when Easter will fall on 30 March. The dates for Easter in the center circle are valid for the nineteen years between 1466 and 1483.

The bottom right wheel is used to determine the golden number of a given year. So long as there is a particular year for which the golden number is known, the user can find out the golden number by counting forward (clockwise) or backward (counterclockwise) until one reaches the year for which the number is sought. The dots after *m cccc lxvi* in the wheel lead to *iiii*, which is indeed the golden number for 1466. Under the golden number ten, a handwritten inscription says *hic incipi* [begin here], and immediately underneath it, near the number nine, is inscribed [14]91. The users subtracted nineteen years from the base year, 1491, and then used the golden number for the year 1472, which is identical to it.[2]

The bottom left wheel is used to determine the dominical letter, indicating the dates on which Sundays fall in a particular year. So long as the dominical letter of a particular year was known, one could then go around the wheel (clockwise) counting from that letter until one reached the year for which the dominical letter is sought. Just above the *g-a* leap-year dominical letters, under the letter *b,* is a hand-written inscription, again, of *91*. This calculation fits in nicely with the year 1491 during which Sundays indeed fell on *b*-lettered days (i.e., 2 January, 9 January, and so on), and 1492 was a leap year with Sundays falling on *a* and *g*.

SK

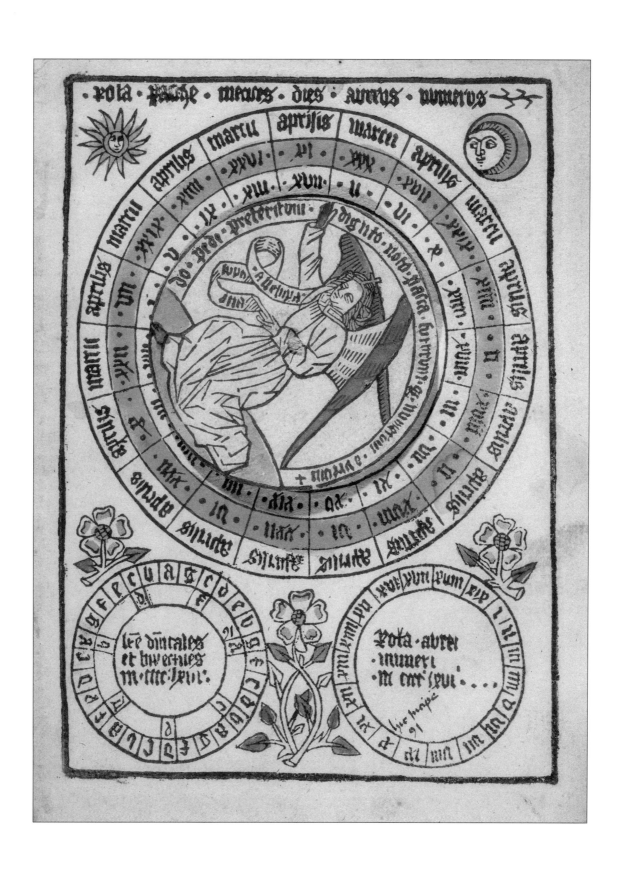

42A,B  The Exterior and Palm
of the Left Hand

*The Exterior and Palm of the Left Hand*,
1492
Anonymous
Woodcut
Image: 5¹⁄₁₆ x 3¹¹⁄₁₆" (12.9 x 9.4 cm)
Anianus (fl. 1300)
*Compotus cum commento*
Lyons: Matthias Huss, 1492, fols. 5v.-6r.
Inscribed:
Fol. 5v.: *Auricularis, Medicus, Medius,
Index, Pollex* (Little finger, ring finger,
middle finger, index finger and the
thumb); *Prima sub ungula* (First joint
under the nail); *Secunda sub ungula*
(Second joint under the nail); *Grossa
Radix* (Large base); *Summitas Pollicis,
Supra Radix, Radix Pollicis* (Tip of the
thumb, above the base of the thumb,
the base of the thumb); *Manus
Sinistra pro parte exteriori* (Left hand,
exterior side)
Fol 6r.: *Pollex, Index, Medius, Medicus,
Auricularis* (Thumb, index finger, mid-
dle finger, ring finger, the little finger);

*Summitas Pollicis, summitas indicis,
summitas medii, summitas medici,
summitas minimi* (Tip of the thumb,
tip of the index finger, tip of the
middle finger, tip of the ring finger, tip
of the little finger); *tertia supra radix,
tertia supra radix, tertia supra radix,
tertia supra radix* (Third joint above
the base); *supra radix, secunda supra
radix, secunda supra radix, secunda
supra radix, secunda supra radix*
(Above the base, second joint above
the base); *Radix pollicis, prima radix
indicis, prima radix medii, Radix
medici, radix minimi sive auricularis*
(Base of the thumb, first base of index
finger, first base of middle finger, base
of ring finger, base of little finger,
namely the ear finger); *Manus sinistra
pro parte interiori* (Palm of the left
hand). History of Medicine Division,
National Library of Medicine,
National Institutes of Health,
Bethesda, Maryland

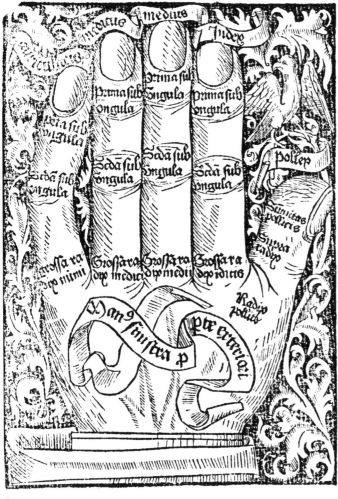

A

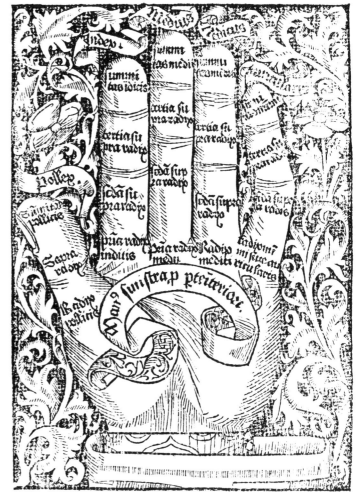

B

AN OTHERWISE UNKNOWN AUTHOR, A "MAGISTER ANIANUS," composed in the late thirteenth century a "manual" for determining the date of Easter using the left hand. It was written in the form of a verse of 244 lines that explains ways of using the left hand as a mnemonic table for solar and lunar cycles. Although this was not the only *computus* text to be written in verse, it was certainly one of the most popular manuals on the subject. This incunable edition is one of the earliest printed works with a commentary.[1]

Anianus' *computus* typically begins with images of the palm and outside of the left hand, the names of the fingers, and their relative positions. The thumb is called "pollex"; the index finger is next; followed by the middle finger; ring finger, or "medicus"; and the little finger, or "auricularis" (pertaining to the ears) is also called the "smallest."[2]

In all, fifteen places were identified on the exterior of the fingers of the left hand. Together with the places on the palm of the left hand, they form the basis for a mnemonic system to determine the phases of the moon on a particular day, as well as to establish the dominical letter (see Cat. 41).

Folio 6r. represents the interior (palm) of the left hand. The thumb has three places: the base, the joint above the base, and the tip. The other fingers have four positions, namely the first joint on the base, the second joint above the base, the third joint above the base, and the tip. Thus in all, there are nineteen positions on the palm of the left hand. For mnemonic locators of dominical letters, the sixteen positions on the inside and the twelve on the outside of the fingers (excluding the thumb) are used.[3] The nonsensical verse "Filius esto Dei celum bonus accipe gratis" serves as a mnemonic, the initial letters of each word indicating the dominical letters, *F-E-D-C-B-A-G*. The student therefore recites the verse, placing each word of the verse consecutively across the joints, starting from the base of the index finger *(filius)*, moving sideways to the base of the middle finger *(esto)*, base of the ring finger *(Dei)*, then to the little finger. The little finger stands for the leap years, so two letters *(celum, bonus)* were always allotted to it. The student then goes back to the index finger, next joint up, and continues the same process, repeating the seven-word verse until the place of the number of the remainder is reached. The initial letters of the word that fall on that place is the dominical letter for the required year. Anianus' "handy" tables were widely copied in later *computus* manuals. The use of the hand as a mnemonic table was not, however, unique to the *computus* literature, as it was also used in music textbooks (see Cat. 46, 47, 49, and 50).

SK

1. See the discussion in the author's essay, 28; David Eugene Smith, *Le comput manuel de Magister Anianus* (Paris: E. Droz, 1928); and S. B. Gaythorpe, "The Lunar Hand-Calendar of Magister Anianus," *Journal of the British Astronomical Association* 69/1 (1959):80-87; and Florian Cajori, Comparison of Methods of Determining Calendar Dates by Finger Reckoning," *Archeion* (1928):31-42.

2. See also the Introduction by Claire Richter Sherman, 14-15.

3. See the discussion in the author's essay, 31-32.

Pacioli's Finger-
Reckoning System

*Pacioli's Finger-Reckoning System*, 1494
Anonymous
Woodcut
Image: 9⅜ x 7⁷⁄₁₆" (23.8 x 18.9 cm)
Luca Pacioli (Lucas de Borgo)
(c. 1445-1517)
*Somma di aritmetica*, etc.

Venice: Paganino de Paganinis, 10-20
November 1494, fol. 44v.
Inscribed:
*1—9,000*
The Walters Art Gallery,
Baltimore, Maryland

1. S. A. Jayawardene, "Luca Pacioli,"
*DSB* 10:269-272; Karl-August Wirth,
"Fingerzahlen," *Reallexikon zur deutschen
Kunstgeschichte* (Munich: C. H. Beck'schen
Verlagsbuchandlung, 1987), 8:col. 1274.

LUCA PACIOLI LEARNED MATHEMATICS FROM VENETIAN MERCHANTS before
joining the Franciscan order in the 1470s. He then traveled through Italy, teaching
mathematics at the universities of Perugia, Naples, and Rome, and wrote
arithmetic treatises for his students. He dedicated the *Somma di aritmetica,
geometria, proporzioni, et proporzionalita* (1494) to Guidobaldo da Montefeltro,
Duke of Urbino (1472-1508), who was probably his pupil. In 1497 Pacioli
joined the court of Ludovico Sforza, Duke of Milan (1451-1508), where he met
Leonardo da Vinci. Pacioli helped Leonardo with mathematics, and Leonardo
in turn drew the figures of solid bodies for Pacioli's *Divina proportione*
(1496-1497). They left Milan together after the fall of Ludovico and journeyed
through Mantua and Venice. Pacioli then taught mathematics at the universities
of Pisa and Bologna. He became superior of his order for the Romagna region
and joined the monastery of Santa Croce in Florence. He also translated Euclid's
*Opus elementorum* into Italian and wrote a book on chess.[1]

The *Somma di aritmetica* is a comprehensive encyclopedia of arithmetic,
written in Italian, that drew upon earlier works of Euclid, Boethius, Sacrobosco,
and Fibonacci. It contains a summary of Euclid's *Elements,* a table of moneys,
weights and measures, double-entry bookkeeping, and elements of algebra.
This book was widely read by sixteenth-century mathematicians. In explaining
the finger-counting system, Pacioli altered Bede's system, where the figures for
the 100s and the 1,000s on the right hand corresponded to those for the 10s and
the digits, respectively. Pacioli inverted the figures for the 100s and 1,000s so
that the order of gestures would stay the same as that on the left hand. This
"new" system of finger-reckoning was widely copied, and Bede's system came
to be seen as an ancient model.

SK

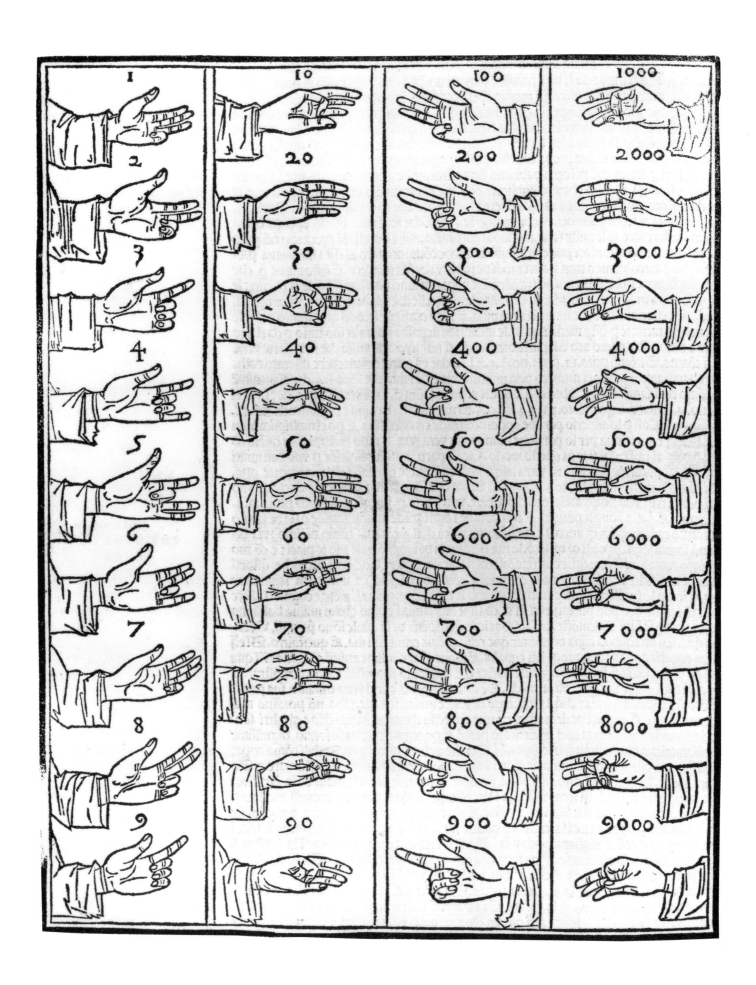

*The Hand as a Sundial,* 1534
Anonymous
Woodcut
Image: 4⅝ x 3¾" (11.9 x 9.5 cm)
Jacob Köbel (1494-1533)
(Image next page rotated 90° clockwise for clarity.)
*Bauern compas*
Mainz: Peter Jordan, 1534, fol. 3v.
Inscribed:
*Sonnuhr in des Menschen Hand zuerlernen* (To learn the sundial in a man's hand); *Mitternacht. Uffgang der Sonnen. Mittag. Nidergang der Sonnen.* (Midnight, sunrise, midday, sunset); *Berg des Daumens.* (Mound of the thumb); *der Daum* (Thumb); *Linie des lebens* (Line of life); *Zeygen Finger. Mittell Finger. Golt Finger. Ore Finger* (Index finger, middle finger, ring [lit. "gold"] finger, little [lit. "ear"] finger); *vor/nach mittag* (Before/after midday). The Folger Shakespeare Library, Washington, D.C.

1. Kurt Vogel, "Jacob Köbel," *DSB* 7:418-420; Josef Benzing, *Jakob Köbel zu Oppenheim 1494-1533, Bibliographie seiner Drucke und Schriften* (Wiesbaden: Guido Pressler, 1962), 79, no. 137.

2. Penelope Gouke, *The Ivory Sundials of Nuremberg, 1500-1700* (Cambridge: Whipple Museum of the History of Science, Cambridge, 1988), 9-15; A. J. Turner, *Time: A Catalogue* (Amsterdam: Foundation Time for Time, 1990), 124-132.

JACOB KÖBEL STUDIED FIRST AT THE UNIVERSITY OF HEIDELBERG, then he apparently moved to the University of Cracow to learn mathematics, where he may have been a fellow student of Nicholas Copernicus. By 1494 Köbel had settled in Oppenheim, where he worked as town clerk, official surveyor, and manager of the municipal wine tavern. Reflecting his occupation, Köbel's publications include manuals on barrels, volumes, land-surveying, commercial arithmetic, and paper instruments. These works on practical mathematics were printed in German for the use of laymen. His work is also important in the history of mathematics for disseminating knowledge of Hindu numerals.[1]

Here, in the *Bauern Compas* (The Farmer's Compass), Köbel shows how the hand may be used as a sundial. The German word *Sonnenuhr,* used here, had been coined around 1474 by Johannes Regiomontanus. The principle of a sundial is based on the changing direction of the sun in the sky.[2] The shadow cast by the sun over the gnomon, or indicator, changes direction (fifteen degrees every hour) as the sun rises and sets. A dial marked with hour lines can thus be used to tell time, so long as it is aligned properly (the midday line has to be aligned to the local meridian, usually with a magnetic compass). Designed as a sundial, the hand holds a stick as a gnomon between the thumb and the index finger. The midday-midnight signs outside the hand indicate the direction of the meridian against which the hand has to be placed. At noon the shadow cast by the stick should then fall on the part of the palm marked twelve. The numerals between one and twelve around the finger tips thus indicate local time. The hand as a sundial has obvious drawbacks, in as much as it only provides a very rough guide; it lacks a mechanism for precise alignment with the meridian or for latitudinal adjustment. Individual differences in the shape of the hand will also render the markers for time imprecise. It is, however, characteristic of Köbel to try to popularize the use of instruments for the layman.

SK

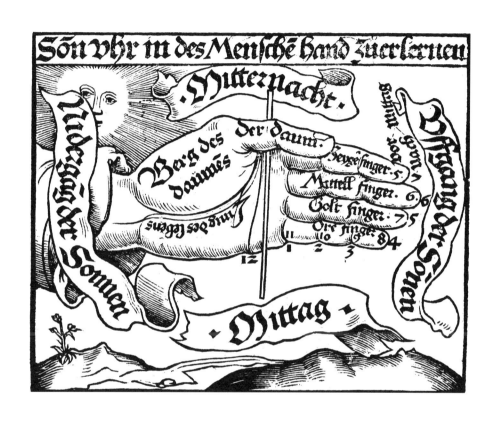

*Lunario for 1581*, 1580
Diana Scultori (Mantovana) (1547/1548-1612) after Francesco da Volterra
(d. 1594)
Engraving
Plate mark: 18 x 12⅜" (45.7 x 31.4 cm)
Sheet: 22 x 16³⁄₁₆" (55.9 x 41.1 cm)
Inscribed:
Top: *LVNARIO PER LANNO M.D.L.XXXI AL MERIDIANO DI ROMA/CONGLI CARATHIRI DEL* [sic] *FIGURI ET LA MVTATIONE DE TEMPI* (*Lunario* for the year 1581 for the meridian of Rome, with characters of figures and the change of season) *GREGORIO . XIII . P . M . PRIVILEG./ DIANA INCIDEBAT ROMA* (Privilege by Pope Gregory XIII. Diana engraved [this]. Rome); Base: *Mandoti Diana il disegno del lunario calculato per l'anno avvenire, accioche tu non perdi tempo d'intagliarlo, mentre io sto qui ocupato in ista nostra Fabrica. Et perche il tempo è breve, solecitalo, che io ancora presto saro da te. Di Volterra il primo di novembre 1580. Tuo Consorte Francesco detto il Volterra* (I am sending to you Diana the design for the *Lunario* calculated for the year to come, so that you do not have to lose time engraving it while I am here busy at this our workshop. Since time is short, hurry him up; and I, too, shall be there with you soon. From Volterra, 1 November 1580, your husband Francesco Volterra)[1]
Philadelphia Museum of Art: The Muriel and Philip Berman Gift, acquired from the John F. Phillips bequest of 1876 to the Pennsylvania Academy of the Fine Arts, with funds contributed by Muriel and Philip Berman, gift (by exchange) of Lisa Norris Elkins, Bryant W. Langston, Samuel S. White 3rd, and Vera White, with additional funds contributed by John Howard McFadden, Jr., 1985-52-2313

1. Inscription translated by Marina Frasca Spada.

2. Georg Kaspar Nagler, *Die Monogrammisten und diejenigen bekannten und unbekannten Künstler aller Schulen* (Munich and Leipzig: G. Hirth's Verlag, n.d.), 2:445-449; Valeria Pagani, "A *Lunario* for the Years 1584-1586 by Francesco da Volterra and Diana Mantovana," *Print Quarterly* 8/2 (1991):140-145; and Evelyn Lincoln, "Making a Good Impression: Diana Mantuana's Printmaking Career," *Renaissance Quarterly* 50 (1997):1101-1147.

3. Francesco was probably then working on the ceiling of Volterra cathedral (Lincoln 1997, 1131).

4. See also the discussion in the author's essay, 32 and Cat. 57.

DIANA SCULTORI (Diana Mantovana) was a daughter of Giovanni Battista Mantovano, decorator and engraver at Mantua. In 1575 she married a designer, architect, and carpenter, Francesco Capriani da Volterra, and moved to Rome the next year. There she obtained a papal privilege for making and marketing her prints, an unusual occurrence for the time. Diana was not trained in drawing, so her engravings were mostly based on designs by others, including her husband's. This was certainly the case with her *Lunario,* as the message from her husband, at the bottom, indicates.[2]

This engraving contains the almanac for the year 1581, issued in 1580.[3] It includes saints important to Volterra, Francesco's hometown, such as Iusto and Clement (5 June), Saints Attinea and Greciana (16 June), and Saint Ottaviano (1 September). A list of characters indicates the variety of information commonly included in such single-sheet calendars of the period—ember days (sign of the fish), eclipses (solar and lunar), Sundays (white half-circle), weekdays (black half-circle), wind (bald man in profile breathing out wind), rain (S-shaped curve), daytime hours (an hourglass with the sun), phases of the moon (black circles denoting a new moon; white ones, a full moon), nighttime hours (an hourglass with the moon), Carnival (a mask), cold (a hand), variable weather (m̲-like, horizontal squiggles), heat (a hatlike shape), and the best days for bleedings (an arrow) and taking medications (a cup). The band underneath the dates of the month indicates the location of the moon in the zodiac, and the "zodiac man" in the top left corner is a reminder of the astrological belief that governed the contemporary practice of bloodletting.[4] The figures of the labors of the month in the outside columns are unusually classical, closely resembling the classical patterns of the Sala dei Venti in the Palazzo del Te in Mantua, where Diana's father had worked under Giulio Romano.

It is likely that this plate for the *Lunario* for 1581 had previously been used for 1580. Faint traces of the Resurrection figure for Easter can be seen on 3 April. Similarly, one sees signs of a burnished out 29 February. The previous year, 1580, was a leap year and Easter had fallen on 3 April.

SK

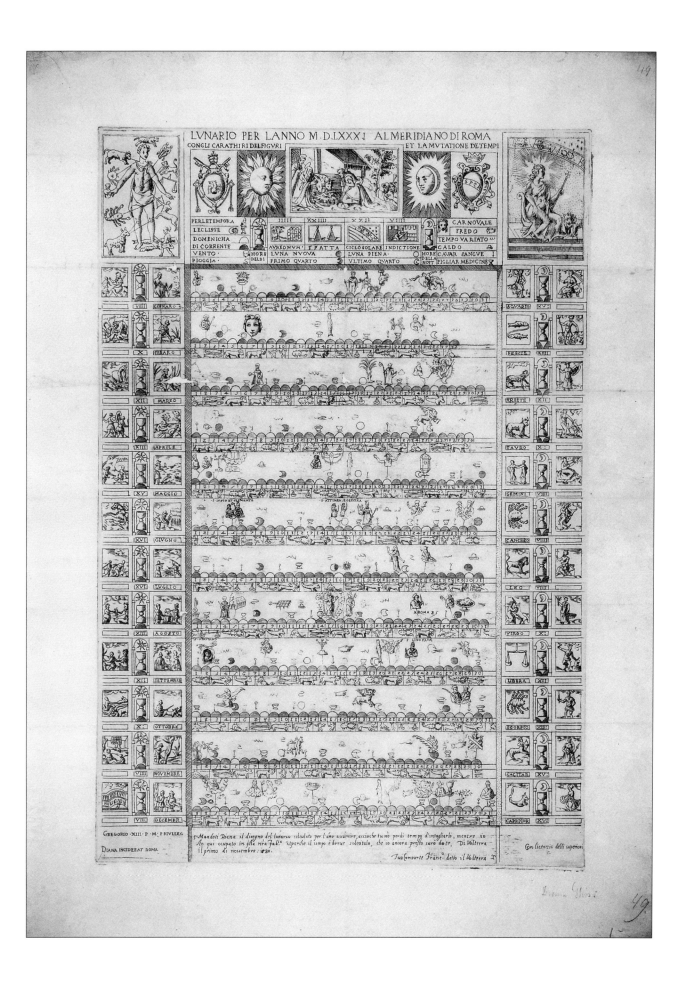

# The Guidonian Hand *and* Lady Music

The Guidonian Hand *and* Lady Music
Fifteenth century
Anonymous
Drawings in red and brown ink
Image: 9¾ x 6⅞" (24.8 x 17.4 cm)
Guido d'Arezzo (Guidone Aretino)
(c. 1000-c. 1050)
*Micrologus*
Chart from Chapter 16; single folio:
"Hand" on recto, "Lady Music"
on verso
Inscribed:
Guidonian Hand:
*monochordum boetij seu veterum per litteras minio factas exprimitur quattuor principalis quattuor mediae quattuor disiuncte tres excellentes:* (The monochord of Boethius, or of the ancients, by means of letters made, expressed four principals, four means, four disjunct, and three excellent [?] [intervals].)
Lady Music:
*Musica est vocum moderatio hoc est consequens motio* (Music is the arrangement of voice / This is suitable motion); *Iunguntur ipse sibi altera altri similiter et dissimiliter Secundum laxationes acuminis augmenti detrimenti modorumque varias qualitates* (These things are joined one to another similarly and dissimilarly / according to the spacings, variously augmented and diminished, of the various qualities of the modes.)
Music Division, Library of Congress, Washington, D.C.

1. Michel Huglo, "L'auteur du *'Dialogue sur la musique'* attribué à Odon," *Revue de Musicologie* 55 (1969):119-171; Hans Oesch, *Guido von Arezzo Biographisches und Theoretisches unter besonderer Berucksichtigung der sogenannten odonischen Traktate* (Bern: Paul Haupt, 1954); Claude Palisca, "Guido of Arezzo," *NGD* 7:803-807; Joseph Smits van Waesberghe, *De musicopaedagogico et theoretico Guidone Aretino eiusque vita et moribus* (Florence: L. S. Olschki, 1953), chap. 5, "De Manu Guidonica," 114-118; Joseph Smits van Waesberghe, "Guido von Arezzo," *MGG* 5:1071-1078; Joseph Smits van Waesberghe, *Guidonis Aretini Micrologus* (Rome: American Institute of Musicology, 1955).

THIS FOLIO APPEARS IN A FIFTEENTH-CENTURY MANUSCRIPT of Guido's *Micrologus*, copied by an anonymous English scribe. The drawing of the hand (46A), in two colors of ink, and that of Lady Music (46B) are included in chapter 16 of the *Micrologus*. Guido never mentions the hand in any of his writings, but his association with it, by means of early copies, became a trope of musical literature from 1100 to the present day. Many copies of his treatise, written years after his death, contain the image of the hand, almost always in conjunction with the teaching of the solmization syllables and the hymn *Ut queant laxis*, a poem with an acrostic containing the syllables of the six-note scale (hexachord), *ut re mi fa sol la*, used by Guido for his model song.[1] On the verso is a colored drawing of Lady Music holding a monochord labeled with some of the letters of the scale (gamut), *GABCDEFgabcd*. Under each letter—slightly out of alignment—are written the solmization syllables *ut re mi fa sol la sol fa mi*. Lady Music sits on a chair or throne and holds the monochord in her right hand while gesturing with her left thumb and forefinger, over which the syllables *ut* and *re* are written. In the Middle Ages, the classical liberal art, music *(Musica),* is depicted as a female accompanied by a plucked stringed instrument, such as a psaltery, lute, or monochord. The monochord contained a single string that could be stopped at various points along its length. It was often used as a pedagogical device in conjunction with the teaching of intervals and theoretical concepts to singers. All the information contained on the folio surrounding Lady Music, including the abbreviations and Latin names for the intervals (*s* = *semitonium* = half-step; *t* =*tonus* = whole step, etc., the ascending and descending hexachords) could be taught by using the monochord. The information and the principles of solmization could also be conveyed by the hand alone, without aid of the instrument, thus making the hand a valuable and, indeed, more portable, pedagogical device. The hand in the drawing has the letters in red to the left of the fingers; the syllables inside each of the fingers indicate whether they fall on lines *(linea)* or on spaces *(spatio)*. Other inscriptions mention the three hexachords, the natural, the soft and the hard, starting on c, f, and g, respectively (see Cat. 47).

SFW

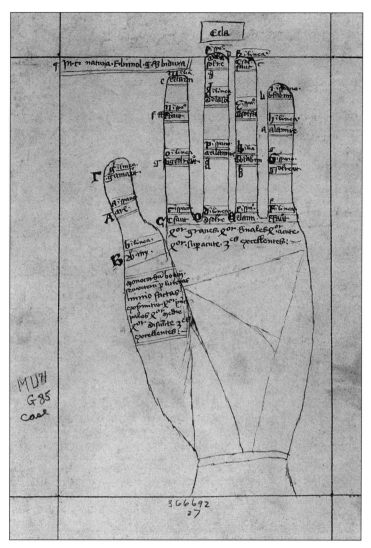

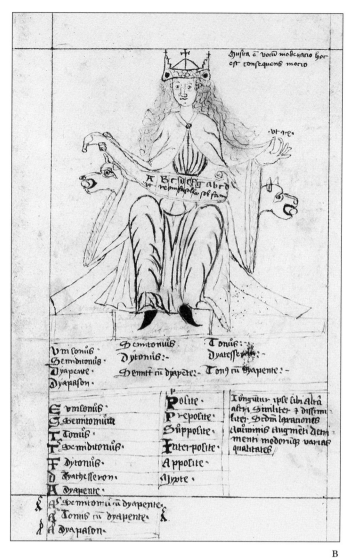

A                                                                                B

*Guidonian Hand*, 1488
Anonymous
Woodcut
Image: 6³⁄₁₆ x 4³⁄₁₆" (17.3 x 10.6 cm)
Hugo Spechtshart of Reutlingen,
or Hugo von Reutlingen (Hugo
Reutlingensis) (c. 1285-c. 1360)
*Flores musicae omnis cantus Gregoriani*
Strasbourg: Johann Prüss, 1488, p. 19
Inscribed:
*Sex vocum arsis et thesis*
*c　　　　f　　　　g*
*In natura b mollis que b dura*
*a　　　　d　　　　e*

(Six voices ascending and descending /
in natural (c-a), soft (f-d), and hard
(g-e) [hexachords]);
*Disce manum tuam si vis bene*
　　*discere cantum*
*Absque manu frustra disces per*
　　*plurima lustra*
(Learn your hand well if you want to
learn how to sing / Without the hand
you learn in vain through many years)
The Walters Art Gallery,
Baltimore, Maryland

1. See edition by Carl Beck, printed in Stuttgart, 1868 as part of the *Bibliothek des litterarischen Vereins,* vol. 89. Beck's edition includes the original Latin, a German side-by-side translation, some facsimile pages of notation, the Guidonian hand, the monochord, and transcriptions of the music.

2. See Cecil Adkins, "Spechtshart, Hugo," *NGD* 17:821; Karl-Werner Gümpel, "Hugo von Reutlingen," *MGG* 6:867-870; Karl Wolfgang Niemöller, "Nicholaus Wollick," *NGD* 20:512; Lilian M. C. Randall, "*Flores musicae*: A Musical Bouquet," *The Walters Art Gallery Bulletin* 29/3 (1979):1-3; Susan F. Weiss, "Musical Pedagogy in the German Renaissance," in *Constructing Publics: Cultures of Communication in the Early Modern German Lands,* forthcoming.

DATING FROM THE FOURTEENTH CENTURY (original manuscripts from 1332 and 1342), but not printed until a century later, is a treatise by a German schoolmaster named Hugo von Reutlingen (family name Spechtshart) that was probably used to teach young choristers. Hugo was also the author and chief source of music and information on the fourteenth-century *Geisslerlieder,* as well as books on logic, dialectic, and grammar. Hugo's text was so popular that it was translated from Latin into German and found in printed editions through the second half of the nineteenth century.[1]

The treatise is written in the form of a didactic poem, with some pointers on practical matters and attempts to add a little music history along the way. This treatise illustrates the characteristics seen in other Latin medieval treatises, covering subjects espoused by Guido concerning the rules and principles of ecclesiastical chant, the gamut, the monochord, the intervals, the church tones, and their use. It contains full-page illustrations, such as the so-called Guidonian hand, as well as diagrams of the mathematical principles behind the monochord and the ratios of intervals. There are two identical full-page woodcuts, one as a frontispiece and one a little later on, depicting in the background the biblical patriarch Jubal chiseling musical notes onto columns. In the foreground, two men in the blacksmith's shop beat on iron producing notes by striking an anvil with hammers of different weights, while Pythagoras stands behind them weighing the hammers. Hugo includes this illustration for several reasons, not the least of which is that a picture is worth a thousand words. His young students are learning the story of the discovery of the musical intervals and also the importance of preservation. The columns are brick and probably marble, substances that in the event of flood (notice the boat in the background) or fire would preserve the basics of musical knowledge for future generations. In a later hand is the inscription "Monastery of S. Petri in Salzburg." The palm of the hand contains the ascending and descending hexachord on g with the Latin inscription describing the three hexachords, natural, soft, and hard, under which is the poem that urges the student to use the hand in order to save time in learning his songs. The Walters Art Gallery owns another, slightly later, copy of the *Flores,* published in 1492.[2]

SFW

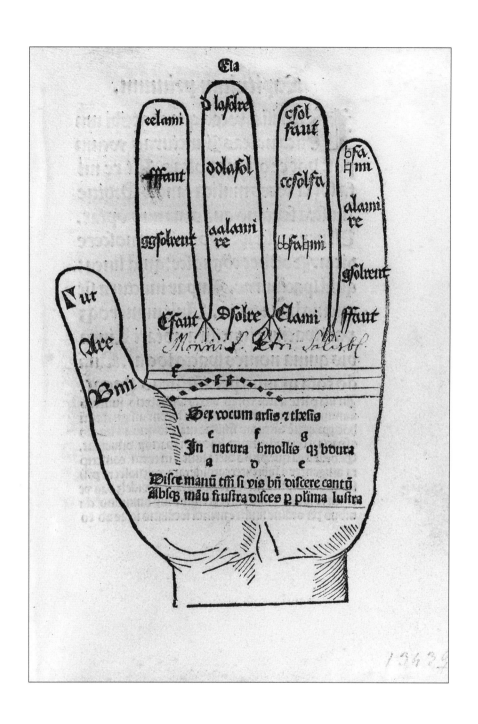

*Musical Performance*, 1507
Anonymous
Woodcut
Image: 4 x 3¹¹⁄₁₆" (10.1 x 9.3 cm)
Balthasar Prasperg (Balthasser
Praspergium) (died c. 1511)
*Clarissima plane atque choralis musicae
interpretatio*
Basel: Michael Furter, 1507, frontispiece
Inscribed:
*Clarissima plane atque choralis musicae
interpretatio D͟o͟mini Balthasser*

*Praspergij Merspurge͟n͟s͟is, cum
certissimis regulis atq͟u͟e Exemplor͟u͟m
annotationib͟u͟s et figuris multum
splendidis. In Alma Basileor͟u͟m
universitate exercitata.* (The clearest
interpretation of chant and choral
music by Balthasar Prasperg of
Meersburg with rules and annotated
examples and many splendid figures
used at the University of Basel.)
Music Division, Library of Congress,
Washington, D.C.

1. See Dragotin Cvetko, "Praspergius," *MGG*
10:1599, and his *Zgodovina glasbene umetnosti
na Slovenskem* (Ljubljana: Drzavna zalozba
Slovenije, 1958-1961), 68, 369; Robert Eitner,
*Biographisch-bibliographisches Quellen-
Lexikon* (Leipzig: Breitkopf and Hartel, 1902),
2d ed. (New York: Musurgia, 1947), 51;
Heinrich Hüschen, "Der Musiktheoretiker
Balthasar Prasperg," *Kirchenmusikalisches
Jahrbuch* 35 (Cologne: J. P. Bachem, 1951),
31-35; Hugo Riemann, *Musik Lexikon* (Mainz:
B. Schott, 1975), 1:411; Andreas Weissenbäck,
*Sacra Musica: Lexikon der Katholischen
Kirchenmusik* (Vienna: Augustinus Druckerei,
1937), 321. See also Sebastian Virdung, *Musica
getutscht: A Treatise on Musical Instruments
(1511),* trans. and ed. Beth Bullard (New York
and Cambridge: Cambridge University
Press, 1993).

THIS WOODCUT DEPICTS A MUSIC TEACHER GESTURING with his left hand to a
banner inscribed with the solmization syllables *ut re mi fa sol la,* while a young
noblewoman (judging from her clothing) plucks the strings of the harp she is
holding. The picture is a clue to the intention of this book, which is aimed at a
wider audience, one that is probably not advanced in its knowledge of music.
It has instead the appearance of being "user-friendly." Prasperg's little book
contains only nineteen folios and begins with the customary mixture of legend
and history, music's supposed invention by Tubal and its philosophy according
to Boethius. What follows is the Guidonian system of hexachords and a section
on chant followed by one on mensural music. There are numerous diagrams
with examples of music written in *hufnagel* notation (similar to that found in
Hugo's *Flores).* There is also a pull-out section on the Greek scale. The book
was printed in Basel in 1507 by Michael Furter, whose colophon pays homage
to Prasperg, mentioning the lyra of Orpheus and the cithara of Sappho.
Perhaps the woman playing the harp is meant to be the pagan Sappho, who has
been depicted playing her harp in a late fifteenth-century miniature in
Boccaccio's *Des cleres et nobles femmes* (New York Public Library, Spencer MS
33, fol. 24). An earlier edition of Prasperg's book was published in Basel in 1501
by Michael Furter, who also published Sebastian Virdung's *Musica getutscht,*
the first printed manual on musical instruments, published in 1511.[1]

SFW

# Clariſſima plane

atq̃ choꝛalis muſice interpꝛetatio
Dñi Balthaſſer Pꝛaſpergñ Mer
ſpurgeñ.cum certiſſimis regulis
atq̃ Exemploꝛ Annotationib̾
ꜩ figuris multum ſplendidis. In
Alma Baſileoꝛũ vniuerſitate ex
ercitata.

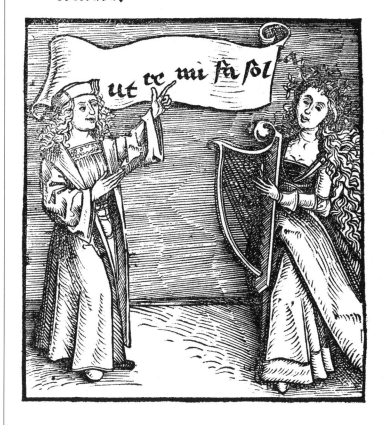

*Musique*, 1587
Attributed to Jean Cousin the Younger
(c. 1522-c. 1594)
Woodcut
Image: 16 x 12½" (40.7 x 31.8 cm)
Christofle de Savigny (c. 1530-1608)
*Tableaux accomplis de tous les arts liber-
aux contenans brievement et clerement
par singuliere methode de doctrine, une
generale et sommaire partition des dicts
arts, amassez et reduicts en ordre pour
le soulagement et profit de la jeunesse*

(Tables of all the liberal arts contained
briefly and clearly by a singular
method, etc.)
Paris: Jean & François de Gourmont
frères, 1587, fol. D
Inscribed:
*Musique* (Music); *Pseaulme de Davit.
CIII* (Psalm of David, 103) "*Sus.louez
Dieu mon ame en toute chose*" (Bless
the Lord, my soul, in all things)
The Folger Shakespeare Library,
Washington, D.C.

1. François de La Croix du Maine attributes the illustrations to N. Bergeron, but Papillon and others agree on the Savigny/Cousin collaboration. See Michèle Beaulieu, "Pierre Bontemps et les Cousins Père et Fils, artistes sénonais de la Renaissance," in *Clio et son regard: Mélanges d'histoire de l'art et d'archéologie offerts à Jacques Stiennon à l'occasion de ses vingt-cinq ans d'enseignement à l'Université de Liège*, eds. Rita Lejeune and Joseph Deckers (Liège: Pierre Mardaga, 1982), 35-48. Included is a figure that reproduces plate 24 from *Le livre de Fortune* by the younger Cousin. The design and calligraphy match the illustrations in the *Tableaux* of Savigny (ibid., 43).

2. This last section on theology may have actually been written by the lawyer Bergeron who had been credited with the entire work when it was translated into Portuguese by Manuel Pinto Villalobos. See Abbé Jean-Baptiste Joseph Bouillot, *Biographie ardennaise*, (Paris: Chez l'éditeur, rue de l'Arbe-Sec, no. 9, 1830), 2:362-377; Jacques Charles Brunet, *Manuel du Libraire* (Paris: Firmin Didot Frères, 1864), 155; Ambrose Firmin Didot, *Étude sur Jean Cousin* (Paris: A. F. Didot, 1872), 195-197; Henri-Jean Martin, "Classements et conjonctures," in *Histoire de l'édition française* (Paris: Promodis, 1982), 1:429-462; Ruth Mortimer, comp., *Harvard College Library, Department of Printing and Graphic Arts: Catalogue of Books and Manuscripts, Part 1: French Sixteenth-Century Books*, vol. 2 (Cambridge, Mass.: Harvard University Press, 1964); Jean-Michel Papillon, *Traité historique et pratique de la gravure en bois* (Paris: Pierre Guillaume Simon, 1766), 2:279-295.

SAVIGNY WAS BORN AROUND 1530 IN SAVIGNY-SUR-AISNE, a town near the Ardennes, and died in 1608 in the same area. He came from an aristocratic family and was learned in languages. This unique work—not far removed from the genre of an oversize modern coffee-table book—is dedicated to Ludovico Gonzaga, Duke of Nevers and Rethel and Prince of Mantua, for whom Savigny worked. There are at least eighteen illustrated tables, each followed by a page of explanatory text, which are believed to have been executed by both Savigny and the important sixteenth-century artist Jean Cousin the Younger.[1] In one of the tables, each of eighteen arts and sciences appears in small links forming a large circle around dozens of terms linked to one another within the circle. The subjects include grammar, rhetoric, poetry, dialectic, arithmetic, geometry, optics, music, cosmography, astrology, geography, physics, medicine, metaphysics, ethics, jurisprudence, history, and theology.[2] Each of these sections consists of a smaller number of parts, seventy-eight for grammar, sixty-six for ethics, and so on. Savigny's schematization of knowledge—or encyclopedic tree of knowledge—is said to have been a precursor to the writings of Francis Bacon, whose work *Two Books of the Proficence and Advancement of Learning Divine and Humane* was published in 1605 in London. A second edition was published in Paris in 1619 by Jean Libert. The music page consists of a border of all of the important instruments of the time including lutes, viols, organs, bagpipe, hurdy-gurdy, drums, recorders, shawms, sackbut, cornetto, vihuela, psalteries, and clavichords. Within the border are the iconographic and verbal signs and symbols of musical theory, including the Guidonian hand, notation for the three hexachords, the head motto of Psalm 103 and a scroll containing notes arranged from increasing to decreasing duration atop a smaller scroll containing the symbols for rests. In Savigny's narrative on the following page, he begins by stating that "Musique c'est l'art de bien chanter," an indication that his system is meant to produce practical results. The table, in its schematic design, is intended as a mnemonic for helping young musicians both to memorize and to understand the principles behind the fundamental concepts of musical theory.
SFW

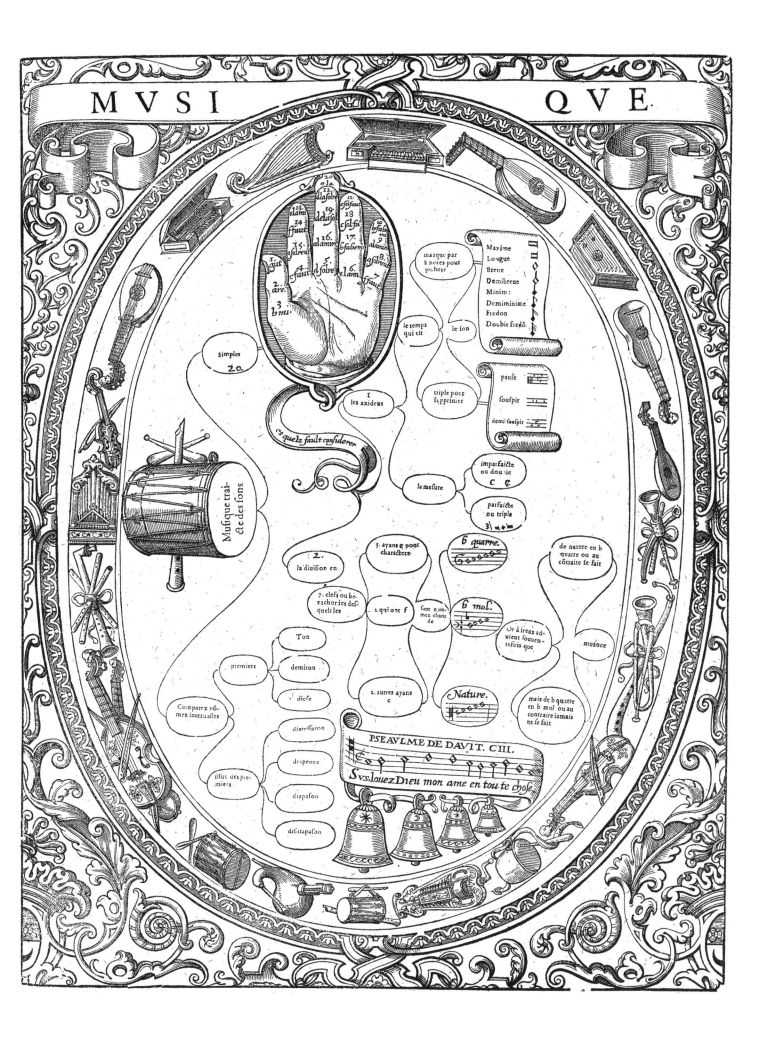

*Guidonian Hand*, 1636
Anonymous
Woodcut
Image: 6⅛ x 4½" (15.2 x 11 cm)
Marin Mersenne (1588-1648)
*Harmonie universelle, Traitez de la voix et des chants*, vol. 2
Paris: Sébastien Cramoisey, 1636, p. 350
Inscribed:
Page above the woodcut: *Ordres des sons: Joint qu'elle monstre le Tetrachorde divisé en 12 sons, ou 12 chordes à costé gauche, & en haut la mesme Quarte divisée en 9 chordes, & que les jointures, & les extremités des doigts sont marquez des lettres & des syllabes que nous avons expliqué dans cette premiere partie*, etc. (The order of the sounds: that shows the tetrachord divided into 12 sounds or 12 strings at the left side and above the same divided into 9 strings, and the joints and extremities of the fingers are marked with the letters and syllables that we have explained in this first part, etc.)

Below the woodcut is an inscription that reads: *Composition du mesme auteur à 8 parties*. (Composition by the same author in 8 parts [two sopranos, two altos, high and low tenor, and two basses.]) The text of the piece is *Ecce quam bonum & quam iucundum/habitare fratres in unum* (Behold how pleasant it is for brethren to dwell together in unity)
Music Division, Library of Congress, Washington, D.C.

1. This is the second time Mersenne presents the Guidonian hand, the first having appeared in volume 2 on page 144.

2. See Albert Cohen, "Marin Mersenne," *NGD* 12:188-190; Peter Dear, *Mersenne and the Learning of the Schools* (Ithaca, N.Y.: Cornell University Press, 1988), 96-160, 226-229; John Bernard Egan, "Marin Mersenne, *Traité de l'harmonie universelle*: Critical Translation of the Second Book" (Ph. D. diss., Indiana University, 1962); Frederick B. Hyde, "The Position of Marin Mersenne in the History of Music," (Ph.D. diss., Yale University, 1954); Marin Mersenne, *Harmonie Universelle* (Paris: Sébastien Cramoisey, 1636), facs. ed., ed. François Lesure (Paris: Éditions du Centre National de la Recherche Scientifique, 1963); Jane R. Stevens "Hands, Music, and Meaning in Some Seventeenth-Century Dutch Paintings," *Imago musicae* 1 (1984): 91-92. Frances Yates, *The French Academies of the Sixteenth Century* (London: Warburg Institute, University of London, 1947), 284-290.

THIS WOODCUT APPEARS IN BOOK 6, "L'ART DE BIEN CHANTER," at the end of the first part of Mersenne's second volume.[1] Mersenne sets out to explain all the characteristics necessary for writing and composing all sorts of music: for voice, organ, lute, and all other imaginable instruments. In this instance the hand functions as a part of the larger picture of music theory, a kind of pictorial summary—not unlike Savigny's—that makes associations between Guido's system, that of the ancient system of tetrachords (on the left and above), and symbols and rhythmic durations in the surrounding borders. Mersenne's hand contains two or three notes placed above each syllable, indicating whether they are on lines or spaces. At the bottom of the page is a composition for eight voices, written by the author, using solmization letters without staff notation. Mersenne was a French mathematician, music theorist, philosopher, and leading thinker of the seventeenth century. He combined an interest in speculative theory with one based on practice and formed an important link between the accomplishments of past theories with the new attitudes and developments of his own time. He used science and mathematics, and in many cases, mechanics, to explain musical harmony. He did so in an attempt to validate the Pythagorean numerical ratios, that standard account of consonance, known from the time of Boethius' *De institutione musica*, written in the fifth century. Fifteenth and sixteenth-century theorists had begun to question the ancient theories and such didactic devices as the monochord and the hand. With the advent of polyphony, the employment of thirds and sixths as consonant intervals rendered the older theoretical system obsolete with respect to contemporary musical practice. Mersenne's assumption that mathematical ratios govern the structure of the universe led him to defend the Pythagorean basis of musical theory, by relating consonance and dissonance to the mechanical properties of sounding bodies. He is credited with many important musical-theoretical concepts. Among them are laying the foundation for what is now the science of acoustics, establishing rules that govern how strings vibrate, and contributing to the theory of tuning and temperament. With regard to this last, he favored equal temperament for the practical application in the construction of certain instruments. He is also credited with adding the note *si* to the scale, *ut re mi fa sol la si*.[2]

SFW

# Ordres des fons.

Ioint qu'elle monſtre le Tetrachorde diuiſé en 12 ſons, ou 12 chordes à coſté gauche, & en haut la meſme Quarte diuiſée en 9 chordes, & que les jointures, & les extremités des doigts ſont marquez des lettres & des ſyllabes que nous auons expliqué dans cette premiere partie; comme fait auſſi la main de la premiere prop. du 3 liure des Genres, dont la lecture peut grandement ſeruir à ce Traité. Mais ſi l'on deſire ſçauoir les raiſons de toutes les diuiſions de ces Tettachordes il faut lire les 2, & 3 prop. du 2. liure des Diſſonances, ou les 4 9, & 10 du 3 liure des Genres.

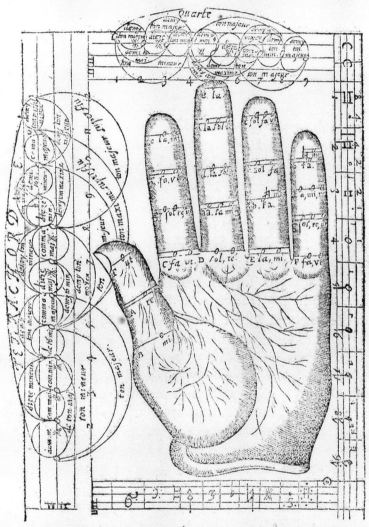

## Compoſition du meſme auteur à 8. parties.

| | | | | | | | | | | | | | | | | | | |
|---|---|---|---|---|---|---|---|---|---|---|---|---|---|---|---|---|---|---|
| I Deſſus | l | m | m | m | m | m | z | u | ſ | r | | u | u | u | u | u | m | m |
| II Deſſus | m | m | m | m | m | u | s | s | s | | | ſ | m | l | l | l | l | m z m |
| I Haute-contre | L u | L | z | M | u | z | m | r | r | | | m m m m L m l | ſ l |
| II Haute-contre | u L | L | s | s | L | z | s | z z | | | | ſ | u u u u u L z u |
| Haute Taille | L M | M | M | Z | M | S | V R R | | | | | u s L L L L u m m |
| Baſſe Taille | M M | V | z | Z | V | R | M s s | | | | | M M M F M M M M |
| I Baſſe | l | m | m | m | m | m | z | u | ſ | r | | s s V V V V V z L |
| II Baſſe | L L | L | M M | L | S | S S S | | | | | v v L L F L L M L |
| | Ecce quàm bonum & quàm iucundum | | | | | | | | | | habita re fratres in v num. |

The Three Doctors

*The Three Doctors,* c. 1513-1515
Marcantonio Raimondi (c. 1480-1534)
Engraving
Sheet (trimmed to image): 2⅞ x 4"
(7.3 x 10.1 cm)

National Gallery of Art, Washington,
D.C., Gift of W.G. Russell Allen, 1941

1. Fritz Graf, "Gestures and Conventions: The Gestures of Roman Actors and Orators," in *A Cultural History of Gesture,* ed. Jan Bremmer and Herman Roodenburg (Ithaca, N.Y.: Cornell University Press, 1991), 36-58.

2. The first to make this identification was Henri Delaborde, *Marc-Antoine Raimondi, étude historique et critique suivie d'un catalogue raisonné des oeuvres du maître* (Paris: Librairie de l'art, Paris, 1888), cat. nos. 211 and 212, 234-235.

3. See Innis H. Shoemaker, *The Engravings of Marcantonio Raimondi,* exh. cat. (Lawrence, Kansas: Spencer Museum of Art, 1981), cat. no. 25, 106, and fig. 25.

4. See Lino Marini, "Amadeo Berruti," *DBI* 9:410-414.

5. Shoemaker 1981, cat. no. 25, 106 n. 2.

6. For the identification of the engraving, see *The Illustrated Bartsch,* ed. Konrad Oberhuber, 27:94: [B. 404]. For biographies of the artist, see Babette Bohn, *DOA* 25:858-860; Shoemaker 1981, xiv-xvi.

7. G. Dillon, "Marcantonio Raimondi," *Dizionario enciclopedico Bolaffi dei pittori e degli incisiori italiani dall'XI al XX secolo* (Turin: Giulio Bolaffi Editore, 1975) 9:303.

THIS ENGRAVING INTRODUCES THE SUBJECT OF HAND GESTURES as a means of visual communication and expression. In Greece and Rome the effective use of gesture was an important indication of oratorical and rhetorical skills.[1] The continuity of this tradition is suggested by John Bulwer's inclusion in his *Chironomia* (1644) of an illustrated set of codified gestures acceptable for rhetorical purposes (Cat. 55). In the present work, the movements of the figures' hands express an interchange of views. The gesture of the man on the right may signal an enumeration of points in an argument. The pointing finger of the figure opposite indicates a response addressed to the first man either of affirmation or denial, while the clenched right fist of the central figure (and his open mouth) suggest opposition to the argument.

Indeed, the title of the engraving, as well as the dress of the three men, imply that some kind of oral debate concerning theological or philosophical issues is taking place. Scholars identify the figure on the right as Amadeo Berruti, bishop of Aosta.[2] The identification results from his resemblance to the author in another engraving by the same artist in the frontispiece of a *Dialogus* entitled *Amadeo Berruti with Austerity, Friendship, and Amor.*[3] The *Three Doctors* may have been a preparatory study, later abandoned, for the frontispiece. Berruti, originally from Savoy, held prominent posts in Rome at the courts of Popes Julius II and Leo X.[4] Since he was appointed bishop of Aosta in 1515, his appearance in doctoral rather than bishop's robes probably makes likely a date previous to this event.[5]

The engraver, and likely designer, was Marcantonio Raimondi.[6] Born and raised in Bologna, the artist was imbued with a love of antique forms and subject matter. He learned the craft of engraving from Francesco Francia, goldsmith, niellist, and painter, with whom he worked for many years. Around 1506 Raimondi traveled to Venice. His acquaintance with the paintings of Giorgione,

such as *The Three Philosophers,* and their reflection in the engravings of Giulio Campagnola may in part account for the pastoral setting and rustic buildings in *The Three Doctors.*[7] This engraving was produced during Raimondi's stay in Rome and shows the "systematic graphic vocabulary of his mature style" highlighted by "a clearer articulation of forms that are more sculptural and easily readable."[8]

During his Venetian stay, Raimondi acquired Dürer's woodcuts (Cat. 26 and 28) and made engravings of his *Life of the Virgin* series, complete with the latter's monogram. After Dürer protested to the Venetian senate, Raimondi removed it but was allowed to issue the engravings. Some years later, Dürer agreed to have Raimondi engrave his *Small Passion* series (Cat. 28).[9] Such efforts by Raimondi and his followers led to the growth of engraving as a reproductive medium and the development of an important commerce in prints. Paintings and works of art were adapted in various engraving techniques for collectors, who could not afford the original works, and for artists, who wanted to have readily available these sources of pictorial inspiration by important masters. Raimondi, who because of his collaboration with Raphael became a crucial figure in assessing the possibilities of reproductive engravings, was an interpreter and translator of monumental works rather than a mere copier. Reproductive engravings thus became a vital means of disseminating works of art freely, particularly the heritage of the high Renaissance, as a portable "museum without walls."[10]

While *The Three Doctors* was apparently Raimondi's original design, the role of gesture in the composition harks back to classical literary models. Gesture, companion of eloquence, gives the hand an important role as a visual language that enhances verbal communication. This collaborative communication provides a means for teaching and learning using the example of ancient and contemporary models.

CRS

8. Bohn, *DOA* 25:859. For a full discussion of Raimondi's sources and stylistic development, see Shoemaker 1981, 2-18.

9. See Elizabeth Broun, "The Portable Raphael," in Shoemaker 1981, 22.

10. Ibid., 21-46.

A Manual Alphabet

*A Manual Alphabet*, 1579
Anonymous
Handcolored woodcuts
Images: 5³/₁₆ x 3⅝" (13.2 x 9.2 cm)
Cosimo Rosselli (Cosmas Rossellius)
(d. 1578)
*Thesaurus artificiosae memoriae*

Venice: Antonio Padovani, 1579, fols.
103v.-104r.
Inscribed:
*E, F, G, H, I, L, M, N*
The Folger Shakespeare Library,
Washington, D.C.

1. Volkmann ("Ars memorativa," 170) states that Rosselli's manual alphabet is the first of its kind.

2. Lois Bragg, "Visual-Kinetic Communication in Europe before 1600: A Survey of Sign Lexicons and Finger Alphabets prior to the Rise of Deaf Education," *Journal of Deaf Studies and Deaf Education* 2/1 (Winter 1997):18. Bragg infers that Rosselli was familiar with a variety of finger alphabets used in Europe at this time.

3. Ibid., 14-18. See the essay by Sachiko Kusukawa, "A Manual Computer for Reckoning Time" in this volume, 28.

4. Bragg 1997, 18. For an extensive discussion of Della Porta's contributions to cryptology, see David Kahn, *The Codebreakers: The Story of Secret Writing* (New York: Macmillan, 1968), 137-143.

5. For the connection between memory images and the search for a universal language in the seventeenth century, see James Knowlson, *Universal Language Schemes in England and France, 1600-1800* (Toronto and Buffalo: University of Toronto Press, 1967), 78. Knowlson cites Paolo Rossi, *Clavis universalis: Arti mnemoniche e logica combinatoria da Lullo à Leibniz* (Milan: R. Ricciardi, 1960), chaps. 2, 5, 6, and 7; and Yates, *The Art of Memory*, 364.

CONTINUING A SERIES OF VISUAL ALPHABETS, including the one based on association with instruments (Cat. 36) in Rosselli's richly illustrated volume on artificial memory, the present woodcuts belong to a group of five folios depicting the letters made by a system of finger gestures.[1] Each series consists of a grid of twelve spaces divided into four vertical and three horizontal rows. Such an arrangement, similar to that in Cat. 36, has the advantage of placing each image in an isolated, ordered place following a logical sequence. Here the interior colored frames facilitate the process of separating the individual images. Each horizontal row presents different versions of making the same letter with varied positions of the fingers and hands.

Rosselli gives instructions (fols. 101v.-102v.) on how to position the fingers in order to make the individual letters. For example, to form the letter *E,* the author states that one should extend three fingers simultaneously, not upward toward heaven nor down in the direction of earth but turned toward himself. On the opposite folio, Rosselli says that to make *I* any finger will do, if it is held in an upright position. As for *L,* if either the index or thumb is raised upward, the other must be turned sideways. In these directions, Rosselli uses the Latin anatomical terms for the fingers, showing the positions on either the left or right hand. The rather primitive quality of the woodcuts, however, sometimes makes it difficult to distinguish between the variations in finger positions.

The finger alphabet has obvious advantages, such as allowing one to construct a list of persons, things, or ideas to be remembered by actually making and repeating the letters on the hand in a familiar order. Once learned, this system is a readily available reminder valuable in preaching sermons and allied activities.[2] Another use of such a finger alphabet for silent communication also comes to mind. As Sachiko Kusukawa indicates, in the Middle Ages a related method, finger calculus (Cat. 40 and 43)—a coded system of finger gestures for counting from one to a million—was employed for visual communication. Furthermore, the Venerable Bede in whose treatise finger calculus achieved widespread diffusion, adapted a system of substituting letters for numbers in order to form words that could then serve as the basis for a silent message.[3] A landmark in cryptology by the polymath Giambattista della Porta, *De furtivis literarum notis,* published in 1563, further developed the use of the hand to form a secret language. Among the sophisticated methods devised by Della Porta was an alphabet formed by touching a body part which begins with a Latin letter (*C* for *caput,* or head).[4] In the seventeenth century manual alphabets became a vehicle for teaching the deaf to communicate (Cat. 53 and 56). Rosselli's finger alphabet thus not only continues the mnemonic tradition but also suggests further development of the fingers and the hand as an instrument of visual communication, allied with, but effective as a substitute for oral and written language.[5]

CRS

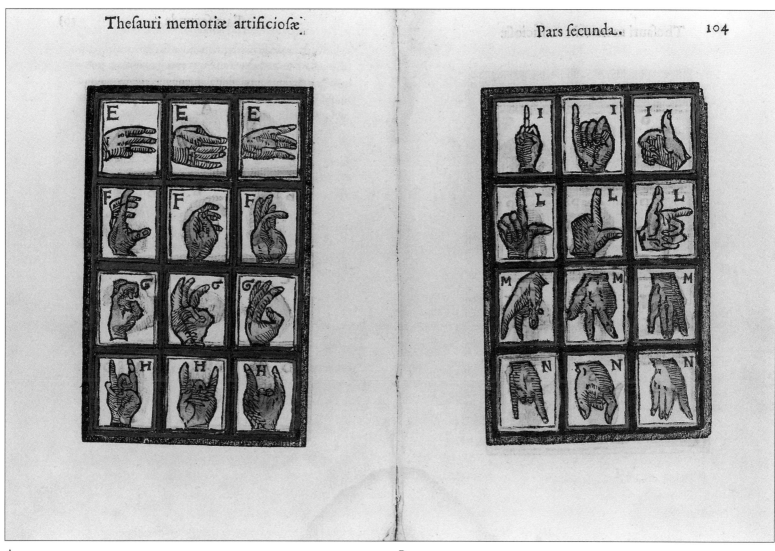

A                                                                    B

# Finger Positions for the Letters O, P, and Q in a Manual Alphabet for the Deaf

*Finger Positions for the Letters O, P, and Q in a Manual Alphabet for the Deaf,* 1620
Diego de Astor the Elder (c. 1585-1590-c. 1650)
Engraving
Plate mark: 6½ x 4⅛" (16.5 x 10.5 cm)
Juan Pablo Bonet (1579-1633)

*Reduction de las letras, y arte para enseñar a ablar los mudos*
Madrid: Francisco Abarco de Angulo, 1620, sixth of eight plates (n.p.)
Inscribed:
*O. o.; P. p.; Q. q.*
The Folger Shakespeare Library, Washington, D.C.

1. Ismael Gutiérrez Pastor, "Diego de Astor, the Elder," *DOA* 2:645-646.

2. The author shows his familiarity with mnemonic theories, including a reference to Giambattista della Porta's *De furtivus literarum notis vulgo de ziferis, Libri IIII* of 1563, in which letters of the alphabet are associated with parts of the body beginning with that letter (fols. 38v.-39r.). For further details, see Cat. 52. Bonet also wrote a separate treatise in the *Reduction de las letras* on ciphers (pp. 280-288), citing della Porta's text.

3. The book is dedicated to King Philip III and contains a eulogy by Lope de Vega Carpio, the famous playwright. For an account of Bonet's career, see Susan Plann, *A Silent Minority: Deaf Education in Spain, 1550-1835* (Berkeley and Los Angeles: University of California Press, 1997), 42.

4. For an account of these developments, see ibid., chap. 1. The author explains how the deaf children's use of "home signs" among themselves and the use of a monastic sign-lexicon (long sanctioned for periods of silence) may have influenced Ponce de Léon's efforts.

5. Ibid., 31. For an earlier manual alphabet, in which deaf people are mentioned, *Libro llamado refugium infirmorum* of 1592 by the Franciscan Fray Melchor de Yebra, see ibid., 40; and Lois Bragg, "Visual-Kinetic Communication in Europe before 1600: A Survey of Sign Lexicons and Finger Alphabets Prior to the Rise of Deaf Education," *Journal of Deaf Studies and Deaf Education* 2/1 (Winter 1997):19-20.

6. Plann 1997, 41-42.

7. Bragg 1997, 22.

8. Plann 1997, 45.

THIS ELEGANT ENGRAVING OF THREE LETTERS OF A FINGER ALPHABET by Diego de Astor, a Spanish engraver born in Flanders, is the sixth of eight plates inserted in the first published book on the education of the deaf.[1] The engravings in this volume differ from the woodcuts in Rosselli's memory treatise (Cat. 52) in which different versions of the same letter are depicted from various viewpoints. Except for the folio containing the letters *M* and *N*, where downward vertical positions of the hand are required, de Astor's plates in this book consistently show the letters formed by the back of the right hand in horizontal extension facing the reader. The larger scale of the manual letters and the three-dimensional character of the hand achieved by the subtle modeling technique contribute to the clarity and elegance of the full-page engravings. Set off by the geometric patterns of the interior frames, the effect of lucidity and ease of movement may account for the subsequent popularity of this manual alphabet. Although the book does not belong to the art of memory genre, the letter-images lend themselves to the volume's larger didactic functions, including mnemonic mastery.[2]

The title of the book by Bonet, a scholar, man of letters, soldier, and a highly placed figure at the Spanish court, is translated as *Adaptation of the Letters and the Art of Teaching the Mute to Speak.*[3] Pathbreaking efforts to teach deaf children of aristocrats to speak, read, and write had been undertaken during the sixteenth century in Spain at the Benedictine monastery of San Salvador at Oña by Fray Pedro Ponce de Léon.[4] Until this time, deaf people were regarded as ineducable because lack of speech (equated with language) and hearing, associated with the soul and reason, made them incapable of learning. Ponce de Léon's success in teaching two members of a prominent aristocratic family to read, write, and speak was considered miraculous. Through eyewitness reports and the success of his students, his achievement received great notoriety, although he never published a book on his methods. Yet in the one surviving page, perhaps from an otherwise lost manuscript, Ponce de Léon advocated that the students write the letters of the alphabet on the joints of their hands as a method of learning and remembering them.[5]

Before the publication of Bonet's volume, teaching deaf children of prominent aristocrats continued at the Spanish court. Indeed recent scholarly opinion considers that Bonet modeled his method of teaching the deaf on that of a contemporary tutor at the Spanish court, Ramírez de Carrión.[6] The first part of Bonet's book deals with teaching reading not by learning the names of the letters but by the sounds associated with them.[7] In his thorough explanation of each letter, Bonet describes the type of breathing necessary and how lips form the letter, and gives examples of words beginning with the specific letter, using capitals, double capitals, and lower case forms of the letter. Although Bonet's instructions are written in Spanish, the words following the alphabet's letters are in Latin. The second section of the book, in which the manual alphabet appears, gives further instructions for pronunciation of the letters. Bonet

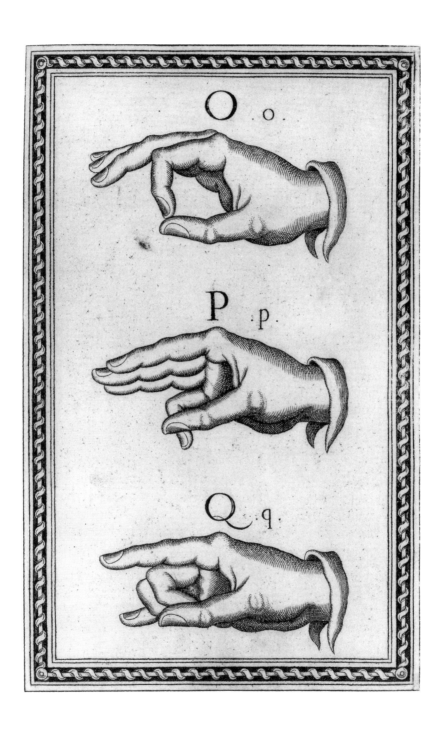

believed the deaf could learn to speak by compensating for the lack of hearing with the sense of sight. Association of sound with visual shapes, of which the manual alphabet was the first step, connected the shape of letters with its verbal sign. At the same time as students learned to write the letters, they formed them with the fingers. The plates of Bonet's finger alphabet, entitled *Abecedario demonstrativo,* became known first in Europe and then spread to the Americas, where, with some variations, deaf persons continue its use to the present day.[8] The finger alphabet provides an important example of the hand's vital role in fostering visual communication and cognitive functions.

CRS

## 54 An Alphabet of the Natural Gestures of the Hand

An Alphabet of the Natural Gestures of the Hand, 1644
William Marshall (fl. c. 1617-1650)
Engraving
Plate mark (trimmed on right):
5⅞ x 3¹¹⁄₁₆" (15 x 9.3 cm)
John Bulwer (fl. 1654)
Chirologia, or the Naturall Language of the Hand
London: Tho. Harper, 1644, p. 155
Inscribed:
A. Munero (I provide); B. Auxilium fero (I bring aid); C. Irascor (I am angry); D. Demonstro non habere (I show that I do not have [anything]); E. Castigo (I chastise); F. Pugno (I fight); G. Confido (I confide in); H. Impedio (I impede); I. Recommendo (I recommend); K. Officiose duco (I lead in an official capacity); L. Impatientiam prodo (I betray impatience); M. Sollicite cogito (I think anxiously); N. Pudet (He is ashamed); O. Adoro (I adore); P. Conscienter affirmo (I affirm in good conscience); Q. Poenitentiam ostendo (I display contrition); R. Indignatione timeo (I fear with indignation); S. Data fide promitto (I pledge my faith); T. Reconcileo (I reconcile); V. Suspicionem et odium noto (I note suspicion and hate); W. Honoro (I honor); X. Reservatione saluto (I greet with reservation); Y. Furacitatem noto (I show thievery); Z. Benedico (I bless)
Rare Book and Special Collections Division, Library of Congress, Washington, D.C.

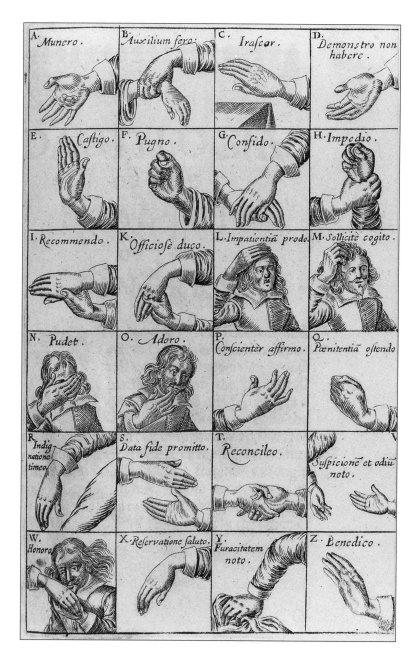

Fig. 34. William Marshall, *The Powers and Language of the Hand*, engraving. From John Bulwer, *Chirologia or the Naturall Language of the Hand* (London: Tho. Harper, 1644), frontispiece. Rare Book and Special Collections Division, Library of Congress, Washington, D.C.

1. For a discussion of these issues, see James Knowlson, *Universal Language Schemes in England and France, 1600-1800* (Toronto and Buffalo: University of Toronto Press, 1975), 7-27, 212-217.

2. The modern edition of the text is *Chirologia: Or the Natural Language of the Hand and Chironomia: Or the Art of Manual Rhetoric,* ed. James W. Cleary (Carbondale and Edwardsville: Southern Illinois University Press, 1974).

3. For a brief account of his life and publications, see Thompson Cooper, "John Bulwer," *DNB* 7:262-263; and H. J. Norman, "John Bulwer the Chirosopher," *Proceedings of the Royal Society of Medicine* 36 (1943):589-602.

TEACHING OF THE DEAF, the quest for a universal language, and the use of gesture as a secret language come together in the present work.[1] John Bulwer's two treatises, the *Chirologia* (*The Naturall Language of the Hand*) and the *Chironomia* (*The Art of Manuall Rhetorique*), were published in one volume.[2] Both texts take hand gestures as their central topic. In the first work, the ancient subject of praise of the hand takes on new significance. Bulwer stresses that the hand's movements, connected with its ability to form gestures linked with thought and emotion, constitute a natural language common to all cultures. The *Chironomia,* the second treatise, deals with the rules of gesture in oratory as set forth in classical and contemporary works on rhetoric.

Four years after the publication of the *Chirologia* and the *Chironomia,* Bulwer, a physician of wide-ranging interests, composed the first English publication on the education of the deaf, the *Philocophus: The Deafe and Dumbe Man's Friend.*[3] Bulwer, like Bonet (Cat. 53), believed the deaf could be taught to speak. Bulwer's confidence in the power and universality of gesture as a natural and superior substitute for speech certainly connects his two publications.[4] Also, as Bulwer states in his indexes to the *chirograms,* or plates of gestures, in the *Chirologia* (p. 154) and *Chironomia* (p. 64), these codified gestures "are so ordered to serve for privy cyphers for any secret intimation."[5] Showing his familiarity with the language of the fingers, as distinguished from those made by the whole hand, the author also includes *chirograms* of expressive gestures (*Chirologia,* p. 188), as well as those of finger calculus (*Chironomia,* p. 95) inherited from Bede (Cat. 40).[6]

The frontispiece of the *Chirologia* (Fig. 34), executed by the English engraver William Marshall, introduces the methods followed by Bulwer in the exposition of the meaning of the gestures in the *chirograms.*[7] The power of the hand, sent from heaven as the divine instrument of communication, is personified by two female allegorical figures, Nature on the left, and on the right, Polyhymnia, muse of oratory. Below them on an architectural structure are pictured images of the hand's powers in spheres subject to the personifications' rule, including eloquence, arithmetic, and logic. In the center, the well of *Chirosophiae* (wisdom of the hand) contains labeled hand gestures signifying intellect, will, memory, and knowledge.

The goals of knowledge and memory are served in the present plate, the second *chirogram* of the natural gestures of the hand. Twenty-four gestures, each associated with a letter of the Latin alphabet, are arranged in a rectangular grid of six horizontal rows divided into four rectangles. This clearly delineated grouping, designed to place each clear image in an ordered place, recalls those of memory treatises such as Rosselli's (Cat. 36 and 52). Each labeled image is connected on the facing page with an index that gives the location in the text for a numbered gesture. Those explanations, preceding the plates, consist of a definition of each gesture designed to confirm Bulwer's interpretation of its meaning. To buttress his argument, he discusses the action, meaning, and examples of each gesture drawn from religious and historical sources.[8] The author gives far more extensive explanations of gestures that have moral or religious significance, such as those for *T, X,* and *Z.*

The gestures depicted, which show the hand as actor and performer, are of three types. Nine involve a single hand (the right) moving in space, with fingers flexed, outstretched, or bent. The hand is seen from either the palm or exterior

view, in a vertical, side, or horizontal position as demanded by the action. The presence of objects in *A* (coins to show that aid is provided) and their absence in *D* (proof of none) assist in defining the gestures. Eight examples in which both hands appear denote a relationship to another person, some positive as in *G,* others negative, as in *H.* Of the remaining five, representing bust-length figures of males in contemporary dress, four show gestures involving touching another part of the same person's body, the head *(L, M, N, and O).* The last, a gesture of honor *(W),* involves kissing another person's hand. The sensitive modeling of the hands, drawn to scale, animate and differentiate the gestures. Altogether the verbal and visual arrangement of information affords a systematic classification of actions of the hand that convey expression of human thought and action.

CRS

4. Lois Bragg, "Visual-Kinetic Communication in Europe before 1600: A Survey of Sign Lexicons and Finger Alphabets prior to the Rise of Deaf Education," *Journal of Deaf Studies and Deaf Education* 2/1 (Winter 1997):22.

5. For an extensive discussion of such relationships, see Gerhard F. Strasser, *Lingua universalis: Kryptologie und Theorie der Universalsprachen im 16. und 17. Jahrhundert* (Wiesbaden: Otto Harrassowitz, 1988).

6. Bulwer's source for the *chirograms* is the popular and widely diffused publication by Giovanni Pierio Valeriano Bolzani, *Hieroglifica,* "a compendium of all known communicative characters and symbols," including a plate of "finger digitation." See Cleary 1974, editor's introduction, xxii. In the *Hieroglifica* edition of 1614 (Frankfurt am Main: Anton Hierat), the illustration of the numbers 1 to 9,000 occurs in book 37, 454.

7. Christopher Foley, "William Marshall," *DOA* 20:478. It is not clear whether Marshall executed the plates or *chirograms* in addition to the signed frontispieces.

8. Cleary 1974, editor's introduction, xv.

The Canons of the Rhetoricians, 1644
William Marshall (fl. c. 1617-1650)
Engraving
Plate mark trimmed on right:
5⅞ x 3¹¹⁄₁₆" (15 x 9.3 cm)
John Bulwer (fl. 1654)
Chironomia, Or the Art of Manuall
Rhetorique
London: Tho. Harper, 1644, p. 65
Inscribed:
A. Pacificat (He quiets down [the
crowd]) B. Auditores mitigabit (He will
sooth the audience); C. Neotericis orditur
(He begins from recent events); D. Ad
monstrandum valet (He is good for
instructing); E. Modus agendi (Shows
a method); F. Admiratur (He admires);
G. Hortatur (He exhorts);
H. Rationes profert (He advances argu-
ments); I. Flocci facit (He dismisses as
trivial); K. Deprecatur (He pleads an
excuse); L. Sic ostendebit se ipsum
(In this way [the orator] will refer to
himself); M. Negabit (He will show
denial); N. Perspicuitatem illustrat
(He shows the obvious);
O. Exclamationem aptat (He furnishes
an exclamation); P. Antithesin exornat
(He illustrates an antithesis); Q.
Argumenta digerit (He walks through
arguments); R. Benevolentiam ostendit
(He shows good will);
S. Commiserationem denotat
(He denotes sympathy); T. Immensitatem
aperit (He reveals vastness); V. Valdè
aversatur (He rejects vehemently);
W. Execratione repellit (He fends off
curses); X. Addubitabit (He will show
doubt); Y. Dolebit (He will show grief);
Z. Benedictione dimittit (He dismisses
[the crowd] with a blessing)
The Folger Shakespeare Library,
Washington, D.C.

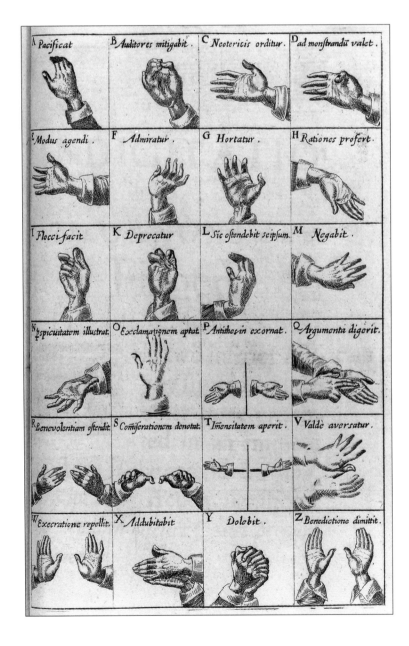

THIS *CHIROGRAM* BELONGS TO THE SECOND OF BULWER'S TREATISES on hand gestures used in public speaking, the *Chironomia.* The frontispiece (Fig. 35), signed by William Marshall (Cat. 54), again shows the divine origin of the author's subject, sanctified by the winged personification of Grandiloquence. Set in an architectural, templelike space, Greek and Roman exemplars of rhetoric, acting, and politics grace the scene.[1]

Following the same scheme used in the *Chirologia* (Cat. 54), a grid of twenty-four images, keyed to the letters of the alphabet and separated by individual frames, fosters orderly and sequential association of the words with gestures. The first fourteen of the gestures *(A-O)* show the right hand alone in different positions: vertical, horizontal, or sideways, with the palm or exterior side visible. Of great importance are the flexed or bent positions of the fingers, which are carefully prescribed in Bulwer's text. The rest of the gestures *(P-Z)* utilize both hands to make their points. The space between the hands *(R, S, W,* and *Z),* or their joining *(X* and *Y)* in horizontal or vertical positions lend variety to the gestures. In two cases *(P* and *T)* the division of the picture space expresses separate directions in which the gesture can go to make opposing points. In *Q* and *V* the angle of the hands' display is crucial in showing the forcefulness of the gesture. Foreshortened and drawn to scale, the carefully modeled hands are successfully differentiated from one another and convey convincingly the expressive quality of each gesture.

While the gestures of the *Chironomia* are in some respects similar to those of the *Chirologia,* Bulwer focuses in his second treatise on the correct actions of the hands and lower arms in public speaking. His main sources are the Bible and the writings of classical authors on rhetoric such as Cicero and Quintilian, as well as those of the contemporary Jesuit Ludovicus Cresollius.[2] Bulwer discusses forty-nine gestures of the hands, of which twenty-four appear in the present *chirogram.* As in the *Chirologia,* for each law or canon of gesture he defines the action as well as its meaning, and provides historical examples. In the *Chironomia,* however, Bulwer gives precise rules for proper "elocution" as essential to the presentation of a persuasive argument. Although the actions of the hand provide the natural basis for a universal language, in the *Chironomia* instruction in their proper formation becomes necessary in order to improve their efficacy as an instrument of communication.[3] Bulwer's praise of the hand extends to making it the rival of the tongue as the companion of reason and agent of the mind. His carefully classified system provides examples of gestures that demonstrate proper expression of persuasive arguments. Bulwer treats the hand as a prime instrument of visual communication in human discourse.

CRS

Fig. 35. William Marshall, *Great Orators of Antiquity,* engraving. From John Bulwer, *Chironomia or The Art of Manuall Rhetorique* (London: Tho. Harper, 1644), frontispiece. The Folger Shakespeare Library, Washington, D.C.

1. Beginning in the roundel on the upper left Cleon speaks, balanced on the right by Hortensius. Below, the philosopher Andronicus points to Cleon, while supporting the mirror before which Demosthenes practices gestures. Opposite them the actor Roscius and the orator Cicero gesticulate. The Greek exemplars occupy the left half of the space; the Romans, the right.

2. For Bulwer's sources and methods in the *Chironomia,* see the introduction to the modern edition of the text, *Chirologia: Or the Natural Language of the Hand and Chironomia: Or the Art of Manual Rhetoric,* ed. James W. Cleary (Carbondale and Edwardsville: Southern Illinois University Press, 1974), xx-xxiii. See also Fritz Graf, "Gestures and Conventions: The Gestures of Roman Actors and Orators," in *A Cultural History of Gesture,* eds. Jan Bremmer and Herman Roodenburg (Ithaca, N.Y.: Cornell University Press, 1991), 36-58.

3. Cleary 1974, xxiii-xv.

*A Manual Alphabet*, 1680
Anonymous
Engraving
Plate mark: 5 x 3⅛" (12.8 x 8 cm)
George Dalgarno (1626?-1687)
*Didascalocophus or the Deaf and
Dumb Man's Tutor*
Oxford: Printed at the Theatre, 1680,
frontispiece

Inscribed:
Top of thumb to base, *A, m, B, H;*
Top of index to base, *E, C, K, P;*
Top of middle finger to base, *I, n, D, L,
Q;* Top of ring finger to base, *O, F, M,
R;* Top of smallest finger to base and
side, *U, G, N, S; Y;* Palm of hand
[above] *h, l, r, s, T* [repeated below]
*h, l, r, s, V, W, X, Z*
The Folger Shakespeare Library,
Washington, D.C.

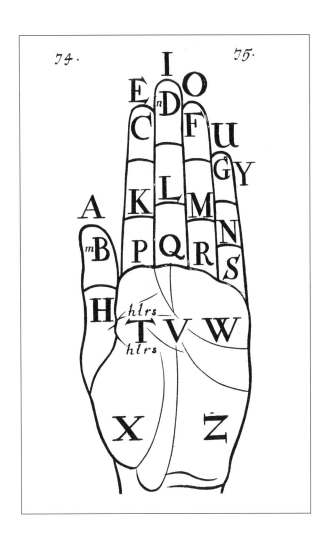

THIS DIAGRAM OF A ONE-HANDED MANUAL ALPHABET for teaching the deaf is the only illustration in this short treatise by George Dalgarno. The present system differs from the engravings in Bonet's work (Cat. 53). There the gestures of the fingers themselves form the letters of the alphabet. In the present book the letters are inscribed on a form constructed on the joints and palm of the left hand. Thus a series of places, familiar from memory treatises, recalls the pair of woodcuts from the *Schatzbehalter* (Cat. 37) or the images representing the Guidonian hand (Cat. 46 and 47). Here the sequence of letters located on the joints is more complex, as the vowels, separated from the consonants, occupy places above the fingers. Furthermore, the fourteen joints are too few in number to house the remaining letters that occupy upper and lower locations on the palm. The cursive, lower case letters refer to the occurrence of double consonants in English words. Dalgarno recommends different methods of touching the places on the left hand with the right for separate situations. For example he recommends (p. 74): "1. Touch the places of the Vowels with a cross touch with any finger of the right hand. 2. Poynt to the Consonants with the Thumb of the right Hand." To aid the beginning student in remembering the places, the author suggests the use of a pair of gloves (p. 88). The student would wear the one of the left hand, inscribed with the letters of the alphabet, to which the teacher would point with the blank right glove. Another important point is the need for the deaf person to have a companion versed in finger spelling (pp. 89-90), since communication is the goal of learning manual spelling.

Dalgarno's practical approach to teaching the deaf reflects his long experience as a schoolmaster. Born and educated in Scotland, he taught in Oxford for many years.[1] During that time he became part of a circle of linguistic philosophers searching for methods to achieve a universal language. Dalgarno's treatise of 1661, the *Ars signorum,* represents an important milestone in this endeavor.[2] In one sense the present work shows an application of his theoretical work, the goal of which was to create a language for teaching the deaf. Another of Dalgarno's motives may have been inspired by the broader movement in England toward educational reform. Dalgarno knew Samuel Hartlib, a sponsor of Comenius (Cat. 33), who was a leader of this movement.[3] The latter was also an advocate of a universal language.

Dalgarno's *Didascalocophus* was part of a larger European commitment to teaching the deaf.[4] Like Bulwer, he believed the hand was the equal of the tongue in expressing inward thought and as a means of communication. Although he does not dwell on gestures as the basis of a visual language (as did Bulwer), Dalgarno does state (p. 22) that "Words laid up in the deaf Boyes memory, are like Characters engraven in Steel or Marble." But he believes also that sign language based on finger spelling has an appeal to a broader audience as a means of communication when silence is necessary (as in a sick room) or when secrecy is desirable, a familiar advantage. Lastly, Dalgarno (pp. 91-92) believes that such a method of communication is a useful cognitive and pleasing pastime, especially for young children who should "know their letters upon an Hand-book." He goes on to say: "And who will not acknoweldg[e] that it were a thing desirable, and deservedly to be esteemed as a peice *[sic]* of liberal education; to be able to speak as readily with the Hand as with the Tongue?"

CRS

1. See Gordon Goodwin, "George Dalgarno," *DNB* 13:389-390.

2. James Knowlson, *Universal Language Schemes in England and France, 1600-1800* (Toronto and Buffalo: University of Toronto Press, 1975), 95-98; Gerhard F. Strasser, *Lingua universalis: Kryptologie und Theorie der Universalsprachen im 16. und 17. Jahrhundert* (Wiesbaden: Otto Harrassowitz, 1988), 208-216.

3. See Yates, *The Rosicrucian Enlightenment,* 216-222.

4. R. C. Alston, "note" in George Dalgarno, *Didascalocophus, 1680* (English Linguistics, 1500-1800, No. 286), facs. ed. (Menston, England: Scolar Press, 1971), [2], n.p.

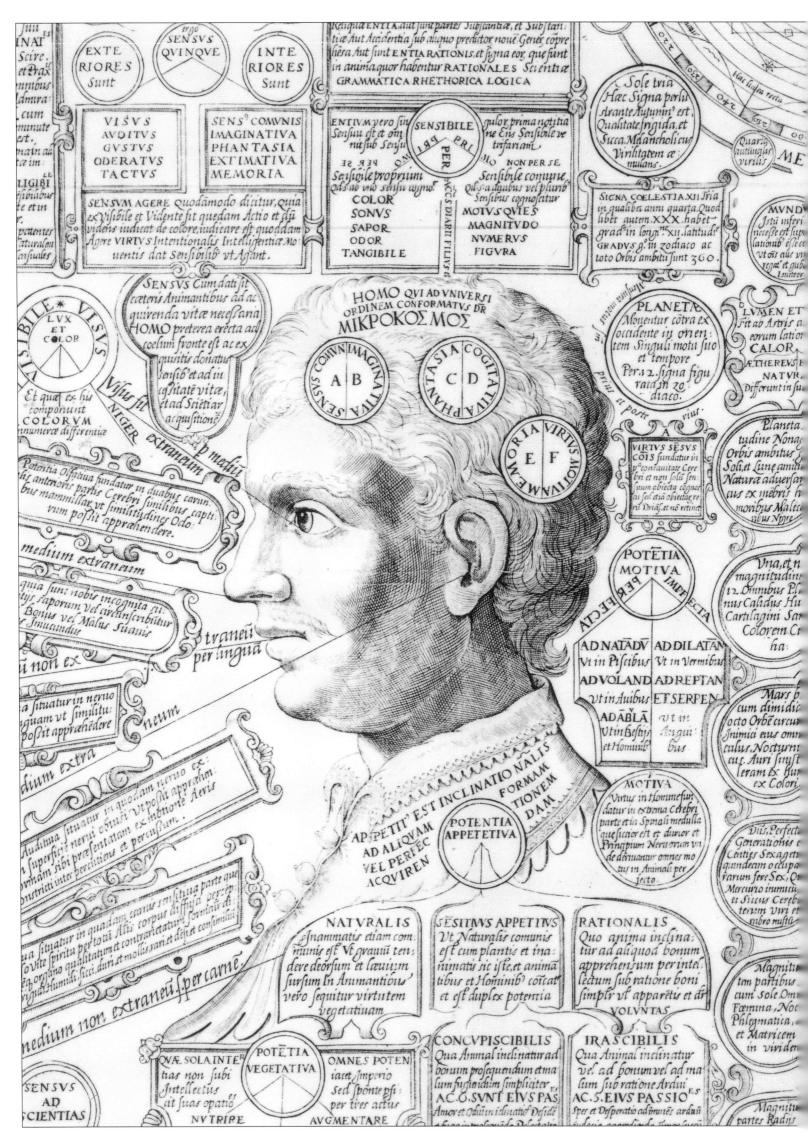

# v. The Whole World in the Hand

*The Body as Microcosm: Cat. 57-62*
*Signs Upon the Hand: Cat. 63-68*
*The Hand of the Philosopher: Cat. 69-73*

*Zodiac Man,* 1522
Anonymous, Italian
Woodcut
Image: 11½ x 8¼" (29.2 x 21 cm)
Sheet: 12⁵⁄₁₆ x 8½" (31.3 x 21.6 cm)
Johannes de Ketham (Johann von Kirscheim?) (fl. fifteenth century)
*Fasciculus medicinae*

Venice: Cesare Arrivabene, 1522
Inscribed with the signs of the zodiac
Philadelphia Museum of Art: SmithKline Beecham (formerly SmithKline Beckman) Corporation Fund for the Ars Medica Collection, 1949-97-3e

1. George Boas, "Macrocosm and Microcosm," in *Dictionary of the History of Ideas,* ed. Philip P. Wiener (New York: Charles Scribner's Sons, 1973) 3:126. See also, Donald Levy, "Macrocosm and Microcosm," in *The Encyclopedia of Philosophy,* ed. Paul Edwards (New York: Macmillan and Free Press, 1967) 5:121-125.

2. For a convenient summary, see David Pingree, "Astrology," in *Dictionary of the History of Ideas,* 1:118-126. See also T. S. Pattie, *Astrology as Illustrated in the Collections of the British Library and The British Museum* (London: British Library, 1980).

3. See Charles West Clark, "The Zodiac Man in Medieval Medical Astrology" (Ph.D. diss., University of Boulder, Colorado; Ann Arbor, Mich.: University Microfilms International, 1979), chap. 2.

4. For the origins of the term, see ibid., 2-3.

5. Ibid., 1-2.

6. Ibid., chap. 4. See also Harry Bober, "The Zodiacal Miniature of the *Très Riches Heures* of the Duke of Berry—Its Sources and Meaning," *JWCI* 11 (1948):1-34; and Fritz Saxl, "Macrocosm and Microcosm in Mediaeval Pictures" in *Lectures* (London: Warburg Institute, University of London, 1957) 1:58-72.

7. The following outline summarizes these

THIS STRIKING WOODCUT embodies two related cosmological theories. The first is that the body and mind of man (microcosm) is identical with the whole universe (macrocosm). In other words, "the macrocosm is the universe as a whole, whose parts are thought of as parts of a human body and mind. The microcosm is an individual human being whose parts are thought of as analogous to the parts of the larger universe."[1] The second belief involves astrology, in which the heavenly bodies, including those of the zodiac, control vital aspects of human life.[2] The zodiacal entities, connected with the months in which they appeared, had long ago received names and symbols, many of which are identified with animals.[3] An important correlation is that certain parts of the body are ruled by specific zodiacal signs, beginning with Aries (the ram) at the head and ending with Pisces (the fish) at the feet. The present image, known as a *melothesia,*[4] belongs to the realm of astrological medicine, in which forms of treatment depended on the position of the moon "in the heavens, since it was a medieval commonplace . . . that one neither touched with iron nor with medication the part of the body in whose zodiacal sign the moon was at that particular moment."[5]

The zodiacal man, a naked male figure with arms and feet spread apart, whose body parts were inscribed or associated with the twelve signs, appears with growing frequency in illustrated manuscripts beginning in the fourteenth century.[6] The zodiac man was consulted by physicians, barber-surgeons, and laymen for favorable times to conduct bloodletting, surgery, or other popular forms of medical therapy. The signs of the zodiac and their relationship to the months and the parts of the body emphasize the times for refraining from treatment. This information appears in the inscriptions starting with the head at the upper left and then moving to the right in descending order ending with the feet.[7]

The present image is one of six woodcuts illustrating a series of medical tracts, the *Fasciculus medicinae,* first published in Venice in 1491. This Latin edition was followed by Sebastiano Manilio's Italian translation two years later. The volume, with other treatises gradually added, enjoyed great popularity; many later editions followed in both languages, as well as in other vernacular translations.[8] The authorship of the text is usually attributed to Johannes de Ketham, considered to have been a German physician residing in Venice. His name may be a corruption for that of Johann von Kirscheim, a professor of medicine in Vienna around 1460.[9] The Philadelphia zodiac man comes from a Latin edition of the *Fasciculus medicinae* dated 1522, although the image is identical with the woodcut from the 1493 Italian translation.[10]

The image (fol. 7), the third illustration in this edition, occurs after the treatise on phlebotomy or bloodletting. Explanations of the signs appear on the preceding folio. The figure of the zodiac man follows the traditional diagrammatic mode, but the influence of antique sculptural forms and naturalistic

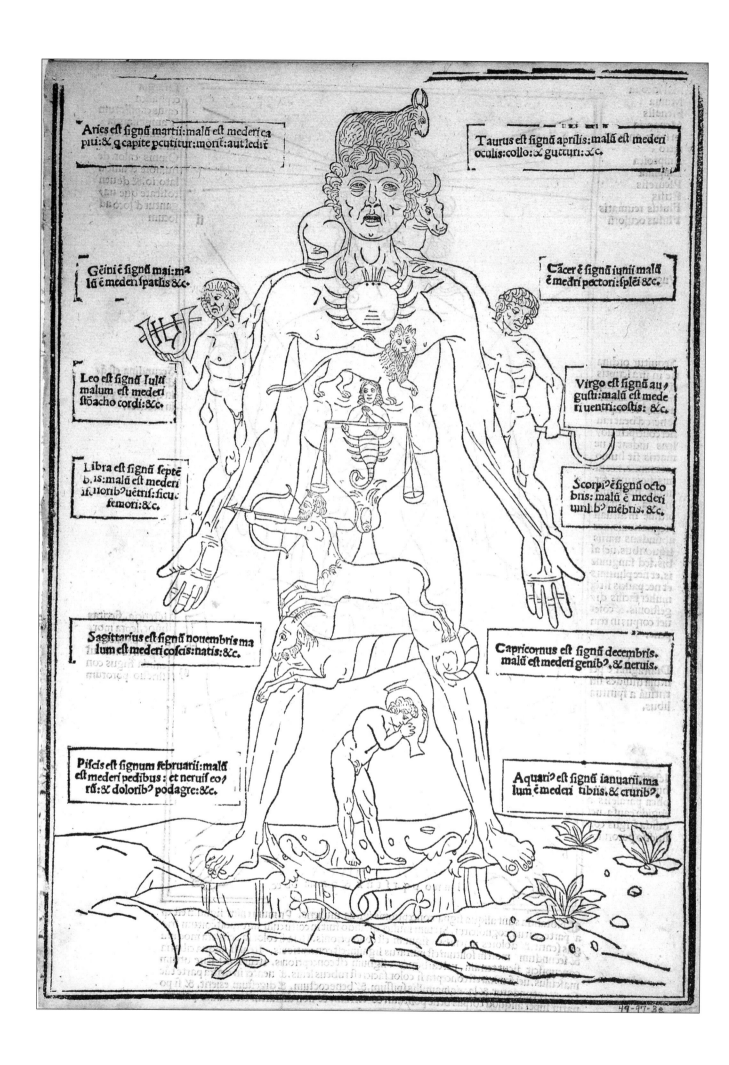

Aries est signū martii: malū est mederi capiti: & q capite pcutitur: morit: aut ledit

Taurus est signū aprilis: malū est mederi oculis: collo: & guttūri: &c.

Gēini ē signū mai: malū ē medeñ spatlis &c.

Cācer ē signū iunii malū ē medeñ pectori: splēi &c.

Leo est signū Iulii malum est mederi stōacho cordi: &c.

Virgo est signū augusti: malū est mederi uentri: costis: &c.

Libra est signū septēb. is: malū est mederi renoribꝰ uentris: sicut femori: &c.

Scorpiꝰ ē signū octobris: malū ē mederi uiñl bꝰ mēbris. &c.

Sagittarius est signū nouembris malum est mederi coscis: natis: &c.

Capricornus est signū decembris. malū est mederi genibꝰ. & neruis.

Piscis est signum februarii: malū est mederi pedibus: et neruis eoꝰ rū: & doloribꝰ podagre: &c.

Aquariꝰ est signū ianuarii. malum ē mederi tibiis. & crurib.

associations: the Ram, Aries, March (the head); the Bull, Taurus, April (the neck, eyes, and throat); the Twins, Gemini, May (the shoulders, arms, and hands); the Crab, Cancer, June (the chest and spleen); the Lion, Leo, July (the stomach); the Maiden, Virgo, August (the abdomen and ribs); the Scales, Libra, September (the hips, haunches, and what lies below the private parts); the Scorpion, Scorpio, October (the male organs); the Centaur, Sagittarius, November (the buttocks and thighs); the Goat, Capricorn, December (the knees and their nerves); the Water Bearer, Aquarius, January (the shins and lower legs); the Fish, Pisces, February (the feet and their nerves, the pains of gout, etc.) I am grateful to Luke Demaitre for his transcriptions and translations of the inscriptions.

8. For a history and description of the editions, see Choulant, *History and Bibliography of Anatomic Illustration*, 115-122. For a facsimile of the 1491 edition, see Karl Sudhoff, *Der Fasciculus medicinae des Johannes de Ketham, Alemannus* (Milan: Lier, 1923); for the first Italian edition, see *The Fasciculo di Medicina, Venice, 1493*, intro. Charles Singer, 2 vols. (Florence: Lier, 1925). See also Max Sander, *Le livre à figures italien depuis 1467 jusqu'à 1530*, reprint ed. (Nendeln/Liechenstein: Kraus Reprint, 1969) 2:nos. 3743-3754, 647-649.

9. See Diana H. Hook and Jeremy M. Norman, *The Haskell F. Norman Library of Science and Medicine* (San Francisco: Jeremy Norman, 1991) 1:no. 1211, 442. Hook and Norman believe that Ketham may have owned the manuscript from which the text was printed, rather than being the author. For a fuller biographical treatment, see Sudhoff 1923, 41-43.

10. For an analysis of the differences between the zodiac men of the 1491 and 1493 editions, see Singer 1925, 17.

11. See Roslynne Valerie Wilson, "Collaborations in Art and Medicine, 1491-1543: The Development of Anatomical Studies in Italian Medical Treatises" (Ph.D. diss., Case Western Reserve University, 1988; Ann Arbor, Mich.: University Microfilms International, 1988), 71-73; and Cazort, *The Ingenious Machine of Nature*, cat. no. 1, 105.

12. See Clark 1979, 1 n. 1.

representation of the body lends added authority and pathos to the linear design of the figure, particularly in the stoic expression of the head and the prayerlike position of arms and hands. The figures of Gemini and Aquarius, as well as that of Sagittarius, reflect further influence of ancient sculpture. Also noteworthy is the sketchy landscape on which the zodiac man firmly plants his feet. This terrain contains plants and a small pool occupied by twin dolphins symbolizing Pisces and Aquarius. The latter, fulfilling his astrological function, empties his water pitcher into the pool. The placement of animal and hybrid zodiacal signs, although dictated by anatomical considerations, shows ingenuity and wit. Particularly attractive are the ram atop the figure's head and the goat, whose tail is wound around his knee. Scholarly opinion connects the style of the woodcuts with the contemporary workshops of the leading Venetian painters and to book illustration.[11]

While the zodiac man and other illustrations in the various editions of the *Fasciculus medicinae* preserve medieval anatomical types, such as the wound man (Cat. 11), the full-page woodcuts are the first to appear in medical books and complement the beautiful graphic design of these masterpieces of early Venetian printing. The cognitive value of the illustrations in teaching sets an important precedent for the anatomical textbooks of Berengario da Carpi (Cat. 12 and 18) and Vesalius (Cat. 13 and 19). While the zodiac man vanished from medical books after the seventeenth century, the image continues to appear in calendars and almanacs to the present day—a testimony to an undiminished loyalty to the macrocosmic-microcosmic world view and astrological belief systems.[12]

CRS

## 58 A Synoptic Table of the Microcosm-Macrocosm Analogy

*A Synoptic Table of the Microcosm-Macrocosm Analogy*, 1596
Theodor Galle (1571-1633) after Natale Bonifacio (1538-1602)
Engraved broadside
Plate mark: 24 x 16¾" (61 x 42.6 cm)
Andrea Bacci (1524-1600)

*Ordo universi et humanarum scientiarum prima monumenta*
Antwerp: Theodor Galle, 1596
Inscribed profusely (see below)
History of Medicine Division,
National Library of Medicine,
National Institutes of Health,
Bethesda, Maryland

THIS BROADSIDE OFFERS A DETAILED BUT COHESIVE explanation of the microcosm-macrocosm analogy. Although its frame of reference, like that of the zodiac man (Cat. 57), includes medical and astrological elements, the structures described in this work are far broader, encompassing theology, philosophy, and psychology. Except for the profile head, the explanation relies on an interrelated series of diagrams in which verbal information is organized within a series of geometric figures. The most important is the circle, followed by rectangles (some enclosed within ornamental frames), which are united by directional lines.[1] The organization of information is hierarchical, beginning with the divine realm at the top and center of the sheet and proceeding to the human sphere directly below in the lower half of the diagram. Left and right positions on the sheet are also important organizing principles. As the title on the top states, the human, or microcosmic, sphere unfolds on the left, while the macrocosm, or universe, occupies the opposite side. A series of eight cartouches, three on each side and two at the top and bottom, enlighten the reader about the overall arrangement and contents. Henri D. Saffrey, who has exhaustively analyzed the broadside, calls it a synoptic table, a format summarizing information familiar from medical and philosophical treatises.[2]

Perhaps the most arresting part of the broadside is the only visual image, the profile bust of a young male, beautifully modeled by the engraver.[3] Representing the microcosmic man, the head contains a familiar localization of functions of the brain and the five external and six inward senses (Cat. 26 and 27). The author does not neglect the description (on the upper left) of the various divisions of the soul, followed below the figure by an extensive account of other mental faculties.[4] Also of great interest is the representation of the universe, or macrocosm. The respective spheres of the celestial and terrestrial worlds are encompassed within the circle diagram, including a map of the world designating four continents. On its circumference, surrounding the four compass directions, are a series of small circles related to the signs of the zodiac and inscribed with the names of the four seasons, temperaments, and the four ages of man.[5] Below it are found detailed explanations of the planets, including their location in relation to the earth, their orbits, and the time of their revolution. The author also provides affinities with other planets, their sex, qualities of heat and humidity, and their influence on the parts of the body.[6] The sequence concludes with the four elements.

In the lowest cartouche on the left, (the author), Andrea Bacci, discusses the pedagogic function of the broadside. He explains that as a student he had composed a diagram of the principal relationships governing nature and the world. When he became a professor (at the University of Rome, "La Sapienza") his students encouraged him to revise it as a teaching tool.[7] Saffrey has identified the probable prototype and model for Bacci's earlier diagram in a woodcut

1. For a discussion of the use of geometric figures as cognitive aids, see John E. Murdoch, *Album of Science: Antiquity and the Middle Ages* (New York: Charles Scribner's Sons, 1984), parts 2, 3, and 6.

2. Henri D. Saffrey, "L'homme-microcosme dans une estampe médico-philosophique du seizième siècle," *JWCI* 57 (1994): 89-90. The following discussion is based on this article.

3. For a detailed explanation, see ibid., 112-113.

4. Renato G. Mazzolini, "Schemes and Models of the Thinking Machine (1662-1762)," in *The Mill of Thought*, 86-89, fig. 2, 7.

5. Saffrey 1994, 112, and pl. 12.

6. Ibid., 114-116, and pl. 16.

7. Ibid., 93.

8. Ibid., 106-110, pl. 19; Clarke and Dewhurst, *An Illustrated History of Brain Function*, 28, fig. 37. Especially striking similarities are the circle containing the divine realm, the scheme of the universe on the right, and the profile portrait of the microcosmic man. The current location of this work is unknown.

9. Mario Crespi, "Andrea Bacci," *DBI* 5:29-30.

10. Saffrey 1994, 91. For the engraver's career, see Thieme-Becker, "Natale di Girolamo Bonifazio,"5:294; Milan Pelc, "Natale Bonifacio," Saur 12:548-549.

11. Saffrey 1994, 97. For the printer, see Christine Van Mulders, "Theodor Galle," *DOA* 12:16. Theodor was the son of Philip Galle (Cat. 69).

12. The Jesuit college in Rome used a later version of the broadside as a teaching tool (Saffrey 1994, 98-104); Jean Adhémar, "L'enseignement par l'image," *GBA* 97 (February 1981):53-54, fig. 1.

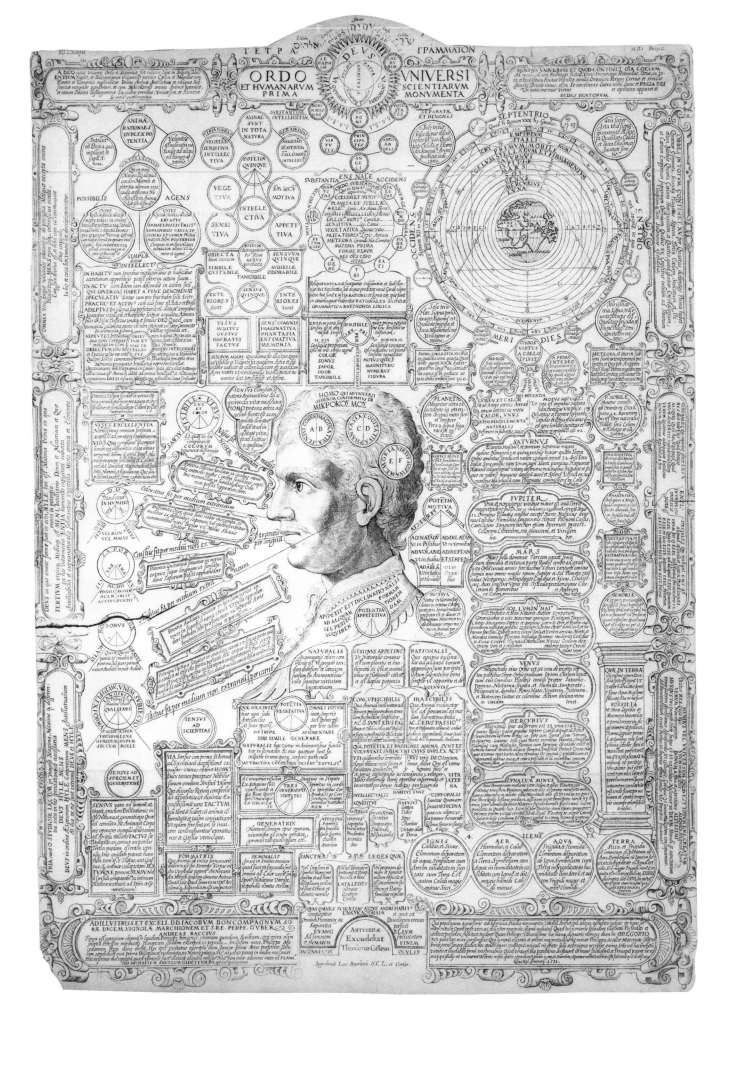

dated 1543 by Agostino Dario, which presents a similar but simplified arrangement of the broadside's major features.[8]

The present broadside was dedicated to a prominent figure of the papal court, Giacomo Boncompagni, the natural son of Pope Gregory XIII. Bacci, trained as a physician, derived his prestige not from the practice of his profession but from his position as professor of botany and writer on pharmacology, hydrology, and zoology.[9] Further documentation on the commission comes from the contract Bacci signed in 1580 with the engraver, Natale Bonifacio, to work in the author's house and to complete the broadside within forty to fifty days.[10] Although Bacci attempted to prevent copies of the work from being printed without permission, a second version by Adrian Huybrechts was published in Antwerp in 1585. The present version in the National Library of Medicine, printed in the same city by Theodor Galle six years later, represents the second state of the Antwerp copy.[11]

Blending Christian theology with antique philosophical thought, the broadside offers an artfully compressed presentation of the microcosm-macrocosm analogy. The arrangement of all these elements on a single sheet in a carefully designed sequence and order testifies to its pedagogic functions.[12] Also impressive is the representation in all its complexity of man and the universe as God's unique creation.

CRS

The Creation of Man
(Adam and Eve):
The First Plate

*The Creation of Man (Adam and Eve):*
*The First Plate*, 1613
Lucas Kilian (1579-1638)
Engraving with flaps
Plate mark: 14³⁄₁₆ x 10³⁄₈"
(36.3 x 26.4 cm)
Sheet: 16½ x 12" (42 x 30.4 cm)
Johann Remmelin (1583-1632)
*Catoptrum microcosmicum: Visio prima*
Augsburg: Stephan Michelspacher, 1613
Inscribed:
Left pedestal, base, *I. R. Inventor,*

[Johannes Remmelin] Designer; *L. K.*
*Sculptor* [Lucas Kilian] Engraver; Left
roundel, *Ora et labora; Anno aetate*
*XXX; Musica*; (Work and Pray, Thirty
Years of Age, Music); Right pedestal,
base, *Stephan Michelsbacher excudit*
(Stephan Michelsbacher printed it);
Right roundel, *Deum time; Anno christi*
*MDCXIII* (Fear God, A.D. 1613); etc.
Library of the College of Physicians
of Philadelphia

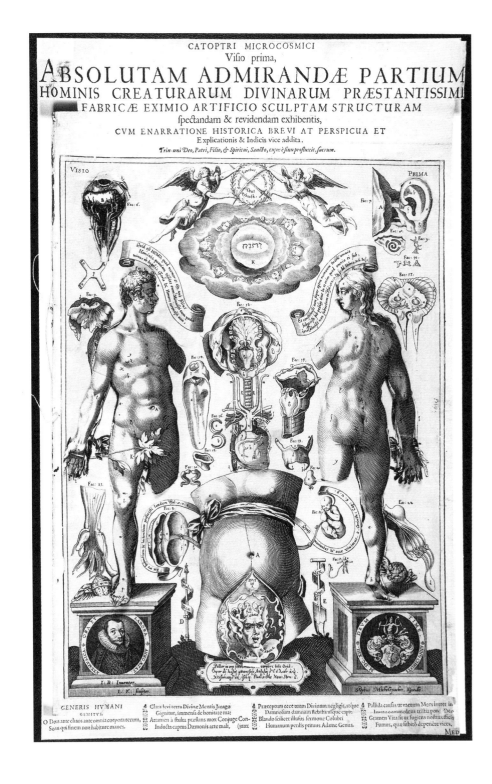

THIS ENGRAVING, whose title is translated as the *Microscopic Mirror,* represents male and female anatomy within the context of the microcosm-macrocosm analogy. The mystical significance of divine creation, indicated by the Hebrew name of God inscribed on a cloud, is witnessed by two sword-carrying angels holding an explanatory wreath. Below on the left a male nude in frontal view, imitating a classical nude, stands with one foot on a pedestal. Opposite and facing him is his female counterpart seen from the back. Surrounding them are details of various body parts, of which the most prominent is the large-scale torso in the center that depicts the female reproductive system.

Symbols of the perfect bodies created by God, the two nudes are depicted as Adam and Eve.[1] This convention, which coincides with the increase during the sixteenth century of anatomical study, legitimizes the moral and practical aspects of the enterprise. Verses from the Old Testament (Psalms 8:4-6) glorifying man as God's creation occupy the scrolls next to the figures' heads. Further moralizing verses (Psalms 8:2) surround the female genitalia and the newborn child, while a negative, minatory view of woman's sexuality emerges from the inscriptions and images concealing her genital region.[2] Between the pedestals supporting Adam and Eve, inscribed emblems emphasize the fleeting quality of human existence.

Why do the two figures stand on one foot and display only one arm? The answer lies in the genre of the anatomy with flaps. This device, designed to reveal the underlying structures and organs of the body, originated in the 1530s in southern Germany and Venice.[3] The various layers of hinged flaps, cut to scale, and fastened to the top surface, are characteristic of fugitive (single) printed sheets. These prints, cheaper to produce than whole books, were intended for practical consultation in the chambers of barber-surgeons, apothecaries, and bathhouses. Usually printed in the vernacular, fugitive leaves were directed to a popular audience and probably used in teaching, although the anatomical knowledge they contained was not always current.

The size, elaborate symbolism, and attention to detail make this plate a climactic monument of the flap-anatomy genre. A synoptic anatomical atlas, it is accompanied in later editions by a complex index. This system relies on an intricate scheme of inscribing lower and upper case letters on the figures' bodies to identify all the surface and underlying body parts. The author of the text and designer of the program is Johann Remmelin (Rümelin), whose naturalistic portrait and crest appear in the roundels of the left and right pedestals. There, cryptic allusions to alchemy appear in the references to music, work, and prayer (See Cat. 71). Remmelin, a physician who practiced in Ulm and Augsburg, wrote also on mathematics, astrology, and magic.[4] The engraver is Lucas Kilian, an important printmaker of the early seventeenth century, whose style combines Italian and German elements.[5] The three plates, first published in 1513 by Stephan Michelspacher, were printed in many later editions. Michelspacher, also a physician and author, dedicated one of his alchemical treatises to Remmelin.[6] The presence of mystical, alchemical symbolism in the *Visio prima,* as well as the mixture of anatomical details, classical figure style, and moralizing content, bring about a visual dissonance. This effect results from the different representational modes joined in one image to describe the naturalistic structures and details of human anatomy within the ideal framework of the microcosm-macrocosm analogy.

CRS

1. For discussion of this convention, see Roberts, *The Ingenious Machine of Nature,* 87-89 and 91-92; Cazort, ibid., cat. no. 10, 116-118, cat. nos. 27-28, 133-135, and cat. no. 55, 169-170.

2. Cazort, ibid., cat. no. 56, 171-172.

3. Ibid., cat. nos. 13-14, 120-122. See also Julie V. Hansen and Suzanne Porter, *The Physician's Art: Representations of Art and Medicine,* exh. cat. (Durham, N.C.: Duke University Medical Center Library and Duke University Museum of Art, 1999), cat. nos. 6a-b, 40-41. Hansen and Porter cite Andrea Carlino, *Paper Bodies: A Catalogue of Anatomical Fugitive Sheets in the Age of Printing and Dissecting* (London: Wellcome Institute for the History of Medicine, 1999).

4. W. Haberling, "Johannes Rümelin," *Biographisches Lexikon der hervorragenden Ärtze aller Zeiten und Völker,* ed. August Hirsch, 2d ed. (Berlin: Urban and Schwarzenberg, 1932) 4:916-917; Cazort, *The Ingenious Machine of Nature,* cat. no. 56, 170-171.

5. Irene Haberland, "Lucas Kilian," *DOA* 18:42-44.

6. For a discussion of the complex history of the publication, see W. B. McDaniel 2d, "The Affair of the '1613' Printing of Johannes Rümelin's *Catoptron,*" *Transactions and Studies of the College of Physicians of Philadelphia* (1938-1939) 6:60-72; Cazort, *The Ingenious Machine of Nature,* cat. no. 56, 171-173.

Nature as God's
Appointed Ruler
of the Microcosm

*Nature as God's Appointed Ruler of the
Microcosm*, 1617
Matthäus Merian the Elder (1593-1650)
Engraving
Plate mark: 13⅞ x 13⁹/₁₆" (35.3 x 34.5 cm)
Robert Fludd (1574-1637)
*Utriusque cosmi maioris scilicet et
minoris metaphysica, physica, atque
technica historia,* Volume 1

Oppenheim: Johann Theodor de Bry,
1617, fols. 4v.-5r
Inscribed:
*Integra Naturae speculum Artisque
imago* (The Mirror of the Whole of
Nature and the Image of Art); etc.
Library of the College of Physicians of
Philadelphia

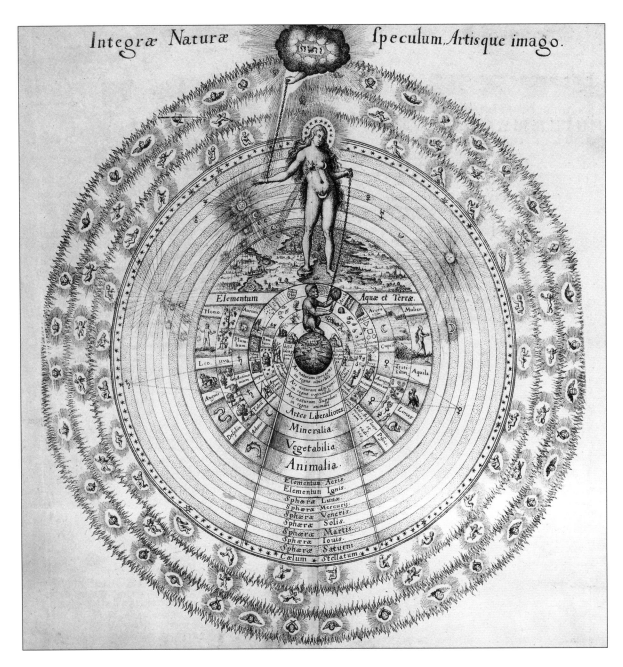

1. Joscelyn Godwin, *Robert Fludd: Hermetic
Philosopher and Surveyor of Two Worlds*
(London: Thames and Hudson, 1979), pl. 4,
22. Godwin offers translations of passages
from *Utriusque cosmi historia* (1:7),
containing the author's explanation of the
illustration. Fludd states there that Nature
"is she who turns the sphere of the stars and

THIS ENGRAVING, the second in the magnificent two-volume encyclopedia
translated as *The History of the Macrocosm and the Microcosm,* represents the
fullest visual realization of this cosmology. Among its ancestors is the right half
of the Bacci broadside (Cat. 58) with its diagram of the parts of the universe.
Expanded to a bifolium format, the engraving features a personification of
Nature, the dominating human figure, as the world soul. Nature is personified

as a beautiful virgin exemplifying the female creative principle. Above her and emanating from a central, divine cloud are three outer circles representing the heavenly spheres consisting of the cherubim, seraphim, and archangels. They surround the orbits of the stars, the planets, air, and water. Nature receives a chain from God (symbolized by his Hebrew name, Jehovah), and through divine power "governs the subcelestial world."[1] The sun on one of her breasts "is Nature's heart, and her belly is filled with the moon's body."[2] Her right foot stands on earth, symbolizing sulphur, and her left on water, emblematic of mercury. In alchemical thought the joining of these elements is essential for generation and growth.[3]

Nature's chain passes under her left foot to an ape, a traditional symbol of Art. Art, imitating Nature by observing her and learning her secrets, is "her helper, and produces things similar to her."[4] Seven inner circles "represent animals, vegetables, minerals, the 'more liberal' arts, 'Art Supplementing Nature in the Animal Kingdom,' 'Art Helping Nature in the Vegetable Kingdom,' and 'Art Correcting Nature in the Mineral Kingdom.'"[5] Verbal information or visual depictions of animals, plants, metals, and minerals fill these spheres.[6]

Robert Fludd, the author of this elaborate program of illustration accompanying his text, exemplifies the broad range and seemingly conflicting character of seventeenth-century intellectual and spiritual currents. Educated at Oxford, Fludd was trained in medicine and was a member of the Royal Society of Physicians. Among his interests were natural philosophy, alchemy, and music theory.[7] Fludd was a friend of William Harvey (Cat. 23), whose controversial views on the circulation of the blood he was the first to accept in a published work, his *Medicina catholica* of 1629 (Cat. 83). Fludd, however, based his endorsement not on medical grounds but on his views of microcosmic-macrocosmic cosmology.[8] Among Fludd's influential friends and patrons were Kings Charles I and James I. Indeed, the latter was the dedicatee of the first volume of the *Utriusque cosmi historia*. Fludd, who traveled widely in Europe, came into contact with occult and alchemical ideas associated with the disciples of Paracelsus, the medical reformer and mystic.[9] Fludd maintained close ties with many continental intellectuals and was an advocate of the Rosicrucian movement, which contained many elements of Neoplatonic thought, including hermetic and cabalistic ideas.[10] The *Utriusque cosmi historia* unites these currents of occult thought "with a practical examination of nature" and a "spiritual view of the universe as an intelligent hierarchy of beings." Drawing from a wide variety of philosophic and religious sources, Fludd's views "provided for human enquiry and science within a meaningful and divine Creation; its proper end was the direct knowledge of God."[11]

Fludd's *Utriusque cosmi historia* is an outstanding achievement of printing and engraving. Because of favorable financial terms and practical experience, the author chose as printers the continental firm of Johann Theodor de Bry, publishers of lavishly illustrated books, including alchemical treatises.[12] The engraver of the principal plates, Matthäus Merian the Elder (see also Cat. 77 and 81), was related to the de Brys by marriage.[13] The collaboration of author, engraver, and publisher in this ambitious undertaking produced a remarkable series of illustrations that became the cognitive and aesthetic standard in realizing the full meaning of the microcosmic-macrocosmic analogy.[14]

CRS

disposes the planetary influences to the elemental realms, nourishing all creatures from her bosom."

2. Wayne Shumaker, *The Occult Sciences in the Renaissance: A Study in Intellectual Patterns* (Berkeley and Los Angeles: University of California Press, 1974), 123.

3. For the sulphur-mercury theory, see John Read, *From Alchemy to Chemistry,* reprint ed. (New York: Dover Publications, 1995), 17-22.

4. Godwin 1979, pl. 4, 22. The explanation continues: Art "forms the terminus of the chain of being, bearing the same relation to Nature as she to God."

5. Shumaker 1974, 123.

6. For a complete description, see ibid.

7. For a biography with bibliography, see William H. Huffman, *Robert Fludd and the End of the Renaissance* (London and New York: Routledge and Kegan Paul, 1988).

8. Gweneth Whitteridge, *William Harvey and the Circulation of the Blood* (London and New York: McDonald and American Elsevier, 1971), 150.

9. For a brief discussion of Paracelsus, see Brian P. Copenhaver's essay in this volume, 53-54. For an introduction to the subject, as well as a discussion of Paracelsus' ideas, see E. J. Holmyard, *Alchemy,* reprint ed. (New York: Dover Publications, 1990), esp. chap. 8.

10. For a classic exposition, see Yates, *The Rosicrucian Enlightenment.* In chapter 6 Yates discusses Fludd's involvement with this movement and that of his publisher, Johann Theodor de Bry.

11. Nicholas Goodrick-Clarke, introduction to *Robert Fludd: Essential Readings,* selected and ed. William H. Huffman (London: The Aquarian Press, 1992), n.p. [2].

12. See Frances A. Yates, *Theatre of the World* (London: Routledge and Kegan Paul, 1969), 69-75.

13. See Lucas Wüthrich, "Matthäus Merian," *DOA* 21:151-152; Wüthrich, *Das Druckgraphische Werk von Matthaeus Merian D. Ae.* (Basel: Barenreiter Verlag, 1972) 2:no. 66, 80-82.

14. Yates, *The Art of Memory,* chap. 15.

The Nomenclature of
the Hand and the Planets

The Nomenclature of the Hand and the
Planets, 1501
Anonymous
Handcolored woodcut
Image: 6¾ x 4½" (17.2 x 11.4 cm)
Magnus Hundt the Elder (1449-1519)
*Antropologium de hominis dignitate,
natura, et proprietatibus*
Leipzig: Wolfgang Stöckel, 1501, fol. I4
Inscribed:
External inscriptions from the left:
*Mo<u>n</u>tes* (Mounts);

*Auricularis* (Ear finger); *Annularis*
(Ring finger); *Medius* (Middle finger);
*Index* (Index finger); *Pollex* (Thumb);
Bottom right, *Prima Iu<u>n</u>ctura*
(First joint); *Secu<u>n</u>da Iu<u>n</u>ctura*
(Second joint); Upper right, *Ungula*
(Nail); *Prima Iunctura, <u>secu</u>nda, tertia*
(First, second, and third joints); etc.
History of Medicine Division,
National Library of Medicine,
National Institutes of Health,
Bethesda, Maryland

1. For a discussion of chiromancy and its relationship to astrology, see the essay of Brian P. Copenhaver in this volume, 48-55.

2. For an interpretation of the lines and marks, see ibid., 52.

3. Karl Sudhoff, *Die medizinische Fakultät zu Leipzig im ersten Jahrhundert der Universität* (Studien zur Geschichte der Medizin 8) (Leipzig: Johann Ambrosius Barth, 1909), 116-121. Sudhoff regards the *Antropologium* as the fifth printed book featuring anatomical illustrations.

4. Choulant, *History and Bibliography of Anatomic Illustration*, 126.

5. Sudhoff 1909, 116-117.

6. Vern L. Bullough, "Magnus Hundt," *DSB* 6:562.

THIS WOODCUT REPRESENTS THE HAND AS A MICROCOSM of the body, which itself is a microcosm of the world. The hand's place in the body's anatomy, conspicuous like the head's, invites the reading of its shapes, markings, and lines as signifiers of an individual's fate and character.[1] Physiognomy, the interpretation of the features of the head and body, and the allied procedure of chiromancy, divinatory reading of the hand, are ancient practices in many cultures. Astrology connects the fingers and mounts of the hand to the planets and stars, thereby providing another basis for prediction.

In this full-page woodcut, the right hand is such a cognitive map of chiromantic and astrological information. Crimson accents highlight the joints, thumbnail, and cuff of the sleeve. The principal markings on the palm of the hand are the *linea mensalis* (table line), *linea media naturalis* (middle line), and *linea cordis et vitae* (lifeline). Also important are the *percussio manus,* or striking part opposite the thumb, and the *[linea] restricta* (bracelet) at the bottom of the palm.[2] Instead of the planets' theriomorphic and other symbols featured in the woodcut of the zodiac man (Cat. 57), a different set of signs appears. Most important are the graphic signs inscribed on the *montes* [mounts] below each of the fingers: the index belongs to Jupiter; the middle digit, to Saturn; and the Sun and Mercury, to the ring and smallest fingers, respectively. The mound of Venus is at the base of the thumb; Mars, in the central triangle; and the Moon, near the percussion.

These microcosmic and chiromantic features appear in one of the first printed books with anatomical illustrations.[3] Although very crude, the woodcuts in the *Antropologium* include early representations of the internal organs.[4] The volume contains eighteen woodcuts: eleven were borrowed from an earlier work; seven, including the present illustration, are original; and five occupy a full page. The woodcut of the hand contains the usual nomenclature for the digits, numbers, and joints. The text describes the anatomical, psychological, and spiritual nature of humanity.[5] The author, Magnus Hundt the Elder, was a physician and theologian educated at the University of Leipzig, where he worked for many years as a professor.[6] Like other physicians (Cat. 57-60), Hundt understood human anatomy in a framework of microcosm and macrocosm that includes beliefs in physiognomy and chiromancy.

BPC and CRS

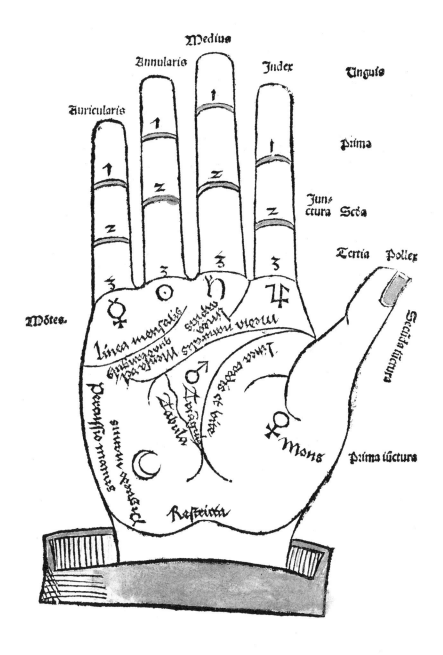

The Finger of Mercury and the Place of the Moon on the Palm

*The Finger of Mercury and the Place of the Moon on the Palm*, 1558
Anonymous
Woodcuts
Images: 2⅞ x 1⅞" (7.3 x 4.8 cm)
Johannes ab Indagine (c. 1467-1537)
*Brief Introductions Both Naturall and Pleasaunte . . . unto the Art of*

*Chiromancy and Phisiognomy*
Translation by Fabian Withers
London: John Day, 1558, fols. H4v. and H5r.
For inscriptions, see below
The Folger Shakespeare Library, Washington, D.C.

1. Ruth Samson Luborsky and Elizabeth Morley Ingram, *A Guide to English Illustrated Books, 1536-1603* (Tempe, Arizona: Medieval and Renaissance Texts and Studies, 1998), 1:no. 14075, 473-475.

2. For further discussion of these images, see the essay in this volume by Brian P. Copenhaver, 52.

3. See Dietrich Kurze, "Johannes ab Indagine," *NDB* 10:168-169. The chiromancer has often been confused with a Benedictine monk of the same name, whose biography by Klemens Honselmann appears in ibid., 10:168.

THESE TWO WOODCUTS SHOW MORE CLEARLY than Hundt's illustration (Cat. 61) the practical application of the theory of the hand as a microcosm of the body. Astrological considerations are also more clearly formulated here. Following chapter 13 of *The Boke of Palmistry,* the author attempts (fol. H1) "chiromantial prognostication or manual divinations, according to the places of the .vii. planets." The assignment of the planets to the fingers (fols. H1v.-H5r.) and certain natural marks on the fingers are the content of these illustrations.

Short paragraphs immediately above these woodcuts depicting the palms of the right hand connect image with text.[1] Assigned to Mercury is (fol. H4v.) "the little finger with certaine lines, whereby you may perceive and know a Mercurial here briefly expressed, they betoken benefites or offices, all other signifie sadnesse, melancholy and heaviness." The facing illustration (fol. H5r.) deals with the position of the moon: "The place of the Mone is in the pomel of the hande. Wherefore if thou perceive the lines here discribed rising from the wreste: it sheweth sluggishnes, in the place of Iupiter dulnesse and folishnes, and speciallye in women, whiche by nature are not very wise."[2] Gender stereotypes certainly influence the reading of the configurations described here.

Simple messages derived from astrological and natural signs enable readers to interpret character and fortunes, and the author assures the reader (fol. H5v.) that the required knowledge will come without much pain or labor. This English version of a Latin original in a small format with simplified illustrations suggests its use as a portable manual for a lay audience.

The original work, published in 1522, was widely influential. Numerous vernacular translations and related versions appeared through the sixteenth and seventeenth centuries. The author, Johannes ab Indagine, was a priest in Steinheim, a small town on the Main river east of Frankfurt, but he also worked as a court astrologer to the Electors of Mainz and Brandenburg.[3]

BPC and CRS

## The boke of

### Of the finger of Mercury.

They haue appointed vnto Mercurye the little finger with certaine lines, whereby you may perceiue and know a Mercurial here briefly expressed, they betoken benefites or offices, all other signifie sadnesse, melancholy, and heauines.

## Palmestrye.

### Of the place of the Moone.

The place of the Mone is in the pomel of the hande. Wherfore if thou perceiue the lines here discribed rising from the wreste: it sheweth sluggishnes, in the place of Iupiter dulnesse and folishnes, speciallye in women, whiche by nature are not very wise.

A

B

# The Fortune-Teller and the Lady

*The Fortune-Teller and the Lady*, c. 1608
Andries Stock (c. 1572 or 1580-c. 1648)
after Jacques de Gheyn II (1565-1629)
Engraving
Sheet: 12 x 8" (30.4 x 20.3 cm)
Inscribed:
*Cui media turgot vena, dum medicum quaerit / Qui rite tundat, et diu nimium sperat; / Adiit vagantem torridae cutis Nubam: / Futura discit quae placent, et hoc tantum. / Eheu misella, sicne emis palam falsa / Futura credis: Quin pete auxilium praesens.* (A woman whose middle vein is swollen has need of a doctor who will give her proper blood-letting. Instead she consults a wrinkled old Nubian fortune-teller. Alas, wretched lady, why are you paying for this? Why do you believe these obviously false predictions? Seek help immediately!)
Signed lower right: *IG invenit; N. de Clerck excudit* (Jacques de Gheyn designed it; N. de Clerck printed it)
The Metropolitan Museum of Art, The Elisha Whittelsey Collection, The Elisha Whittelsey Fund, 1949, 49.95.1327

THIS IMAGE REFLECTS THE WIDELY HELD BELIEF that knowledge of an individual's future can come from correct reading of the lines and shape of the hand.[1] Since the thirteenth century, texts and images in manuscripts and prints instructed the reader in the correct methods of interpreting these natural signs (Cat. 61-62, 64-68). During the seventeenth century the theme of fortune-telling by palm reading became a favorite subject in painting and the graphic arts. Combining love of the exotic and the disreputable with naturalistic treatment, this genre proved attractive as a moralizing theme cautioning against fraud and gullibility.[2]

Here a gypsy stretches out her hands to receive a coin from a young woman whose fortune she has told or will tell. The hands of the two main parties bridge the noticeable gap between them, relieved only by a clump of grasses. The disheveled figure of the gypsy, silhouetted against a huge, ominously leaning withered tree, dominates the composition. Her "heavy, full-length robe wrapped under one arm and fastened over the opposite shoulder to cut diagonally across the chest" identifies her as a gypsy.[3] Her eagerness to reach out contrasts with the reticence of the fashionably clad young woman, whose downcast eyes avoid contact with the fortune-teller. The lady's elegance is reinforced by the dress of her servant and the small dog. In contrast, two untidy and wary children accompany the gypsy. Although plants grow in the foreground associated with the elegant figures on the left, the rest of the setting contributes to the atmosphere of unease. The withered branches framing the lady and her companion, as well as the tree roots, indicate a "blasted heath," a backdrop for a forbidden and frightening encounter. In short, the artist distinguishes clearly between two social realms. The fortune-teller's clothes and demeanor signify her marginal and outsider status, while the lady and her servant belong to the fashionable and wealthy ranks of society. Both parties, however, are depicted unfavorably: the figures on the left are gullible victims; the hag on the right takes advantage of their credulity in uttering worthless prognostications. The verses below the engraving reinforce these messages.

The engraving, now attributed to Andries Stock, a pupil of de Gheyn, reverses a preparatory drawing by the latter now in the Herzog-Anton-Ulrich Museum in Brunswick.[4] Like Goltzius (Cat. 30 and 74), with whom he worked in Haarlem from 1585 to 1590, de Gheyn was an immigrant, who received his training from his father, the first of three generations of artists with the same name. Born in Antwerp, the younger de Gheyn settled in Holland and married a woman from a prominent family whose social position brought him important commissions and consequent prosperity.[5] De Gheyn had long been interested in the occult, particularly witches.[6] Drawings of women resembling the fortune-teller and the unruly children, as well as of menacing trees, bear witness to his preoccupation with these themes.[7] In the *Fortune-Teller and the Lady* de Gheyn effectively expresses his skepticism about the worthiness of the knowledge gained from palm reading, a trade associated with wily outsiders from the margins of society. This attitude demonstrates how chiromancy, once associated with theories accepted by serious scholars, has been reduced to a disreputable practice.

CRS

1. For further discussion, see the essay by Brian P. Copenhaver, 47 and 48-52.

2. Gail Feigenbaum, "Gamblers, Cheats, and Fortune-Tellers," in *Georges de la Tour and His World,* ed. Philip Conisbee, exh. cat. (Washington, D.C.: National Gallery of Art, 1996), 168-170.

3. Ibid., 169.

4. See Alfred von Wurzbach, "Andries Stock," *Niederländisches Künstler-Lexikon* (Vienna and Leipzig: Verlag von Halm and Goldmann, 1910) 2:663-664; Thieme-Becker, "Andries Stock," 32:70. For the engraving, see Hollstein 7:205. For the attribution of the engraving to Andries Stock, see Jan Piet Filedt Kok, "Jacques de Gheyn II: Engraver, Designer, and Publisher," *Print Quarterly* 7/3 (1990):279-281 and 7/4 (1990):cat. no. 105, 377. For the drawing, see I. Q. van Regteren Altena, *Jacques de Gheyn: Three Generations* (The Hague and Boston: Martinus Nijhoff Publishers, 1983) 1:89; 2:cat. no. 534, 87; 3:pl. 301. See also J. Richard Judson, *The Drawings of Jacob de Gheyn II* (New York: Grossman Publishers, 1973), 27; and A. W. F. M. Meij and J. A. Poot, *Jacques de Gheyn II, 1565-1629, Drawings,* eds. A. W. F. M. Meij and J.A. Poot, exh. cat. (Rotterdam: Museum Boymans-van Beuningen and Washington, D.C.: National Gallery of Art, 1986), cat. no. 63, 68.

5. A. Th. van Deursen, "The Age of Jacques de Gheyn," in *Jacques de Gheyn II* 1986, 9-12; E. K. J. Reznicek, "Two 'Masters of the Pen,'" in ibid., 13-18; and Reznicek *DOA* 12:529-532. In the latter publication (12:531), Reznicek states his belief that de Gheyn himself made the print of *The Fortune Teller and the Lady.*

6. There was also considerable scientific interest in the gypsies and their customs, which perhaps de Gheyn shared. See Meij and Poot, *Jacques de Gheyn II* 1986, cat. no. 63, 68.

7. Ibid.

Two Chiromantic Hands

*Two Chiromantic Hands*, c. 1475
Anonymous
Handcolored woodcuts
Images: 11⅛ x 7¾" (28.3 x 19.8 cm)
Johann Hartlieb (c.1400-1468)

*Die Kunst der Ciromantia*
Augsburg, c. 1475, pls. 10 and 11
Inscribed profusely (see below)
The Pierpont Morgan Library, PML 10,
New York City

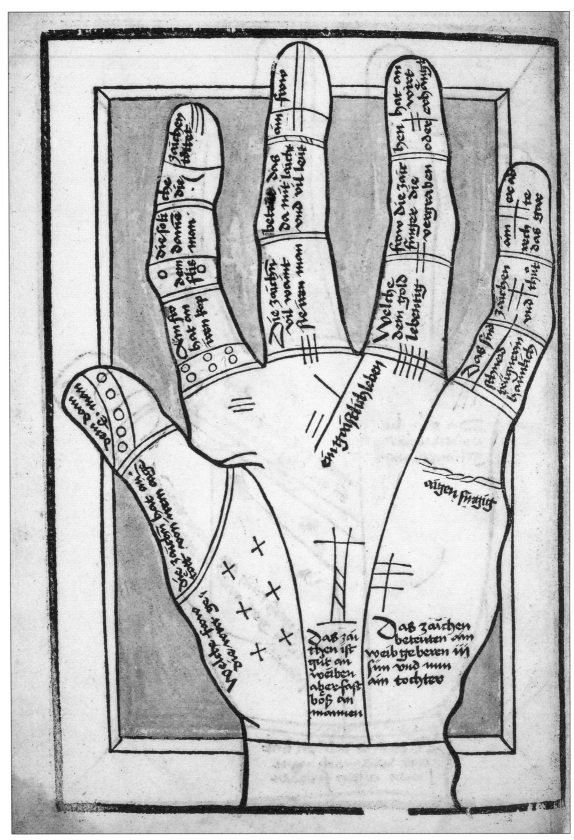

A

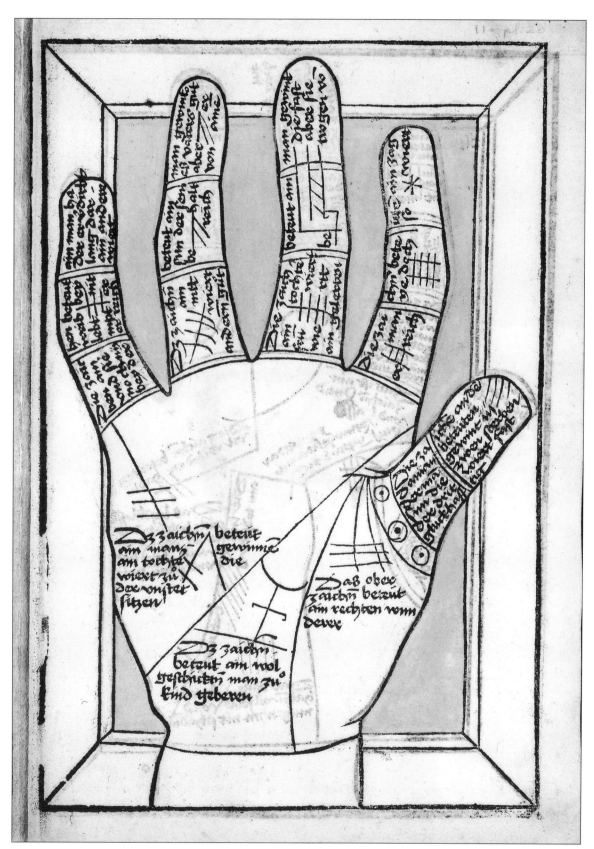

B

1. Wilhelm L. Schreiber, *Manuel de l'amateur de la gravure sur bois et sur métal au XVe siècle* (Leipzig: Otto Harrassowitz, 1902), 4:428-432. For a facsimile, see *Die Kunst Chiromantia*, ed. Ernst Weil (Munich: A. Gaus, 1923).

2. For the symbolism of left and right in the representation of hands, see the Introduction in this volume, 20.

3. I am greatly obliged to Prof. Albrecht Classen for transcribing and translating the inscriptions of these plates.

4. *Catalogue of Manuscripts and Early Printed Books from the Libraries of William Morris, Richard Bennett, Bertram, Fourth Earl of Ashburnham, and Other Sources, Now Forming Portions of the Library of J. Pierpont Morgan* (London: Chiswick Press, 1907), 1: no. 10, 7. The recently rebound Morgan copy does not follow the order of the plates in the facsimile. Thus plates 10 and 11 in the Morgan work (our Cat. 64A and 64B) correspond to plates 5 and 20 in the facsimile (Weil 1923). I am grateful to Anna Lou Ashby for providing this and other information on the Morgan copy. For a description of another copy of this edition, see Ilona Hubay, *Incunabula der Staats- und Stadtbibliothek Augsburg* (Wiesbaden: Otto Harrassowitz, 1974), no. 2, 2; and Helmut Gier, *450 Jahre Staats- und Stadtbibliothek Augsburg*, exh. cat. (Augsburg: Staats- und Stadtbibliothek Augsburg, 1987), no. 3, 33. Both these entries say that the signature and intervention of Jörg Schapf (supposedly found on fol. 8v.) is a feature not of the second, but of the third and fourth editions. For a contrary position, see Robert Zillma, comp., and Tilman Falk, ed., *Hollstein's German Engravings, Etchings, and Woodcuts, 1400-1700* (Rotterdam: Sound and Vision Interactive, 1997), 44:100.

5. Weil 1923, fol. 1; see Frank Fürbeth, *Johannes Hartlieb: Untersuchungen zu Leben und Werk* (Tubingen: Max Niemeyer Verlag, 1992), 72-75.

6. For a discussion of an important manuscript tradition, see Roger A. Pack, "A Pseudo-Aristotelian Chiromancy," *Archives d'historie doctrinale et littéraire du moyen âge* 44 (1969):189-241. For the first printed version of this pseudo-Aristotelian text (Ulm: Johann Reger, 21 July 1490), see Peter Amelung, *Der Frühdruck im deutschen Südwesten, 1473-1500*, exh. cat. (Stuttgart: Württembergischen Landesbibliothek, c. 1979), cat. no. 151, 340-341.

THESE TWO IMAGES REPRESENT the first printed work on chiromancy. The Morgan example is a very rare blockbook in which both text and image are cut from the same piece of wood.[1] A sequence of twenty-two folios represents diagrams of hands with predictions written on the fingers and palms. The verso always depicts a left hand, predicting the fate of women, and the recto, a right hand devoted to the fortunes of men. The gendered character of these prognostications may reflect the traditional notion of the inferiority of left to right positions in spatial and symbolic terms.[2] Furthermore, the predictions written on the woman's hand are far more negative and pessimistic than those inscribed on the man's in the folio opposite. For example, on the thumb, a translation of the inscription reads: "The woman with the signs on her thumb will be killed by her own husband." On the ring finger, the translation declares: "The woman who has these signs on her gold finger [ring finger] will be buried alive or hanged."[3] The rest refer to the deceptive and conniving character of such a woman. As for the man's hand on the recto, the emphasis falls on the riches he or his family will receive. The inscription on the little finger reads: "These signs mean a man has a wife who causes his downfall, whereas she lives. Not long after he takes another wife with whom he acquires many riches." Despite such good fortune, the misogynistic tone continues in the prediction written on the middle finger: "These signs mean that a man gets a daughter who almost becomes saintly [?], yet she will be cheated by a scholar."

The full-page format and large scale of the woodcuts with their dark lettering are set off by green and pink handcolored backgrounds that function as framing devices. Printed on both sides of the sheet, the Morgan volume, one of three known copies of the second edition, is incomplete, with sixteen of the twenty-six folios. The role of Jörg Schapf, whose signature is found in later editions, is unknown. He may have been the book's woodcutter, bookbinder, or distributor.[4] Also difficult to establish are the manuscript models for the text and its original author, since Hartlieb refers to himself on the dedication page as its translator.[5] The text lacks the complexity of chiromantic description in the Latin manuscript tradition that was addressed to a learned audience.[6] For example, the work lacks a preliminary explanation of the parts and the lines of the hand, usually provided in contemporary manuscripts or early printed chiromantic treatises (Cat. 65). The use of the vernacular and the down-to-earth prognostications show that Hartlieb's work was directed to a lay audience.[7] Indeed, during the fifteenth century, manuscripts written in other vernacular languages also indicate a shift of audience, intensified by the spread of printing in the sixteenth and seventeenth centuries (Cat. 62 and 67).[8]

The first edition of the *Kunst der Ciromantia,* dated 1448, was dedicated by Johann Hartlieb to Duchess Anna of Brunswick-Grubenhagen. Hartlieb, the details of whose early life remain somewhat shadowy, served Duke Louis of Bavaria-Ingolstadt in the 1430s and studied medicine in Vienna and later Padua.[9] Well documented is his entry in 1440 to the service of Anna's husband Duke Albrecht III of Bavaria as physician and diplomat. Hartlieb continued during this decade to write and translate works on the Alexander legend, the occult, and an herbal.[10] Until the end of his life he remained in Munich, where he became a prosperous citizen. Hartlieb is an early example of the trained physician who saw no conflict in studying chiromancy as part of the microcosm-macroscosm parallel (Cat. 57, 59, 60, 61, 66, and 83).

CRS

7. For a detailed analysis of the chiromantic content of Hartlieb's work, see Wolfram Schmitt, *Magie und Mantik bei Hans Hartlieb* (Salzburger Beiträge zur Paracelsusforschung, 6) (Vienna: Notring der Wissenschaftlichen Verbände Österreichs, 1966), 11-13.

8. For a fifteenth-century English example, see Hardin Craig, *The Works of John Metham* (London: K. Paul, Trench, Trübner, 1916), esp. xxv-xxviii.

9. For biographical information, see Wolfram Schmitt, "Johannes Hartlieb," *NDB* 7: 722-723; and Fürbeth 1992, 12-41.

10. For a chronology of Hartlieb's work, see Fürbeth 1992, 42-43.

*A Chiromantic Hand*, 1493
Anonymous
Woodcut
Image: 5⁵⁄₁₆ x 2¹⁵⁄₁₆" (13.5 x 7.5 cm)
Anonymous
*Chiromantia*

Venice: Bernardo Benagli (Benali),
October 1493, fol. c2
Inscribed with signs of the planets
History of Medicine Division,
National Library of Medicine,
National Institutes of Health,
Bethesda, Maryland

1. For bibliographic references to this copy, see Dorothy M. Schullian and Francis E. Sommer, *A Catalogue of Incunabula and Manuscripts in the Army Medical Library* (New York: Henry Schuman, 1950), no. 152, 68.

2. See the *Gesamtkatalog der Wiegendrucke* (Leipzig: Verlag von Karl W. Hiersemann, 1934) 6:nos. 6637, 6638, and 6641, 462-463.

3. Ibid., nos. 6633 and 6643, 460 and 462. A second Latin edition, using Ratdolt's material was published in Padua by Mathaeus Cerdonis (ibid., no. 6635, 460). See also Gilbert Richard Redgrave, *Erhard Ratdolt and His Work at Venice: A Paper Read before the Bibliographical Society 20 November 1893* (London: Bibliographical Society, 1893), nos. 47 and 63, 41 and 63.

4. Comparison with the 1484 *Chiromantia* in the National Library of Medicine (*Gesamt Katalog der Wiegendrucke* 6: no. 6635; Schullian and Sommer 1950, no. 151) established the similarities between the two copies.

5. See Brian P. Copenhaver's essay in this volume, 50.

UNLIKE THE CHIROMANTIC HANDS in the Hartlieb blockbook (Cat. 64), this diagram shows astrological relationships by assigning a symbol of the planets to the mount of each finger and to locations on the palm (See Cat. 61 for explanation of these symbols.) Furthermore, all of the twenty-one full-page woodcuts represent only the right hand. Thus the interesting gender contrast between the left and right hands in the Hartlieb is missing, as is the dense verbal interpretation of the signs written on the fingers of the earlier work. Instead, a two-line Latin inscription atop each woodcut of the present treatise explains the significance of the signs. The only difference in the crudely drawn woodcuts is a change in the character and placement on the palms of individual lines, marks, and creases. For example, the signs on fol. c2 (apparently part of a graphic symbolic system) are placed under the mount of the smallest finger, subject to the influence of Mercury. Here the lines are interpreted positively, testifying to the individual's ability as a serious, pious speaker who mingles with accomplished religious men of high standing. The inclusion of such a full program of woodcuts, which dominates the textual material, testifies to the importance of indicating visually the proper locations of signs and planetary symbols in determining predictions of character.

In order to establish its authority, the text of this *Chiromantia*, like other contemporary works of this genre, is falsely attributed to Aristotle (fol. a1). More systematically organized than the Hartlieb, the treatise provides explanations of the parts of the hand, while the symbols of the planets precede the woodcut sequence.[1] This particular printing of the *Chiromantia* is the second of three incunable editions published by Benagli. The first dates from 1486 and the last from 1499.[2] Benagli was not, however, the first printer in Venice to publish this text. Erhard Ratdolt, the famous printer who came to the city from Augsburg in 1476, issued the *Chiromantia* around 1480 in Latin and Italian.[3] The text and twenty-one woodcuts of Ratdolt's 1480 edition were reused in the later printings.[4] Twelve editions of this work issued between 1480 and 1499, including two Italian versions, demonstrate how quickly the spread of printing fostered the diffusion of chiromantic texts. As Brian Copenhaver points out, the recovery of Neoplatonism in fifteenth-century Florence actually encouraged belief in astrology and divination.[5]

CRS

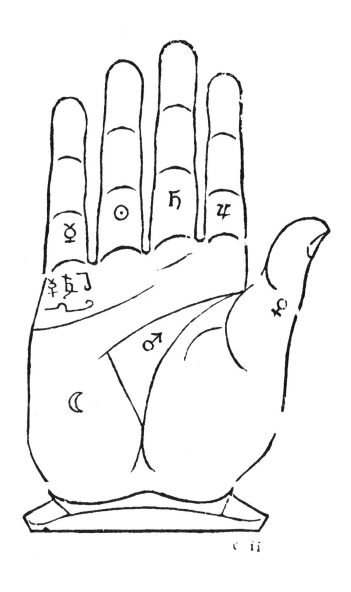

c ij

*A Chiromantic Hand,* 1557
Anonymous
Woodcut
Image: 4¾ x 3¹⁄₁₆" (12 x 7.8 cm)
Girolamo Cardano (1501-1576)
*De rerum varietate libri XVII*

Basel: Heinrich Petri, 1557, p. 560
Inscribed with the names of the digits
and parts of the hand (see below)
The Folger Shakespeare Library,
Washington, D.C.

1. For further discussion of Cardano, see the essay by Brian P. Copenhaver in this volume, 53-55.

2. Cardano's reference to this physician (fl. late first century B.C.E. to mid-first century C.E.) as the source of the nomenclature is confirmed by consulting the modern French translation facing the Greek text, *Au nom des parties du corps humain.* See *Oeuvres de Rufus d'Ephèse,* ed. Charles Daremberg and Charles Emile Ruelle (Paris: Imprimerie nationale, 1879), 143-144. See also Fridolf Kudlien, "Rufus of Ephesus," *DSB* 11:601-603.

3. See Thorndike, *A History of Magic and Experimental Science,* 5:563-579; Mario Gliozzi, *DSB* 3:64-68; and Nancy G. Siraisi, *The Clock and the Mirror: Girolamo Cardano and Renaissance Medicine* (Princeton: Princeton University Press, 1997), 3-12. For another biography, see Anthony Grafton, *Cardano's Cosmos: The Worlds and Works of a Renaissance Astrologer* (Cambridge, Mass.: Harvard University Press, 2000).

4. *The Book of My Life (De vita propria liber),* trans. Jean Stoner (New York: E. P. Dutton, 1930).

5. Ibid., 196.

6. Ibid., 168.

THIS SMALL AND CRUDELY DRAWN WOODCUT of the palm of a right hand is unusual in combining novel anatomical nomenclature with information about the lines of the hand.[1] Written across the fingers are the familiar Latin names, beginning with the thumb: *pollex, index, medius, annularis,* and *auricularis.* But other parts of the hand, such as the joints and locations on the palm, carry Latin transliterations of Greek terms. For example, the top joint is called *metacondylus;* the middle, *condylus;* and the lowest, *procondylus. Stethos* is the ball of the thumb; *thenar,* the space between the thumb and the index finger; and *hypothenar,* the ridge on the opposite side. The author cites as the source of this nomenclature the Greek physician Rufus of Ephesus.[2]

This mixture of anatomical and chiromantic terminology is characteristic of its idiosyncratic author. Girolamo Cardano was a brilliant and flamboyant character,[3] his life a melodrama of poor health, a troubled career, and family disasters, all compounded by political and religious instability. Analytical, eccentric, and supremely sure of himself, Cardano, at the end of his life, wrote a bizarre but still entertaining autobiography.[4] Contemporaries admired his achievements in mathematics, medicine, and natural philosophy, all of them blended with astrology, natural magic, and divination. In 1560 the Inquisition accused Cardano of heresy; casting Christ's horoscope was especially imprudent.

Cardano wrote more than two hundred works. The book in which the chiromantic diagram appears is a supplement to the first of two encyclopedic projects, *De subtilitate libri XXI,* published in 1550. Both his encyclopedias enjoyed great contemporary popularity and range widely in subject matter, including cosmology, mechanics, the natural sciences, technology, cryptology, and the occult sciences. Cardano's extensive treatment of chiromancy in chapter 79 of the *De rerum varietate* begins with an enumeration of the parts of the hand, viewed as an instrument of the body and a book of the soul (p. 557). He discusses the influences of the planets, as well as the numbers, names, and significance of marks on the hand, its lines, spots, colors, and creases. His autobiography tells us that he saw his own destiny in the lines of his own hand,[5] yet the same work distances him from the form of divination that became riskier as the century wore on.[6]

BPC and CRS

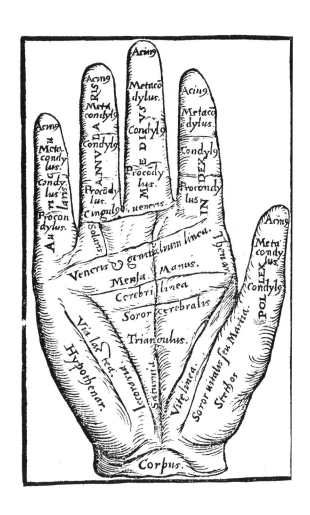

*Chiromancy and Astrology: A Case
History*, 1652
Anonymous
Woodcut
Image: 3⁷⁄₁₆ x 3⁷⁄₁₆" (8.8 x 8.8 cm)
Johann Rothmann (fl. 1595)
*Keiromantia or the Art of Divining,*

Translation by George Wharton
(1617-1681)
London: Nathaniel Brooke, 1652, ex. 16,
pp. 104-105
Inscribed with lines and symbols of a
horoscope.
The Folger Shakespeare Library,
Washington, D.C.

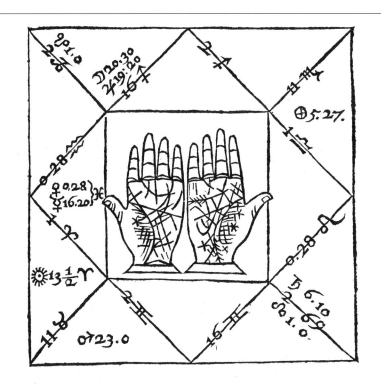

We wil now confider of the *Queſtion* former-
ly put at the beginning of this *Tract*,[whether
the *Left* or *Right Hand* is moſt commodiouſly
to be aſſumed, that thence we might frame
a conſtant judgement ¦ Or whether both
*Hands* are to be confidered ˙?] For, I find that
both exhibite *Lines* that be clear enough ˸
Wherefore feeing that this Man was *Borne* by
Night, whilſt a *Maſculine* Signe Aſcended,
and when *Jupiter* (eſpecially) and *Venus* had
Domi-

THE COMBINATION OF CHIROMANCY WITH HOROSCOPIC ASTROLOGY is the
subject of a book by the German physician Johann Rothmann, published in
that language in 1595.[1] The English translation by Sir George Wharton, only one
of five books on chiromancy published in England between 1500 and 1700, is
dedicated to Elias Ashmole, distinguished antiquarian, alchemist, and natural
philosopher.[2] Ashmole was Wharton's lifelong friend and protector, when the
latter suffered imprisonment and poverty for his royalist sympathies during
the English Civil War.[3] Wharton gained fame as a publisher of almanacs that
combined astrological and astronomical information.[4]

The expanded title page of Wharton's translation reveals its aims: *Keiromantia or the Art of Divining by the Lines and Signatures Engraven in the Hand of Man by the Hand of Nature, Theorically, Practically, Wherein You Have the Secret Concordance and Harmony betwixt It and Astrology, Made Evident in 19 Genitures.* Underneath the author's name a Latin quote refers to the hand as the body's most eloquent organ.

The frontispiece (Fig. 36) shows the major lines of the hand inscribed with planetary symbols. The quotation from Job 37:7 authorizes the enterprise: "He sealeth up the hand of every man, that all men know his work" (see also Cat. 68). As the author explains in his dedicatory letter (fol. A4), "God adorned all things created with signatures, so that the minde of an ingenious man might delight it selfe by a diligent searching unto the Nature and Disposition thereof, and thence boldly acknowledge the wonderful Workes of God."

The sixteenth of the nineteen genitures, or horoscopes, advertised on the title page had been cast by Rothmann for a man born in Thuringia on 24 March 1592. The illustration imbeds two heavily marked hands in a horoscopic chart. The author comments that both hands are necessary for prognostication, since the birth occurred at night with a masculine sign (Aries in the first place of the chart, opposite the left thumb) in the ascendant, and Venus (also opposite the left thumb) ruling with Jupiter (in the third place, above the left hand). The case study continues with an interpretation of lines in relation to planetary signs on the hands. For example, the lifelines on both hands reveal "a diseased infancy." Rothmann claims that both hands are clear in what they predict, but he asks whether the right hand (dominant in most people) or the left (less used and therefore with lines less worn) is better for chiromancy.

Rothmann's work is regarded as the first work published on astro-palmistry, based on the "theory that the hand and the horoscope reveal the same information."[5] Case studies inform readers of the practice behind astrological and chiromantic theory in achieving accurate knowledge of the course of an individual's life. The translator specifies that the author (fol. A3) directs his work to readers who "were sober and skilfull, not to men that were Mighty and Ignorant, or Learned and Malitious."

BPC and CRS

1. See Thorndike, *A History of Magic and Experimental Science*, 6:506-507.

2. Andrew Fitzherbert, *The Palmist's Companion: A History and Bibliography of Palmistry* (Metuchen, N.J., and London: Scarecrow Press, 1992), no. 336, 137; and Fred Gettings, *The Book of the Hand: An Illustrated History of Palmistry* (London: Paul Hamlyn, 1965), 179, 187.

3. See Richard Garnett, "Elias Ashmole," *DNB* 1:644-646; Charles Webster, "Elias Ashmole," *DSB* 1:316-318; and *Elias Ashmole (1617-1692): His Autobiographical and Historical Notes, His Correspondence, and Other Contemporary Sources Relating to His Life and Work*, ed. C. H. Josten, 5 vols. (Oxford: Clarendon Press, 1966). Ashmole's relationship with Wharton is described in these volumes.

4. See Sidney Lee, "George Wharton," *DNB* 20:1313-1315; and Allan Chapman, "George Wharton," *DSB* 14:285-286.

5. Fitzherbert 1992, 66.

Fig. 36. Anonymous, *Chiromantic Hands with Signs of the Planets*, woodcut. From Johann Rothmann, *Keiromantia or the Art of Divining* (London: Nathiel Brooke, 1652), frontispiece. The Folger Shakespeare Library, Washington, D.C.

# A Visual Guide to Chiromancy and Metoposcopy

*A Visual Guide to Chiromancy and Metoposcopy*, 1661
Johann-Baptist Paravicini (Palavicini)
(fl. 1656-1664)
Engraving
Plate mark: 7¼ x 5½" (18.5 x 14 cm)
Johann Praetorius (Hans Schulze)
(1630-1680)
*Ludicrum chiromanticum Praetorii; Seu thesaurus chiromantiae*

Leipzig: Johann Bartholomew Oehler and Jena: Kaspar Freyschmidt, 1661, frontispiece
Inscribed profusely in Latin and Greek (see below)
History of Medicine Division, National Library of Medicine, National Institutes of Health, Bethesda, Maryland

1. For further background, see Brian P. Copenhaver's essay in this volume, 47, 48 and 51.

2. For the engraver see Thieme-Becker, "Johann-Baptist Paravicini (Palavicini)," 26:227.

3. For a description of some of the texts included by Praetorius, see Fred Gettings, *The Book of the Hand: An Illustrated History of Palmistry* (London: Paul Hamlyn, 1965), 181-182. The treatise by Robert Fludd (Cat. 60 and 83) is "lifted piecemeal from his *Utriusque cosmi historia*" (ibid., 181). For other works by Praetorius, see Thorndike, *A History of Magic and Experimental Science,* 7:490-491.

4. See Friedrich Zarncke, "Johann Praetorius," *ADB* 26:520-529. Zarncke credits Praetorius with thirty-nine publications.

THIS FRONTISPIECE compresses an encyclopedia of chiromancy and metoposcopy into a page; metoposcopy is the art of divining a person's fate or character by reading the lines of the forehead.[1] Just as the text speaks authoritatively on these subjects, the frontispiece condenses verbal and visual wisdom of the same type while abandoning a harmonious composition. The author and engraver must have collaborated in fashioning such an elaborate program.[2]

The title, *A Chiromantic and Metoposcopic Diversion,* gives clues to the diverse messages that the author wants to convey in his theatrical frontispiece.[3] Praetorius, a scholar, humorist, poet-laureate, and prolific writer on many subjects, was educated in Leipzig. His love of all kinds of verbal puzzles is obvious here.[4] *Ludicrum* is a playful and entertaining game, while *thesaurus* is a treasure. The two terms convey the author's ambivalence about his subject. In one sense, chiromancy and metoposcopy are authoritative and valuable methods of divination, as described in the treatises collected in the book. But the anagrams and proverbs on the frontispiece show that such knowledge may be nothing more than an elaborate game, a parlor trick.

The composition of the frontispiece reflects divergent views of divination. Maxims drawn from biblical sources such as the scroll at the very top assure the pious reader that there is a righteous chiromancy: "I will teach you by the hand of God" (Job 27:11). Likewise, at the top-left corner, two well-lined and giving hands reach out from heavenly clouds with the words of Isaiah 49:16 between them: "Behold, I have graven thee upon the palms of my hands." Beneath the right hand another scroll says of Wisdom that "Length of days is in her right hand," while a scroll beneath the left hand completes the verse from Proverbs 3:16: "And in her left hand riches and honor." From the top right, on a partly furled scroll next to a hand and pen, another quotation from Job (37:7) speaks about divine seals.

After all this scriptural encouragement, the hand at the upper right fills another scroll, the largest on the page, with secular wisdom from Horace (*Epistles* 1.18.66): "A supporter will praise your study *[ludum]* with both thumbs up." Next, below in large Greek capitals, come three words from Pindar (*Odes* 10.21), "with divine help," where the literal meaning of the third word is palms.

Columns frame these honorable aspects of chiromancy at the top of the page, but the message on the bases of the column advises the reader that the art can be used "to win praise" or "abused to commit crime." From this point, the negative side of chiromancy shows itself. At the center a metoposcopic head and shoulders are marked astrologically and flanked by two hands. The right hand shows the usual lines and signs, but next to these tokens of astrology comes a warning of criminal abuse. Below the contrasting statement on the left—*Usus habet laudem*—another scroll encourages the reader (in Greek) to

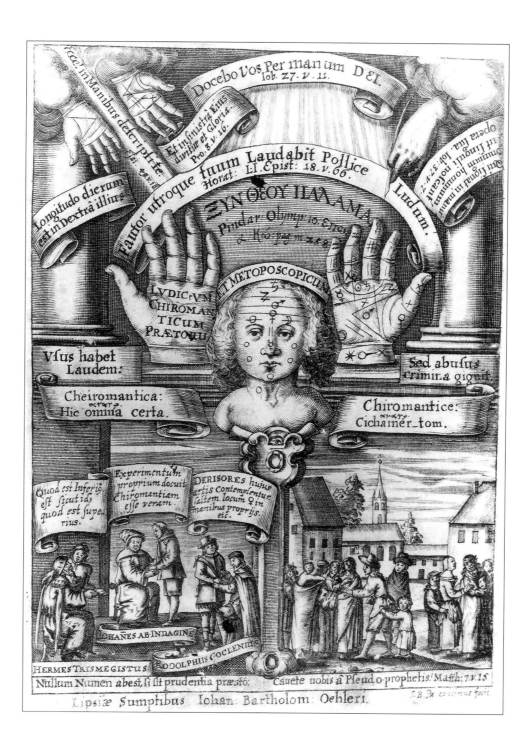

make an anagram of the word *Cheiromantica* and supplies the answer: *Hic omina certa,* meaning that "here [on the left] the predictions are reliable." On the scroll opposite appears almost the same word, *Chiromantice,* with one letter missing and another changed. The resulting imperfect anagram of *Hic omina certa* suggests that on the right side of the page the omens have gone wrong.

Below the divine and classical realms, vignettes at the bottom left of the frontispiece depict three human theorists and practitioners of the art: on the left, Hermes Trismegistus; Indagine (Cat. 62); and Rudolph Goclenius, who warns that "those who deride this art should at least examine the place of Venus in their own hands." This sharp remark, from a prolific chiromancer of an earlier generation, leads to the crude genre scene at the lower right, where the hands of pickpockets and mountebanks work the edge of a crowd, while a main event of palm-reading keeps the crowd distracted. Finally, at the very bottom, the show ends twice: with a parting shot from the goddess Fortune, "If people had any sense, you would have no power," and a Gospel caution from Matthew: "Beware of false prophets."

This ornate advertisement for a *Chiromantic Diversion* diverts the reader from the author's liability as false prophet and sinner against religion. While serving notice that Praetorius is aware of the moral ambiguity of his topic, it makes a game of the problem. The composition of the frontispiece ingeniously devises a vertical descent from unimpeachable authorities—divine, biblical, and classical—to human exemplars.

BPC and CRS

## 69   The Alchemist

*The Alchemist*, c. 1558
Philip Galle (1537-1612) after Pieter
Bruegel the Elder (c. 1525/1530-1569)
Engraving
Sheet trimmed to plate mark: 12⁹/₁₆ x
17¹¹/₁₆" (31.9 x 45 cm)
Inscribed:
Upper right, over the door: *lospital*;
*Debent ignari res ferre et post operari/*
*Ius lapidis cari vilis sed denique*
*rari / Unica res certa vilis sed ubique*
*reperta /Quatuor inserta naturis in*
*nube reperta / nulla mineralis res est ubi*
*principalis / sed talis qualis reperitur*
*ubique localis* (Men of ignorance
should acquire things and then take an
interest / in the power of the worthless
though rare gemstone / the only thing
that is undoubtedly worthless yet to be
found everywhere / Mingling in abun-
dance with the four elements in a
cloud / Where no mineral thing
predominates / But locally it is to be
found everywhere)
Signed upper left: *Brueghel inve[nit]*;
on the pavement, the name of the
publisher *H. Cock excud[it] cum*
*privilegio*
National Gallery of Art, Washington,
D.C., Print Purchase Fund (Rosenwald
Collection), 1970

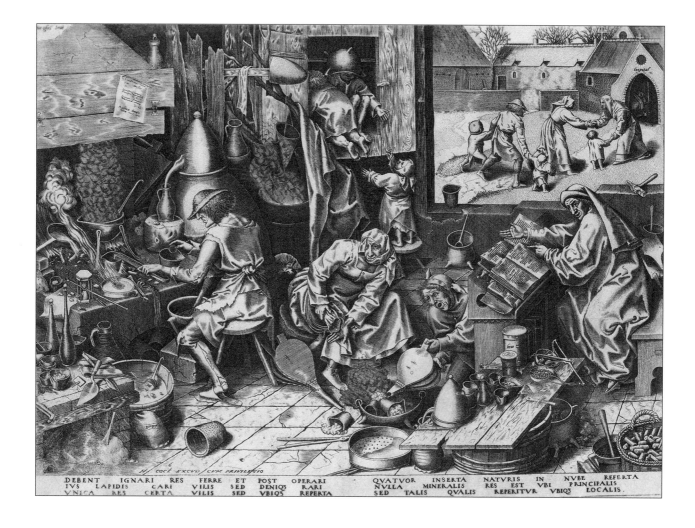

1. Donald Levy, "Macrocosm and Microcosm," in *The Encyclopedia of Philosophy*, ed. Paul Edwards (New York: Macmillan and Free Press, 1967), 5:122.

2. This paragraph relies on citations from the introduction by Allen G. Debus to Elias Ashmole, *Theatrum chemicum brittanicum* (The Sources of Science, no. 39) (New York and London: Johnson Reprint Corporation, 1967), xi-xiv.

3. E. J. Holmyard, *Alchemy,* reprint ed. (New York: Dover, 1990), 15.

4. Ibid., 15-16.

5. Kupferstichkabinett, KdZ 4399. See Matthias Winner, in *Pieter Bruegel der Ältere als Zeichner,* exh. cat. (Berlin: Staatliche Museen Preussischer Kulturbesitz, 1975), no. 67, 60-64.

6. Robert Halleux, "Alchemy," in *Dictionary of the Middle Ages,* ed. Joseph R. Strayer (New York: Charles Scribner's Sons, 1982-1989), 1:134.

7. René Van Bastelaer, *The Prints of Peter Bruegel the Elder, Catalogue Raisonné,* trans. and rev. Susan Fargo Gilchrist (San Francisco: Alan Wofsy Fine Arts, 1992), no. 197, 263.

8. For a useful summary of the artist's achievement, see Alexander Wied, "Pieter Bruegel I," *DOA* 4:894-910.

9. For the family, see Christine Van Mulders, "Galle," *DOA* 12:15-17. Philip's son, Theodor, was the engraver of the Bacci broadside (Cat. 58).

10. Giorgio Vasari, *Lives of the Most Eminent Painters, Sculptors, and Architects,* trans. Gaston Du C. de Vere (New York: Harry N. Abrams, 1979), 2:1263-1264.

11. For humanist influences and graphic prototypes, see Winner 1975, 63-64.

ALTHOUGH NOT APPARENT FROM THIS ENGRAVING, a fundamental theory on which alchemy rests is the microcosm-macrocosm analogy. The idea that order in the universe comes from "one spiritual principle stimulated the wish for direct mystical union with this soul, and even for influence over things through it, as easily as it encouraged the pursuit of systematic understanding of the world."[1] Alchemy shared both the search for knowledge in a mystical sense, as well as in a systematic investigation of nature for medical and chemical applications. Given the "essential unity of nature, significant correspondences might be sought successfully between the celestial and the sublunary worlds, or between the stars, the earth, and man."[2] Although sometimes difficult to separate, alchemy has two sides, the exoteric, or outward, directed to preparing "a substance, the philosophers' stone, or simply the Stone, endowed with the power of transmuting the base metals lead, tin, copper, iron, and mercury into the precious metals gold and silver."[3] The esoteric side stems from "the belief that it [the Stone] could be obtained only by divine grace or favour." These ideas resulted in "a devotional system where the mundane transmutation of metals became symbolic of the transformation of sinful man into a perfect being through prayer and submission to the will of God."[4] The alchemist, or natural philosopher, often relied on a complex and secret symbolic system to convey and protect the essential principles of the art in which mercenary considerations combined with the search for rational and mystical knowledge.

This engraving by Philip Galle, after a drawing by Pieter Bruegel the Elder, now in Berlin, satirizes alchemy as a worthless confidence game that results in the poverty of its practitioner.[5] While both sides of alchemy are present, since the adept or learned man leans heavily on the open books on his desk, the emphasis falls on the exoteric quest for "the art and science of transforming base metals into the noble metals, silver and gold."[6] In a kitchenlike setting crammed with instruments, materials, and vessels, the adept gesticulates with his right hand toward an assistant with donkey's ears, personifying a fool, who blows on bellows. With his left hand the alchemist points to open books inscribed with the names of various chemicals and on top of the page the phrase *Al ge mist.* A pun on the word for alchemist, the expression also can be translated as "all is rubbish." A scruffy figure on the left, clad in rags, sits before a hearth, putting a coin in one crucible and wielding tongs in the other. He applies alchemical learning to extracting gold or silver from base metals. Facing the spectator, a crouching woman in the center of the composition tries to remove coins from an empty purse. She personifies the family's poverty that results from her husband's obsession with alchemy. The three children searching fruitlessly in a cupboard for sustenance echo this theme. A coda to this useless activity is enacted in the vignette behind the unshuttered opening. In an open courtyard, the family of the alchemical practitioner moves toward the building labeled the hospital, or poorhouse. Bruegel sympathetically depicts this procession in a clearly organized space that contrasts with the chaotic interior. The group, seen only from the back, straggles toward its unhappy destination. The Latin verses written below the scene reinforce the satirical intent of the engraving.

The National Gallery's print [B. 205] represents the first state of the engraving, issued by the Antwerp publisher Hieronymus Cock, after Bruegel's drawing.[7] The work of the artist, the first of four generations of his family, was active in the southern Netherlands. Bruegel's famous allegories and landscapes

that combine religion and humanism are universally recognized for their original representation of peasant and folklife.[8] Philip Galle, the engraver, who was a publisher and print dealer, belonged to another family of artists that was active for many generations.[9] As Vasari's contemporary description attests, Bruegel's drawing achieved immediate fame.[10]

The attitude toward alchemy expressed in the verses and the composition stems from a humanist suspicion of the bombastic and secret symbolism of alchemy as a disguise for its materialist goals.[11] Dürer's woodcut of *The Alchemist* in Sebastian Brant's *The Ship of Fools* depicts an earlier version of this negative view of alchemy. Furthermore, the artist contrasts the satirical representation of the alchemical confidence game with the sympathetic depiction of its poverty-stricken victims. Bruegel's remarkable draftsmanship, faithfully reproduced in the print, enhances the comedic nature of the subject, developed in a series of fine details and character studies.

CRS

*Faust*, c. 1652
Rembrandt Harmenz. van Rijn
(1606-1669)
Etching, drypoint and burin
Sheet trimmed to plate mark:

8⅜ x 6⅜" (21.2 x 16.2 cm)
Inscribed in circle (see below)
National Gallery of Art, Washington,
D.C., Rosenwald Collection, 1943

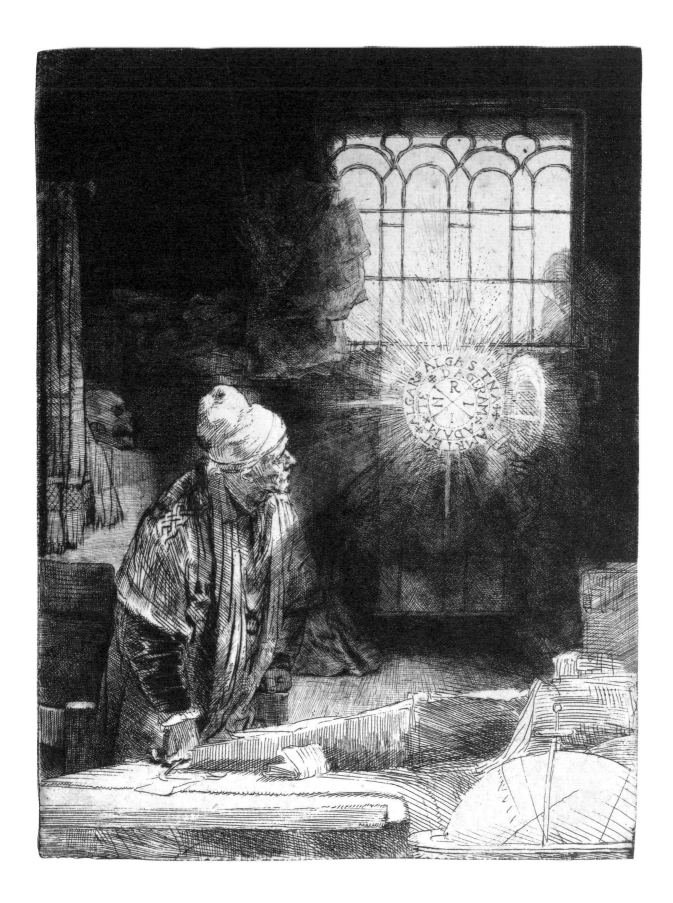

IN CONTRAST TO THE NEGATIVE, satirical depiction in the Galle engraving after Pieter Bruegel's drawing of *The Alchemist* (Cat. 69), this work of Rembrandt presents the seeker after knowledge of nature's secrets in a favorable light. The print has had the traditional title of *Faust* since the eighteenth century. An inventory identified the subject with Dr. Faustus, the notorious German sixteenth-century historical personality and literary figure. Yet an earlier inventory of Rembrandt's work dating from 1679 gave the title of an etching associated with this print as *The Practicing Alchemist*.[1] Scholars believe both titles have some merit, although neither exactly fits existing literary or iconographic sources. Recent discussions have tended to emphasize Rembrandt's connection with persons in Amsterdam, such as Menasseh-ben-Israel, versed in cabalistic literature and ideas.[2] The difference of opinion regarding the print's name is, however, indicative of the extensive art-historical discussion on the meaning of Rembrandt's luminous but mysterious image that continues to resist specific interpretation.[3]

Rembrandt has depicted an aged, half-length figure standing in a setting suggestive of a scholar's study. The skull on the left, the astrolabe at the right, the writing instrument in the figure's right hand, and the open books on his lectern indicate his status. Rembrandt shows the moment of a revelation as the figure arises from his investigations, observed by a ghostly head seen at the right of the intricately designed window. The scholar turns toward an apparition that illuminates a drawn curtain. Its head contains a disk imprinted with letters arranged in three tiers that suggest an anagram. As an aid to decipher the inscriptions, the hand of this apparition points to a mirror located next to the disk. Scholars have proposed various readings of the disk, both Christian and cabalistic. One such translation invokes the Hebrew name for God (Jahweh) and his power for magically affecting the natural world and concludes in the innermost circle with a reference to the name of Jesus *(INRI)*.[4] Similar features were found in a contemporary amulet.[5] By the time Rembrandt produced this etching, the iconography of the alchemist as a devout mystic who sought such truths was widespread (Cat. 71). In such representations the astrological elements, such as the astrolabe, are present, as are the cabalistic and Christian invocations.[6] As scholars have pointed out, however, any specific references to the alchemical laboratory or equipment are missing here.[7]

The National Gallery's print [B. 270] represents the first state of the etching with strong contrasts of dark and light tones. The impression shows Rembrandt's practice in his later prints of combining etching with drypoint to achieve deep shadows.[8] The first impressions are characterized by printing "with light surface tone" and "show heavy burr at the left hand side of the plate, particularly on the curtain, the skull, and to the left of Faust."[9] While the scholar's head, depicted in profile, is brightly illuminated, his features are only sketchily defined. Rembrandt's manipulation of light tones is crucial in establishing the contrast between the naturalistic and supernatural elements of the setting. Thus the light illuminating the disk and the scholar's head is differentiated from the corporeal forms of his drapery or the fluttering curtain. Whatever its precise meaning, the etching offers a positive view of the dignified scholar as a disinterested seeker after truths that magically reveal the secrets of nature. As book illustrations indicate, alchemists shared similar claims to powers bestowed by divine blessings (Cat. 71-73).

CRS

1. See Barbara Welzel, *Rembrandt: The Master and His Workshop, Drawings, and Etchings*, exh. cat. (New Haven and London: Yale University Press and National Gallery Publications, 1991), cat. no. 33, 259-260.

2. See Lottlisa Behling, "Rembrandts sog. *Dr. Faustus*, Johann Baptista Portas *Magia naturalis* und Jacob Böhme," *Oud Holland* 79 (1964):60, 65. See also Hans Thomas Carstensen and Wolfgang Henningsen, "Rembrandts sog. Dr. Faustus: Zur Archäologie eines Bildsinns," *Oud Holland* 102 (1988):305-307.

3. For an extensive summary of these discussions with bibliography, see H. van de Waal, "Rembrandt's Faust Etching, a Socinian Document, and the Iconography of the Inspired Scholar," *Oud Holland* 79 (1964):7-48.

4. See Douglas Lewis, "A Scholar in His Study Watching a Magic Disk 'Dr. Faustus,'" *Rembrandt in the National Gallery of Art*, exh. cat. (Washington, D.C.: National Gallery of Art, 1969), cat. no. 46, 49.

5. Behling 1964, 59-60. For the author's discussion of the anagram and its visual relationships to works on natural magic and mysticism, see ibid., 57-66.

6. For a discussion of astrological and magical ideas and prototypes, see Carstensen and Henningsen 1988, 294-301.

7. Welzel 1991, cat. no. 33, 260.

8. For a discussion of Rembrandt's etching techniques in his later career, see Felice Stampfle and Eleanor A. Sayre, "Rembrandt van Rijn," *DOA* 26:172-174.

9. Christopher White and Karel G. Boon, *Rembrandt's Etchings: An Illustrated Critical Catalogue*, Hollstein 18:123 [B. 270].

*The Alchemist in His Study*, 1609
Peter (incorrectly identified as Paullus)
van der Doort (fl. 1600) after Hans
Vredeman de Vries (1527-1606)
Engraving
Plate mark: 12⅛ x 17" (30.7 x 43.2 cm)
Heinrich Khunrath (c. 1560-1605)
*Amphitheatrum sapientiae aeternae*
Hanover: Wilhelm Anton, 1609, p. 10
Inscribed:
*Henricus Khunrath Lips: Theosophiae
amator et Medicinae utriusque Doctor,*

*DEI gratia.* inventor: *Paullus vander
doort Antwerp scalpsit* [sic] (Heinrich
Khunrath of Leipzig, lover of
theosophy and doctor of both
medicines, thanks be to God, designer.
Paullus van der Doort of Antwerp
engraved [it]); etc. (see below)
Signed in center: *HF vries pinxit.*
History of Medicine Division,
National Library of Medicine,
National Institutes of Health,
Bethesda, Maryland

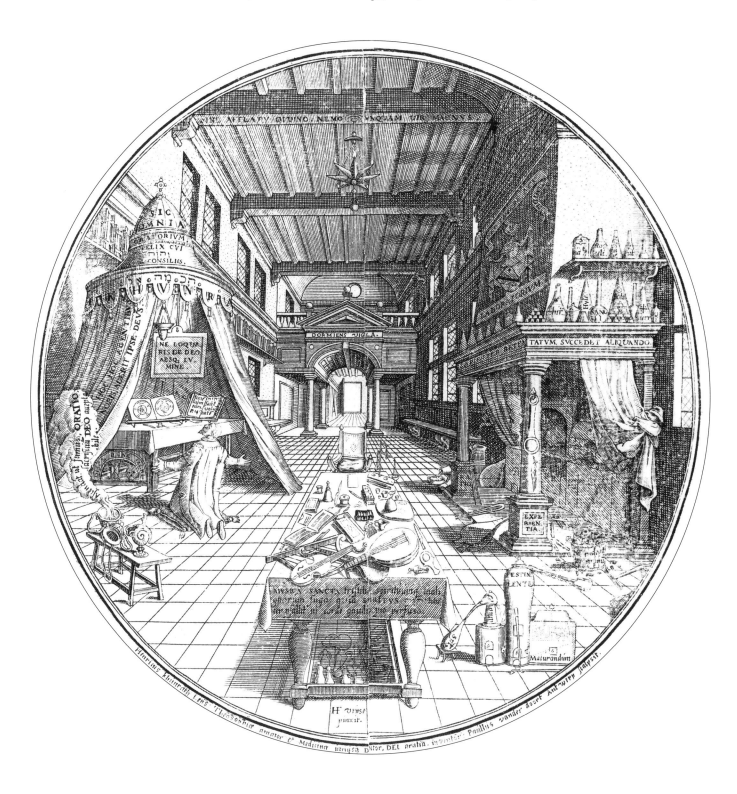

IF REMBRANDT'S ETCHING (Cat. 70) alludes to the environment and pursuits of the alchemist, the present engraving offers a detailed, almost encyclopedic, account of this world at its most elevated level. The title page of the author's work of 1609, translated as *The Amphitheater of True Wisdom* describes his dual but united vocations.[1] Khunrath, a physician who practiced in Hamburg and Dresden, received his medical degree from the University of Basel. Influenced by Paracelsus, he regarded himself as an "adept of various spiritual traditions of alchemy dominated by the Paracelsian belief in the divine science of medicine as a privilege of the initiated. . . ."[2] "Khunrath ardently sought to find and demonstrate the secret, divine primary matter endowed with the universal virtue of ruling all natural processes. . . . These efforts would, he claimed, afford eternal wisdom."[3] The subtitle of Khunrath's book summarizes the heterogeneous sources of its doctrines embracing the "emphasis on Magia, Cabala, and Alchymia as in some way combining a religious philosophy which promises a new dawn for mankind."[4]

From the inscription at the bottom of the print, it appears that Khunrath was also the author of its elaborate program. He must have collaborated closely with the designer of the engraving. Hans Vredeman de Vries was a Dutch architect and designer, urban theorist, and painter of architectural scenes, who was widely influential because of the many volumes of his architectural engravings issued by print publishers.[5] The intricate perspectival construction and harmonious composition are characteristic of his style.[6] The actual engraver was Peter (not Paullus) van der Doort.[7] This edition of the book was published posthumously, and Khunrath's work continued to enjoy popularity in many later printings.[8]

The engraving of the laboratory in this work unites the operations of alchemy, as the word *laboratorium* contains *labor* [work] and *oratorium* [a place devoted to prayer]. At the same time the composition divides the two activities into separate spheres corresponding to the material and the spiritual realms inhabited by the alchemist. Placed in a spacious hall, meticulously delineated in perspective, Heinrich Khunrath, portrayed as alchemist and hermetic philosopher, kneels before a tabernacle, perhaps an allusion to the tent of the Hebrews in the desert.[9] Within the tabernacle, an inscription reads: "Do not speak of God without Light."[10] Above are written the words: "Happy is he who follows God's counsel." The table, testifying to the magical/religious frame of reference, contains a magic book with pentacles and a Bible. The latter is "opened at the psalm: 'Then they were in great terror; for God was with the righteous generation.'"[11] In the smoke of the incense burner are the words: "Prayer rises like smoke, a sacrifice agreeable to God."[12] The inscriptions testify to the philosopher's union with God and the divine in his search for knowledge of God's creation of matter.

On the right is the alchemical laboratory, housed in a gigantic fireplace and graced by classical columns and inscriptions. The base of the columns contain the words *Ratio* and *Experientia,* since reason and experience are necessary for the alchemical operation. The crossbeam bears the message: "Without divine inspiration nobody is great." The three vessels in the foreground are linked to the musical instruments in the center, which symbolize "the three Principles of the Great Work, Salt, Sulphur, and Mercury (of the Wise) whose harmonious combination is the reason why alchemy is often called the Art of Music."[13] In addition, the words written on the tablecloth declare that "sacred music disperses

1. Stanislas Klossowski de Rola, *The Golden Game: Alchemical Engravings of the Seventeenth Century* (London: Thames and Hudson, 1988), 30.

2. Hans Kangro, "Heinrich Khunrath," *DSB* 11:355.

3. Ibid., 356.

4. The subtitle is translated as "The Amphitheatre of the eternal and sole true Wisdom, a Christian / Kabbalist, Divine / Magical, Physico / Chemical, Thrice / three / in / one Compendium." Klossowski de Rola 1988, 29. See Yates, *The Rosicrucian Enlightenment,* 67-68.

5. Hans Mielke, "Hans Vredeman de Vries: Verzeichnis der Stichwerke und Beschreibung seines Stils sowie Beiträge zum Werk Gerard Groennings" (Inaugural diss., Freie Universität Berlin, 1967), no. 30. In his discussion Mielke traces the complex history of the book's editions.

6. See Madeleine van de Winckel, "Hans Vredeman de Vries," *DOA* 32:724-727.

7. Thieme-Becker, "Peter van der Doort," 9:465.

8. See Mielke 1967, no. 30.

9. Klossowski de Rola 1988, 42, n. 5.

10. Ibid.

11. Kurt Seligmann, *A History of Magic and the Occult,* reprint ed. (New York: Gramercy Books, 1997), 88. The author interprets the allusion to generation as an oblique reference to the philosophers' stone.

12. Klossowski de Rola 1988, 42, n. 5.

13. Ibid.

14. John Read, *From Alchemy to Chemistry,* reprint ed. (New York: Dover Publications, 1995), 72.

sadness and malignant spirits," a hint that "music was regarded as an antidote to alchemical melancholy, as well as exerting a beneficent influence upon alchemical processes."[14] A final reminder of the need for eternal watchfulness *(Dormiens vigilia)* comes from the inscription on the pediment closing off the hall. In short, the laboratory engraving illuminates the lofty goals of the hermetic philosopher, including the alchemical art as a religious, mystical experience of the highest order. Such imagery of the alchemist philosopher as a noble seeker of wisdom contrasts sharply with the Philip Galle engraving after Bruegel (Cat. 69).

CRS

## 72  Alchemical Operation

*Alchemical Operation*, 1675
Anonymous artist after Adriaen van de
Venne (1589-1662)
Engraving
Plate mark: 2³⁄₁₆ x 2¾" (5.5 x 7 cm)
Goossen van Vreeswyk (Vreeswijck)
(1626-after 1689)
*Vervolg van't Cabinet der Mineralen,*

*of de Goude Son der Philosophen*
Amsterdam: Johann Jansson van
Waesberge, 1675, p. 125
History of Medicine Division,
National Library of Medicine,
National Institutes of Health,
Bethesda, Maryland

THE REQUIREMENT OF A SECRET LANGUAGE, both visual and verbal, extends to the imagery of this alchemical treatise. The full title gives some idea of its complex content: *Continuation of the Cabinet of Minerals or the Golden Sun of the Philosophers. Wherein all the works of metals and minerals, with the tools appertaining thereto, their openings, colours and tinctures, together with divers excellent medicines and other highly useful arts, are set forth from his own experience by Goossen van Vreeswijck, master miner.*[1]

The author was also a metallurgist and alchemist.[2] Widely traveled and sought by various governments to find mineral deposits in their New World colonies, van Vreeswyk had written a previous series of alchemical treatises, among them the *Red Lion* and the *Green Lion.*[3] Van Vreeswyk's work reveals a conflict between his experience with minerals and metallurgy and the Paracelsian doctrine of universal marks or signatures.[4] These marks appear on natural phenomena and are susceptible to interpretation by the adept. Yet the illustrations in the present treatise show no evidence of van Vreeswyk's empirical observations but instead follow the more traditional Paracelsian doctrines.[5] In the author's earlier alchemical works, rich series of engravings offer cycles of hermetic emblems, some of which reappear in the *Continuation of the Cabinet of Minerals.* Bernhard Scholz has established that in the latter work van Vreeswyk has added alchemical symbols to images borrowed from emblem books by the most popular Dutch writer of the century, Jacob Cats (Cat. 80).[6] Such is the case with the present image, taken from Emblem 36 of Cats' *Emblemata moralia et oeconomica.*[7] The artist for all Cats' illustrated books was Adriaen van de Venne. His engravings were reused in the author's various publications, as well as in works like this one.[8]

Prominently featured in this text is a group of engravings in which hands carry out actions related to the Great Work, the process for reaching the ultimate goal of the philosophers' stone. The hands, inscribed with symbols of metals or minerals, frequently derived from signs of the planets as astral

1. Stanislas Klossowski de Rola, *The Golden Game: Alchemical Engravings of the Seventeenth Century* (London: Thames and Hudson, 1988), 260.

2. For biographical information, see Bernhard B. F. H. Scholz, "Alchemy, Metallurgy, and Emblematics in the Works of the Seventeenth-Century Dutch 'Bergmeester' Goossen van Vreeswijck (1626-after 1689)," in *Emblems and Alchemy* (Glasgow Emblem Studies 3), eds. Alison Adams and Stanton J. Linden (Glasgow: University of Glasgow, 1998), 5-8; and H. A. M. Snelders, *De geschiedenis van de scheikunde in Nederland* (Delft: Delft University Press, 1993), 17-19.

3. See Lyndy Abraham, "Red Lion" in *A Dictionary of Alchemical Imagery* (Cambridge and New York: Cambridge University Press, 1998), 166-167.

4. See Brian P. Copenhaver's essay in this volume, 53.

5. Scholz 1998, 7-16.

6. Ibid., 6.

7. Jacob Cats, *Sinne en minnebeelden en spiegel van den ouden en nieuwen tijdt* (Amsterdam: Ian Iacobsz Schipper, 1665), reprint ed. (The Hague: Van Goor Zonen, 1977), 116.

8. See Christiaan Schuckman, Hollstein 25:5.

9. Bernhard B. F. H. Scholz, "Ownerless Legs or Arms Stretching from the Sky?" in *Andrea Alciato and the Emblem Tradition: Essays in Honor of Virginia Woods Callahan,* ed. Peter M. Daly (New York: AMS Press, 1989), 265.

10. Klossowski de Rola 1988, fig. 460, 264.

11. I am grateful to Prof. Bernhard B. F. H. Scholz for translating relevant passages of the poem and dialogue.

12. Klossowski de Rola 1988, fig. 454, 264.

13. Ibid., fig. 463, 264.

qualities, issue from cloudlike formations. As Bernhard Scholz has observed, the question raised is whether these hands indicate a divine or secular origin. In other words, do these images represent the hand of God or the hand of the philosopher-alchemist? Perhaps, as Scholz suggests, the human hand, while carrying out the divine will, imitates natural forces created by God in the performance of alchemical processes.[9] Whatever the answer, this type of iconography again shows the profound fusion of alchemical thought with natural science and religious ideals.

The engravings constitute an analogous system of allegorical reference challenging to the modern reader. The role of the hand is, however, clearly differentiated from that of the John of Holland text (Cat. 73). In the latter, the hand serves as an ordering and mnemonic structure for the entire body of knowledge controlled and possessed by the skilled and committed adept. In contrast, the hands in the *Continuation of the Cabinet of Minerals* cycle indicate the power and agency of the divine or human performer. For example, the program of several engravings, as interpreted by Klossowski de Rola, is to construct operations that refer to the skilled activity of the alchemist in manipulating nature.[10]

In the present illustration, the seventh in the series, left and right hands issuing from clouds, join together to light two candles. A cupid seated on the ground gestures toward the right hand. Each candle is inscribed with the planetary symbol for the sun, which in alchemical language symbolizes gold. Between them appears a symbol for antimony, a metal associated with gold. The poem beneath the engraving refers to an alchemical process that involves gold and antimony. In the pages preceding and following this engraving, a lengthy allegorical dialogue questions the relationship between the two metals.[11] Antimony may refer to "the first conjunction of Mars with Venus" to "emphasize the action of the Secret fire, mediator and promoter of the Work."[12] Klossowski de Rola interprets the meaning of the illustration as showing how the "Philosophers' Gold must be added as a ferment to their Stone at the end of the Work. . . . Once this is accomplished, the conversion becomes as easy as lighting one candle from another."[13] Although the allegorical meaning is difficult to penetrate, it is clear that the hand once again stands for creativity, intelligence, and skill.

CRS

## 73 The Hand of the Philosophers

*The Hand of the Philosophers*, 1773
Anonymous
Engraving
Plate mark: 7¹⁄₁₆ x 10³⁄₁₆" (18 x 26 cm)
Johann Isaac Hollandus (John Isaac of Holland) (Fifteenth century?)

*Sammlung unterschiedlicher bewährter chymischer Schriften*
Vienna: Johann Paul Krauss, 1773, p. 11
Rare Book and Special Collections Division, Library of Congress, Washington, D.C.

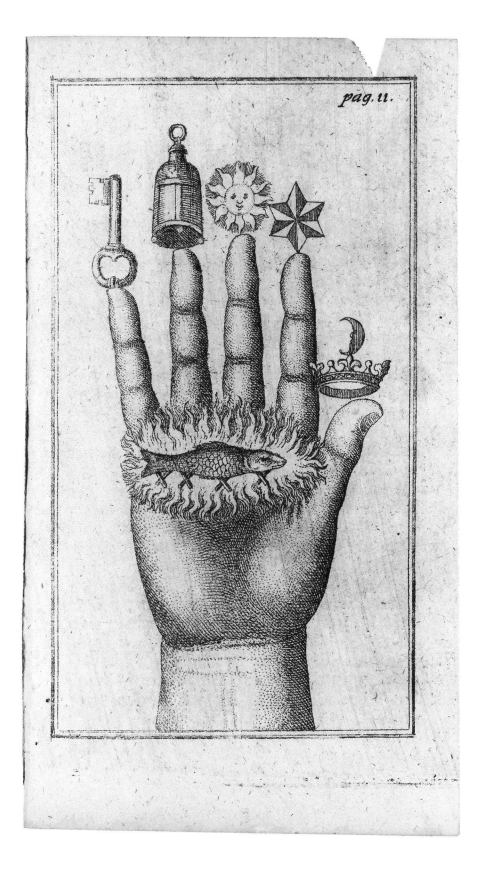

1. The relevant passages were kindly translated (15-16 March 1996) by Beat Krummenacher and Maury, members of the Alchemy Forum, reached on the Internet via the Alchemy Virtual Library (alchemy@zz.com) organized by Adam McLean.

2. For this edition of the text, see *Alchemy and the Occult: A Catalogue of Books and Manuscripts from the Collection of Paul and Mary Mellon Given to Yale University Library* (New Haven: Yale University Press, 1977) 2: no. 157, 548-551.

3. The quotations of this and the following passages occur on pp. 14-17 of the 1667 edition and on pp. 11-15 of the 1773 edition.

4. For explanation of color symbolism, see John Read, *From Alchemy to Chemistry,* reprint ed. (New York: Dover Publications, 1995), 44; and Johannes Fabricius, *Alchemy: The Medieval Alchemists and Their Royal Art,* reprint ed. (London: Diamond Books, 1994), 110 and 170.

5. See Massimo Luigi Bianchi, "The Visible and the Invisible: From Alchemy to Paracelsus," in *Alchemy and Chemistry in the Sixteenth and Seventeenth Centuries,* eds. Piyo Rattansi and Antonio Clericuzio (Dordrecht: Kluwer Academic Publishers, 1994), 19.

THIS IMAGE, A FULL-PAGE ENGRAVING reused from an earlier edition, occurs in the first treatise of the collected writings of Johann Isaac Hollandus (John Isaac of Holland) translated as *The Hand of the Philosophers.*[1] Although Hollandus remains a mysterious fifteenth-century figure, his works were printed in two German editions (Frankfurt, 1667, and Vienna, 1773), as well as in seventeenth- and eighteenth-century English and Italian manuscripts. The collection and publication of earlier alchemical texts was characteristic of seventeenth century efforts to construct a history of the field. The author's work belongs to a tradition of alchemy featuring secrecy, piety, and allegory.[2] To understand the context of the engraving, the opening section is revealing: "This is the hand of the philosophers with their dear secret signs, with which hand the old sages have united and took oaths. Nobody can understand this hand with its secret signs, unless he becomes first a juror of the philosophers, and has loyally served them in the art of alchemy."[3] The author goes on to say that he will teach the secrets to his child and stipulates that no one can use them without taking an oath of secrecy and another oath "that man should not use the Art except for the salvation of the soul."

The outstretched right hand may refer to these oaths. But the explanation of the symbols and their placement deals with the qualities associated both with the fingers and the substances for which they stand. The ensemble starts with the thumb, traditionally identified as the master digit in respect both to its anatomical properties and its leading position on the hand. Above the thumb stands a crown, closely related to the moon. The text explains: "First look at the thumb on which stands the crown next to the moon, one quarter old. By this is meant saltpeter. For just as the thumb vigorously finishes off the hand, saltpeter does in the Art Alchemia, for he is the King and Lord of all salts. He is the mill through which everything must be ground."

Next, above the index finger, is a six-pointed star. As the index is the second most important finger after the thumb, so vitriol is the "greatest and strongest salt after saltpeter." We see over the third finger, the longest digit, the powerful symbol of the sun, standing for sal ammoniacum, "for apart from saltpeter and vitriol, no thing more powerful is found than *S.* That is why it is the third secret." The lantern over the ring finger, the fourth sign of the philosophers, indicates alumen roche, "for without alum, no perfect work can be accomplished, because it is required for the Red and the White. [This is a reference to two essential stages of the Great Work.] It has an astonishing nature and the most subtle Spiritus."[4] The symbol above the little finger contains the fifth secret, a key, referring to "the lock of the hand." The author explains "that is why the key is standing on it," the symbol for common salt, because "salt is the key in this art."

The text then moves to the middle of the palm, dominated by the sign for the fish. This central position also signifies the power and dominant qualities of the substance Mercury. "For without Mercurius, or the fish, nothing can be done. He is the beginning, the middle, and the end, and he is the priest who must marry everything. And he is the male and the seed; he is the water out of which all metals have originated; and he is the principal of all arts, and the greatest of all secrets."

The seventh and final sign of the philosophers on the palm is fire, designating sulphur. The text explains: "It is the earth and beginning of all metals. It is the female who brings forth the fruit. For no seed can grow unless

it be first thrown into fertile soil. Then beautiful fruit will come from it. Thus it also happens that when a pure Mercury is joined to a pure sulphur, it brings forth pure fruit. Thus, they are man and woman, father and mother, fire and water, seed and earth. This is sufficient about the seven secret signs of the philosophers. He who understands well this hand and its signs, and can work with it, will derive joy from it." This final paragraph alludes to the stages of the alchemical operation in a language of concealment well known to its adepts.

The hand of the philosopher is, then, a figure that, like the allegorical language of alchemy, both obscures and illuminates, while it unites the material and spiritual aspects of the alchemical operation. In other words, verbal and visual language manifests what is concealed and at the same time conceals what is revealed.[5] Finally, the image itself expresses the control, skill, and knowledge commanded by the alchemical philosopher.

CRS

# VI. Guiding Hands

*Defenders of Faith: Cat. 74-78*
*Guardians of Morals: Cat. 79-83*

*St. James Minor,* 1589
Hendrick Goltzius (1558-1617)
Engraving
Plate mark: 5⅞ x 4" (15 x 10.2 cm)
Sheet: 6³⁄₁₆ x 4⁵⁄₁₆" (15.7 x 11 cm)
Inscribed:
*Sanctam Ecclesiam Catholicam*

*Sanctorum Communionem*
(The Holy Catholic Church and the communion of saints)
Monogram HG, lower left
The Metropolitan Museum of Art,
Harris Brisbane Dick Fund, 1917,
17.3.884-10

1. For examination of the earlier monastic tradition, see Mary Carruthers, *The Craft of Thought: Meditation, Rhetoric, and the Making of Images, 400-1200* (Cambridge and New York: Cambridge University Press, 1998). For definitions of meditation during the sixteenth century, see J. Mesnard, introduction, in *La méditation en prose à la Renaissance* (Cahiers V. L. Saulnier 7) (Paris: Presses de l'École Normale Supérieure, 1990), 7-16. For an introduction to a definition and history of the term in Christian thought up to the Reformation, see Klára Erdei, *Auf dem Wege zu sich selbst: Die Meditation im 16. Jahrhundert* (Wolfenbütteler Abhandlungen zur Renaissanceforschung 8) (Wiesbaden: Otto Harrassowitz, 1990), 9-47.

2. For a detailed discussion, see Erdei 1990, 48-252.

3. Otto Hirschmann, *Verzeichnis des graphischen Werks von Hendrick Goltzius, 1558-1617,* 2d ed. (Braunschweig: Klinkhardt and Biermann, 1976), no. 43, 23; Hollstein 8: no. 46; Walter L. Strauss, *Hendrik Goltzius, 1558-1617: The Complete Engravings and Woodcuts* (New York: Abaris Books, 1977) 2: no. 276, 484; Strauss, *The Illustrated Bartsch:* 3 (commentary), no. 052.S3, 59; and Jan Piet Filedt Kok, "Hendrick Goltzius—Engraver, Designer, and Publisher, 1582-1600," *Nederlands Kunsthistorisch Jaarboek* (42-43) 1991-1992:no. 55, 210. For preparatory drawings for the series, see E. K. J. Reznicek, *Die Zeichnungen von Hendrick Goltzius* (Utrecht: Haentjens Dekker and Gumbert, 1961), 1:cat. nos. 63-65, 255-256.

4. For disparities between the roman and arabic numerals on the prints, see Strauss 1977, no. 267, 466.

5. For a summary, see H. W. van Os "Credo," *Lexikon der christlichen Ikonographie,* ed. Engelbert Kirschbaum, S.J. (Rome: Herder, 1968) 1:cols. 461-464. For a detailed discussion, see R. Ligtenberg, "Het Symbolum apostolicum in de Ikonografie der Middeleeuwen," *Het Gildeboek* 12 (1929):9-34.

6. See F. X. Murphy, "The Apostles' Creed," *NCE* 4:436-438.

THIS ENGRAVING EMBODIES THE CONCEPT OF MEDITATION as a solitary pursuit encompassing an individual's reading of a sacred text, inward reflection, and consequent moral action.[1] Fifteenth-century examples of the hand as an instrument of meditation in late medieval devotional images for clergy and laity occur in other parts of the exhibition (Cat. 1, 2, 37, and 75). During the religious upheaval in the sixteenth century resulting in the Reformation and Counter-Reformation, new emphasis on meditation in both secular and religious theory and practice finds expression.[2]

St. James Minor [B.52] is the tenth of a suite of fourteen prints by Goltzius known as the Apostle series. Depictions of Christ and St. Paul supplement those of the twelve disciples.[3] The Metropolitan Museum image represents the third state of the engraving.[4] (For biographical information on the artist, see Cat. 30.) Depictions of the Apostles with articles of the Creed have a long iconographic tradition.[5] In the Goltzius' prints the articles in Roman numerals appear below the Apostles' images and provide a means of arranging their places in the sequence, while inclusion of the traditional attributes of their martyrdom permit identification of each. The Apostles' Creed is one of the fundamental belief statements of the Roman Catholic and Protestant churches.[6] The issue of apostolic succession and items of the Creed may have had special resonance in the Netherlands during a period of extreme religious and political controversy.[7]

St. James Minor is one of Goltzius' imaginary portraits of the Apostles distinguished by age, activity, and physiognomy.[8] A similar group in the *Schatzbehalter* woodcut (Cat. 37) of 1491 attempts in summary fashion such differentiation. Almost a century later, Goltzius' exceptional skill as a draftsman, as well as rapid advances in engraving and printing, have greatly expanded the range of these representations. The influence of humanistic values and the religious crises of the sixteenth century brought about emphasis on the individual, both physically and spiritually. Goltzius' Apostles exhibit in pose, setting, and gesture varied but intense emotional reactions, stimulated perhaps by the section of the Creed associated with them.

St. James Minor, traditionally identified as a member of Christ's family, is depicted in half-length format.[9] Sheltered in a hilly, cavelike setting appropriate for meditation, the saint is framed by a dramatic light source: a shallow, arched opening in the rocks. The tilted angles of the composition are repeated on each side by the flail (the attribute of St. James' martyrdom) and a tree that leans precariously forward. A ledge accommodates the saint's open book propped up on a stone. Constructing an angled, pyramidal form pushed toward the spectator, Goltzius portrays the saint as a strong, middle-aged man. Leaning on his elbows and enveloped in drapery, the Apostle's powerful frame dominates the picture field. Goltzius' manipulation of key areas of light and shade enable him to convey the saint's intensity. For example, the angle of his heavily

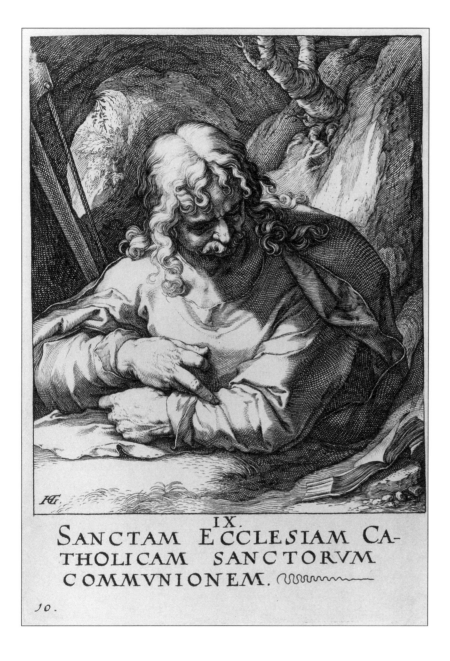

SANCTAM ECCLESIAM CA-
THOLICAM SANCTORVM
COMMVNIONEM.

7. For Goltzius' religious associations as expressed in the iconography of his work, see Reznicek 1961, 1:185-192. See also J. J. Hughes, "Apostolic Succession," *Dictionary of Religion* (Washington, D.C.: Corpus Publications, 1979), 1:230-231.

8. For the full range of the images, see Strauss 1977, 2: nos. 267-278, 466-488.

9. For the identification, see J. A. Lefrançois, "James (Son of Alphaeus), St.," *NCE* 7:805-806.

shadowed head directs attention to his intense, absorbed gaze. The Apostle's folded arms and extended middle finger of his right hand serve also as "body language" expressive of his spiritual deliberation. St. James' concentration and reflection on the text convey the essence of meditation as an intermediary stage between reading and taking moral action.

CRS

Chiropsalterium

*Chiropsalterium*, 1510
Anonymous
Woodcut
Image: 7¾ x 5¾" (19.7 x 14.5 cm)
Jan Mombaer (Johannes Mauburnus)
(c. 1460-1501)
*Rosetum exercitiorum spiritualium et sacrarum meditationum*
Paris: Jehan Petit, 1510, fol. K 4v.
Inscribed:
Top: *Laudate dominum quoniam bonus est psalmus.*
*Deo nostro sit jocunda decoraque laudatio* ([Psalm 147; Vulgate 146]:
Praise ye the Lord for it is good to sing praises unto our God; for it is pleasant,

and praise is comely.);
*Laudate eum et sono tubae in psalterio et cythara /David autem et omnes Israel laudebant coram Domino in omnibus lignis fabrefactis, et cytharis, et lyris, et tympanis, et sistris, et cymbalis. 2. Reg. 6,5.* (Praise him with the sound of the trumpet, psaltery, and harp / David and all the house of Israel played before the Lord on all manner of instruments made of wood, on harps, on psalteries, on timbrels, on cornets, and on cymbals [2 Samuel 6:5].)
*Chiropsalterium Divine Laudis et Deo Psallens Complectens spiritualiter omnes genus musicorum.*
(Handpsalter of divine praise and performing psalms unto God, embracing all kinds of musicians in the Holy Spirit.)

At base:
*Chorea et concertus ecclesiastice unitatis angelis a lateribus*
*Qui habitans in hortis amici auscultant te/ Pro evenerunt principes coniuncti psallentibus in medio tympanum iuvencularum*
*Chorea iuvencularum ad vocem musicorum* (The dance and harmony of ecclesiastical unity with the angels on either side. "Thou that dwellest in the garden, the companions hearken unto you" [Song of Solomon 8:13]. "Princes went before joined with singers, in the midst of young damsels playing on timbrels" [Psalm 67:26 Vulgate]. The dance of the damsels to the sound of the musicians.)[1]
Music Division, Library of Congress, Washington, D.C.

1. I would like to thank Leofranc Holford-Strevens, Dolores Pesce, Thomas Izbicki, and Matthew Roller, in addition to Chris Francese for their help with the Latin translations.

2. The *Devotio moderna* was founded in the fourteenth century by the philosopher, teacher, and theologian Gerard Groote (Gerhardus Magnus), who, once aware of the vice, vanities, and dangers of the church, entered on a devout and pious existence. With his colleagues and disciples he founded at Zwolle the Brethren of the Common Life. His successor, Florence Radewyns, organized clerics into a community of canons at Wildesheim. Followers of the *Devotio moderna* were responsible for the spread of knowledge and development of the vernacular in the Netherlands and in Germany. See Ross Fuller, *The Brotherhood of the Common Life and Its Influence* (Albany: State University of New York Press, 1995); Albert Hyma, *The Brethren of the Common Life* (Grand Rapids, Mich.: Eerdmans, 1950); and Hyma, *The "Devotio moderna"* (Grand Rapids, Mich.: Reformed Press, 1924); and John H. Van Engen, *Devotio moderna: Basic Writings* (New York: Paulist Press, 1998).

JAN MOMBAER (Johannes Mauburnus) was a monastic reformer and ascetical writer who was born in Brussels, studied at a cathedral school in Utrecht and entered a monastery at about age twenty near Zwolle, a house of the Congregation of Windesheim where he came under the influence of the *Devotio moderna*. In 1496 he was called to France in order to initiate reforms, which he attempted to accomplish through the incorporation of the Parisian community of canons known as St. Victor into the congregation of Dutch Brethren of the Common Life, also known as the *Devotio moderna*.[2] The attempt failed because the canons wanted to hold on to their past, but Mombaer became abbot at St. Livry and at ten other abbeys. The *Rosetum* is a book of meditation, a classic of spiritual literature, that was used by novices and monks, including Martin Luther. It is a unique document that combines scholasticism, humanism, and mysticism with ancient musical, choreographic, rhetorical, and poetical traditions. Mombaer's hand was a mnemotechnic device to describe his method of prayer and to meditate on the Psalms. This hand psalter was a way of meditating by using the joints of the fingers of the left hand. Each one is associated with a specific mystical-theological meaning and also with specific Psalms, musical instruments, and dances. The book is constructed along the same lines as speeches of ancient jurisprudence. The connections to music, both vocal and instrumental, and also to dance are unique in the history of books of meditation. In this chapter (18) there is a discussion and pictures of musical instruments and a bit later, a description of choral music (19). The hand itself is inscribed with Latin words denoting certain spiritual exercises. There is an earlier incunable edition printed in Zwolle in 1494.[3]

SFW

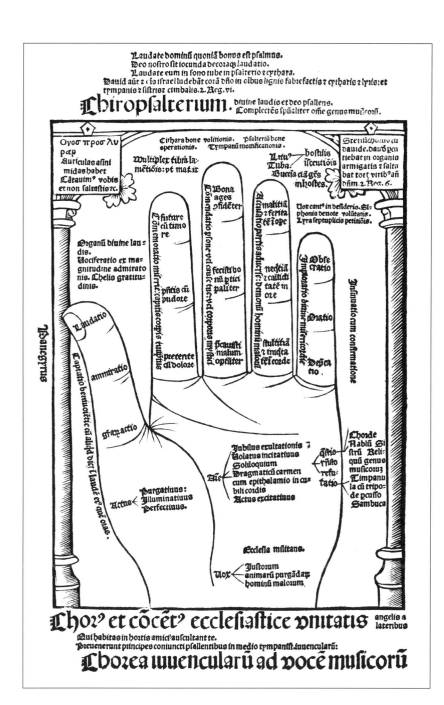

3. Alberto Ampe, "Jan Mombaer," *EC* 8:1232-1233; Ernest Benz, *Meditation, Musik und Tanz. Uber den "Handpsalter," eine spätmittelalterliche Meditationsform aus dem Rosetum des Mauburnus*, (Abhandlungen der Geistes- und Sozialwissenschaftlichen Klasse der Akademie der Wissenschaften und der Literatur) (Mainz: Steiner, 1976); Pierre Debongnie, *Jean Mombaer de Bruxelles* (Louvain: Librairie Universitaire, 1927); Pierre Groult, *Les mystiques des Pays-Bas et la litterature espagnole du seizième siècle* (Louvain: Librairie Universitaire, 1927); Jack C. Wilke, "Mombaer, John", *NCE* 9:106. See also Geneviève Hasenohr, "Méditation et mnémonique: un témoignage figuré ancien (XIII-XIVe s.)," in *Clio et son regard: Mélanges d'histoire de l'art et d'archéologie offerts à Jacques Stiennon à l'occasion de ses vingt-cinq ans d'enseignement à l'Université de Liège*, eds. Rita Lejeune and Joseph Deckers (Liege: Pierre Mardaga, 1982), 365-382. Hasenohr describes a manuscript (British Library, MS Harley 273) dating from the fourteenth century that presents two mnemotechnical hands, a right and a left, used as an aide-mémoire for learning elementary and pragmatic meditations (368-371). Between this manuscript and the *Chiropsalterium* of Mombaer, Hasenohr describes other meditation methodologies, in particular those practiced in communities of the so-called *Devotio moderna*. She also mentions use of the hand as a pedagogical device employed in the teaching of *computus* and music. (See the essays by Sachiko Kusukawa and Susan Forscher Weiss in this volume.) Mombaer's hand combines earlier techniques with a complex scheme of symbolic associations with musical instruments.

*Sic vivo*, 1584
Pierre Woeiriot (1532-1599)
Engraving
Plate mark: 3⁹⁄₁₆ x 3⅞" (9.1 x 9.8 cm)
Georgette de Montenay (1540-1581 [?])
*Emblemes ou devises chrestiennes*
Zurich: Christoph Froschauer, 1584,
emblem 21, p. 21
Inscribed:
*Pingue oleum sitiens, exosam lampada
bubo / Non tamen ipse sua comprimit*

*ante manu. / Et Satan, Veri impatiens
inimica malorum / Saevus in insontes
commovet arma ducum.* (Although he
is thirsty for the rich oil, nevertheless
the owl does not himself extinguish
with his own hand the lamp flame,
which he hates. Satan, who cannot
endure the [flame of] Truth, cruelly
mobilizes the hostile weapons of
wicked leaders against the innocent.)
The Folger Shakespeare Library,

1. For a facsimile of the first edition, see Georgette de Montenay, *Emblemes ou devises chrestiennes, 1571* (Continental Emblem Books No. 15), ed. John Horden and intro. note C. N. Smith (Menston, England: 1973). Smith gives full details of the author's biography and the four editions of her work [n.p.].

2. See Alison Saunders, *The Sixteenth-Century French Emblem Book: A Decorative and Useful Genre* (Geneva: Librairie Droz, 1988), 235.

3. Régine Reynolds-Cornell, *Witnessing an Era: Georgette de Montenay and the Emblèmes ou Devises Chrestiennes* (Birmingham, Alabama: Summa Publications, 1987), 41.

4. Claire Richter Sherman, "The Queen in Charles v's *Coronation Book*: Jeanne de Bourbon and the *Ordo ad reginam benedicendam*," *Viator* 8 (1977):279 and fig. 12. The language in the second part of the *subscriptio* in the first French edition mentions kings, not leaders, as malevolent forces. Also more explicit is its Christian content: "In the same way the Antichrist thinks to [also] use kings to extinguish the flourishing reign of Christ, living and constant light, in order to devour the innocents afterwards."

5. For information about Philippe de Castellas, who wrote a laudatory epistle to Montenay, see Reynolds-Cornell 1987, 24. For the career of Woeiriot, see ibid., 24-25; Thieme-Becker 63:162-163; and Marianne Grivel, "Pierre Woeiriot," *DOA* 33:289.

6. Reynolds-Cornell 1987, 29.

THIS VOLUME IS UNUSUAL because of its Christian content and feminine authorship. Cited as the first religious emblem book, the Folger copy represents the second of four editions of this work, which enjoyed international recognition.[1] Reversing the usual procedure, the explanatory verses were translated into Latin in this edition, while retaining on the facing page the original French ones. Moreover, the work's continued popularity was acknowledged in the polyglot 1619 edition, published in Frankfurt.

The author, Georgette de Montenay, came from a noble family residing in southwestern France. She lived at the court of Jeanne d'Albret, Queen of Navarre, daughter of Queen Marguerite of Navarre, humanist, writer, and supporter of religious reform. Niece of King Francis I and a convert to Protestantism, Queen Jeanne was the dedicatee of Montenay's book. In her introductory letter to her readers (fols. b1-b2v.), Montenay takes pains to distinguish her aim from those of secular emblem books in fostering reflection on spiritual and Christian values. Her portrait (Fig. 37) with pen in hand, accompanied by a lute and books of music, emphasizes her role as a writer dedicated to singing Christ's praise. The verses below the portrait and the inscribed sheet of paper on the table allude to the pen in her hand as a worthy instrument. In her dedication Montenay (fol. a4) encourages other women to avoid idleness and emulate her example in writing similar works of moral edification.[2]

In the present illustration, Montenay adheres to the usual tripartite structure of the emblem book. The motto, a moral or satirical statement of the theme, is followed by a picture whose significance is explained in the verses (known as the *subscriptio*) below it. Here an owl, seated in an exterior landscape, through an opening in a wall extends a rod terminating in a left hand. The index finger points to, and touches, a large, burning lamp hung from the ceiling. The verses, supplemented by Régine Reynolds-Cornell's interpretation, lead to an explanation of this visual puzzle, a characteristic of emblem books. The owl stands for "the Pope, or for conservative theologians, 'who deny the truth of Christ.'" These enemies manipulate kings "to extinguish the light of faith in order to enrich themselves without being detected." Thus "the unwise king's hand is burned in this image, while the owl sits outside, protected by the darkness, which is its natural element and which will allow it to safely drink the oil from the lamp. The owl is, in other words, depriving the world of the light it needs and fattening itself at the expense of the gullible."[3]

Montenay may have chosen such veiled language because of her attack on Catholic and royal French authority. The rod with the hand may allude to a traditional French monarchic symbol, the scepter ending in the hand of

*xxj.*

*Pingue olenm sitiens, exosam lampada bubo*
  *Non tamen ipse sua comprimit ante manu.*
*Et Satan, Veri impatiens, inimica malorum*
  *Sauus in insontes commouet arma ducum.*

h          Scire

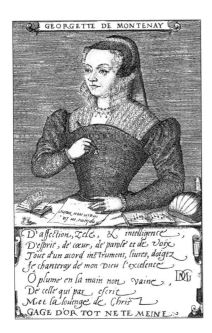

Fig. 37. Pierre Woeiriot, *Portrait of Georgette de Montenay*, engraving. From Georgette de Montenay, *Emblemes ou devises chrestiennes* (Zurich: Christoph Froschauer, 1584), frontispiece. The Folger Shakespeare Library, Washington, D.C.

justice.[4] The first edition of Montenay's work, published in 1571, reflects the precarious position of the French Protestant community (the Huguenots) during the Wars of Religion. A catastrophic event, the St. Bartholomew's Massacre, marked by the assassination of Huguenot leaders and exile of many members of the community, took place in 1572, a year after the first printing of Montenay's work.

The editor of the first edition of Montenay's work, Philippe de Castellas (himself a Huguenot), chose Pierre Woeiriot as illustrator.[5] Woeiriot, a goldsmith, painter, medallist, and sculptor from Lorraine, must have collaborated with the author (perhaps with the help of the editor) in setting the program of the original cycle, which is repeated in this edition.[6] Although how instructions were communicated to Woeiriot remains unclear, the illustrator faced a considerable challenge in translating abstract and allegorical notions into intelligible visual form. The present engraving shows Woeiriot's considerable ability in this technique to solve difficult problems of representation by differentiating textures, materials, and landscape features. The integration of the motto with its elaborate, scrolled frame into the already strange composition adds another fantastic note to the arresting ensemble. An important element is the use of the hand as a performer and agent essential to solving the emblem's puzzle.

CRS

**77  Affligor
(I Am Beaten)**

*Affligor* (I Am Beaten), 1624
Matthäus Merian the Elder (1593-1650)
Engraving
Plate mark: 3⅞ x 3¼" (9.8 x 8.3 cm)
Daniel Cramer (1568-1637)
*Emblemata sacra*
Frankfurt am Main: Luca Jennis, 1624,
emblem 48, p. 205
Inscribed:
Top: *Et fui flagellatus tota die, et
castigatio mea in matutinis.*

(I have been whipped through the
whole day, and my chastistement
comes [again] in the morning hours.)
Bottom: *Nocte dieque simul multa
vibice flagellor:/Quid tum? namque, ego
sum filius, ille pater.* (Night and day
I receive many stripes from the whip.
And why not? For I am the son, and
he is the father.), etc.
The Folger Shakespeare Library,
Washington, D.C.

1. Sabine Mödersheim, "Biblische Metaphorik in Daniel Cramers *80 Emblemata Moralia Nova*," in *The European Emblem, Selected Papers from the Glasgow Conference 11-14 August, 1987,* eds. Bernard B. F. H. Scholz, Michael Bath, and David Weston (Leiden and New York: E. J. Brill, 1990), 108.

2. Mödersheim, "Herzemblematik bei Daniel Cramer," in *The Emblem in Renaissance and Baroque Europe, Tradition and Variety,* (Selected Papers of the Glasgow International Emblem Conference, 13-17 August, 1990), eds. Alison Adams and Anthony J. Harper (Leiden and New York: E. J. Brill, 1992), 90-101.

3. Mödersheim, "Nachwort," in Daniel Cramer, *Emblemata sacra,* facs. ed. (Hildesheim and New York: G. Olms, 1994), 3-7. For a fuller treatment of Cramer's career and writings, see Mödersheim, *"Domini Doctrina Coronat": Die geistliche Emblematik Daniel Cramers, 1568-1637* (Frankfurt am Main and New York: P. Lang, 1994).

4. See Mario Praz, *Studies in Seventeenth-Century Imagery: A Bibliography of Emblem Books* (Studies of the Warburg Institute 3), ed. Fritz Saxl (London: Warburg Institute of the University of London, 1947) 2:43-44; and John Landwehr, *German Emblem Books, 1531-1888: A Bibliography* (Utrecht: Haentjens Dekker and Gumbert, 1972), nos. 212 and 215, 58-59. Conrad Bachmann wrote parts of the distichs of the second group of emblems added to the 1624 edition.

5. Edith Trenczak, "Lucas Jennis als Verleger alchimistischer Bildertraktate," *Gutenberg Jahrbuch* (1965):324-337.

6. See Lucas Wüthrich, *Das druckgraphische Werk von Matthaeus Merian D. Ae., Die weniger bekannten Bücher und Buch-illustrationen* (Basel: Bärenreiter-Verlag, 1972) 2:no. 81a, 99. For a discussion of the circular format of the images, see Cat. 79.

IN THE SECOND PROTESTANT EMBLEM BOOK IN THE EXHIBITION, the left and right forearms and hands issuing from two clouds, represent divine—not secular—authority and agency. (For the first Protestant example, see Cat. 76.) Their clasping gesture placed in the center of the circular composition confirms their support of two instruments of punishment, a scourge and a whip. Other visual elements include a landscape on which stands a heart, prominently displayed in the center of the composition.

The arrangement of the three parts of the emblem structure furnishes clues as to the meaning of the page. Following the number of the emblem (forty-eight in a sequence of fifty) comes a verse from Psalms 73:14. On the inner frame appears the motto and a repetition of the emblem number. The *subscriptio,* from the same Psalm, explains the major theme of the need for self-punishment and atonement for sin. On the facing page additional lines reinforce the message: "All through the day and all through the night I feel the whip and the cane; indeed, they are piercing my skin. But this pain comes from the Father, who holds the realms of heaven and of the earth in fear: I am his son."

The need for such individual recognition of sin was a major theme of Protestant theology founded on biblical study as a source of meditation and consequent moral action. Indeed, this collection of emblems was the first grounded exclusively on biblical sources.[1] Furthermore, the image of the heart, a symbol soon to appear frequently in both Protestant and Catholic emblems, was also based on biblical, patristic, and Lutheran theology. The heart signifies that the spiritual and emotional response it symbolizes comes from deep within the individual. In these emblems, the author expressed the belief that the heart is the seat of both thought and will, the mediator between body and soul.[2]

The composer of these emblems was the Lutheran preacher and theologian Daniel Cramer. Cramer, who lived in the east German city of Stettin, in the Duchy of Pomerania (now part of Poland) was a prolific writer of religious and historical works both in the vernacular and Latin.[3] Cramer was also the author of an earlier emblem book (with a different title) published in 1617 with forty emblems, which was expanded to fifty in a second edition of 1622. The present edition of 1624 added a second group of fifty more emblems.[4] The publisher was Luca Jennis, who, perhaps inspired by the 1619 polyglot edition of Georgette de Montenay's work (Cat. 76), followed this example in the present edition. Jennis, famous for his publication of alchemical and Rosicrucian treatises, like the engraver Matthäus Merian the Elder (Cat. 60 and Cat. 81), had married into the family of Johann Theodor de Bry, the prominent publisher.[5] Merian himself is credited with executing the present engraving and several others in Cramer's emblem book.[6]

CRS

## 78 God Teaching Writing

God Teaching Writing, 1640
Michel Natalis (1610-1668) after
Abraham van Diepenbeeck (1596-1675)
Engraving
Plate mark: 4 x 5½" (10.2 x 14 cm)
Jean de Bolland (Johannes Bollandus)
(1596-1665)
*Af-beeldinghe van d'eerste eeuwe der
Societeyt Jesu*
Translation by Adriaan Poirters, S.J.,
and Laurent Uwens, S.J.
Antwerp: Plantin, 1640, p. 298
Inscribed:
*De principaelste lesse vande Christelijcke
leere: Eenen Godt, en dry persoonen*
(The primary lesson of the Christian
faith: One God, in three persons)
*Sic trinus & unus Discitur/Dry en een,*

*Godt alleen* (Three and one, God alone)
*Een leer kindt spreeckt* (A pupil speaks)
*Als ick eerstmael ghingh ter scholen,/
Dat my neerstigh was bevolen / (Want
de kinders op de straet / Leeren anders
niet als quaet) / Doen moest ick voor
'teerst gaen weeten / Hoe dat al de
letters heeten, / Wat dat is een A oft B,/
Wat dat voor gaet, C oft D* (When I
went to school for the first time, which
was strongly recommended to me,
because the children in the street learn
nothing but bad things, then I had to
learn for the first time the name of all
these letters, whether it was an *A* or *B*,
or which comes first, *C* or *D*.)
The Folger Shakespeare Library,
Washington, D.C.

1. For their translation of the text accompanying the emblem on pages 298-299 of Bolland's *Af-beeldinghe van d'eerste eeuwe der Societeyt Jesu*, I am grateful to Profs. Paul and Marianne Meijer.

2. Charles Moseley, *A Century of Emblems: An Introductory Anthology* (Aldershot, G.B.: Scolar Press, 1989), 16-17; and Robert Paultre, *Les images du livre: Emblèmes et devises* (Paris: Hermann Éditeurs des Sciences et des Arts, 1991), 119-120. For the first two Jesuit examples, see Paultre 1991, 120-137.

3. Bolland's fame rests on an outstanding accomplishment, the organization of a small group of Jesuits in Antwerp (the Bollandists) to undertake a massive study of the lives of the saints, the *Acta sanctorum*, a landmark in hagiography. See Mario Scaduto, "Jean Bolland," and "Bollandisti," *EC* 2:1782-1790; P. Roche, "Bollandists," *NCE* 2:648-649.

4. For the bibliographic descriptions of the Latin and Dutch versions, see *The Jesuit Series*, part 1 (*A-D*), eds. Peter M. Daly and G. Richard Dimler, S.J. (Montreal and Kingston: McGill-Queen's University Press, 1991), nos. J.47 and J.48, 56-59.

5. Hans Vlieghe, "Abraham van Diepenbeeck," *DOA* 8:877-879.

6. Thieme-Becker, "Michel Natalis," 25:353.

**UNLIKE THE ILLUSTRATION IN THE MONTENAY VOLUME** (Cat. 76), the motto in the present example is separate from the massive and elaborate Baroque frame, which dominates the page. Within the curves of its interior cartouches, two overlapping arms and hands emerge from a cloud. The hands mutually support a pen with which they trace the letter *M*. Unlike the identical heavenly pair in the Cramer illustration (Cat. 77), these two differ from one another: one arm is clothed, the other bare. To arrive at an identification with God the Father and the Son, respectively, the reader must turn to the text.[1] The two lines in Latin and Dutch provide a vital clue: a formula for learning the doctrine of the Trinity. Then there follows a verse narrative, which continues on the facing page. Spoken by a child, the poem humorously relates his experiences in learning first to read and then to write. In discussing his difficulties in making his letters, he says:

> But when he came to hold my hand,
> And managed to softly push it,
> And steered it here and there,
> Then I learned the art.
> So he pushed, so he turned,
> So he taught me this letter
> That one writes with three legs
> But that is nevertheless one letter,
> Then he started to show me here,
> One God, and three persons,
> Father, Son, and Holy Ghost.

In short, two visible persons of the Godhead, perhaps guided by the invisible Holy Ghost, are inscribing the formula for the doctrine of the Trinity by making the letter *M*. Its united but tripartite form echoes the formula of the motto above, "Three and one, God alone." The technique of the narrative suggests its use as a tool for teaching this basic doctrine to children. Both the narrative device and the two-line verse form were useful as pedagogical techniques.

This emblem book was published to commemorate the centenary of the Society of Jesus (known also as the Jesuit order). Established by St. Ignatius Loyola, the Jesuits, by their missionary, educational, and scholarly activities

De principaelſte leſſe vande Chriſtelijcke leere : Eenen
Godt, en dry perſoonen.

Sic trinus & vnus  { Dry en een,
Diſcitur.  { Godt alleen.

Een leer-
kindt
ſpreeckt.

ALs ick eerſtmael ghingh ter ſcholen,
Dat my neerſtigh was beuolen,
(VVant de kinders op de ſtraet
Leeren anders niet als quaet)
Doen moeſt ick voor 'teerſt gaen weeten
Hoe dat al de letters heeten,
VVat dat is een A oft B,
VVat dat voor gaet, C oft D.

Doch

became a potent force in the Catholic Counter-Reformation. The religious emblem book was a shortcut method of explaining to diverse groups the order's basic ideals, as close ties between text and image aided the reader's cognitive and mnemonic processes. The publication of a series of emblem books issued by the Jesuits, chiefly in Flanders and Germany, began in 1605.[2]

The idea for the celebratory publication came from Jean de Bolland, a distinguished Belgian Jesuit scholar, who served as its principal editor. The first version of this volume detailing the achievements of the Society of Jesus was published in Latin but the same year was translated into Dutch.[3] The engravings in the present volume, which use the plates from the Latin edition, are fewer in number and are placed both after the prologues and at the end of each of the six books. The present emblem occurs after the lengthy account in book 3 of the Jesuits' emphasis on education, from establishing schools for children to the foundation of new universities and praise of the order's leading scholars.

The 104 engravings are unsigned, although the title page lists the designer as Abraham van Diepenbeeck and Michel Natalis as the engraver.[4] The former was a well-known and prolific Flemish painter, stained-glass artist, draftsman, and illustrator greatly influenced by the style of his compatriot Peter Paul Rubens.[5] Natalis is known for his work with Diepenbeeck and the engravers of Rubens' work.[6]

The heavenly hands in this engraving, like those in the Cramer emblem (Cat. 77), perform actions to aid the vulnerable individual. Here the united persons of the Godhead serve as spiritual guides to learning and remembering the fundamental doctrine of the Trinity. In their hands, writing is again sanctioned as a divinely inspired activity (see Cat. 8).

CRS

Aequari pavet alta minor, 1605
Johann (Hans) Sibmacher
(fl. 1590-d. 1611)
Engraving
Plate mark: 2⅝ x 2⅝" (6.6 x 6.6 cm)
Joachim Camerarius (1534-1598)
*Symbolum et emblematum centuriae tres*
Leipzig: Vögelin, 1605, emblem 76, p. 78
Inscribed:
*Quid sibi Tarquinius? Cum summa*

*papavera frangit?/Sors quia sic plebem
terret iniqua Patrum.* (What is
Tarquinius doing? Why is he breaking
the tallest poppies? Because in this way
the common people are terrified by the
unjust fate suffered by the upper class.)
History of Medicine Division,
National Library of Medicine,
National Institutes of Health,
Bethesda, Maryland

1. For discussion of this tale, see Claire Richter Sherman, *Imaging Aristotle: Verbal and Visual Representation in Fourteenth-Century France* (Berkeley and Los Angeles: University of California Press, 1995), 218. The moral drawn in the Camerarius emblem differs somewhat from the outcome described in the classical sources.

2. Wolfgang Harms and Ulla-Britta Kuechen, "Einführung," in Joachim Camerarius, *Symbola et Emblemata (Nürnberg 1590 bis 1604),* facs. ed. (Graz: Akademische Druck-u. Verlagsanstalt, 1988), 2/2:2-5. This introduction provides an excellent account of the sources and processes of Camerarius' work, on which my description heavily depends.

3. Ibid., 6-14.

4. Ibid., 7, 19-28.

5. Ibid., 7-8, 33-34. See Frederick John Stopp, *The Emblems of the Altdorf Academy: Medals and Medal Orations, 1577-1626* (London: Modern Humanities Research Association, 1974), 83-87. The Altdorf Academy apparently became in 1620 Altdorf University. The university served the city of Nuremberg, of which Altdorf was then a part. See "Altdorf University" in *The Oxford Companion to German Literature,* ed. Mary Garland, 3d ed. (Oxford and New York: Oxford University Press, 1997), 18-19.

6. Harms and Kuechen 1988, 29. See John Landwehr, *German Emblem Books, 1531-1888: A Bibliography* (Utrecht: Haentjens Dekker and Gumbert, 1972), no. 166, 47.

7. Harms and Kuechen 1988, 13-14, 38-39 nn. 27-28. Sibmacher's monogram is found on the title page of the first century (hundred) of emblems and on the image of emblem 16 of the second group. See also, Jane S. Peters, "Johann (Hans) Sibmacher," *DOA* 28:649-650.

IN THIS EMBLEM, the hand no longer is associated with meditation or divine agency (Cat. 77 and 78); it stands instead for the arbitrary and secret power of the secular ruler. The action of cutting off the tallest heads of poppies comes from a story told in an older Greek version by Herodotus and Aristotle and in a Latin form by Diogenes Laertes, Livy, and Valerius Maximus. When the tyrant Tarquinius was asked by his son Sextus what to do with a too powerful faction that threatened his rule, the father went into a field in the presence of a messenger and cut off the heads of the tallest poppies. The gist of this response, too dangerous to put into words, is that Sextus should get rid of his opponents by assassination or ostracism.[1] Here the motto interprets the strategy as a means of instilling terror in the lower classes, who fear that they will suffer the fate of the higher born should they refuse to submit to the tyrant's will.

The author of this emblem book, Joachim Camerarius (the Younger), cites the ancient sources of this venerable tale on the page opposite the emblem. Camerarius came from an eminent German intellectual family involved with late humanist culture and religious reform.[2] His father (Joachim Camerarius the Elder) was an eminent classical philologist and associate of the Lutheran theologian and scholar Philipp Melanchthon. The son was trained in medicine at the universities of Wittenberg, Padua, and Bologna and practiced in Nuremberg. There he became city physician and founded a college of medicine. The younger Camerarius was also an eminent botanist interested in the application of plants to medicine. He wrote several herbals and knew and corresponded with the most renowned contemporary scholars in natural history and philosophy.

Camerarius conceived the project of writing a series of natural history emblem books over eleven years.[3] Although he is the principal author, his correspondence with various colleagues confirms that they contributed explanatory verses, the *subscriptio*. Manuscripts of Camerarius' sketches for half of the four hundred emblems finally published still survive.[4] Of particular interest is the circular form of the picture, related to academic medals given yearly as prizes by the Altdorf Academy.[5] Later emblem books such as Cramer's and Zincgref's (Cat. 77 and 81) adopted this abstract and idealizing format for their pictures.

Camerarius' series was divided systematically by subject into four groups of a hundred. The first encompassed plants and roots; the second, quadrupeds; the third, birds and insects. The fourth part on fish and reptiles, unfinished at the time of Camerarius' death, was completed by his son Ludwig and issued in 1605 as an enlarged second edition.[6] The engravings were made by the Nuremberg artist Johann (Hans) Sibmacher, a prolific printmaker known particularly for his designs of books of heraldry and needlepoint.[7] His delicate

LXXVI.

AEQVARI·PAVET
ALTA·MINOR,

*Quid sibi Tarquinius? Cur summa papavera frangit?*
*Sors quia sic plebem terret iniqua Patrum.*

technique was well adapted to his painstaking description of plants and animals in the small-scale format of Camerarius' emblem pictures.

Camerarius uses the emblem form as his strategy to organize and explicate systematically the description and terminology of natural forms.[8] He situates his reading of the book of nature in a moral and religious frame of reference explored in his extensive page of commentary preceding the individual emblem.[9] Camerarius cites as sources of knowledge ancient authorities on natural science, poets, and religious writers. His approach, which combines empirical description with moral and literary reflections, may account for the great influence and popularity of his emblem books, published in many later editions.[10] The present emblem displays Camerarius' appealing blend of the naturalistic depiction of the poppy and moral, philosophical, and literary allusions associated with the action of the hand.

CRS

8. See Wolfgang Harms, "On Natural History and Emblematics in the Sixteenth Century," in *The Natural Sciences and the Arts: Aspects of Interaction from the Renaissance to the Twentieth Century, An International Symposium* (Stockholm: Almqvist and Wiksell International, 1985), 75-80.

9. Jean-Marc Chatelain, *Livres d'emblèmes et de devises: Une anthologie, 1531-1735* (Paris: Klincksieck, 1993), 89.

10. Harms and Kuechen 1988, 29-35.

*Donare, est perdere*, 1622
Anonymous artist after Adriaen van de
Venne (1589-1662)
Engraving
Plate mark: 4¹⁵⁄₁₆ x 4¹⁵⁄₁₆" (12.5 x 12.5 cm)
Jacob Cats (1577-1660)
*Monita amoris virginei*
Amsterdam: Willem Janz Blaeu, 1622,
emblem 29, p. 75
Inscribed:
Below, left: *Nihil mulier viro det;
foemina enim quae dat, se dedit.* (Let a
woman give nothing to a man; for the
woman who gives has given herself.)

Below, right: *Et ratio esse potest, quod
ille qui donat creditur captare velle
benvolentiam ejus, cui donat; juxta illud
Martialis, "Dum me captabas, mittebas
munera nobis."* (The reasoning behind
this might also be that he who gives is
thought of as courting the favors of
the person to whom he gives; Martial
says something similar: "While you
were courting my favor, you used to
send me gifts.")
The Folger Shakespeare Library,
Washington, D.C.

**DONARE, EST PERDERE.**
**XXIX.**

75

Vives lib. 1 de Chrift. Fœm.
*Nihil mulier viro det ; fœmina enim
quæ dat , ſe dedit.*

*ET ratio eſſe poteſt , quod ille qui donat
creditur captare velle benvolentiam
ejus, cui donat ; juxta illud Martialis :*
Dum me captabas, mittebas munera
nobis.

K k 2                                    Des

WHILE THE ENGRAVER HAS KEPT THE CIRCULAR FORMAT of the picture in the Camerarius emblem (Cat. 79), the present image now has a lively, down-to-earth character drawn from everyday life, characteristic of seventeenth-century Dutch art and culture. Yet the hint of a higher authority emanates from the right hand issuing from the clouds outside the interior space. This hand inserts a frying pan containing a burning substance into a flaming hearth. The image reminds the viewer of the proverbs, "Out of the frying pan into the fire" or "The fat into the fire." Such a reading connects with the lofty motto of the emblem, translated as "To give is to waste." For the fat (interpreted as a metaphor of the chaste body) in the pan is ruined by unwise exposure to the flame, associated with passion caused by physical desire. Another possible moral is that such imprudent conduct results in an uncontrollable, chaotic situation.

The message conveyed by the motto, picture, and explanatory verses, or *subscriptio,* is a warning to young girls to retain their chastity.[1] The title of the emblem book confirms the target of such counsel. *Monita amoris virgenei* (Advice about Love to a Maid) is the Latin version of the Dutch title in the first edition entitled *Maechden-plicht* (The Maidens' Duty) published in 1618. The commentary page opposite adds a French distich to the Latin and Dutch verses. The emblem belongs to the genre of conduct books for women. The first half of the explanatory verses below the picture of the present emblem refers to a treatise by the Spanish humanist Juan Luis Vives. The sixth chapter of the first volume discusses virginity as an essential concern in the education of young girls.[2]

Anna Roemers Visscher suggested the subject of a pedagogical work for young girls to the author of the *Monita amoris virginei,* Jacob Cats.[3] Cats, a renowned poet, was the most popular Dutch literary figure of the seventeenth century and known as "Father Cats."[4] A poet herself, Anna Roemers Visscher was also a translator of Georgette de Montenay's volume of religious emblems (Cat. 76), and revised her father's book of emblems, the *Sinnepoppen.*[5] Cats dedicated the present book to Anna Roemers Visscher and gave her first name to one of the two characters involved in the dialogue form of the *Monita amoris virginei.* Anna is the more responsible of the duo, who imparts moral instruction and counters the views of the less thoughtful Phyllis.[6] In the spirit of conduct books, Anna's warning to preserve a girl's virginity against momentary passion is a foundation of middle- and upper-class moral and economic doctrines necessary for a socially acceptable marriage.[7]

One of a series of emblem books by Cats, by 1644 the *Monita amoris virginei* enjoyed seven later printings.[8] The lively emblems after Adriaen van de Venne, illustrator of all of Cats' emblem books, undoubtedly contributed to the popularity of this one.[9] The present example manages to communicate its strict moral message in an allusive, but immediately understandable and humorous, visual form.

CRS

1. For chastity as an essential component of women's training, see Ruth Kelso, *Doctrine for the Lady of the Renaissance* (Urbana: University of Illinois Press, 1956), 41-44.

2. For a recent edition, see *De institutione feminae christianae,* ed. C. Fantazzi and trans. C. Matheeussen (Leiden and Boston: E.J. Brill, 1998), 1:53-64.

3. Karel Porteman, "'Embellished with Emblems': About the Incorporation of Emblems in Other Genres in Dutch Literature," in *The Emblem in Renaissance and Baroque Europe: Tradition and Variety,* (Selected Papers of the Glasgow International Emblem Conference 13-17 August 1990), eds. Alison Adams and Anthony J. Harper (Leiden and New York: E. J. Brill, 1992), 73.

4. Maria A. Schenkeveld, *Dutch Literature in the Age of Rembrandt: Themes and Ideas* (Amsterdam and Philadelphia: John Benjamins Publishing Co., 1991), 31.

5. Ibid., 22-23; and Michael Bath, "Anglo-Dutch Relations in the Field of the Emblem," in *Emblems in Glasgow: A Collection of Essays Drawing on the Stirling Maxwell Collection in the Glasgow University Library* (Glasgow: University of Glasgow French and German Publications, 1992), 35.

6. Porteman 1992, 73-74.

7. See Bonnie S. Anderson and Judith P. Zinsser, *A History of Their Own: Women in Europe from Prehistory to the Present* (New York: Harper and Row, 1989) 1:394-401.

8. For the editions, see Anne Gerard Christiaan de Vries, *De Nederlandsche Emblemata: Geschiedenis en Bibliographie tot de 18$^{de}$ eeuw,* reprint ed. (Utrecht: HES Publishers, 1976), nos. 100-109, 50-55; and John Landwehr, *Emblem and Fable Books Printed in the Low Countries, 1542-1813,* 3d ed. (Utrecht: HES Publishers, 1988), nos. 132-145, 79-83.

9. See Martin Royalton-Kisch, "Adriaen (Pietersz.) van de Venne," *DOA* 32:230-232. While earlier authors on the emblem books suggest Jan Swelinck as the possible engraver after van de Venne (de Vries 1976, no. 100, 61), later scholarship does not identify a specific artist. See Christiaan Shuckman, Hollstein 25:5 and nos. 118-163; the present emblem is no. 147.

*Omnia nec tanti*, 1666
Matthäus Merian the Elder (1593-1650)
Engraving
Plate mark: 3¹⁄₁₆ x 2¹⁵⁄₁₆" (7.8 x 7.6 cm)
Julius Wilhelm Zincgref (1591-1635)
*Emblematum ethico-politicorum*
*centuria*

Heidelberg: Clemens Ammon, 1666,
emblem 93
Inscribed:
*Sardanapalus*, etc. (see below)
Rare Book and Special Collections
Division, Library of Congress,
Washington, D.C.

1. For this edition, see John Landwehr, *German Emblem Books, 1531-1888: A Bibliography* (Utrecht: Haenjtens Dekker and Gumbert, 1972), no. 667, 158. See also Julius Wilhelm Zincgref, *Hundert Ethisch-Politische Embleme mit den Kupferstichen des Matthaeus Merian,* eds. Arthur Henkel and Wolfgang Wiemann, facs. ed. (Heidelberg: Carl Winter Universitäts Verlag, 1986), 1:7-10. (Henkel alone wrote the "Nachwort" in vol. 2 of this edition cited in the following notes.) See also Yates, *The Rosicrucian Enlightenment,* 105-106.

2. For de Bry's publishing activities and ties to the Elector Palatine, see Yates, *The Rosicrucian Enlightenment,* 103-105.

3. Henkel 1986, 2:134-135.

4. Ibid., 2:122-123.

5. For a political and cultural account of the Palatine court, see Yates, *The Rosicrucian Enlightenment,* chap. 1.

6. Henkel 1986, 2:122-123.

7. For the identification of these authorities, cited in the margins of Zincgref's commentary, see Henkel 1986, 2: 113-121.

8. Henkel 1986, 2:139-143; "Julius William Zincgref," in *The Oxford Companion to German Literature,* ed. Mary Garland, 3d ed. (Oxford and New York: Oxford University Press, 1997), 944.

9. Athenaeus, *The Deipnosophists,* trans. Charles Burton Gulick (London: W. Heinemann, Ltd., 1933), 5:12, 528-530.

THIS EMBLEM WAS ENGRAVED AND SIGNED on the frontispiece by Matthäus Merian the Elder (Cat. 60 and 77) for the first edition of this collection of a hundred ethical-political emblems published in 1619 by Johann Theodor de Bry (see Cat. 60).[1] De Bry's printing operation was then located in Oppenheim, a town on the Rhine, in the Palatinate (now Pfalz).[2] The present volume preserves the original engravings reprinted in the third edition of 1664.

Like the images in the Camerarius emblem book (Cat. 79), Merian chose a circular format in which to frame the striking hand rising from a tomb set against the ruins of an ancient city. Merian, although still a young man, had previous experience in engraving emblem books. The engraver was living in Heidelberg during the production of the first edition of the *Emblematum ethico-politicorum centuria* (1619). He had married a daughter of the publisher Johann Theodor de Bry, who had close ties with the Palatine court. Merian had the opportunity to collaborate with its author, Julius Wilhelm Zincgref, in setting the program of the emblems' pictures.[3] Zincgref was a young lawyer trained at the University of Heidelberg, where he had received a humanist education.[4] Heidelberg was the capital of the Protestant Palatine Elector, Frederick v, whose court was a center of culture and learning.[5] The court librarian was Jan Gruter, a humanist scholar and mentor of Zincgref, who asked for his help in locating ancient literary sources for the emblems.[6] Zincgref followed the precedent of Camerarius in providing a commentary citing the authorities for the story on the page opposite the emblem. This method, favored by contemporary scholars, allowed him to display his knowledge of ancient texts.[7] Zincgref, whose family had long been eminent in the Palatinate court, was greatly affected by the defeat in 1620 of the Elector's army at the Battle of White Mountain, an important early battle of the Thirty Years' War. Two years later the capture of Heidelberg by Catholic forces led to Zincgref's exile. Until his early death from the plague, Zincgref moved from one city to another as diplomatic translator and city clerk. His current reputation rests on the collections of proverbs and apothegems he published after his departure from Heidelberg.[8]

The theme of the emblem expressed in the motto is that "the world is not worth so much." The *subscriptio* in French and German (appended to the first edition) explains: "Everything crumbles. Man is mortal and even more vain than vanity itself; and there is nothing which so resembles vanity as the king of today. Tomorrow, he will be dust." The topos of earthly vanity embodied in earthly rulers is exemplified by the Assyrian ruler Sardanapalus, whose name is inscribed on the front and side of the tomb he commissioned. Sardanapalus was condemned for his extravagant lifestyle. He became in Western political and ethical writing a legendary symbol for bad rule and self-indulgence associated with the Near East. Later sources relate that after a two-year siege of his capital, Nineveh, by the Medes, he ordered his palace, court, and himself burned to death. The account states further that Sardanapalus had himself commissioned a tomb with a hand snapping its fingers in disgust at the vanity of earthly pleasures.[9]

**XCIII.**

**OMNIA NEC TANTI.**

93

*Tout est Caduc.*

L'homme mortel est encore plus vain,
Que vanité fondue toute ensemble:
Et vanité n'est rien qui luy ressemble,
Aujourd'huy Roy, pouldre sera demain.

Es ist keiner Bonen werth.

Was ist die Welt mit ihrer Pracht?
Eitelkeit/weit und breit
Vnd derer man im Grabe lacht/
Meide sie/aber frue.

A a 2                                    *Caßnum*

Merian's representation of the theme is a powerful condensation of the emblem's verbal messages. The elegant, solidly modeled sarcophagus, decorated with classical motifs, itself embodies the theme of vanity. More delicately rendered, the classical ruins in the background convey the idea of the fragility and futility of political ambition. But the most powerful expression of these themes is the hand, speaking from the tomb, and pointing to the motto. The theme of the snapping fingers communicates both the fleeting nature of such pleasures and perhaps defiance of the message. Again (see Cat. 79), the hand stands for the authority of the ruler whose lack of ethical ideals leads to a disastrous political end.

CRS

*Pulse-Taking*, 1534
Anonymous
Woodcut
Sheet trimmed to image: 5¹⁄₁₆ x 4½"
(13 x 11.4 cm)
Stefan Falimirz
(Early sixteenth century)

*O Ziolach i o moczy ich*
Cracow: Florian Ungler, 1534
Philadelphia Museum of Art,
SmithKline Beecham (formerly
SmithKline Beckman) Corporation
Fund for the Ars Medica Collection,
1969-190-127

HANDBOOKS OF MEDIEVAL MEDICINE include a treatise on the pulse as an essential tool of diagnosis. The relationship between the heart, the organ most essential to life, and the pulse gave ample attention to pulse-taking as an indication of health and disease. Measurement of the heartbeat by counting the number of movements per minute of a patient's pulse concerned not only the frequency and length of heartbeats but also their strength or weakness, and their regularity or irregularity.[1] Another element is the duration of expansion (diastole) or contraction (systole) of the heart's action on the arteries. Also given were instructions on the choice of the pulse, placement of the fingers, and position of the physician next to the patient. Indications of various diseases could emerge from changes in the rate, rhythm, and force of the pulse.

The present woodcut, with its figures and space modeled by bold black-and-white contrasts and thick linear strokes, depicts two physicians taking the pulses of two patients. An aged man, seated in an elaborate chair, is attended by a man wearing the academic robes of a physician. A second figure, holding a cane, stands up as a second physician takes his pulse. The scene takes place in a room with an ocular opening that suggests a public space, perhaps a hospital.[2] A figure entering at the right holds a urine bucket, another standard diagnostic tool of medieval and early modern medical practice.

The inscription above the woodcut, absent in this print, specifies that the text discusses teachings about the pulse of both sick and healthy persons. The explanation specifies that the doctor must place himself beside the patient. After a brief conversation, the physician needs to place his own four fingers very lightly on the patient's right wrist so that the first (index) finger can lie close to the others alongside it and the palm. The physician must pay careful attention to the throbbing of the vein, because its different movements indicate relationships to the four humors, an essential component of medical theory. For example, a fast and frequent beat signifies the presence of the sanguine humor, while a slow, lazy beat denotes a phlegmatic and melancholic individual.[3] The woodcut seems to follow these instructions quite closely, although the printing of the woodcut reverses the first patient's arm from right to left.

This image appears in a section on diagnosis in a popular encyclopedia of medicine and natural sciences, the first to be published in Polish.[4] The use of a vernacular language demonstrates that its author and publisher wished to reach a wider public beyond that of academic readers versed in Latin. The title of the book is translated as *Herbs and Their Efficacy*, because the first of the major text divisions is a translation of a German herbal, the *Gart der Gesundheit*, or a slightly later Latin text, the *Hortus sanitatis*.[5] The printer, Florian Ungler, who ran a publishing office in Cracow, issued about 246 titles in Latin, Polish, Greek, and Hungarian.[6] Of Bavarian origin, Ungler took a special interest in mathematics and natural science. The present volume, with more than 550 woodcuts, is the most profusely illustrated of his publications.[7] Ungler encouraged the author Stefan Falimirz to compile this book, which enjoyed great popularity.[8]

This woodcut demonstrates the double role of the hand as an active performer in medical diagnosis. The hand, instrument of the brain, performs the measurement and calculation of an essential bodily function. The wrist of a second person is the recipient of the action. While the relationship between heart and hand here largely refers to vital physiological functions, pulse-taking also involves reference to psychological types and behavior.

CRS

1. For this account, see John E. Murdoch, *Album of Science, Antiquity and the Middle Ages* (New York: Charles Scribner's Sons, 1984), no. 261, 307.

2. Another image from this book depicting the administration of medicinal herbs also takes place in a similar space. See Diane R. Karp, *Ars medica*, no. 28c, 174.

3. I am grateful to Dr. Jadwiga Krupski for translating these passages.

4. See H. Swiderska, "Polish Books," *British Library Journal* 12/1 (1986):102. I would like to thank Janet Zmroczek of the British Library for bringing this information to my attention. Although the Folger Shakespeare Library recently received a copy of the Falimirz volume, it is not complete. I consulted a microfilm available from the Harvard University Library. Anna Rachwald of the National Gallery of Art Library helped with translations.

5. See Ellen Shaffer, *The Garden of Health; An Account of Two Herbals, the Gart der Gesundheit and the Hortus sanitatis* (San Francisco: Book Club of California, 1957).

6. Swiderska 1986, 102.

7. See Barbara Bienkowska and Halina Chamerska, *Books in Poland: Past and Present*, eds. and trans. Wojciech Zalewski and Eleanor R. Payne (Wiesbaden: Otto Harrassowitz, 1990), 8.

8. Swiderska 1986, 102.

# God Taking
# the Pulse of Man

*God Taking the Pulse of Man,* 1629-1631
Anonymous
Engraving
Plate mark: 6¹¹⁄₁₆ x 5¹⁵⁄₁₆" (17 x 13.6 cm)
Robert Fludd (1574-1637)
*Pulsus; seu, Nova et arcana pulsuum
historia.* . . . In volume 9 *(Integrum
morborum mysterium),* of *Medicina
catholica; seu, Mysticum artis
medicandi sacrarium*
[Frankfurt am Main: William Fitzer,
1629-1631], frontispiece of part 3,
section 3
Inscribed:
Above: *Nocte os meum perforatur*

*doloribus et/ Pulsus mei non recumbunt
(Job 30.17)* (At night my mouth is
pierced with pains and my pulse does
not settle down.)
Around image: *A quatuor ventis veni
spiritus et insufla super infectos istos et
reviviscant et ingressus est in eos spiritus
(Ezek. 37)* (Come, spirit, from the four
winds, and breathe over those dead
men, and let them come back to life.
And the spirit entered into them.)
Library of the College of Physicians of
Philadelphia

1. J. B. Craven, *Doctor Robert Fludd
(Robertus de Fluctibus), the English
Rosicrucian: Life and Writings* (Kirkwall,
G.B.: W. Peace, 1902), 231.

2. See E. Weil, "William Fitzer, the Publisher
of Harvey's *De motu cordis, 1628,"
Transactions of the Bibliographical Society,*
n.s., 24 (1944):142-164.

3. For Fludd's use of biblical citations and
prophetic utterances, see Jacqueline Proust,
"Sur une iconographie de *Medicina
catholica* (1631) de Robert Fludd: L'invasion
du bastion de la santé," in *L'Europe de la
Renaissance: Cultures et civilisations*
(Mélanges offerts à Marie-Thérèse Jones-
Davies), eds. Jean-Claude Margolin and
Marie-Madeleine Martinet (Paris: Jean
Touzot, 1988), 244.

4. See Christine English, *High Matter,
Dark Language: The Philosophy of Robert
Fludd, 1574-1637,* exh. cat. (London:
Wellcome Institute for the History of
Medicine, 1988), 15.

5. Allen G. Debus, *The English Paracelsians*
(London: Oldbourne, 1965), 114-115.

6. Ibid., 115.

7. Walter Pagel, *William Harvey's Biological
Ideas: Selected Aspects and Historical
Background* (Basel and New York: S. Karger,
1967), 110.

8. See ibid., 113-114.

9. Ibid., 115.

**THIS ARRESTING FRONTISPIECE INTRODUCES** in an emblematic fashion Robert Fludd's treatise on the "new and secret history of the pulses, drawn from sacred sources yet compared with the sayings and authority of the pagan physicians." This work is the last part of an unfinished work, the *Medicina catholica,* an encyclopedia of medical knowledge concerned with physical and metaphysical aspects of health and disease. Fludd displays his dual approach to the pulse as a physical and mystical entity in the five books of the treatise. The first part deals with revealing "the radical mystery of the pulse"; the second, "the essential definition of the pulse"; the third, "the multiform difference in the method and progression of the pulse"; the fourth, "the different species of pulses"; and the fifth, "how the pulse demonstrates the presence of disease."[1] Fludd finished it by 1629, but the whole work was not published until 1631 by William Fitzer. An Englishman who had married into the family of the famous printer Johann Theodor de Bry (Cat. 60 and 81), Fitzer later established his own publishing firm. In 1628, perhaps at Fludd's suggestion, Fitzer published the first edition of William Harvey's revolutionary treatise on the circulation of the blood, *De motu cordis* (Cat. 23).[2]

Issuing from the clouds, the right hand of God is taking the pulse of a person, whose extended arm he holds. Following the prescribed directions for placing four fingers on the wrist of the patient's right hand, God acts as a physician, diagnosing the health or illness of his subject. Perhaps he responds to the words of the prophet Job, who complains of the pain he suffers at night, when his pulse or heartbeats do not slow down.[3] In typical fashion, Robert Fludd constructs complex allusions to his mystical interpretation of medical theory in terms of the analogies between the workings of the macrocosm and the microcosm (see Cat. 60). God, like the physician, diagnoses a patient's ailment by taking his pulse. The inferences drawn from this procedure take on a moral character, because of the connections between the pulse rate (equated with the heartbeat), disease, the four humors, and individual temperament. God can, therefore, judge a person's spiritual state by his or her physical condition, indicated by the nature of the pulse rate.

In Fludd's thinking, God also imparts life to man through spirits in the air brought by the four winds, corresponding to the four elements and four humors.[4] In the universe another life-giving force, light, comes from the rays of the sun. Fludd still maintains that the sun daily moves in a circular motion around the earth and, in a central tabernacle, houses God at its heart.[5] Below,

# PVLSVS.

## Seu

## NOVA ET ARCANA

# PVLSVVM
## HISTORIA, E SACRO
## FONTE RADICALITER
## EXTRACTA, NEC NON MEDI-
### CORVM ETHNICORVM DICTIS
#### & authoritate comprobata.

##### Hoc Est,

### PORTIONIS TERTIÆ PARS TERTIÆ,
### DE PVLSVVM SCIENTIA.

#### Authore ROBERTO FLVD

Armigero, & in Medicina Doctore Oxoniensi:

Nocte os meum perfora=  tur doloribus et
PVLSVS mei non re=  cumbunt. Job: 30. 17.

in the circular image, the heart is shown as analogous to the sun, as the organ that nourishes life by means of the blood moving throughout the body. Affected by the sun, the four winds "contain the breath of the Lord, which is the vital nutriment that is breathed into our bodies, formed into arterial blood, and then given to the body as that spiritual nourishment without which we would all perish."[6] The quotation from the prophet Ezekiel in the inner frame of the image asks that these winds breathe new life into the dead, symbolized by the dry bones and skulls distributed among them. Thus, in fulfillment of Ezekiel's prophecy (37:7-10), God restores life to their bodies by the breath imparted by the four winds.

Although the images in several emblems of the exhibition adopted a circular format (Cat. 77, 79, and 80), its use in the present engraving has special importance. The circular form had long symbolized connections between the macrocosm and the microcosm; here analogies occur between the life-giving, circular movement of the sun and the circulation of the blood, with the heart as its moving force.[7] In his treatise on the pulse (p. 11), Fludd, a friend and colleague of William Harvey (Cat. 23), voices the first published acceptance of the latter's revolutionary theory on the circulation of the blood.[8] Fludd does not ground his endorsement on physiological grounds, although he had witnessed Harvey's experiments. Instead he stressed the analogy of the contraction and relaxation of the heart's movement in circulating blood to the movement of the moon and the ebb and flow of the tides "to incite the spirit of the blood, and therefore the blood itself . . . to follow in a 'circular' movement."[9]

While the frontispiece is not an emblem book but part of a larger scientific-mystical work, the engraving shares the characteristics of a motto, explanatory verses, and a cryptic image. Here God's pulse-taking activity extends the role of the hand as a dual symbol of medical and spiritual authority.

CRS

# Bibliography of Frequently Cited Sources

*ADB*
> *Allgemeine deutsche Biographie.* Bayerische Akademie der Wissenschaften, Historische Kommission. Leipzig: Duncker and Humblot, 1875-1912.

*Ars Medica*
> Philadelphia Museum of Art. *Ars medica: Art, Medicine, and the Human Condition.* Exh. cat. Diane R. Karp et al. Philadelphia: Philadelphia Museum of Art, 1985.

[B.]
> This abbreviation, followed by a number, identifies a specific print in an individual volume of *The Illustrated Bartsch.* Edited by Walter L. Strauss. New York: Abaris Books, 1978–(Original ed., Bartsch, Adam von. *Le peintre graveur).*

Brückner, "Hand und Heil"
> Brückner, Wolfgang. "Hand und Heil im *Schatzbehalter* und auf volkstümlicher Graphik." *Anzeiger des germanischen Nationalmuseums* (1965):60-109.

Carruthers, *The Book of Memory*
> Carruthers, Mary J. *The Book of Memory: A Study of Memory in Medieval Culture.* Cambridge and New York: Cambridge University Press, 1990.

Cazort, Kornell, and Roberts, *The Ingenious Machine of Nature*
> Cazort, Mimi, Monique Kornell, and K. B. Roberts. *The Ingenious Machine of Nature: Four Centuries of Art and Anatomy.* Exh. cat. Ottawa: National Gallery of Canada, 1996.

Choulant, *History and Bibliography of Anatomic Illustration*
> Choulant, Ludwig. *History and Bibliography of Anatomic Illustration.* Translated by Mortimer Frank. Revised edition. New York: Schuman's, 1945.

Clarke and Dewhurst, *An Illustrated History of Brain Function*
> Clarke, Edwin, and Kenneth Dewhurst. *An Illustrated History of Brain Function.* Berkeley and Los Angeles: University of California Press, 1972.

*DBI*
> *Dizionario biografico degli Italiani.* Rome: Istituto dell' Enciclopedia italiana, 1960-.

*DOA*
> *The Dictionary of Art.* Edited by Jane Turner. 34 vols. New York: Grove's Dictionaries, 1996.

*DNB*
> *Dictionary of National Biography.* Edited by Leslie Stephen. 63 vols. London: Smith, Elder, 1885-1901.

*DSB*
> *Dictionary of Scientific Biography.* Edited by Charles Coulston Gillispie. 16 vols. New York: Charles Scribner's Sons, 1970-1980.

*EC*
> *Enciclopedia cattolica.* 12 vols. Vatican City: Ente per l'Enciclopedia cattolica e per il libro cattolico, 1949-1954.

*GBA*
> *Gazette des Beaux-Arts.*

Hollstein
> Hollstein, F. W. H. *Dutch and Flemish Etchings, Engravings, and Woodcuts, c. 1450-1700.* Amsterdam: M. Hertzberger, 1949-.

*JWCI*
> *Journal of the Warburg and Courtauld Institutes.*

Kemp, "'The Mark of Truth,'"
> Kemp, Martin. "'The Mark of Truth': Looking and Learning in Some Anatomical Illustrations from the Renaissance and Eighteenth Century," in *Medicine and the Five Senses.* Edited by W.F. Bynum and Roy Porter. Cambridge: Cambridge University Press, 1993, 85-121.

*Medicine and the Five Senses*
> *Medicine and the Five Senses.* Edited by W.F. Bynum and Roy Porter. Cambridge: Cambridge University Press, 1993.

*MGG*
> *Die Musik in Geschichte und Gegenwart: Allgemeine Enzyklopädie der Musik.* Edited by Friedrich Blume. 17 vols. Kassel: Bärenreiter-Verlag, 1949-1986.

*NCE*

    *New Catholic Encyclopedia.* 17 vols. Palatine, Ill.: J. Heraty, 1967-1979.

*NDB*

    *Neue deutsche Biographie.* Berlin: Duncker and Humblot, 1953-.

*NGD*

    *The New Grove Dictionary of Music and Musicians.* Edited by Stanley Sadie. 20 vols. London: Macmillan, 1980.

Roberts and Tomlinson, *The Fabric of the Body*

    Roberts, K. B., and J. D. W. Tomlinson. *The Fabric of the Body: European Traditions of Anatomical Illustration.* Oxford: Clarendon Press, 1992.

Saunders and O'Malley, *The Illustrations from the Works of Andreas Vesalius*

    Saunders, J. Be. de C. M., and Charles D. O'Malley. *The Illustrations from the Works of Andreas Vesalius of Brussels.* Reprint edition. New York: Dover Publications, 1973.

Saur

    *Allgemeines Künstler-Lexikon: Die bildenden Künstler aller Zeiten und Völker.* Munich: K.G. Saur, 1992-.

Schupbach, *The Paradox of Rembrandt's "Anatomy of Dr. Tulp"*

    Schupbach, William. *The Paradox of Rembrandt's "Anatomy of Dr. Tulp."* (*Medical History,* supplement no. 2, 1982). London: Wellcome Institute for the History of Medicine, 1982.

*The Mill of Thought*

    Corsi, Pietro, ed. *The Mill of Thought: From the Art of Memory to the Neurosciences.* Exh. cat. Milan: Electa, 1989.

Thieme-Becker

    Thieme, Ulrich, and Felix Becker. *Allgemeines Lexikon der bildenden Künstler.* 37 vols. Leipzig: Seeman, 1908-1950.

Thorndike, *A History of Magic and Experimental Science*

    Thorndike, Lynn. *A History of Magic and Experimental Science.* 8 vols. New York: Macmillan, 1923-1958.

Volkmann, "Ars memorativa"

    Volkmann, Ludwig. "Ars memorativa." *Jahrbuch der kunsthistorischen Sammlungen in Wien,* n.s., 3 (1929):111-203.

Yates, *The Art of Memory*

    Yates, Frances A. *The Art of Memory.* London: Penguin Books, 1969.

Yates, *The Rosicrucian Enlightenment*

    Yates, Frances A. *The Rosicrucian Enlightenment.* Frogmore, St. Albans, England: Paladin, 1975.

# Index of Authors
and Their Works

Hollandus, Johann Isaac (John Isaac
of Holland) (fifteenth century?)
*Sammlung unterschiedlicher bewährter
chymischer Schriften*
Cat. 73, pp. 239-242

Host von Romberch, Johannes
(c. 1480-1532/33)
*Congestorium artificiose memorie*
Cat. 35, pp. 148-149

Hundt, Magnus, the Elder (1449-1519)
*Antropologium de hominis dignitate,
natura, et proprietatibus*
Cat. 61, pp. 210-211

Indagine, Johannes ab (c. 1467-1537)
*Brief Introductions Both Naturall and
Pleasaunte...unto the Art of Chiromancy
and Phisiognomy*
Cat. 62, pp. 212-213

Ketham, Johannes de (Johann von
Kirscheim?) (fl. fifteenth century)
*Fasciculus medicinae*
Cat. 57, pp. 200-202

Khunrath, Heinrich (c. 1560-1605)
*Amphitheatrum sapientiae aeternae*
Cat. 71, pp. 234-236

Köbel, Jacob (1494-1533)
*Bauern compas*
Cat. 44, pp. 170-171

Marafioti, Girolamo
(Hieronymous Marafiotus)
(sixteenth–seventeenth century)
*De arte reminiscentiae per loca, &
imagines, ac per notas, & figuras in
manibus positas*
Cat. 39, pp. 158-159

Mersenne, Marin (1588-1648)
*Harmonie universelle, Traitez de
la voix et des chants*, vol. 2
Cat. 50, pp. 182-183

Meyssens, Jean (1612-1670)
*Images de divers hommes d'esprit
sublime*
Cat. 9, pp. 80-81

Mombaer, Jan (Johannes Mauburnus)
(c. 1460-1501)
*Rosetum exercitiorum spiritualium et
sacrarum meditationum*
Cat. 75, pp. 246-247

Montenay, Georgette de (1540-1581?)
*Emblemes ou devises chrestiennes*
Cat. 76, pp. 248-250

Pacioli, Luca (Lucas de Borgo)
(c. 1445-1517)
*Somma di aritmetica*
Cat. 43, pp. 168-169

Paré, Ambroise (1510-1590)
*The Workes of That Famous Chirurgion
Ambrose Parey*
Cat. 20, pp. 110-112

Peter Wiechs von Rosenheim,
(Petrus von Rosenheim) (c. 1380-1433)
*Rationarium evangelistarum, omnia in
se evangelia prosa, versu, imaginibusque
quam mirifice complectens*
Cat. 34, pp. 145-147

Petraglia, Francesco (fl. 1788) and
Pietro Berrettini [see above]
*Tabulae anatomicae ex archetypis egregi
pictoris Petri Berrettini Cortonensis*
Cat. 15, pp. 98-100

Praetorius, Johann (Hans Schulze)
(1630-1680)
*Ludicrum chiromanticum Praetorii;
Seu thesaurus chiromantiae*
Cat. 68, pp. 226-228

Prasperg, Balthasar (Balthasser
Praspergium) (died c. 1511)
*Clarissima plane atque choralis musicae
interpretatio*
Cat. 48, pp. 178-179

Pruthenus, Ludovicus (Ludwig
of Prussia) (fl. 1456-1494)
*Trilogium animae*
Cat. 26, pp. 128-129

Reisch, Gregor (d. 1515)
*Margarita philosophica*
Cat. 27, pp. 130-131

Remmelin, Johann (1583-1632)
*Catoptrum microcosmicum: Visio prima*
Cat. 59, pp. 206-207

Reutlingen, Hugo von (Hugo
Reutlingensis) [see Spechtshart, below]

Rosselli, Cosimo (Cosmas Rossellius)
(d. 1578)
*Thesaurus artificiosae memoriae*
Cat. 36 and 52, pp. 150-152
and 186-187

Rothmann, Johann (fl. 1595)
*Keiromantia or the Art of Divining*
Cat. 67, pp. 224-225

Saunders, Richard (1613-1687)
*Physiognomie and Chiromancie*
Cat. 4, pp. 70-71

Savigny, Christofle de (c. 1530-1608)
*Tableaux accomplis de tous les arts liber-
aux contenans brievement et clerement
par singuliere methode de doctrine....*
Cat. 49, pp. 180-181

Spechtshart of Reutlingen, Hugo
(Hugo von Reutlingen, Hugo
Reutlingensis) (c. 1285-c. 1360)
*Flores musicae omnis cantus Gregoriani*
Cat. 47, pp. 176-177

Valverde de Hamusco, Juan
(c. 1525-1587)
*Anatomica del corpo humano*
Cat. 14, pp. 96-97

Vesalius, Andreas (1514-1564)
*De humani corporis fabrica libri septem*
Cat. 5, 13 and 19, pp. 72-73; 92-95;
108-109

Vesling, Johann (1598-1649)
*Syntagma anatomicum*
Cat. 24, pp. 121-122

Vreeswyk (or Vreeswijck), Goossen van
(1626-after 1689)
*Vervolg van 't Cabinet der Mineralen,
of de Goude Son der Philosophen*
Cat. 72, pp. 237-238

Zincgref, Julius Wilhelm (1591-1635)
*Emblematum ethico-politicorum centuria*
Cat. 81, pp. 260-261

# Index of Artists

## Photographic credits

# Contributors

The curator of the exhibition is Dr. Claire Richter Sherman, author of *The Portraits of Charles V of France (1338-1380)* and *Imaging Aristotle: Verbal and Visual Representation in Fourteenth-Century France*. Dr. Sherman is Research Associate Emerita and former Project Head of *Sponsored Research in the History of Art*, published by the Center for Advanced Study in the Visual Arts, National Gallery of Art. She has published widely on medieval art and art historiography and lectures throughout the United States and Europe.

Brian P. Copenhaver is Professor of History and Philosophy and Provost of the College of Letters and Science at UCLA. Professor Copenhaver has served as a Dean or a Provost for eighteen years, eleven of them at the University of California. He is also a distinguished authority on philosophy and science in late medieval and early modern Europe. He is a Fellow of the American Academy of Arts and Sciences and past President of the *Journal of the History of Philosophy*. He serves, or has served, on the board of this journal and on those of *Renaissance Quarterly, Annals of Science*, the *Journal of the History of Ideas, Early Science and Medicine*, the International Archives of the History of Ideas, and the I Tatti Renaissance Library. Professor Copenhaver was educated at Loyola College (AB, 1964), Creighton University (MA, 1966) and the University of Kansas (Ph.D., 1970). He was a Fulbright Scholar at the University of Lyons in France, and as a Fellow of the American Council of Learned Societies he pursued post-doctoral studies at the Warburg Institute of the University of London (1975-1976).

Martin Kemp is British Academy Wolfson Research Professor of the History of Art at the University of Oxford. He studied natural sciences and art history at Cambridge and at the Courtauld Institute of Art, London. He is the author of *Dr. William Hunter at the Royal Society of Arts* (1975), *Leonardo da Vinci. The Marvellous Works of Nature and Man* (1981, winner of the Mitchell Prize), *The Science of Art, Optical Themes in Western Art from Brunelleschi to Seurat* (1990), *Behind the Picture: Art and Evidence in the Italian Renaissance* (1997) and numerous studies of the relationships between representation in art and science. He is currently researching issues in scientific imagery (specialist and popular), and writing a regular page on images in art, science, and culture for *Nature*. Forthcoming publications include *From a Different Perspective: Visual Angles on Art and Science from the Renaissance to Now*, and *Structural Intuitions: The 'Nature' Book of Art and Science*.

Sachiko Kusukawa is Fellow in the History and Philosophy of Science, Trinity College, University of Cambridge. She is the author of *The Transformation of Natural Philosophy: The Case of Philipp Melanchthon (Cambridge: Cambridge* University Press, 1995) and has research interests in the science and culture of the Renaissance and early modern period. Her recent publication includes "Leonhart Fuchs on the Importance of Pictures," *Journal of the History of Ideas* 58/3 (1997): 403-427. She is currently working on a monograph on the history of scientific illustration.

Susan Forscher Weiss is Chair of the Musicology Department at The Peabody Conservatory of the Johns Hopkins University. She is the author of *Bologna Q 18: I-Bologna, Civico Museo Bibliografico Musicale, Ms. BolC Q 18 (olim 143)*, Introduction and Facsimile Edition (Belgium: Peer, 1998); "Medieval and Renaissance Wedding Banquets and Other Feasts" in *Food and Eating in Medieval Europe* (London, 1999); "Bologna Q 18: Some Reflections on Content and Context," *The Journal of the American Musicological Society* 41 (1998); entries in *The New Grove Dictionary of Music and Musicians* (forthcoming in the seventh edition); articles and reviews on early modern music in numerous international journals and collections.

Design:
Studio A
Alexandria, Virginia

Printing:
Hagerstown Bookbinding and Printing
Hagerstown, Maryland

Paper:
Finch Vanilla Opaque, 80# Text
Vintage Velvet, 100# Cover

Type:
Minion